Discarded
SSCC

SHELTON STATE COMMUNITY
COLLEGE
JUNIOR COLLEGE DIVISION
LIBRARY

PR
5674
.T54
Z9

Trevelyan, Raleigh.

A Pre-Raphaelite
circle

DATE			

SHELTON STATE COMMUNITY
COLLEGE
JUNIOR COLLEGE DIVISION
LIBRARY

D1213052

© THE BAKER & TAYLOR CO.

A PRE-RAPHAELITE CIRCLE

By the same Author

★

THE FORTRESS
A HERMIT DISCLOSED
THE BIG TOMATO
PRINCES UNDER THE VOLCANO
THE SHADOW OF VESUVIUS

A
PRE-RAPHAELITE
CIRCLE

By

RALEIGH TREVELYAN

Discarded SSCC

Rowman and Littlefield
Totowa, New Jersey

First published in the United States 1978
by Rowman and Littlefield, Totowa, N.J.

ISBN 0–8476–6025–7

All rights reserved. No part of this publication
may be reproduced, stored in a retrieval sys-
tem, or transmitted in any form, or by any means,
electronic, mechanical, photocopying, recording
or otherwise, without prior permission

© Raleigh Trevelyan, 1978

Printed in Great Britain by
REDWOOD BURN LTD
Trowbridge and Esher

CONTENTS

PLATES

'Pauline, Lady Trevelyan, was a woman of singular and unique charm; quiet and quaint in manner, nobly emotional, ingrainedly artistic, very wise and sensible, with an ever-flowing spring of most delicious humour. No friend of hers, man or woman, could ever have enough of her company; and these friends were many, and included the first people of the day in every province of distinction.'

GEORGE OTTO TREVELYAN, writing to Edmund Gosse.

'As I approached the house, the door was opened, and there stepped out a little woman as light as a feather and as quick as a kitten, habited for gardening in a broad straw hat and gauntlet gloves, with a basket on her arm, visibly the mistress of the place.'

WILLIAM BELL SCOTT, on his first visit to Wallington.

'There once was a Lady Trevillian
Whose charms were as one in a million.
Her husband drank tea
And talked lectures at she,
But she had no eyes but for William.'

DANTE GABRIEL ROSSETTI.

'A monitress-friend in whom I wholly trusted.'

JOHN RUSKIN, writing about Pauline Trevelyan in 'Praeterita'.

'Except Lady Trevelyan, I never knew so brilliant and appreciative a woman.'

ALGERNON CHARLES SWINBURNE, writing about Elizabeth Siddal.

CHAPTER ONE

THE JERMYNS

THEY called her Pauline, but her real name was Paulina. She was born in 1816 at four minutes to eight in the evening of Thursday, January 25th, the feast of St. Paul, at Hawkedon Parsonage near Bury St. Edmunds. Her father, George Bitton Jermyn, was the curate at Hawkedon and, in later years, became well known as a genealogist, antiquarian and naturalist. He was proud of the family name, so he had her christened Paulina Jermyn Jermyn, to make sure that it would remain with her if she married.

She was the eldest child. Three brothers and two sisters survived. On her mother's side she had Huguenot blood, being descended from an exceptionally courageous woman, Louise Guichard, who had escaped from France in a cask. This Louise had married Jean Turenne, a master goldsmith from the Auvergne, another refugee though born a Catholic. Pauline was to suffer a great deal in later life, and no doubt her bravery was an inheritance from these people. One also imagines that she owed other qualities to them: her aptitude as a designer, her quick intelligence and her gift for languages. Her memory was extraordinary. She was unconventional and totally uninterested in 'Society'. She could have been accused of lion-hunting in the case of writers and artists, but popular success did not concern her—she sincerely wanted to meet and know those whose works she admired. In general company she tended to be quiet, but when alone with friends she was vivacious and teasing. She was small, just over five foot. Her hair was light brown, her eyes—her main feature—hazel. Her forehead was protuberant, which even in middle age made her look like a child. Her lips were full, as though pouting. Some thought her appearance attractive, others were uneasy in her presence and not therefore so taken by her looks. She believed in being totally frank and expected total frankness in return. She had a way of seeming to look straight through you on first acquaintance, of summing you up. She also enjoyed searching for hidden or innate talent, and encouraging it. Her correspondence was enormous. She was the sort to whom

7

people would unburden themselves and know that she would not betray their secrets.

Her father had been born in 1789, the son of a Suffolk solicitor. His grandfather had been a ship's captain, and his uncle was Henry Jermyn, a leading antiquarian in the county. He had gone to Caius College, Cambridge, in 1808, but after a long journey round the southern Mediterranean on heraldic research, had removed himself to Trinity Hall, taking his degree as a bachelor of civil law in 1814, the year in which he was also ordained into the Church of England. In 1826 he obtained his doctorate.

The name Jermyn was thought to be a corruption of German, though a family tradition linked it with St. Germanus of Auxerre. All Jermyns hailed from Suffolk, and the grandest of them had been another Henry, created Earl of St. Albans at the Restoration, Master of the Household to Queen Henrietta Maria and according to gossip her secret husband. It was he who gave his name to Jermyn Street in London, and who laid out St. James's Square and St. Albans Market (destroyed to make room for Waterloo Place). Pauline's father, however, in spite of his genealogical expertise, was never quite able to trace his exact relationship with this Henry, whose flamboyance and wealth were so far removed from the world in which he struggled to survive, first at Hawkedon, then for a couple of years at Littleport in the Isle of Ely, and finally for some nineteen years at Swaffham Prior near Newmarket. Henry's nephew had been the even more disreputable Lord Dover, in his turn supposed to have been married to Princess Mary of Orange (he was certainly a lover of Lady Castlemaine) and in due course a member of James II's Catholic cabal. The family seat of these Jermyns since the thirteenth century had been Rushbrooke Hall, near Bury St. Edmunds, probably the reason why Dr. Jermyn had been so attracted to Hawkedon in the first place.

Like his daughter Dr. Jermyn had a strong sense of humour. He also appears to have been somewhat vague, which was not at all the case with her, and consequently improvident, which she was not either. Whilst at the University he had made his mark as a botanist and entomologist, so that by the time he reached Swaffham Prior only a few miles away, he was already held in high regard in professional circles. He pursued all these various interests with tremendous verve, and expected his children to do likewise.

His wife had been born Catherine Rowland and was three years younger than himself. They were married at St. Martin-in-the-Fields on March 29th 1815. The Huguenot connection was on her mother's

side. Her Rowland grandfather had been a general, and her father,
Hugh Rowland, had run away from school in Bangor to seek his
fortune in London, eventually to become secretary to Lord Cardigan,
Comptroller to the Household to another Queen, Charlotte—hence
the fact that Catherine came to be born in St. James's Palace. One's
heart does rather go out to poor Mrs. Jermyn, with her ill-health, so
many children, very little money and a charming but feckless husband,
absorbed in his own hobbies. The family income was helped along by
Dr. Jermyn taking in pupils from Cambridge as lodgers, which
obviously added—as far as she was concerned—to household anxieties.
And yet in spite of all she remained cheerful and was even able to write
two or three (unpublished) novels on Italian Renaissance themes.

Another daughter was born in 1817, but died twenty days later.
Helen, or Nellie, was born at Littleport in 1818; Hugh Willoughby
in 1820; Turenne, or Tenny, in 1822; Rowland, or Powley, in 1824;
Mary St. Albans, or Moussy, in 1826. The elder children, particularly
Pauline and Nellie, were carefully trained to be industrious and helpful
about the house. The family as a whole was very high-spirited, with
the exception of Hugh—appropriate no doubt for one who was not
only destined for a Bishopric but a Primacy. Moussy (pronounced
Moossy) as a baby was exceptionally vociferous, but later she grew
very shy and there was even a suggestion that she might become a
nun—otherwise (Pauline being the reverse of shy) she was said to be
the one who most resembled her eldest sister.

On January 15th 1828 Mrs. Jermyn was delivered of a stillborn child.
She had been suffering from tuberculosis and had been told that her end
was near. A pathetic letter written to her mother on the 13th shows
that her spirit was nearly broken: '. . . My cough is almost gone away
with the frost, but in other respects I hardly know whether I may go
on suffering until the end of the month, or wish it soon over. . . . All I
know is that I suffer most miserably now, and yet dread the conclu-
sion still more.' No pupils were forthcoming from Cambridge, and
finances were low, which also 'fidgeted' her. Then on January 20th
she died. She was thirty-six. Pauline, soon to be twelve, was left to
run the household.

Swaffham Prior Vicarage, a red brick Queen Anne building, still
stands today in its circle of lawn, embowered all round by trees,
a perfect place for children to play in. The village has the unusual
feature of two adjacent churches, both with octagonal towers. When
the Jermyns came to Swaffham they found the newer church recently

modernized in the Gothic style, and the older and more famous one derelict. Some of the houses were sixteenth century. There were also two windmills. But the most exciting feature of the area, for such a family as the Jermyns, was the fact that it was on the edge of the Fen country, and close to Wicken and Burwell Fens, their undrained meres, reed beds, sedgefields and marshes unique then as now as sanctuaries for plant, insect and animal life. Pauline soon became almost as expert a botanist as her father.

From 1828 the neighbouring village of Swaffham Bulbeck had as its vicar a well-to-do young man with a name so similar to Jermyn that it caused much joking and punning in the neighbourhood: Leonard Jenyns. A courteous, rather formal person, he had coincided at Cambridge with Charles Darwin, whose close friend he became and who often went to visit him. It is said that Darwin had originally been put off by Jenyns' grim and sarcastic manner, but later found him to possess 'a good stock of humour'. Jenyns was also friendly with 'Beetles' Babington, who in 1827 had been succeeded as Professor of Botany at Cambridge by the great John Stevens Henslow, Jenyns' brother-in-law no less. Henslow was first approached for the position of naturalist on board the 'Beagle'; he had refused, and in turn had suggested Jenyns, who had in turn suggested Darwin. A story in the Jermyn family is that Jenyns turned down the chance for love of Pauline, by then fifteen.

Henslow, a man 'totally free from all selfishness, all vanity'[1], was also a good friend of Dr. Jermyn's. His enthusiasm made him one of the great pioneers in the teaching of natural history at Cambridge. He kept open house once a week, and Pauline was one of the few young ladies who were allowed to be regular visitors. She even 'stealthily admitted' herself to some of his lectures. Naturally both he and Darwin were likewise entertained at Swaffham Prior, before setting out on their botanizing and beetle-hunting trips in the Fens. Jermyn and Jenyns saw a great deal of one another and had reciprocal arrangements about taking services in each other's churches.

Alas, Pauline's feelings towards Leonard Jenyns were lukewarm, and she had a habit of disappearing when he was invited to her father's vicarage. She always maintained that she liked older men, and certainly her female contemporaries affected to be scandalized by her friendship with two other dominant personalities in the world of natural history at that time at Cambridge: Adam Sedgwick and William Whewell, both then bachelors, the one four years older than her father and the other five years younger. Sedgwick was Wood-

wardian Professor of Geology and the more immediately attractive character; Darwin had accompanied him on a tour of North Wales in 1831. In many ways Whewell, a tutor at Trinity College and its future Master, was Sedgwick's opposite: muscular, with a splendid brow, admired by women, but rather remote and a bit of a snob. He had been Thackeray's tutor but rarely bothered to see him. Indeed he was so unapproachable that he was said to have reprimanded his servant for not keeping him informed when his pupils died. In the early 1830s architecture and the study of tides were among his main interests, and in 1837 he published his awe-inspiring magnum opus, in three volumes, entitled *The History of the Inductive Sciences from the Earliest Times to the Present Day*. Like Henslow, both Sedgwick and Whewell were in holy orders. They also were frequent guests at Swaffham Prior.

At the end of 1828, the year that Catherine Jermyn died, Dr. Jermyn married for the second time, his bride being Anne Maria, daughter of Henry Fly, chaplain to the Royal Household and a sub-deacon at St. Paul's. As far as the young Jermyns were concerned this marriage appears to have been uneasy. Pauline in particular, is said to have been the 'despair of her stepmother', partly because of conflicts over responsibilities in the house, partly because she would not agree to being pushed into parties with girls and boys of her own age. Even when Thackeray and Edward FitzGerald came to supper, she barely spoke to them (which she was later always to regret). She liked to sit on the floor, kept an uncaged bullfinch in her bedroom, and wandered out alone into the Fens to talk to gypsies and sedge-cutters. No doubt if she had lived longer the new Mrs. Jermyn would have tried to encourage Leonard Jenyns' suit. But she died in December 1830, in childbirth, and her only daughter died five weeks later. It was a grim time for the family.

Pauline was again in charge. Her handwriting for her age was amazingly mature. She was a prolific writer of poetry, typically adolescent and mostly on morbid themes. She also wrote ghost stories. She painted fairly well and would save up her money each year in order to visit the Royal Academy in London. Copley Fielding and Turner were among her favourite artists. She had a very good knowledge of Latin and Greek, but Italian was her special subject, her tutor being the emigré Marchese di Spineto, one of the objects of Whewell's snobbery. The Marchese's daughter, Mary Doria, was one of her great confidantes, the other being Laura Capel Lofft, daughter of Capel Lofft the elder, author and reformer, and living at

Troston Hall, on the other side of Bury St. Edmunds. These two appreciated the teasing which also seems to have disturbed the young ladies of Cambridge. All in all her donnish friends in Cambridge found her fascinating and precociously clever, even alarmingly so.

On June 24th 1833 the third meeting of the British Association for the Advancement of Science opened in Cambridge. Sedgwick took the chair, and Henslow and Whewell were joint secretaries. Jenyns and Jermyn were among the distinguished scientists on the committee.

The first meeting, at York in 1831, instigated in the main by Sir David Brewster, had been a beacon in Natural Science, or Natural Philosophy as it was usually then called. For Natural Science was in a state of revolution and reorientation, particularly in the case of geology which had almost reached the status of a fashionable craze, even more than astronomy, the 'aristocrat' of the sciences. Harriet Martineau was to complain that books on geology sold more copies than a popular novel. Theories on fossils, prehistoric monsters and the stratification of rocks were threatening to overturn all preconceived ideas about the origin of the Earth's formation. The year 1830 had seen the first volume of Charles Lyell's epoch-making *Principles of Geology*, which Darwin had taken with him on the 'Beagle'. Arguments among scientists were fierce, disagreements were profound, religious beliefs were being threatened or shaken. Yet there was relatively little rancour involved; most of the protagonists were exceptionally civilized and likeable human beings, perfectly prepared for shifts in opinion as a result of new discoveries, which were indeed flooding in at a remarkable and exciting rate. One of the aims of the 1833 meeting was to encourage exchanges of ideas, thereby giving a 'stronger impulse and more systematic direction to scientific inquiry'. In later years passions were to be inflamed to an almost violent degree, particularly after the publication of *Vestiges of Creation* and *The Origin of Species*.

Pauline, now seventeen, attended each of the main lectures. Her original intention had been to draw portraits of the chief speakers, but almost immediately she became so absorbed by the lectures themselves that she gave up this plan. Instead she wrote full reports from memory, and so exact and valuable were they that Henslow and Whewell used them as a basis for their own official report when the meeting was over. Her transcription of Sedgwick's brilliant inaugural address— 'faithful and accurate, even to the very words uttered'[2]—had amazed everybody, for the professor's flow of unpremeditated eloquence had been such that reporters had been unable to keep up with it.

Whilst the 1831 meeting had been poorly attended, that of 1833 was packed with names famous in natural history. Coleridge was also to be seen in the audience. Rather surprisingly Jermyn was on the Anatomy and Medicine Committee. And one of the members of the Geology and Geography Committee was the learned, very reserved, darkly romantic, decidedly odd but rich Walter Calverley Trevelyan, aged thirty-six, heir to a baronetcy and great estates in Northumberland and South-West England. He had come to exhibit some coprolites (fossilized saurian faeces).

As things turned out, it is not surprising that Trevelyan and Jenyns did not much care for one another, though at first sight both might have seemed to have characteristics in common. Trevelyan was tall, olive-skinned with drooping moustaches and long brown hair. It is said that occasionally, very occasionally, he was prone to make practical jokes, but one would certainly not have guessed this. His energy was prodigious, his thirst for knowledge relentless—progress of any description, scientific or philosophical, appeared to magnetize him. Although considered by his relatives to be an outsider—a rather awesome one too—he came from a clannish family background, traditionally interested in natural history. Brewster was a friend of his father, and previously of his grandfather. Lyell had been his contemporary and friend at Oxford, and he was particularly famous for his scientific reports after a long expedition to the Faroe Islands in 1821. During the last fifteen years he had spent much time in Edinburgh. His fellow scientists and antiquarians respected him for his complete disdain of self-advertisement, and for the unselfish way in which he would enthusiastically undertake research for them, however arduous it might be.

On the eve of the opening of the Meeting Sedgwick gave a party. Both Trevelyan and Jermyn were invited and immediately became friendly. Trevelyan had expressed a longing to see Wicken Fen, and on July 3rd he drove in a gig to Swaffham Prior.

It was a busy day. In his diary he listed a number of plants, particularly his favourite ferns, that he had been able to collect. He visited the churches, sketched them, walked along the Devil's Ditch and attended a horse fair at the village of Reach. Back to the Vicarage to look at Jermyn's heraldry collection, including forty quarto volumes devoted to the histories of Suffolk families, and some curiosities, such as Greek vases and 'an armbone with amulet found with remains of skeleton and cinerary urn (Roman) in the neighbourhood'. Collections of insects were also produced. Jenyns came to dine, bringing with him

the skin of a Caspian tern. Last but not least he met Pauline, who had of course observed him from the audience seats at the Cambridge Meeting. 'Remarkable talent for languages and science,' he noted approvingly. She showed him the reports she had written, and he was appropriately impressed. 'Inherits her father's anterior development' was his last comment. Since he was a fervent believer in phrenology, this attribute—signifying individuality and order—was another good mark.

Just over a year later, in August 1834, Trevelyan—or Calverley as he was known in the family—was again at Swaffham Prior Vicarage. This time he stayed a week. 'Gave Dr. J. and Miss J. duplicates of my plants collected this year', he wrote, but that was his sole mention of Pauline in his diary. He was back for the night on December 12th. 'Examined with Miss Jermyn some of the wells about Swaffham in most of which there has been this autumn a dearth of water.' She presented him with specimens of maidenhair fern 'from a new locality near St. Ives'. No further comment, but this must finally have won his heart, for on that day they became engaged. Pauline in her journal wrote on December 31st: 'A most eventful year for me. What may be its influence on my fate, God only knows. Soit-il comme il lui plaît.'

Another week was spent at Swaffham in February. It was a tribute to Pauline's talents that Whewell had asked her to read and comment on the manuscript of his *Inductive Sciences*. Again, typically, there is no mention of this in Calverley's diary, in spite of the fact that Whewell himself was so delighted by her criticisms on his Undulatory Theory that he rode over from Cambridge (in a very high wind) to thank her. In any case the Trevelyan family was lukewarm about the romance. Indeed Lady Trevelyan, who soon put it about that Pauline was beyond her 'ken', had hoped that her son, now thirty-eight, would have stayed a bachelor.

On May 5th Calverley was at the Jermyns' once more. On May 20th he baldly wrote: 'Walked to Newmarket heath to gather *cineraria integrifolia*, which were not sufficiently advanced.' The entry on May 21st comes therefore almost as a shock: 'Married $8\frac{1}{2}$ a.m. in Swaffham Church to Pauline Jermyn Jermyn—by Rev. Mr. Casborne—and after breakfast left for London.' The witnesses included the Marchese di Spineto, Pauline's brothers Hugh and Tenny, and her father. Sedgwick, Whewell and Henslow were at the church, but no Trevelyan appears to have been present.

The first four days of their honeymoon were spent at the Crown

Inn, Sevenoaks, and in wandering round Knole Park, where Pauline drew some ancient trees. Then they took lodgings in Tunbridge Wells. Infants' schools, the need for more and better ones throughout the country, were now a special concern of Calverley's, so a stern lookout was kept for these institutions wherever they went on their journeying. Then they moved to London.

Up till now his diary had been mainly filled with dry archaeological, botanical and geological facts. There was rarely anything in it to do with personalities, let alone gossip. But Pauline was behaving as though she had been unleashed. Suddenly details of pictures and exhibitions began to intrude into her husband's diary, and one realizes that he was attempting to fall in with the type of life she had been yearning for. On the first day they went to an exhibition of water-colours by De Wint, G. R. Lewis and her beloved Copley Fielding. On the next they went to two sculpture exhibitions, one by Wyatt. Calverley managed, however, to divert her to a private inspection of Sowerby's collection of minerals and fungi, and they also went to the Zoological Gardens. Somehow, on that same day, they also fitted in a visit to the Deaf, Dumb and Blind Institution.

And in this manner their busy life continued. Pauline took nineteen lessons in watercolour painting from John Varley, who showed them sketches by Blake. They visited the Cosmorama and the Diorama, went to Kew Gardens and the Dulwich Gallery. There was an exhibi-tion of enamels by Henry Bone, and another of Vandycks and Rem-brandts that had been in Sir Thomas Lawrence's collection. Etty, Wilkie and Calcott were on display at Somerset House. The Trevelyans also went to the Unitarian Chapel in Portland Street, and were impressed: 'the form of prayer much improved by alterations and omissions,' wrote Calverley.

No attempt was made to meet his family in other parts of England. In any case time was short: 'Having obtained in London a passport from the Foreign Office signed by Lord Palmerston and dated the 31st July, and had it viséed at the offices of the French, Austrian, Sicilian, Saxon, Würtemburg and Sardinian Ministries, and the Swiss Consulate, I left London with Pauline on the 10th August. After visiting Winchester and Netley and part of the Isle of Wight, we steamed from Southampton at $6\frac{1}{4}$ p.m. on the 14th August, in the Liverpool steamer, 500 tons, for Guernsey.'

They remained abroad for the next three years.

CHAPTER TWO

THE TREVELYANS

IN origin the Trevelyans were Cornish and had been in a position of some prestige ever since an ancestor became powerful at Court in the reign of Henry VI. Calverley's father, Sir John Trevelyan, was the owner of two large houses, Nettlecombe Court in the Brendon Hills of Somerset and Wallington Hall in the Middle Marches of Northumberland. Although he was Deputy Lieutenant of Northumberland, he now spent nearly all his time in Somerset and London.

The Trevelyans, who pronounced their name Trevillian, had moved to Nettlecombe, once the seat of the Raleighs, in the sixteenth century. The house was rebuilt out of red sandstone in 1599, a deer park created, and the deep sleepy valley planted with oaks, a magnificent few having survived into the twentieth century. The family suffered much in the Civil War, so its head was rewarded with a baronetcy at the Restoration.

Sir John's grandfather had married Julia Calverley, sister of Sir Walter Blackett (he had changed his name to inherit property), the richest man in Newcastle, a Croesus 'immortal in the annals of charity and humanity'.[1]* As Sir Walter Blackett had no children, he left Wallington and 20,000 acres to his sister's eldest son, also called John. Each succeeding generation had to decide between Nettlecombe and Wallington as a 'first' home. When the choice became Pauline's and Calverley's it was Wallington. Some people could not understand why Pauline should shun such a beautiful place as Nettlecombe. But Wallington with its sweeping views and huge cloudscapes was as exhilarating as Nettlecombe was drowsy. Wallington, as Pauline used to say, was for those with vigour, but at Nettlecombe you succumbed too easily to its peculiar brand of enchantment and sank too comfortably into a compost heap of Trevelyans and Raleighs.

Wallington had originally been a Border castle. It had been bought by Sir Walter Blackett's grandfather from the Jacobite family of

* Sir Walter Blackett's grandfather on the Calverley side was the original of Addison's Sir Roger de Coverley, who in his turn was the grandson of Walter Calverley, the last man in England to have been pressed to death.

Fenwick and rebuilt in 1688 as a shooting-box.* A complete re-modelling began in 1738, and before long—according to the traveller Arthur Young—it became 'a piece of magnificence that cannot be too much praised'. Today the house, a combination of William and Mary and early Georgian styles, in its serene and stately grounds, presents an ideal eighteenth-century landscape, with just the right amount of ruggedness in the distance (Shafto Crags and Rothley Castle) and elegant softness (the beechwoods and James Paine's hump-backed bridge over the Wansbeck). Capability Brown went to school in the local village, Cambo; he was responsible for the ornamental lake at Rothley, part of the Wallington estate, and may well have assisted Sir Walter Blackett in the design of his park and garden.

Sir Walter loved rococo and employed the Francini brothers, Italians, for the plasterwork of sphinxes, garlands and baskets of flowers on the ceiling of the saloon. He built a Chinese pavilion, imported porcelain from Meissen and had himself painted by Reynolds. One of the loveliest aspects of the whole place was, and is, the clock tower above the stables—a cupola supported by nine columns, eighteenth-century perfection.

Nevertheless Sir Walter's nephew soon found that he preferred living in Somerset, where this huge and lovable man set about 'Adaming' the new wing at Nettlecombe and increasing the estates so that he could drive for nine miles on end over his own land. When his son made a fashionable marriage, to Maria Wilson, youngest daughter of Sir Thomas Wilson of Charlton House near Greenwich, he was glad to give him Wallington—where on March 31st 1797 Walter Calverley Trevelyan was born.

John Trevelyan the younger was very musical. He was also a good artist, had travelled much, was interested like most previous Trevelyans in natural history and antiquarian matters, and was one of the leading horticulturalists in the country. His features were fairly aesthetic, with the long slightly hooked Calverley nose much in evidence. Previous generations had been in Parliament as Tories, but he did not attempt to stand—one assumes because he did not want to upset his father by revealing Whiggish tendencies.

His wife was a handsome girl, high complexioned and of a commanding aspect. She too was blessed with a fine nose. If the Calverley

* Sir John Fenwick had the distinction of being the last man in England to have been beheaded (in 1697). By way of divine justice the horse, White Sorrel, which caused William III's death by stumbling on a molehill, had been bred at Wallington.

strain was in some ways responsible for the literary achievements of later Trevelyans, there is no doubt that her Wilson blood infused elements of eccentricity. One of her sisters married Spencer Perceval, the Prime Minister assassinated in 1812. Her mother was a great heiress, among others things Lord of the Manor of Hampstead, and very learned, if in an esoteric way—she is still regarded as a pioneer coleopterist. Maria was her favourite daughter and therefore benefited much when 'Dame Jane' died in 1818. Indeed, at the end of Maria's life, her income was £40,000 a year.*

By 1815 Maria had given birth to seven sons and six daughters, the two eldest sons previous to Calverley dying in infancy. None of the children, except one—Emma—were particularly good-looking, and some were downright plain. Most were musical, and most were inclined towards natural history. The girls hated being dragged away from Wallington, in spite of their mother's efforts to launch them socially. Ordinary people and country folk found the young Trevelyans brusque almost to rudeness, but this would not have been intentional on their part. Calverley was intellectually by far the most outstanding of them; Emma, who was an artist of some flair, and the cranky Arthur, with his egalitarian views, were the closest to him in interests.

At Harrow Calverley's best friend had been Fox Talbot, the eventual discoverer of the calotype process in photography. Between them the boys compiled a flora of the district. Calverley was in the habit of setting off on his botanizing trips at five in the morning and would often have to rush back to be in time for Chapel at eight. On one occasion he recorded that he rose at 1.30 a.m. Twenty miles or so were an average walk on a whole holiday. In 1816 he matriculated to University College, Oxford, where he was lucky enough to be taken up by that ebullient eccentric, Dr. William Buckland, just appointed Professor of Geology; during the vacations Calverley would undertake field work for him in the north of England.† After obtaining his degree

* Maria's nephew was the much maligned Sir Thomas Maryon Wilson, who has achieved a kind of posthumous notoriety as the man who wanted to turn Hampstead Heath into squares and terraces.

† Hedgehog, puppy, crocodile or even Siberian mammoth, recently hacked out of the ice, might well be on the menu if you were invited to dinner by Buckland. When taken to a foreign church to see a martyr's blood, said to be perpetually liquefied, he knelt down and licked some of it. 'I can tell you what it is', he said. 'It's bat's urine.' In Palermo he caused consternation by recognizing the bones of Santa Rosalia, the patron saint, to be those of a goat.

Buckland was also a family friend of the Trevelyans. On the publication of his *Reliquiae Diluvianae*, inspired by the discovery of fossilized hyena droppings in

he went to Edinburgh, the most convenient and best place to continue his studies, since not only was it within easy range of Wallington but still very much the Athens of the North. It was David Brewster, then editor of the *Edinburgh Journal of Science*, who fired him to visit the Faroes in 1821. Everyone in the scientific world appeared to like Calverley, or at any rate respect him. Alert, questing, reliable, enthusiastic, wealthy to boot, he seemed set for a very successful future. His 'grave demeanour' simply gave authority to his youthfulness. He was created a Fellow of the Royal Society of Edinburgh, and John Hodgson, collecting material for his massive history of Northumberland, relied much on his help and that of Emma, as leading experts on Border history. In 1822 he fell under the spell of George Combe, whose first lecture on phrenology was delivered in May that year. The precepts of this 'science' were to govern his behaviour for the rest of his life. He came to believe that it was not only the key to self-knowledge but the means of treating less fortunate human beings in a more humanitarian manner. People should be trained to work strictly according to their true capabilities, i.e. bumps. Insane persons and criminals could be helped by discovering their real aptitudes and potentialities. Thus he came to be opposed to capital punishment and flogging, and to alcohol, drugs such as opium, and tobacco, as weakening the will-power. He favoured state education for children, rich or poor; in this way one could be sure that every child would receive the correct moral training, which also would help to prevent crime.

Such an approach to life could have its drawbacks too. He had been attracted to a young lady from Oxford, but was compelled to reject her as a possible wife for phrenological reasons. Her bumps showed that she had not enough talent for drawing. Worse, though in due course fortunately for Pauline, she was a 'negative in pecuniary matters' and 'always hesitating in the execution of resolves'.

When Calverley's father inherited the baronetcy at the age of sixty-seven, he decided that he had always preferred Nettlecombe and that henceforward it would be his main base. Unfortunately, Maria had other ideas. She liked Wallington best. As both she and her husband were strong characters, they began to drift apart.

Then gout—the family affliction—began to cripple the new Sir John, and he was often immobilized. He rarely saw his sons and was bored by his daughters (except Emma) and their husbands. As a result

Kirkley Cave, Yorkshire, old Sir John was sent this anonymous rhyme: 'Approach, approach, ingenuous youth/And learn this fundamental truth:/The noble Science of Geology/Is firmly bottomed in Coprology.'

he became very lonely. Occasionally he decided he must visit Wallington. When Maria heard of this, she would move out and arrange for their carriages to pass at a particular spot so that family news could be exchanged through the windows.

He was in his mid-seventies when he suddenly lost his heart to a young girl; and this girl was Clara Novello, whom he had first seen when she was sixteen, singing with Grisi and Tamburini in Westminster Abbey. The story is touching, but its details have no place in this book. She was beautiful and gifted, obviously destined for fame, a contrast to his own offspring. He sent her presents and gave her the right introductions. As her triumphs increased, she continued to write him letters that were unaffected, glowing and genuine.

Naturally the situation did nothing to help with Maria. Nor were her feelings softened when Sir John suggested that she should move out of Wallington, which would then be made over to Calverley, just as his own father had done when they had married. In any case she disapproved of Pauline, who was obviously 'after' Calverley's money. She thought that the Jermyns lacked conventional social graces and it was scandalous that Pauline should have been allowed to spend so much time with bachelor dons. No wonder Calverley was happy to agree to Pauline's proposal that they might live in Rome for a while.

In Rome Pauline at once sought out the artists' colony, especially Joseph Severn, John Gibson and William Ewing (who had been at Keats's funeral). One reads of her brilliant parties, where all the European and American intellectual celebrities of the day foregathered.[2] Presumably they were not altogether teetotal parties, in spite of Calverley being nicknamed the 'Apostle of Temperance', for Pauline in later years insisted that wine should always be available for guests. She attended lectures and sermons, collected books, botanized in the Campagna and was taught Egyptian hieroglyphics. Among her particular friends were the Prussian Minister, Baron Bunsen, a man of enormous erudition, and his English wife; in due course the Trevelyans became their neighbours in an apartment in the 'divinely' situated Palazzo Cefarelli above the Forum. Then, as a disciple of Pusey, she sought out Nicholas Wiseman, Rector of the English College, and 'argued' with him about the Oxford Movement.

After a tour of ancient Etruria the Trevelyans went to Florence, where Pauline became seized with a plan to build up a collection of Italian masterpieces, which one day could be kept at Wallington. Calverley seems to have acquiesced without complaint in such a costly

operation. After much haggling, they bought a Luca Della Robbia, a Domenichino, a Ghirlandaio, a Sodoma and a Piero Della Francesca.*

They went to Naples, which Calverley disliked but Pauline loved. She made him take her out in a boat by moonlight and climb Vesuvius on muleback. They drove as far as Paestum, and on the way back, at Salerno, Pauline danced the tarantella with local men and women on the terrace of the inn until long after midnight. And on June 15th 1838 they embarked for Marseilles, en route to Weymouth and Nettlecombe.

Sir John obviously was impressed by his daughter-in-law, for on arrival she immediately said the right things about his pleasure gardens and was sympathetic about Clara Novello. He even decided to join Calverley and Pauline at the British Association meeting in Newcastle in August—travelling, however, alone by carriage, as Pauline was determined to try out the new Birmingham-Manchester railway.

Surprisingly, Maria was at Wallington to greet them. Not a word, however, was said about her moving out. Calverley's very masculine eldest sister, Julia, was also in the house and took an immediate dislike to Pauline—never to be diminished.

Newcastle was being transformed into an elegant Neo-classic metropolis, one of the most ambitious pieces of town planning so far achieved, even if slightly old-fashioned by 1838 standards. It was booming, mainly owing to the railways and the rapid expansion of the coal and iron industries. Moreover, it was the city of the Stephenson engineering works. An ideal setting therefore for a British Association meeting. Old friends were there—Buckland, Whewell, Brewster, Jenyns—and they all came to stay at Wallington. Other learned guests included Roderick Murchison, who had been speaking on the Silurian System, and Charles Wheatstone, who had just taken out a patent for the telegraph.

Afterwards Pauline and Calverley went to Edinburgh, which Pauline at once decided was her favourite city next to Rome. Since Wallington was obviously not going to be available to them, and Pauline could not abide to be there with Julia, it was decided to make Edinburgh their home when they were not on the Continent.

In those days leading up to the disruption of the Scottish Church Pauline duly 'paid homage' to 'that marvel' Thomas Chalmers, whose sermons—she said—were an even greater experience than listening to

* The Piero is now in the Sterling and Francine Clark Institute, Williamstown, Mass. The Sodoma, reascribed to Procaccini, is now in the National Gallery, London.

Wiseman. She became very fond of the publisher Robert Chambers and his vivacious wife. Occasionally she was permitted to accompany Calverley to lectures at the Wernerian Society, and she also helped in the arrangement of one of the sensations of 1839 in Edinburgh, namely a display of Fox Talbot's 'photogenic drawings'. Calverley was on several committees and attended lectures almost daily, on subjects as varied as oxygen, urine and the parasites of starfish.

The 1840 British Association meeting was in Glasgow. Again familiar faces were to be found there. Buckland was in topmost form, and as peculiar as ever. Thanks to him the young Swiss geologist from Neuchâtel, Louis Agassiz, had also arrived, with his revolutionary theory about the Ice Age. Agassiz and Pauline took to each other immediately, and Calverley found his broad forehead and eyes set far apart interesting phrenological symptoms.* It was therefore suggested that the Trevelyans should join Agassiz and Professor and Mrs. Buckland—an extraordinary figure, who would not seem amiss on the stage today as Charley's Aunt—on a 'glacier hunt' in the Highlands, and in particular to investigate the mysterious parallel roads of Glen Roy, on the side of Ben Nevis. The high-spirited expedition is almost legendary in the annals of Natural History. After some days of noting down details of moraines, scratching, gravel, etc., Agassiz—later to achieve great eminence at Harvard University—became convinced that the whole of Scotland had been under ice in prehistoric times.

That winter Pauline was suffering from a swollen face and *tic douloureux*, rare for someone so young (twenty-five). It persisted so long that the doctors in Edinburgh said she must go abroad again. So it was decided to take up Agassiz's invitation to Neuchâtel and possibly proceed to Greece and the Near East.

Meanwhile the Jermyn family was in a state of disintegration, for Dr. Jermyn was leaving the country, 'like a wandering Jew' never to settle anywhere or even to return to England. Quite why this happened is still a mystery. Was it because of ill-health, or a scandal, or some disagreement over Tractarianism with the Bishop? Or was it— more likely—due to debts? 'My heart is sick,' he had written pitifully to Pauline. So Powley was having to go with the Army in India,

* Calverley read a paper on the Northumbrian historian Hodgson's 'diseased organ of language'. On Hodgson's death in 1845 a thorough post-mortem revealed that some of his main ailments were due to 'torpid lower intestines'. Hodgson had been inordinately fond of game, which he swallowed too greedily, and his intestines had become blocked with lead pellets. A steel pen-nib was also found in his colon.

Hugh into the Church, Tenny with the Navy in China, and Moussy for a while was to live with the Trevelyans. Dr. Jermyn's natural history and antiquarian collections were sold up at auction. All the insects were bought up by the awesome Dr. J. A. Power, tutor in medicine at Clare who promptly proposed to and was accepted by Nellie Jermyn—a relief in a way, as although he too was very hard up, not to say parsimonious, she would at least be cared for.

The brunt of supporting Dr. Jermyn now fell on Pauline. She was writing articles for *Chambers's Edinburgh Journal* and persuaded Robert Chambers to publish some offerings by her father. After a while Dr. Jermyn's work became hopelessly 'involute' and this meagre source of income therefore ceased. He went to live on the island of Maddalena off Sardinia—close to Caprera where Garibaldi was to spend his last days, and here he lived the life of a peasant, perfectly happily.

During the Spring of 1841 Calverley had been approached about standing for Parliament as a Whig. This had been at the instance of his first cousin Charles Trevelyan, Assistant Secretary at the Treasury. However Calverley, although he was a strong supporter of Lord John Russell, did not feel like the expense. He also disapproved of signing any sort of pledge, let alone of canvassing. His opinions, he said, were independent, and he did not think it right that soliciting should come from the proposed candidates, to which Charles had said he was truly sorry, for he believed Calverley to be a 'Whig of the genuine sort'. Pauline announced that she was 'selfishly' pleased about the decision as they would otherwise have had to cancel their foreign travels.

The Charles Trevelyans were to play an important part in Pauline's life. She considered that they lacked warmth, and she was probably right. If they possessed a sense of humour, it was different from hers, and from her point of view they were, quite simply, philistines. Yet she respected them far more than she did her husband's nearer relatives. Charles was married to Macaulay's sister, Hannah, and was a strong Evangelical, a newcomer to the Clapham Sect. He had had a spectacular career in India, where he had met his wife.* Macaulay described him as 'a man of genius, a man of honour, a man of rigid integrity and of a very kind heart . . . zeal boils over in all his talk'. 'Genius' was an exaggeration, but the rest was true. Charles also had a formidable energy, a passion for detail and very great moral courage. But he was

* Whilst in his early twenties in Delhi Charles had succeeded in toppling his superior, the President, Sir Edward Colebrooke, for corruption. He had met Hannah More Macaulay in Calcutta, her brother then being on the Supreme Council.

relentless and lacked humility. What he believed to be right was right, and there was nothing more to it. In several ways he and Calverley had characteristics in common—witness Macaulay's remark that even in courtship Charles's topics had been steam navigation, the equalization of sugar duties and the education of the natives.

Macaulay was M.P. for Edinburgh and Secretary of War. Hannah, whom Pauline found 'very nervous', took her to the great man's chamber in Albany when he was out. It was like 'tiptoeing into a very comfortable shrine', all lined with books and 'not very brightly' furnished. A contrast indeed to visiting Turner in Queen Anne Street, where an old woman 'with her head wrapped up in dirty flannel' opened the door. On faded walls 'hardly weather-tight', and among bits of old furniture 'thick with dust like a place that has been forsaken for years', Pauline saw 'those brilliant pictures all glowing with sunshine and colour—glittering lagunes of Venice, foaming English seas and fairy sunsets—all shining out of the dirt and neglect, and standing in rows one behind another as if they were endless'. The 'Carthage' was at one end of the room and the 'Téméraire' lit another corner. Then there was Turner himself, 'careless and kind and queer to look upon, with a certain pathos under his humour'.[3]

Calverley, on that visit to London, bought Pauline a drawing by John Varley, who came to breakfast and was encouraging about her own sketches done in Elba. She was taken to the Diorama to see David Roberts's views of Bethlehem—'the change of light', as Calverley put it, 'well managed, the illusion assisted by a fine-toned organ (barrel) which plays Mozart's *Gloria*'. The Bucklands, Chamberses, Bunsens were all in London. So was Sir John Trevelyan, again free of gout and thoroughly enjoying himself, driving around with pretty girls like a boy of twenty. He often went with Calverley and Pauline to the Novellos', who always referred to him as the 'gay baronet'. Clara was in Italy—the Scala had offered her a three year engagement, but this had been refused until she could 'command the highest terms'.

Calverley and Pauline left London on June 30th in the bustle of the Election. At Neuchâtel a package from Charles was waiting for Calverley. It contained a volume of reports on the training of pauper children and a letter full of political news following the Tories' victory. 'If you had stood for Wells,' Charles said, 'you would certainly have been elected.'

NEUCHÂTEL, ATHENS, LISBON

1841-46

Within a couple of days of their arrival at Neuchâtel the Trevelyans had climbed up the Hospice de Grimsel, in a desolate basin six thousand feet up, with gigantic peaks on all sides. Some two thousand feet higher, on the Aar glacier, there was a kind of observation shack, known affectionately to scientists as the Hôtel des Neuchâtelois. Pauline was very disappointed when 'that miscreant Caly'. forbade her to spend the night in it with Agassiz and others, all male and including his assistant Desor and James Forbes, the dour Professor of Natural History in Edinburgh. She did however watch Agassiz being lowered by rope 120 feet into the blue heart of the Aar glacier, an extraordinary and very foolhardy undertaking.

Michael Faraday joined them at Grimsel. Then foul weather descended, and everyone was marooned at the hospice for a week. As Forbes wrote later, 'Mr. and Mrs. Trevelyan must often have remembered those pleasant days, when the logs crackled in the great open hearthstone and the storm raged without.'[1] Desor entertained them with impersonations, Agassiz lectured on glaciers, Forbes on the chemistry of heat.

On August 28th Agassiz led a party, again an historic occasion scientifically, up the Jungfrau. On the 23rd Forbes and Calverley had been to the glacier of the Rhone, an expedition with findings that were to lead to violent controversy between Forbes and Agassiz, who became known as 'the fighting glaciators'. Not that Pauline's affection for either party was shaken.

The next six months were spent in Rome, during which time Pauline decided that she had become a republican. Her English friends nicknamed her 'La Cittadina'. Early in April 1842 the Trevelyans landed at Corfu. They put up at a modest hotel, but were almost immediately spotted by the voluble widow of Sir Humphry Davy, who introduced

them to the High Commissioner, James Stewart-Mackenzie. So they soon found themselves staying at the Palace.

The High Commissioner's wife was heiress to the last Lord Seaforth and very formidable. Sir Walter Scott had said of her that she had the 'spirit of a chieftainess in every drop of her veins'. 'With which remark I heartily concur,' said Pauline. A fourteen-year-old Stewart-Mackenzie daughter, Louisa, was just emerging from a serious illness, and Pauline fell entirely under her spell, so much so that when they parted a pact was made that henceforward they would call each other 'sister'. It was a friendship that intensified over the years.

During May and June the Trevelyans visited Athens and toured round mainland Greece. They found Athens to be a city of international plotting and intrigue and formed the greatest contempt for the Bavarian king. The trip round the Peloponnese was arduous, and a guard ('so handsome, in a kilt') was necessary because of the possibility of robbers. Pauline made innumerable sketches, some of which are now in the British Museum. The heat was enormous. 'Even the moonlight seemed too hot' at Olympia. At Tripolitza, however, it was cooler, and here again she joined in a dance with the locals 'to the inharmonious notes of a rude guitar'. Sometimes they camped in olive groves, but at Georgitza a farmer insisted that they should sleep in a barn where silkworms could actually be heard munching in wicker baskets overhead; all evening people came 'peeping through the door, or even walking into the room to stare'. Then they hired a boat and were nearly shipwrecked off Nisida—'worth while' for Pauline because she had to be carried to safety by the muscular sailors (Calverley being too occupied with saving the camera lucida). She obviously tried to be sympathetic when Calverley had to drink retzina as the only alternative to goat's milk, which he hated. Needless to say his diaries were full of scientific jottings. Alluvial plains, elevations of gravel and conglomerate tertiary on the way to Sparta were carefully noted. On his return to Edinburgh he wrote a much praised paper for the Geological Society on the 'scratched surfaces of rocks near Mount Parnassus'.

Further travelling had to be abandoned because of Sir John's illhealth. Pauline, however, could not bear missing Rome again on the way home. First they went to Siena, where they saw the Palio, which Calverley found 'pretentious' but she adored. A main reason for her wanting to return to Rome was because Wiseman, now consecrated a Bishop, had arrived there. Being now a confirmed Tractarian, she had been disturbed by his article on the Donatist heresy, that had appeared

in the *Dublin Review* of July 1839, the very article that had been responsible for Newman's 'agony of conscience'. She did see Wiseman, but we have no record of the results. In any case thereafter there was never any question of her wavering towards the Roman Catholic Church, which had once seemed probable.

It was very hot in Rome, with some thunderstorms. On her last evening Pauline and some sculptor friends hired a carriage and went splashing round the flooded Piazza Navona. Everyone was drenched, and it was fun. Before leaving she and Calverley went up to the Capitol to 'admire for the hundredth time the dying gladiator'. They headed for Perugia, where in turn 'we readmired our favourite Baroccio, "The Descent from the Cross"'. Somehow it was a sad journey home, as if they were seeing Italy for the last time—as indeed turned out to be the case.

Most of the winter of 1842–3 was spent at Nettlecombe, with occasional visits to London. Sir John had not heard that Clara Novello was engaged to an Italian count, Giovanni Battista Gigliucci of Fermo. Pauline called on the Novello parents and was told the news; she also noted that the 'magic wand of the Fairy Godfather' was still exerting its benign influence. She went to Cambridge to see Whewell, who was not only married but now Master of Trinity—she hardly dared to meet 'such a distinguished potentate',[2] she had told him. As for Sedgwick, she predicted, rightly as it turned out—that he was 'such a sad flirt' that he would remain a bachelor 'until the end of the chapter'. She picked up her correspondence with Mrs. Buckland, who disapproved of her religious views. Had Mrs. B. 'seen sense' and got herself converted to Tractarianism yet? To which there was a reply in a now familiar style: 'Cara mia Santa Paulina, I have enough to do to train up my children in the way I consider they should go (that will not be in the Pusey path) without risking the faith I now possess, and for which if I had lived in Bloody Mary's reign, I should have been grilled: an operation by no means pleasing. . . .'

Nor had Mrs. Buckland ceased to tease about Calverley's views on alcohol. After a meeting in London she wrote: 'I hope you do not look so thoroughly fagged today. I shall go on entreating Mr. Trevelyan to get you out of this total abstinence mess. I am sure a glass of porter would invigorate your frame.' A forlorn hope. Calverley was as ardent in the cause as ever, and two years later was responsible for presenting a petition to the Commons for reducing the number of public houses in the country.

The decisive day of the Disruption in Edinburgh had been on May 18th 1843. The Trevelyans dutifully attended Chalmers's first lecture following it. Much as they admired him, and particularly now for the work he was doing for the destitute of the city, they felt alarmed for the fate of the city's Episcopal Church. Lord Medwyn, an Edinburgh judge, gave a music party. During the reception afterwards he proposed that Episcopalians of Tractarian sympathies should build an entirely new church with a school attached in a poor area of Edinburgh. The idea at once caught fire. By January 1844 a temporary school was opened, with an enrolment of a hundred children. Calverley subscribed £20, Pauline £10, Medwyn £30. The list of founders also included the names of four bishops and that of William Ewart Gladstone.

In fact the new church, called St. Columba-by-the-Castle, was not begun until 1845. There had been strong opposition to it in Edinburgh, until the bishops' support became known. Pauline was one of the church's most active propagandists. She donated a window and advised on the design of the font, and it was her brother, Hugh Jermyn, who preached at the consecration on January 19th 1848. The church at the time was the only one with a surpliced choir in Edinburgh. As for the school, it was later fairly claimed that it was an early version of the famous Ragged Schools of Lord Shaftesbury.

Now that he was back in Edinburgh Calverley was busy once more with his scientific studies. He also went to meetings to 'promote baths for the working classes' and 'a weekly music and dancing assembly' in the lunatic asylum. He deciphered an old bede roll found at Nettlecombe. As for Pauline, she was swept away in admiration for *Modern Painters* vol. I, by John Ruskin, referred to as 'Mr. Ruskell' by Calverley, in a letter to Buckland otherwise mostly about the varying shape of fish bones. Indeed she was convinced that the book was a work of genius. Not only did she completely agree with Ruskin's attack on conventionality in art ruining young talent—nothing ought to be tolerated except 'simple bona fide imitations of nature'—but the book said 'everything about Turner I ever felt, or even did not know I felt'.

A friend from Roman days in 1838 was working at the Infirmary in Edinburgh. This was Henry Acland, a member of an old West Country family well known for generations to the Trevelyans. Pauline soon discovered that he had been at Christ Church with Ruskin and pressed for more information about her new idol. It was rumoured that the friendship between the two men had started when Acland intervened as Ruskin was being ragged by commoners in Tom Quad. It has also

since been suggested that Ruskin attached himself to Acland for snobbish reasons, but this is unfair. There is no reason to doubt that Acland gave him 'the good of seeing a young English life in its purity, sagacity, honour, reckless daring and happy piety'. If geology to Buckland was only 'the present occupation of his own merry life', to Acland 'physiology was an entrusted gospel of which he was the solitary and first preacher to the heathen'.[3]

At any rate Pauline was promised an introduction some day. In the early summer of 1844 Acland accompanied the Trevelyans on an expedition to the Bass Rock to look at gannets. Then the Bucklands arrived. Fish-hatching became the great preoccupation on this trip: whether or not it was good policy to feed the fry with sheep paunches. They were all travelling in North Wales when *Vestiges of the Natural History of Creation* burst on the literary and scientific world. Violently attacked or extravagantly praised, it appeared anonymously. The real author was Robert Chambers, and it has been said that only four people knew the secret, one being Robert Cox, editor of the *Phrenological Journal* and George Combe's nephew.

Brilliantly written in popular style the book considered man 'zoologically and without regard to the distinct character assigned him by theology'; man took his place 'as the type of all types in the animal kingdom'. The author was assailed at once as a blasphemer, an atheist and a materialist. Sedgwick attacked the book passionately, and Sir John Herschel was another formidable opponent. Darwin was all in favour, for in many ways it was a herald of his own views in the *Origin*. It was suggested that the Prince Consort might have been the author, or Thackeray, or Lyell, or Combe, or Lady Lovelace, Byron's daughter. There is a description of a dinner party in Edinburgh, when 'a noisy *gobe-mouches*' turned to a fellow guest, a lady novelist, 'a very clever, eccentric person, having besides the reputation of dabbling a little in science'. ' "I have a strong suspicion", the man said, "that my vis-à-vis, Mrs. —, is the author of that naughty book. Is it not so? Come on, confess. You cannot deny it".' The lady pretended to hesitate and look embarrassed. She said nothing, but shook her head 'in a sly significant way'.[4] A theory is that she was Anna Jameson, but Trevelyans like to think she was Pauline. Sometimes Chambers and Calverley would go together to Calton Hill to see Robert Adamson's calotypes, a new sensation in the city. Two years previously Fox Talbot had asked Brewster to find someone to practise calotype professionally, and Adamson, a brother of a colleague of Brewster's at St. Andrews, had volunteered. He was now in partnership with another

of Pauline's friends, David Octavius Hill, secretary of the Scottish Academy. Hill had been present at the Disruption, and again at the suggestion of Brewster, had embarked on the task of photographing all the 474 who had signed the Deed of Demission. A hundred and thirty years later some of the fruits of the Hill-Adamson partnership were acquired by the National Portrait Gallery in London for over £32,000.

Calverley's association with the St. Columba Church venture had made him more aware of the need for better drainage and ventilation in the overcrowded sections of old Edinburgh. He thus found himself in the centre of schemes for erecting model working class apartments, to be let out at specially low rents.

Clara Novello had arrived in London at the end of March 1843. After her first appearance at Drury Lane, in *Sappho*, her father wrote in wildest enthusiasm to Sir John: 'I have no hesitation,' he said, 'in saying that now the enchantress Malibran [died 1836] has been snatched from us, Clara is the greatest singer in the *world*.' He was probably right. Since severe gout had hit Sir John once more, Clara came to see him at Nettlecombe after singing in Dublin. The news was then broken to him about the engagement. He must have taken it very well, for we know he interceded with Mrs. Novello, who was against the marriage. He provided a wedding veil of Honiton lace, sent orange blossom from his greenhouses and pheasants for the breakfast. As Clara's sister Emma told him, the cake was covered with his blossom. 'After the health of the Bride and Bridegroom had been drunk in champagne, yours was given in fine old claret. . . . So you see you were nearly the occasion of some of us getting tipsy!!!!'

Some strain was developing between Calverley and his father. Calverley had been married for ten years, and there was no sign of a child, and he was nearing fifty. It appears that there was a suggestion that Sir John's will should therefore be revised. Nettlecombe was entailed, but not Wallington. According to some later descendants, Sir John at that time was preparing to entail Wallington but Calverley was being deliberately elusive. No doubt Calverley was concerned about inadequate provision for Pauline in the event of his own death.

Property at Seaton in South Devon had recently been returned to the Trevelyan family after a very long chancery suit. Calverley and Pauline visited it, not only for geological reasons but because they had had the exciting idea for turning this pretty little fishing-village into a modern Gothic resort. A school would have to be built, and

there must be a sea wall and a promenade. They would restore the church. . . . Calverley was delighted to hear of the possible discovery of a Roman fort near the town. And Pauline found that at the neighbouring village of Beer, once famous for its smugglers, the local women made beautiful bobbin lace.* They were desperately poor, and her heart was touched. She would help them to get their work known, sell for them in London and Edinburgh, take orders, make designs herself. Plans were 'buzzing' in her head.

Meanwhile Buckland had been appointed Dean of Westminster and was living 'in the shadow of the Abbey'. The family pets included snakes, newts, monkeys and a white-tailed fish-eagle. The Deanery was full of rats, but this was an advantage, as they could be caught and tamed. His son Frank's bear, Tiglath-Pileser, once a well-known figure at Oxford and sometimes to be seen in cap and gown, was now dead, but it had been stuffed and stood on the stairs at Westminster.

Pauline and Calverley saw the Bucklands often whilst in London, and were taken round Barry's new Houses of Parliament. On the whole Pauline tended to avoid the breakfasts when the entertainment was to watch worms and other creatures being electrocuted. There were great plans for improving the living conditions of the boys at Westminster School, and Calverley gave advice on sanitation, gleaned from his work in Edinburgh. Charges were to be reduced, the diet improved, blankets and counterpanes cleaned, a sanatorium created.

At last Calverley consented to Sir John's wish that he should go to Wallington on his way to Edinburgh. It was a surprise visit, ostensibly to make arrangements for a new bailiff. He decided to find rooms in the village of Cambo and not to stay in the house. When at last he made his appearance, he found his mother was about to set off for Rothley Lake, and needless to say he was persuaded to stay the night at Wallington itself. After she had gone, he made a tour. 'Went to gardens and plantations,' he noted, 'and endeavoured to put a stop to the devastation Lady T. is committing on many of the fine trees by cutting off their hanging branches. . . . Too late to save some of those which were most ornamental and near the house.' Then: 'In the evening had a storm for my interference about the unfortunate trees.' There was far worse to come in future years.

Sir John was soon demanding that Calverley should return to

* Honiton lace, as all lace made in that area of South Devon was called, had already gained popularity after it had been used for Queen Victoria's wedding dress.

Nettlecombe. He was very frail and hardly ate, literally starving himself to death, the family said. Instead, on February 16th 1846, Calverley and Pauline sailed from Southampton to Lisbon.

It was quite an adventure, for, as Chambers had warned them, Portugal was 'the very most untrodden ground of any in western Europe', and Lisbon had the reputation of being the dirtiest capital. But Pauline enjoyed it all. She wrote an article called 'Landing in Lisbon' for *Chambers's Journal*. The place was 'enchantment'. The heliotropes, twelve feet high, had a 'delicious fragrance'. The houses were painted yellow or red, or faced with blue and white tiles. There were flowers in pots and screaming parrots on windowsills. Water-carriers cried in the streets. You saw Negroes from Brazil, carts drawn by oxen, hedges of geraniums, orange trees. There were 'quaint-looking family coaches such as one sees in pictures of the last century', each one drawn by four mules, and the public carriages were like cabriolets, on 'excessively high wheels drawn by two horses or mules, with a driver in a broad hat, a great cloak and formidable spurs'.

Calverley, on the other hand, thought that much of Lisbon was in bad taste. He ordered a great quantity of camellias for Nettlecombe and began gathering seeds for John Lindley and the Royal Horticultural Society. In no time Pauline began to want to explore the countryside, in spite of the fact that she would have to travel by donkey along roads that were merely tracks, and that 'you lie at night on the boards of inns to which you would hesitate in England to consign a favourite dog'.[5]

And she asked for trouble indeed. Often they had to take guards. However, on March 20th, whilst admiring a yellow and white anemone and some scillas near Setubal, they found themselves separated from the rest of the party. Calverley wrote: 'I suddenly heard some angry voices, and looking up found we were stopped by two robbers, one an ill-looking man in the dark dress of the country who presented a gun to us, the other a youth of about eighteen with a dagger and a long staff, who called to us to dismount and to give money. I handed him some cruzeiros with which he was not satisfied, and without ceremony put his hand into my pockets helping himself to all the money he could find and returning us my keys. He then demanded my watch, which I took off its hair chain and handed to him. After slightly examining the ladies on whom he observed no gold chain or other valuables, and not meddling with the baggage, probably for fear of being disturbed by other travellers, who could not be far off, they allowed us to proceed. . . .'

It turned out that the robber chief was notorious in the area. Elaborate apologies followed from Lisbon authorities. When the thieves were eventually caught, it was found that the gold of the watch had been melted down. Calverley was compensated in cash, and the working parts of the watch were returned to him.

In due course the Trevelyans sailed for Cadiz, which they seemed greatly to have liked. The British colony was lively and hospitable. Pauline calotyped the Cathedral and conceived a (temporary) passion for Murillo. Then to Seville, which was ruined for Calverley by a visit to a bull-fight, 'unworthy of a civilized or a Christian nation'.

They returned to Cadiz, to prepare for an excursion to Malaga and Granada. Later they hoped to go to Sicily. On the very day of their departure, July 4th, Calverley received the 'melancholy intelligence of my father's death'. They at once caught a steamer home from Gibraltar.

Sir John had died on May 23rd: His successor to the baronetcy, Sir Walter Calverley Trevelyan, and his wife reached London on July 17th. Three days later they were in Nettlecombe, and a new life with new responsibilities began.

FRIENDSHIP WITH THE RUSKINS

1847-49

MARIA now considered that there was even less reason for her to be prised out of Wallington, though Calverley was determined to get down to improving the estate, especially in the way of building cottages and putting in deep drainage. Nettlecombe appears to have been in better shape, but there was much to be done there, a new school being the priority. For the next three years it was to be a main home for Calverley and Pauline, who thereafter rarely visited it.

Pauline's eventual aversion to Nettlecombe seems quite simply to have been due to the presence of her forceful sister-in-law Julia. After Maria's death, when Wallington became the Trevelyans' 'seat', it was decided that Julia should be in charge of Nettlecombe, a state of affairs which lasted for twenty-five years or more. Between 1846–9 Julia would visit her mother, but she was not the type to be tyrannized and thus tended to see less and less of her. As a result she and Pauline at this period found themselves spending too much time together at Nettlecombe.

Many Edinburgh friends were invited to stay, for Pauline loved giving house-parties. She also kept up her correspondence with 'papistical animals', as Mrs. Buckland called the Tractarians. 'I cannot fancy', Mrs. Buckland had written, 'my dear humble modest Mrs. Calverley turned into My Lady. You will be like the old woman in the story book who fell asleep and, meanwhile having her petticoats cut round about, then cries out: "Surely 'tis not true!"' 'Remember,' she added, 'if you want to come to town you can always deposit your little Ladyship at the Deanery.'

There were alarming signs that Calverley was to be plagued with the family gout. This gave Mrs. Buckland the chance to get on to a pet subject: 'I am so vexed. . . . For heaven's sake, my dear, let him live generously, and leave off tee-totalling, or at least ask some proper doctor if he should not do so, or he will get it into his stomach. I

should like to see him in degree as embonpoint as poor dear Sir John [the 4th Bart.], and I should like to see you a little round plump ball.' But Calverley had already poured the contents of his father's wine cellar into the Nettlecombe lake. ·

Pauline did brave the Deanery for one night but decided against another such experience after finding that Frank Buckland kept rat fleas in the wash-basin in her room. Nevertheless she and Calverley continued their frequent (day-time) visits there.

Modern Painters II had been published in April 1846. An exceedingly pious work, a theme being that every form of beauty was in some way divine, it had been better received on the whole than the first. Certainly it had that same eloquence and marvellous handling of words. The preservation of English architecture and landscape, and the glories of Fra Angelico and Tintoretto were other main threads. It did nothing to reduce Pauline's enthusiasm for the author, and on June 4th 1847 she paid a call on the Ruskins at Denmark Hill. Very likely this was their first meeting. Ruskin in *Praeterita* rather priggishly says: 'I have no idea when I first *saw* Pauline, Lady Trevelyan, but she became at once a monitress-friend in whom I wholly trusted—(not that I ever took her advice!)—and the happiness in her own life was certainly increased by my books and me.'[1]

Effie Gray, John Ruskin's future wife and the daughter of Ruskin family friends near Perth, was staying at Denmark Hill. She was a girl of just nineteen, very pretty and feminine, with an oval face and light brown hair. Not that they were actually engaged at the time— indeed Ruskin was considered by his father to be pledged to Charlotte Lockhart, Sir Walter Scott's grand-daughter.

On June 7th Effie wrote to her mother in Scotland that 'on Friday Sir Walter [as Calverley was now known] and Lady Trevylian [sic] and Miss Buckland the Dean's daughter came to lunch.' They stayed some hours, she said. 'Lady Trevylian is a nice little woman, very quiet and rather pretty, excessively fond of painting and had some beautiful sketches done by her in Greece.'[2]

Ruskin at the time was twenty-eight, three years younger than Pauline. In spite of the many portraits and photographs, some today still find it difficult to visualize him. Was he or was he not, for instance, 'handsome'? Rossetti was to find him 'hideous'. Most people thought he was odd. There were those who thought him precious and didactic. Somehow he was better-looking front view, his nose being rather hooked. He was always neatly dressed, and it is obvious that his

eyes (with cravat to match) were his most striking feature. His American friend Charles Eliot Norton gave this description of him some while later (in 1856): 'His abundant light brown hair, his blue eyes and his fresh complexion gave him a young look for his age—he was a little above middle height, his figure slight, his movements were quick and alert, and his whole air and manner had a definite and attractive individuality. There was nothing in him of the common English reserve and stiffness, and no self-consciousness or sign of consideration as a man of distinction, but rather, on the contrary, a seeming self-forgetfulness and an almost feminine sensitiveness and readiness of sympathy. His features were irregular, but the lack of beauty in his countenance was made up for by the kindness of his look, and the expressiveness of his full and mobile lips.'[3]

Pauline was always convinced that Ruskin was a genius, and felt that allowances must therefore be made for any weaknesses. More than most people she was also aware of his fundamental sense of insecurity.

At Denmark Hill that day the Trevelyans were shown drawings by Ruskin's hero, Turner. From Pauline's point of view, the meeting was a great success, and she and Ruskin found that they had several friends in common. Three weeks later they met again at Oxford for the British Association meeting, when both Ruskin and Calverley were attached to the Geological Section.

Two important events for the Trevelyans that autumn were the death of Pauline's second brother Tenny, who had caught a fever in India, and the appointment of Calverley as Deputy Lord Lieutenant of Somerset. Calverley also arranged with the Camden Society to publish some mediaeval Trevelyan papers found at Nettlecombe. He had been discussing the project with Charles, who—almost incredibly— in spite of his intense preoccupations at the Treasury had agreed to be co-editor.*

Charles for the past year had virtually been dictator of relief work in Ireland, where the Potato Famine was reaching a peak of horror, the previous winter having been particularly dreadful. He was attacked, and in modern times has been attacked again. Nevertheless, according to his own strict standards, he behaved with total integrity. The fault was partly due to the fact that, although he was very much an individual and far from being a type, he was a man of his age; like the

* Vols I (prior to 1558) and II (1446–1643) were edited by J. Payne Collier and published by the Camden Society in 1857 and 1863. Vol III (mainly 17th cent.) was edited by Calverley and Charles and published in 1872.

Chancellor of the Exchequer, Sir Charles Wood, he believed fanatically in the principle of laissez-faire—of letting matters take their course and allowing problems to be solved by 'natural means', with as little interference from the Government as possible. As it turned out, terrible mistakes were made, but this is not the place to examine the ins and outs of the Whig Government's policy. Charles was deeply distressed by public criticism. Apart, one might say, from the Trevelyan papers, he was devoting all his time to the Irish problem, and often was at his desk in the Treasury until 3 a.m. His family life suffered. As a reward, in 1848, he was given a knighthood; and in 1874 he was created a baronet.

What is obvious is that, like many political contemporaries, Charles found aspects of the Irish character that exasperated him. Cecil Woodham-Smith has pointed out that this prejudice may have been intensified during an official visit to Ireland in 1843 when he found himself up against 'some slight family difficulties', namely the question of the education of Alfred Trevelyan, Calverley's nephew.

Alfred was then aged twelve and being educated as a Catholic by his Irish mother in Limerick. His father, Calverley's fifth brother, had died, and as Calverley and other brothers in the family were childless, it meant that Alfred was likely to be the heir to the title, to Nettlecombe and perhaps Wallington. Everyone was worried about him, as he was not being sent to a public school. Suffice it to say that Charles's encounter with Alfred's mother was a disaster, and nothing was settled about the boy's education.

Ragged and emaciated Irish were now streaming into England, Wales and Scotland. Pauline allowed some to sleep in the stables at Nettlecombe, and she and Charles Trevelyan's brother Otto tried to arrange a centre at Stogumber nearby (where Otto was Vicar) so that food and clothing could be distributed. Needless to say more and more 'tramps' were attracted to the district. There were outcries about rape and thieving, and the danger of 'fever' being spread. An Irish mother of six was arrested for stealing a goose, and then was found to be carrying a fortune on her person. So Pauline's efforts had to cease.

The Trevelyans went briefly to London early in 1848. Ruskin's first surviving letter, very formal, to Pauline was dated January 19th. It concerned her drawing, on which he had been helping her. She must have said that she was feeling discouraged, for he started consolingly.

Of all those whom he had ever ventured to advise, he said, 'you are the first who has yielded to me a real and faithful compliance'.

Therefore he should have been very grieved if she had not the 'sense' as well as the 'reality' of success. Indeed he had never seen, 'but once before', studies which were so 'courageous, persevering and faithful'. He then proceeded to compliment her on 'marvellously intricate' drawings of a waterside grotto and some ivy and beech, which he thought 'complete and beautiful'.

This must have been very pleasing to her. Shortly afterwards the Trevelyans went north, Pauline to Edinburgh, Calverley for a while to the Assizes in Newcastle.

A delightful individual now entered their circle, someone whose sense of humour matched Pauline's: Dr. John Brown, the 'Scottish Montaigne'. A cousin of Samuel Brown the chemist, he had been an apprentice to the mighty James Syme, Professor of Clinical Surgery at Edinburgh. His literary career had begun two years before with a series of articles on art in the *Witness*. But Pauline had been chiefly drawn to him by his review of *Modern Painters* in the *North British Review*.

Photographs in the 1850s show Dr. Brown to have been benign and baldish, with a high forehead, bushy sidewhiskers and 'granny' spectacles. People said that he was always smiling. 'No vanity', 'impatience with quackery', 'charm in manner and conversation', 'humour to a fine degree, but never buffoonery': these were some of his attributes according to Pauline and her friends. He was a born enthusiast, and the works of John Ruskin were always among his enthusiasms. As Ruskin himself was to say: 'In the simplicity of his affection, [he] liked everything I wrote, for what was true in it, however imperfectly or faithfully expressed.'[4]

Ruskin and Effie were shortly to be married. The facts that the result was disastrous, and that they were totally unsuited to one another, are well enough known. Few marriages have been subjected to more detailed scrutiny and discussion. Ruskin's parents had misgivings, but they were afraid to thwart him, in case he suffered a breakdown such as had followed the collapse of an earlier love affair with a Spanish girl. He was liable to depressions, and there was a history of suicide in the family—his grandfather had cut his throat at, as it happened, Effie's parents' house, Bowerswell. Effie was unspoilt, eager to learn, vivacious, glad to be marrying somebody who was famous. Ruskin obviously thought he could mould her to his own way of life. But a serious writer with a large and concentrated output such as his, has necessarily to be self-absorbed, with long periods of solitude, and neither of them had taken this into account.

She was staying with Lord Cockburn and thoroughly enjoying the gaieties of Edinburgh. She met Pauline again at a party given by Lady Murray, and a most amusing party too, as she wrote to her fiancé: 'The ladies were all perfectly dressed, a great many *nobs* and Dragoons and fine uniforms, great flirtations and splendid music. The music lasted till midnight, then we danced till three in the morning. I got introduced to good partners and got some good polking.'

She also told him about meeting Pauline, with whom she had had a long talk. To which Ruskin replied: 'I am truly rejoiced to hear you are so happy, my love. . . . Lady Trevelyan is very kind—not that I was not sure that everybody would love you and think well of you— still, her saying you were worthy of me is very delightful—because, you know, it is a compliment—(no—a *testimony*) to us *both*, to me more than you, far, but it is very kind of her too; and I know no one— of whom I know so little, of whose friendship I am so desirous for you.'

Pauline had called on Effie on March 9th. 'She seemed to think nobody like John,' Effie told her father, 'and gave me many expressions of kindness and invitations to come and stay with her.' Indeed Pauline was one of the few friends of Ruskin's Effie really took to her heart.

When Ruskin arrived in Edinburgh, Pauline wrote on the 20th in a mocking tone typical of many communications in the future: 'As it appears,' she said, 'you never mean to come and see me, I must set my conscience at rest by delivering to you a message which I have for you.' The message was that Mrs. Alison, 'who you know is Henry Acland's great friend, and who heard histories of you daily for some years (greatly no doubt to her moral improvement)', was very unwell. As Mrs. Alison's husband, an eminent doctor, was too busy making morning calls to get in touch, she therefore wanted Ruskin to 'excuse formalities' and call on her first. It would be a 'grief' to Mrs. Alison not to see Henry Acland's friend. 'That is her message. As for your conduct I make no remarks on it [in not making calls]. Your friends have one melancholy consolation left, in believing that at the present time you may be supposed to be neither a free agent, nor altogether a responsible being—in which comfortable assurance, I remain, Yours very truly, Pauline J. Trevelyan. You are much better off than you deserve.'[5]

Ruskin replied the next day, promising to see Mrs. Alison and ad- mitting that he was far happier than he deserved. 'But I should be very miserable on any other condition.' He rejoiced that 'she whose happiness is now entrusted to me' had been able to obtain for herself 'the promised friendship of one whom I so deeply respect'. Then as a

postscript he added: 'I showed this note to Miss Gray, who thereupon looked dissatisfied and thoughtful. I asked what was wanting—or erring, and after some pause, and a renewed questioning, obtained the following reply "I think, you should tell her that I liked her very much".'

Two weeks later Effie wrote from Bowerswell to tell Pauline about the time and date of her wedding, which was to be at 4 o'clock on April 10th. She added enigmatically in the same letter: 'I have not forgotten your advice about him [Ruskin], and I shall endeavour to follow it even after we are married as it quite accords with my own ideas. I have known him now for eight years and I always thought the same, although he is much changed in many respects since then.' She hoped to see Pauline again soon, 'when you will have some things more to say to me'.

All Pauline's letters to Effie have disappeared. In any case such advice would not have been put in writing. As Ruskin himself was to say, Pauline 'hadn't all her own way at home',[6] and she must have realized that Effie would not get hers either. Effie could not in the end stand the strain. For one thing, she did not have Pauline's strong religious convictions to console her.

When Effie was planning to leave Ruskin in 1854, she wrote this to her father about her disastrous honeymoon: 'I had never been told the duties of married persons to each other and knew little or nothing about their relations in the closest union on earth. For days John talked about this relation to me but avowed no intention of making me his Wife. He alleged various reasons. Hatred to children, religious motives, a desire to preserve my beauty, and finally this last year . . . that he had imagined women were quite different to what he saw I was, and that the reason he did not make me his Wife was because he was disgusted with my person the first evening.'

He had said that he would consummate the marriage after six years, when she was twenty-five.★

Very likely Pauline, being without a mother when she married, at nearly the same age as Effie, had also been ignorant of the duties of married persons. One can only speculate about the reasons for her own childlessness. The secret lies in the grave.

April 10th 1848 was also the day on which the Chartists marched on London. Buckland had been in a state of almost insane excitement and

★ In his statement to the Proctor in 1854 Ruskin also said: 'Though her face was beautiful her person was not formed to excite passion.' Whitehouse, p. 15.

had arranged for the Abbey and its precincts to be fortified. In the flurry of the day before Frank's eagle escaped and was observed watching the assembly of special constables from the roof tops. It was quite a disappointment when the march turned out to be so innocuous.

After all the work Buckland had done to improve the sanitation at Westminster it was ironical that he and his two daughters should be struck down with typhoid. As a result his whole frame was badly weakened, with dire results the following year. Pauline had to be dissuaded from rushing down to help Mrs. Buckland with the nursing. Instead Calverley diverted her to Nettlecombe. Among other things he wanted to get on with the draining of the marshes round Seaton. Meanwhile her sister Moussy had married a fellow Puseyite: the Rev. John Crosier Hilliard, from Cowley near Uxbridge, where he eventually became Rector, and 'as poor as the church cat'.

The situation was very bad now at Wallington. Maria had found herself a bodyguard to help her in enforcing her will, 'an Irish liveried footman of Herculean build'.[7] She had been quite ill early in the year and had not dined downstairs for three whole months. The cold frosty air, she complained, affected her skin, and the house was draughty with 'all these odious French windows'. When spring arrived she was more autocratic than ever before. She loved to drive round the estate in a cart drawn by two donkeys, Neddie and Lizzie. Every now and then she would point with her gold-tasselled walking stick at a tree that she wanted hacked down, and woe betide anyone who tried to stop her Irishman from carrying out her wishes. When the boundary with the Middleton estate was redrawn, she decided she did not agree with it, and took her donkeys to ride all over some newly sown oats. She had no use for fruit and flower shows, maintaining that 'good fruit is best eaten at home'. Once the head gardener showed her a melon that was to be exhibited at a show. Maria unclasped a knife from her girdle, cut a segment from the melon and put it back. 'Tell the judge,' she said, 'that the fruit is unbeatable, and that one has said so who knows what she is talking about.'

'I want enlivening society sadly,' she wrote to a daughter. 'You know my active nature.' The trouble was that everybody was terrified of her. Everybody, that was, except the Irishman and Calverley. After her son's new underplanting of rhododendrons in the West Wood had been rooted out, because the colour of the flowers was 'vulgar', he had a solicitor's letter delivered. She was furious, and at once took a lease of a house nearby. It was intended to be a bluff, but she was never allowed back to Wallington. 'Not pretty,' she told all and

sundry, 'when one's mother is seventy-seven.' So Wallington stood empty.

After the honeymoon Ruskin and Effie spent some while in London. They then, in the company of the Ruskin parents, set off for a stay in Dover, the nearest point to the Continent—travel being debarred in 1848, that year of revolutions. Effie was anxious to keep a lifeline going with Pauline. 'I do not know whether I ought to write to you or not,' she wrote on June 24th, 'but I want to do so, and the temptation of your giving me an address, which would always find you, has strengthened my wishes.' She was disappointed at not seeing her at 'some of the parties we were at' in London. She chattered on in her inconsequential way:

'We were rather early in our Highland Tour [their honeymoon], and John did nothing but abuse every place one after the other when he was awake, for to ride out what he calls the most melancholy country in the world. He slept most of the way, which I am sure you will be most shocked at, and I had the poor advantage of having the beauties all to myself.... The other day through a glass we saw the church spires of Calais. Some alarm is caused today by the non-appearance of the French mail, and they are fearful that a Massacre has taken place in Paris [an uprising of workers in which the Archbishop was accidentally killed].... My husband ... is constantly longing to be on the other side of the Channel, but excepting this I may say he is truly happy and yesterday was one of the most delightful days we have spent since our marriage [making drawings at Canterbury].... John begs me to present all the kind messages I can write that you will accept from him, but I think you know best how much he esteems you.'

She wrote again from Salisbury on July 15th, at the beginning of a disastrous visit, when she became irritated by his parents' possessiveness. The young couple had previously been staying in Oxford with Henry Acland and his wife. No doubt Effie was being polite when she wrote to Pauline of 'your kind friends whose acquaintance you were sure would give me sincere pleasure, which indeed it has, for I think they only require to be seen to know their separate worth'. She could not have had much in common with them, and especially Mrs. Acland, so very different to her impulsive husband, with 'severely trained intellectual powers' and a 'dangerous disputer if roused to controversy'.[8]

Ruskin thought Sarah Acland would be 'perfection' if she were not

plain and did not wear spectacles. A trying part about staying with them was watching the baby have breakfast, which made him feel sick. 'Dr. and Mrs. Acland,' Effie wrote to her mother, 'are I think Puseyites, and so is Lady Trevelyan, and not Roman Catholic but I think she [Pauline] went much further than our friends. . . . You need not be afraid of our turning Puseyite, for I see nothing like it and John is always urging against it.'

The plan had been for both young and old Ruskins, and the Aclands, to come to Nettlecombe after the Salisbury visit, but this fell through, partly because of the fuss over Ruskin's cold, which 'got worse from sketching too much in the Cathedral', and partly because the situation in France had eased and he just could not be restrained from crossing to Boulogne, 'and then going on we don't exactly know where'. Effie was obviously embarrassed at letting Pauline down.

In fact Ruskin and Effie did not go further than Normandy. For the next eleven weeks he was very busy gathering material for *The Seven Lamps of Architecture*, in some respects one of his best works. Effie tried so hard to accommodate herself to her husband's habits. She sat near him on a camp stool 'as quiet as a mouse' whilst he sketched. She followed him on his walks, but as Ruskin told his mother: 'I had no idea of the effect of fatigue on women. Effie if I take her, after she is once tired—is reduced nearly to fainting and comes in with her eyes full of tears.'

Meanwhile they heard of squabbles between their respective fathers about finances. Effie was so worried that she began losing her hair, and Ruskin wrote: 'perhaps these matters are all good for me—I am certainly terribly selfish . . . even when poor Effie was crying last night I felt by no means as a husband should—but rather a bore— however I comforted her in a very dutiful way.'[9]

Against this background Effie wrote a brave letter to Pauline:

Falaise, August 30th, 1848.

'I need hardly tell you that with this beautiful warm weather, heavenly skies, and beautiful scenery, we are as happy and enjoying ourselves as much as possibly can be. I have a letter from Mrs. Acland yesterday, perfectly delighted with Scotland, which she says has made Dr. Acland quite ruddy and good-natured. I am afraid I cannot yet give France the credit of bringing roses into my husband's cheeks, but he is very good tempered and would be perfectly contented were it not for the spirit of restoration in this country which by way of improving or restoring old buildings is pulling them to pieces, not

slowly but in rapid strides. Down they come, the black with age sides of Rouen Cathedral, with all its lace-like work, statues, crochets, foliated windows . . . all being demolished to make room for staring yellow stone uncarved. . . . We have had charming walks, I never saw such a place for walks, and with everything combined to make them perfect: trees and fair green banks, old cottages, rocks, heather, brambles, little streams . . .'

On the very day, October 25th, that Ruskin and Effie returned to England, Calverley and Pauline crossed to Ireland, 'to arrange for Alfred's further education and guardianship'. This was a time following the Young Irelanders' rebellion, the second failure of the potato crop, 'spreading despair and ruin' throughout the country, and a new emigration. Charles Trevelyan had decreed that Treasury grants to distressed Irish unions should cease. Destitute children would no longer be fed, for 'it is a great object not to revive the habit of dependence upon Government aid'.[10]

After such revelations it would be agreeable to discover at least one tender-hearted entry in Calverley's diary. For he and Pauline remained in Ireland until January, a period which was described as 'one long night of sorrow'.[11] Pauline was certainly shocked by the conditions there, but Calverley seems to have been just a bit supercilious, though perhaps he felt that the horrors and scandals around them were somehow too obvious to be recorded in a diary as usual mostly confined to topographical or scientific matters. His entry for the first day in Dublin is entirely filled with details of its museum's contents, whilst the journey to Limerick by rail was remarkable for the view of 'level diluvian country and boulders'. However there are mentions later of the 'untruthfulness of the Irish character', presumably with reference to Alfred's mother, and the fact that Limerick's beggars were 'ragged and picturesque objects', looking as though they were dressed for effect. On the 30th he went into court to hear some of the trials, in connection with evictions the defendants this time were 'wild' and again picturesque. On November 3rd he wrote crossly: 'Went to some of the schools conducted by the Christian brothers, but disappointed—bad discipline—too much rote teaching, and foolish national prejudices inculcated—and most unchristian sentiments [in a history of Ireland] towards the English.'

Some mild victory must have been won about Alfred, because Calverley agreed to pay for the boy's education if he came to England, and it was thereupon fixed that he would cross over immediately.

The Ruskins established themselves in a small rented house in Park Street, Mayfair. Effie was soon writing to Pauline—the number of Irish beggars around was quite dreadful, they had been to hear Jenny Lind, Ruskin had a tiresome cold again, etc., etc. 'He says you do not speak of your drawing, and he wants to know why you send dutiful regards to him; I think he imagines he ought to send his to you.' For it was a conceit of Pauline's over the next years to sign her letters to him 'Yours dutifully'.

Then the letters from Effie ceased for a long while. This presumably was partly due to a miserable sojourn in Denmark Hill, when Effie's relations with her in-laws worsened irretrievably. At the end of January 1849, on receiving news that her small brother was dying, she rushed back to her parents in Scotland. Ruskin was busy with *Modern Painters* III, and managed to get a quick note off to Pauline, signed 'Yours devotedly'; it was chiefly about her drawing, and suggested that she should make studies of skies.

Effie was still with her family in April, when Ruskin and his parents set off on a five months' trip to Switzerland and France.

The year 1849 for the Trevelyans was divided mostly between Nettlecombe and Edinburgh. Pauline did manage to get to the Academy, and saw the paintings by Millais, Holman Hunt and Collinson. And no doubt she wondered at the initials P.R.B. on them. Though no actual comments remain, we know she was enthusiastic.

There had been a scandal in the family, for one of Calverley's sisters, Helena Faussett, had been divorced and described in the House of Lords as a 'very abandoned woman'. The name of Trevelyan was now forbidden in the Faussett household, and nobody explained to the little daughter why Mama no longer lived with Papa. Mrs. Buckland tried to help, but found her so 'morbidly sensitive' to something wrong that she 'shrank away'. After much struggle Pauline managed to make herself the girl's unofficial foster mother and responsible for her schooling.

The Trevelyan brothers and sisters by and large treated Helena very indulgently. One of them indeed, Arthur, had done everything possible to condone her adultery. Her behaviour was a total contrast with Effie's when faced with her own crisis of temptation, and this probably explained some of Effie's indignation at Pauline's moral attitude. Not that Pauline could have been fairly blamed for what Arthur got up to; he believed in 'marrying for principle not for love'—so he announced when he married a housemaid from an Edinburgh hotel.

By the end of the year the Bucklands themselves had been struck by disaster. The Dean collapsed from overwork. His brain had been irretrievably damaged. He could not concentrate. Natural History no longer interested him. He had delusions, and conceived a violent dislike for Mrs. Buckland, who told Pauline that he treated her 'as if I was the *very scum of the earth*'. She added: 'He seems to think he has married his cook. I believe he is completely lost to me.'

The Buckland children were considerably older than the Faussett girl, but in their case too Pauline became like 'another mother'— though it was not always an easy passage with such an eccentric as Frank. Other young people were to join her 'brood'. 'Whatever her private troubles, and they were sometimes many, she always had time to listen to you,' one of them said later.

Dr. John Brown had been reading some of Pauline's poetry, and persuaded her to submit it to the *Scotsman*. To her surprise four poems were selected: *Sunset Thoughts, The Dying Artist, The Scholar's Work* and *Street Music: A Scene in Bristol*. All had been written in 1848 and all, one might say, were more interesting intellectually than rhythmically. The general message was that Art, i.e. Beauty, was something transcendental and God-given (inspired by *Modern Painters*?). In the case of nature, to gaze at a lovely scene (*Sunset Thoughts*), and feel it is divine, is not enough; God can only be reached through prayer. *Street Music*, written in December 1848, seems as if it was inspired more by scenes in Limerick than in Bristol: 'I saw a squalid street/Where crime and misery lower'd side by side;/Where wretched infancy, and ruin'd youth,/And helpless, hopeless age, roll'd down the deathward tide.' There appears a mountaineer who plays a bagpipe 'without one touch of feeling or fire', and the people are delighted. The poet then herself goes up into the mountains, and by way of contrast sees wild flowers blooming and shafts of light which normally no human being can enjoy. . . .

She found that people in Edinburgh were gossiping about the Ruskins' long separation, so she took the opportunity of accepting an invitation from the Stewart-Mackenzies at Brahan Castle near Dingwall, in order that she might call on Effie on the way. Mrs. Stewart-Mackenzie, the Trevelyans' old acquaintance from Corfu, had been widowed, and Pauline and Louisa, known as Loo or Lulu, were drawing closer. Louisa was twenty-two in 1849 and had grown into a handsome, vital woman, described by some as 'Amazonian' and having a 'rich and generous presence'.[12] She was friendly with the

Nightingale family, particularly Florence's sister Parthenope—though after the Crimea Florence was to become the more intimate with her. She was also interested in fossils and minerals, so Calverley soon graduated to the status of 'brother'.

Pauline's attitude to Loo at first was very elder sister. When Loo was struggling to learn to draw, she wrote consolingly: 'Nobody succeeds perfectly at first. You must have patience and draw from nature as much as possible. Don't wait for grand subjects. Draw a stone or a plant, or a bunch of leaves if you can get nothing else.' Thus spoke the disciple of *Modern Painters*.

The Trevelyans had visited Brahan in 1840 after the Buckland-Agassiz trip, and Calverley had then pronounced it old and ugly, with a castellated tower, though containing good portraits and in a beautiful situation above the valley of the Corran. There was a curse on the house. The 'Brahan Seer' had prophesied all sorts of terrible things: 'The day will come when the ravens will drink their fill of the Mackenzies' blood for three successive days'; 'the day will come when, full of the Mackenzies, it [the castle] will fall with a fearful crash . . . when it shall fall into the hands of an Englishman.'[13] (Most of which has in a sense come to pass.)

Calverley's diary entry for the visit to Effie was pithy, to say the least: 'Called on Mrs. J. Ruskin (Miss Gray, Bowerswell) and walked with her to Hill of Kinnoull, from which views of Tay etc., are splendid. Mr. Gray cannot distinguish red and green colours except as shades of the same colour.' As it happened, Ruskin was expected back in England in mid-September and had asked Effie to meet him in London, which she had absolutely refused to do. He must come and fetch her, she said. Could this have been a course that Pauline, afraid for the marriage, could have urged her to take? At any rate he replied in a furious letter: '. . . Why, you foolish little puss, do you not see that part of my reason for wishing you to come to London was that I might get you a couple of days sooner; and do not you see also, that if love, instead of pride, had prompted your reply, you would never have thought what I *ought* to do, or your *right* to ask, you would only have thought of being with me as soon as you could. . . .'

He had to give in though. Effie must have seen the Trevelyans again in Edinburgh, for in his next, and calmer, letter he suggested calling on them on the way south, 'if the weather is not too cold'.

In the event the Ruskins went to Edinburgh for 'one fatiguing day', and the Trevelyans were away, staying with Pauline's brother Hugh, who held the incumbency of the episcopal church at Forres. For whilst

Ruskin was at Bowerswell, Effie had asked if he would take her to Venice. They had wanted to consult her doctor on the way. By October 3rd they were off—without the Ruskin parents. It was a perfect solution. They were both, for a while, to be happy.

Calverley had now taken up mesmerism, and his experiments were innocently enjoyed by the young ladies of Edinburgh. 'Mesmerized Eleanor Robertson for several consecutive days for sprained ankle with very good effect. Tingling sensation and eventual cure of the sprain much sooner than expected'; 'In evening gave Isabella Graham a rock crystal to hold. I thought it had no effect and took it back, but she took it again and I was surprised to find her sound asleep. She did not wake for some time, saying it was "that strong thing" that did it.... Refuses when asleep to let my hand out of hers. Great dislike for least light. Generally not willing to talk. Dislikes proximity of others, and knew when persons were in the room when I did not.'

A recent sensation in the city had been the discovery of the value of chloroform by Dr. James Young Simpson, who had introduced it into obstetric practice against much opposition. Simpson was fast becoming the leading gynaecologist in Britain and Calverley attended his lectures on anaesthetics. Effie had been to consult Simpson in May, to Ruskin's annoyance. And it was he whom they had seen again in October—this time a success, for Ruskin began referring to 'dear Dr. Simpson'. On December 12th Pauline, who had been suffering bad pains and upsets, went to visit him. 'He finds various ills,' wrote Calverley, 'but is to examine again.'

The Trevelyans had planned, at last, to make a home out of Wallington. The house was suffering for not being lived in. At Nettlecombe there was a large established garden, but Pauline felt she could create something of her own at Wallington. Calverley also wanted to build up a shorthorn herd. However her ills were serious, far more than they perhaps realized, which meant that leaving Edinburgh was impossible.

CHAPTER FIVE

OBEDIENCE TO DR. SIMPSON

1850-52

THE Austrians' siege of Venice in 1849 had lasted five months. Ruskin, fearful of damage from the bombardments, was longing to see the city again. Thus it was an engaging, and wise, idea of Effie's to propose going there.

Three weeks after their departure, Effie was writing cheerfully to Pauline from Milan. They were to winter in Italy, she said, partly because Ruskin had 'a good deal of architectural work at Venice before him', partly because 'Dr. Simpson recommended his taking me to Nice or some other place . . . as he did not think my throat better'. The plan therefore was to go to the Riviera after a month in Venice.

She wrote attractively about the Alps and Isola Bella, with its orange and lemon trees, and how Count Borromeo's palace had been turned into a hospital and he had had to pay a fine of £20,000. The Austrians on the whole were behaving very well, but the Milanese were 'boiling with anger' and 'hating their enemies from the very bottom of their souls'.

On January 15th 1850 she wrote again, this time from the Albergo Danieli in Venice, which was the 'most entirely delightful place' she had ever known. Very little harm had been done to the palaces there. 'Mr. Ruskin is busy all day till dinner time and from tea till bed time. We hardly ever see him excepting at dinner, for he has found that the short time we are able to remain is quite insufficient for the quantity of work before him. He sketches and writes notes, takes daguerreotypes and measures of every palace, house, well or any thing else that bears on the subject in hand, so you may fancy how much he has to arrange and think about. I cannot help teasing him now and then about his sixty doors and hundreds of windows, staircases, balconies and other details he is occupied in every day. The weather has interrupted him very much lately, we have had three such snowstorms as the people have not seen here since 1829, one after the other. No sooner had the gondoliers cleared St. Mark's Place and the Riva in

front, than another storm began and the canals were quite full of snow and ice, and when the thaw commenced it was hardly safe to go out for the snow fell in such masses from the house tops.'

From a social point of view life was 'dull and spiritless'. The Italian nobility seemed to be behaving with 'such a want of moral courage'. 'Most of the Venetian families have remained at their country houses, or have gone into other countries, instead of coming back to their palaces here, which [Field-Marshal] Radetzky has entreated them to do, to promote a spirit of industry amongst the trades people.' Radetzky she considered to be mildness itself. He was going to give dinners and balls at Verona.

'If the ladies did not go his officers should waltz together. He gave one ball last week and I asked Madame Miniscalchi if she went. Of course not! she answered, we all had colds! And now she and the Count are en route for London, and intend returning in June to see how things are getting on. We have seen Marshal Radetzky many times. He is truly astonishing. His figure is very upright, and he walks very firmly. His hair is grey and his eyes very much inflamed, which detracts much from his personal appearance. Everyone says he is very good, and those attached to his person have a great affection for him. He sent for his Countess the other day to come and stay with him at Verona. She came and is a thin little old woman with a flaxen wig, no teeth and a cap. They had not met for *thirty* years before but had always corresponded and been on amicable terms, and now I suppose they will continue to live together.'

Ruskin had so much work left undone that it had been decided to remain in Venice until April. The matter of Effie's health had had to take second place; she had been very poorly, with a perpetual sore throat. 'Our friend Mr. Rawdon Brown,' she said, 'who is the only English resident here now, brought a Friar, one of the Fate-bene-Fratelli, to see me ... so kind and humble and quiet that it is a real treat to see him. He brings me a bottle of new milk across the Lagoon every morning from the cows in the Monastery.'

Then there was her 'second doctor', Lieutenant Paulizza, an Austrian officer with curling moustaches, though she did not mention him to Pauline. He became devoted to her, and if she had wanted to let herself have an affair with anybody, no doubt he would have been an easy choice. Ruskin liked Paulizza, and the fact that he even encouraged his wife to see the man was in later years to be used against him. The thought does arise, however, that perhaps he was glad to have someone who could amuse her whilst he was working.

On January 27th Ruskin himself wrote to Pauline, also at some length. He was worried because she had mentioned in a letter to Effie's mother that she was ill. She had been pressing him and Effie to visit Wallington, but was afraid he might find the country 'hideous'. He reassured her. He had loved the bleakness of the north 'with all my heart—ever since at seven years old, I was shut up . . . by a foot and a half fall of snow in Alnwick. Nor indeed have we any right— even here, to speak disparagingly of Northumberland—or any place else—we have had some five weeks of continual frost: and a week of snow—a fall of some nine inches . . . after passing the whole summer in as close neighbourhood to Mont Rose and Mont Blanc as my best climbing could obtain for me, without so much as a snowflake coming in my face—I was within a half gondola's breadth of being *sunk*, *by an avalanche*—in Venice! . . . St. Marks place was a new and most strange scene—one white field like a mountain lake frozen over . . . the domes of St. Marks as white as the Dome du Goûte: and the traceries of the Doge's palace drawn in sugar—and looking like the Gothic on a Twelfth Cake. Nor was the Grand Canal less strange. The rich balconies were all laden with snow . . . instead of with silks and satins

as they used to be—the sky was dark leaden colour above—and the sea water was thrown out in its own pure but gloomy green—looking strangely dark under the white frostwork of the houses—and the sea gulls—driven by the cold up to the Rialto—were drifting about everywhere *slowly* like great snowflakes themselves—with the deep green of the water reflected in a pale aquamarine from their breasts. . . . Effie is—if that be possible—fonder of Venice than I am. . . . While I mourn over cannonshot, and quarrel with carpenters, she is making friends with Austrian officers—and projecting improvements in

saloons—while I mutter and growl at the people, she is chatting to them and laughing at them—and —if she were not still ill, poor thing —would have decidedly the best of it.'

They were not leaving, because of being so contented in Venice, and because it was just as freezing cold all over the rest of Europe; and also —he admitted—because he had so much library work to do. Finally a flattering paragraph: 'I long to see some of the studies [Pauline's] made on the banks of the Findhorn among the pools and pines. You know I have a sketchbook of yours at home—I hope to be able to restore that—and borrow another—this coming spring. Those brown Scotch rivers *are* delightful—and the more so, because one can paint them—as far as one can paint anything: the Swiss greens and blues are very well as long as one can look as the real thing.'

Pauline must have sent on Effie's second letter to Dr. John Brown, who wrote: 'I like "Effie" both for her own sake and "John's". She is a natural, vivid, right-minded girl. How she makes me wish to see Venice before I leave this unintelligible and beautiful and vile world of ours. Do you remember the description of it in *Corinne*?'

Pauline was not the type to complain when she was ill. We do not know what Dr. Simpson diagnosed at that time, but she continued to feel unwell during January and February of 1850. Mrs. Buckland wrote of her pains: 'I suppose they are some of those female ailments which do not kill but only prostrate. Mine seem to have passed.' It was not so simple as that.

On February 20th Calverley clinically noted: '1.30 a.m. P. very ill. Went for Simpson who stayed all night. Threats of peritonitis, but better in morning (value of suppositories).' Thereafter, for a while, things must have been easier, for the social life, lectures and music parties continued.

Pauline was fortunate in having Simpson to care for her. An exuberant, warm-hearted family man, he had many interests outside his professional activities which, however, always took priority. His fame in 1850, especially after his discovery of the uterine sound, was such that there was a perpetual stream of patients to his house. Real need always came first; it did not matter if a duchess had to stand aside for a Newhaven fishwife. The trouble was that he was very bad at keeping appointments.

Calverley, being now High Sheriff of Northumberland, had to attend the Assizes at Newcastle frequently. He was there when he received 'bad accounts' of Pauline. Immediately he took the train

back to Edinburgh. 'P. very uncomfortable,' he wrote, 'a pity Simpson is not more regular.' When Simpson did come, he and Calverley exchanged books—a history of leprosy and a treatise on exorcisms for fever for instance. Calverley was also charmed by Simpson's archaeological and antiquarian knowledge. Iodine drops and ointment were prescribed, and there were warnings that the cure might be tedious.

In spite of her troubles Pauline had meanwhile managed to write a review of a biography of the artist David Scott for the *Scotsman*, in which her poem *Street Music* was published on March 16th. The author of the book was Scott's brother, William Bell Scott, destined some years hence to be of considerable importance to Pauline.

The review was anonymous, but its origin soon leaked out. She had probably met David Scott, who had died in 1849 and was regarded by a select few including David Octavius Hill and Samuel Brown—far too select for the unfortunate man's paranoia—as one of Scotland's finest painters of the day. 'This is the record of a life,' she wrote, 'as calm and uneventful in its outward circumstances, as it was fierce and stormy in its inward experiences. . . . We see a mind perpetually at war and with itself—weary, self-tortured, finding no resting place.'

She suffered a bad setback just before the article's publication. The iodine was causing discomfort. Unfortunately Simpson himself was also ill, with an abscess on the finger that had infected his arm. After Calverley had been to see him on April 6th, he reported: 'Called on Dr. Simpson. Gives me good hopes of my dearest P.'s entire recovery'; and for Calverley this was emotion. Then on the 9th we have the first definite clue to the cause of her illness: Simpson, who was by then slightly better, was 'satisfied about formation of matter and softening of tumour'.

That very day George Combe's wife (a daughter of Mrs. Siddons) approached Pauline to write a review of her husband's book on his brother Andrew who had died from consumption in 1847. Pauline knew very well that the book contained views on phrenology that had annoyed some more orthodox inhabitants of Edinburgh. Incredibly, considering her condition, she not only agreed but wrote the review immediately—so long, over 7,000 words, that it had to be published in two instalments. This must have been partly a question of loyalty to Calverley, who was supporting a non-sectarian school run by George Combe.

She had been persuaded to send in some sepia drawings to an exhibition. Again it was thanks to Dr. John Brown. She said to Loo

Stewart-Mackenzie: 'I forget if I ever told you of my and Mr. Ruskin's great friend here, Dr. John Brown? You would delight in him as much as I do. Well, this said Dr. J.B. propounded to me some time ago his opinion that it was my duty to put some studies into the exhibition, because Mr. Ruskin says the landscape people here don't study half enough and that they ought to do large light and shade things of the same sort as mine. I told him I would do nothing of the sort while Mr. Ruskin was away, but he persisted, persuaded—and teased, so that I was obliged to consent at last, he promising to take all the blame if the Maestro does not approve of the proceedings. So today Mr. D.O. Hill and Dr. J.B. and I have been selecting half a dozen to be sent in.'

She need not have worried. The comments in the *Scotsman* and elsewhere, were very favourable and praised her 'power and originality'. Apropos of her studies of oak and beech leaves (others were of water flags, a cliff at Seaton and tree-trunks), the reviewer said that other artists should ponder over them and 'ask themselves if they may not take a lesson in the highest essentials of art from them'—was 'the true way to study nature, a truthful transcript, a *study* in fact'.

For some while, Dr. Simpson had been saying that cauterization of the tumour might be necessary. It was a blow when he went off to the Continent on a three weeks' holiday, so Calverley had no option but to turn to the other great specialist in Edinburgh, and Simpson's rival, even adversary, Dr. Syme. For two weeks she was under observation, with a junior doctor sleeping in the house. Then at last the tumour was considered 'advanced' enough. On May 9th Calverley jotted down: 'Caustic applied to open an eschar in abdomen. God grant success'; and on the 11th: 'Syme pierced the tumour or cyst, whence came about 1 pint of coffee-looking fluid (blood, urine and pus?).' And indeed she made an amazingly quick recovery. By the 19th they were even able to go out for a drive.

From subsequent correspondence it is clear that chloroform was used on the 11th. It also appears from Simpson's case-books of the period that Pauline's condition approximated to his description of pelvic cellulitis—'Iodine of potassium internally can assist this disease,' he wrote.

One or two pages from Pauline's diary happen to survive at this period. They are written in Pepysian style (the third edition of Pepys's diary having been published in 1848-9). She had been receiving several visitors, including Dr. John Brown, who told her that people at the exhibition thought the name P. J. Trevelyan on the pictures must indicate a man, 'which methinks pleaseth me more than any praise I

have had of them'. '. . . And so to reading and to bed, where Adams [her maid] do rub me with iodine until I scream again, and she do say I shall be rubbed day and night by the space of an hour at a time which do trouble me mightily.'

The Ruskins left Venice early in March. Effie had finally had a wonderful time—whirling from party to party, hob-nobbing with princes and princesses, counts and countesses, and waltzing with handsome hussars. Her friends at home no doubt would have raised eyebrows if they had known with what eagerness she associated with the Austrians. But then, as she reiterated, the Italian aristocrats whom she met were a poor lot.

She wrote very affectionately to Pauline on April 1st from Montélimar, having heard that she was still confined to her sofa. She hoped it was just 'obedience to Dr. Simpson', but 'I did not know what to judge from your long and kind letter to me at Venice, because you write in such excellent spirits. If you have any leisure second in your conversations with Dr. Simpson, who I think one of the good and talented of the earth . . . pray remember me most kindly to him. Say to him I am much better but not well, and that the Italian winter from its severity was particularly unfortunate for me. Sometimes I think I am quite well and then again my throat hurts me and sometimes I think I am as ill as ever. . . . Your illness cannot have interfered with your beloved occupation, drawing, for my brother and Lizzie [Cleghorn, *née* Cockburn] tell me you have some beautiful drawings in the Exhibition, which I assure you rejoices the heart of your *Master*, as you modestly call him.'

Even though her husband had sworn to immure himself when they reached Park Street, she felt sure he would see Pauline and even give her more drawing lessons. 'We spent a pleasant week at Verona, and the Scaliger monument underwent a thorough examination. John had me up at the top of a long ladder to see the features of Can Grande, who he pronounced to be vulgar and commonplace. I did not think much about going up a ladder, as I was to see something I had not seen before at the top of it, but when I reached the ground I was rather annoyed (and covered with blisters) by seeing that the Veronesi had collected to a considerable number and gave me a sufficiency of staring as if I had done something quite out of the ordinary course of things.'

Pauline of course was not strong enough to come south. But Effie, who had arrived in time for the London season, continued her social

life, and loved it all. She was presented at court. The ever talkative Lady Davy took her up, and she became friendly with one of Pauline's few *bêtes noires*: Lady Eastlake, the former Elizabeth Rigby, originally hailing from Edinburgh, a malicious, vigorous and high-powered person, with a flair for journalism and married to Sir Charles Eastlake, artist and future director of the National Gallery. It was Lady Eastlake in whom Effie eventually confided that her marriage had not been consummated and who thereupon urged her to leave Ruskin.

Meanwhile, in that early summer of 1850, Ruskin would leave Park Street every morning after breakfast, to go to Denmark Hill, where he could get on with his writing in peace and without interruption.

Pauline was recovering famously, as she told Loo. Her letters to the younger woman were often very emotional. At the end of April she had written: 'On Sunday, when the doctors and I thought I was going to die, you were among those I thought of most.' And then: 'I dream of you so often, such odd things, they make me laugh when I remember them.'

As for Simpson, he was quite well again. 'He is so kind and dear'; or as Dr. Brown said, 'as overwhelmed with work as ever, and plunging about rejoicing in it, like any seal in the Bay of Baffin.' Mrs. Simpson, when Pauline called at the house, would hide her away in the bedroom, 'so I don't have to fight for precedence with the thirty or forty ladies who assemble in the drawing-room'. He prescribed sea-bathing for the iodine, and cream to fatten her up. So off she went to friends near Arbroath, while Calverley journeyed south to see to business in London, the Nettlecombe area and Seaton.

He had to be away six weeks. In London he went to the Academy, and was not much impressed. 'Turner's extravagances—splendid effects of colour, nothing more. Some foolish attempts at medieval mediocrity.' Presumably this last comment was a reference to the five Pre-Raphaelite pictures exhibited, including Millais' 'The Carpenter's Shop' and Holman Hunt's 'Converted British Family sheltering a Christian Missionary'. In his dislike he was by no means alone. The *Spectator* thought both pictures 'monstrously perverse' and *The Times* considered Millais' works 'plainly revolting'.

Nevertheless the Pre-Raphaelite Brotherhood was the talk of London. When the secret of those mysterious initials P.R.B. had leaked out, it provoked a kind of fury. It was not surprising that their magazine the *Germ* was a failure. They were disillusioned, and recriminations

began. They numbered seven: Dante Gabriel Rossetti, William Holman Hunt, John Everett Millais, Thomas Woolner, James Collinson, Frederic George Stephens and William Michael Rossetti. Only the first three were to achieve real fame. Woolner was primarily a sculptor, and William Michael Rossetti was not in effect an artist at all—he is remembered chiefly as being the main chronicler of the Brotherhood and of his own family. They were young and really felt like brothers; they were constantly together, confiding in one another, and above all in rebellion, if confusedly, against the conventions of art-school teaching and its affectations. Their aim was to achieve the clarity of line and purity of colour seen in the Italian primitives, in addition to total naturalism and accuracy of representation. No wonder *Modern Painters* had been welcomed by them (it especially affected Hunt).

But none of this idealism had touched Calverley. He was more interested to see the first hippopotamus, by name Obaysch, at the Zoo. On his return from Somerset he called on Ruskin, who took him to G. F. Watts' studio. This was a more satisfactory experience than looking at Pre-Raphaelites. 'A man of vast power, in conception and execution. "Time and Oblivion" a very striking picture.'

The Stewart-Mackenzies were also up in London. Pauline was feeling very out of touch. Her letters to Loo were less hectic now. She urged her to call on the Ruskins and to write 'what my master is saying [about the Academy] and how he is looking'. He had already told her that the 'great ones' at the Academy had 'rather failed this year', but that the younger artists had made some advance.

Then gossip: 'And so Alfred Tennyson is going to be married. Did you ever see the lady? She is described to me in a letter I got yesterday as "a mist of white muslin, out of which there comes occasionally a small voice. She is always on the sofa, and always in the *enjoyment* of very bad health".'

The Tennysons were married on June 13th, after a long courtship. It was an unkind description of poor Emily. *In Memoriam* was published that same month, anonymously, but once again the secret was soon out. Pauline was one of the enthusiasts. 'It is much higher and finer than anything he has done before,' she told Loo.

Calverley found Pauline's health greatly improved. Her old friend from Suffolk, Laura Capel Lofft,* a dumpy little woman with an

* Daughter of Capel Lofft the elder, author of the volume of sonnets *Laura* (1814). Her brother Capel Lofft the younger was the author of the best-selling *Self-Formation* (1837).

aptitude for painting portraits, was looking after her—Pauline nick-named her Phluff, or sometimes Lofty. Almost immediately he had to rush down to Northumberland in connection with more High Sheriff duties. Then on August 29th he had to be at another dinner in New-castle in honour of Robert Stephenson. This followed the opening of the new railway station—'With Lord Grey [the Lord Lieutenant] received the Queen etc., at the new station where about 10,000 people were expected. It was a fine sight and things were well arranged. Vide newspapers.'

The newspapers were of course suitably enthusiastic. The Queen was on her way from Castle Howard to Edinburgh. 'Her train,' said the *Illustrated London News*, 'glided in amidst deafening cheers, and the waving of a perfect sea of handkerchiefs and hats. . . . Lord Grey, Sir Walter Trevelyan and a number of the neighbouring gentry joined in the hearty manifestations.' The new building, designed by Dobson, with its graceful iron curves was the first example of railway architec-ture on the grand scale in the country. Curved iron had also been used by Stephenson at Newcastle for his High Level Bridge, finished the previous year and again opened by the Queen (and still in use to this day).

The last half of 1850 was spent by both Trevelyans happily at Wallington. Maria was never mentioned in her son's diary, but she was spending much time taking the waters at Harrogate. Laura Capel Lofft remained with Pauline the whole while, and Dr. John Brown came as 'physician in residence'. There were visits to the seventeenth-century Swinburne mansion, Capheaton, three miles away, as Pauline had become very fond of the eighty-eight year old Sir John Swinburne, a handsome old fellow with a black patch over one eye and who had been educated in France—in younger days it was said, according to his grandson Algernon some years later, that the two maddest things in the North Country were his horse and himself. Besides Sir John's antiquarian interests he had a splendid library; and above all, not only was he a friend of Turner, but he possessed five of Turner's water-colours, all of high quality.

Pauline had been nagging Loo for a letter. At last one came and Pauline replied: 'My darling old Loo, I am so very happy at seeing that elegant *fist* of yours again, that I must sit down at once and tell you so. Dearest old pet, I was not angry with you ("only hurt at your conduct", as the old women say), but I really did begin to be afraid that you were either ill or unhappy, for idle as you are, I thought you had never been so long silent. I do wish you would make friends with

the Ruskins. You would do her good, and I am sure you would delight in him. Can you call on her?—or is it her business to call on you? It is very kind of me to wish it, for there is a great chance of your supplanting me in my master's affections. He is so busy on *The Stones of Venice.* . . .'

From the end of August until the end of October Effie had been at Bowerswell. She must have seen Simpson, for she wrote to Rawdon Brown saying that he had said that if she could have children her health would be restored. Unfortunately her husband did not wish 'any children to interfere with his plans of studies'. 'I often think,' she added rather pathetically, 'I would be a much happier, better person, if I was more like the rest of my sex in this respect.'[1]

She wrote to Pauline from Park Street on November 6th, having also received complaints about slackness in correspondence. Her excuses were that her mother had had another baby at Bowerswell, and Ruskin had insisted on a letter every day. She still hoped Pauline would come to London.

'How I wish I had only one room more that I might lay it at your feet, as the Mexicans say, but my little house is quite full and an extra bedroom is all I want to make it very comfortable for us. John is deep in his stones and occupied with printers' people who do mezzo-tints and lithographs, spoil some and make more work, and John is so delighted with his work and so happy that I assure you it is a great blessing to live with a man who is never cross nor worried but always kind and good. He was at Oxford last Saturday with the Aclands, standing Godfather to their last baby who is about three weeks old. He says they are very well but Dr. Acland has too much to do and he would not lead the life he does for the world.'

Acland certainly had a mania for overworking. If he were not careful, Pauline told him, he would have a collapse similar to Buckland's.

The unfortunate old Dean had lapsed into a near vegetable state. Mrs. Buckland's energies were now being put into a plan for a coffee house for the indigent of Westminster. It was to prove a considerable success. 'We have reached down,' she wrote to Pauline, 'to the lowest scales, at which I rejoice. Costermongers, dustmen frequent us.' Calverley at once, and typically, sent a donation to help.

On February 12th Pauline collapsed again: 'Fears of inflammation in utero. Dr. Simpson came several times, and at night leeches relieved her much.' That evening Simpson had Calverley to dine alone, and must then have told him that Pauline's condition was grave. On the 15th both Simpson and Syme called. An operation was once more necessary.

On the 21st they 'opened the cyst in P.'s abdomen and took out about 20 oz. of muddy red fluid'. Chloroform was again used, hurting her mouth so that it became swollen.

A short while afterwards Calverley had to leave for the Northumberland Assizes. On March 3rd, whilst at Tynemouth, he had a telegraphic despatch saying that Pauline was very ill. Convinced that she was dying, he at once caught a train to Newcastle, and within the hour had hired a special one to Edinburgh. 'Arrived there 7.10 p.m., and rejoiced to find that P. was better. This morning the tumour had been opened and iodine was injected, which soon after produced violent pain and alarming symptoms—which however gradually ceased and she passed a tolerable night.'

Meanwhile Pauline had been asked to write a review of the exhibition at the Scottish Academy for the *Scotsman*. As usual she took enormous trouble, and the article was run on three successive days. All the more important pictures—by D. O. Hill, Wilkie, Etty, Linnell, Landseer, etc.—were reviewed in detail. Then there was Turner's *Wreck of the Minotaur*.—'Everything after it would seem trivial and unmeaning;' it was a picture that would surely appeal to 'every human heart'. She finished the review on March 31st, under exceedingly trying conditions; Calverley wrote on that day that an iodine blister applied to her 'abdomen' had caused much suffering. The editor of the *Scotsman* was so pleased that he wrote hoping she would review the Exhibition again next season.

On April 4th she was given yet another blister, this time by nitrate of silver. And on the following date news came that her mother-in-law Maria had died at Harrogate at 3 a.m.

Calverley did not leave Edinburgh for the funeral until the 11th. Maria had vowed that she would never travel on a train, but her coffin had been sent by rail to Euston. She was buried in the Wilson family vault at Charlton. Nothing of course was left to Calverley out of her large estate, but as a Parthian shot she decreed that the 'Cabinet of Curiosities' at Wallington should be sold for the benefit of the children of her daughters. The Cabinet or museum had been Dame Jane's, who in point of fact had left it to Calverley. Still, rather than quibble, he agreed to buy it back for £450.

When he reached Edinburgh again, he found Pauline out driving. Some of Simpson's prescriptions of this date have survived, mostly containing iodine, that universal panacea. She also—presumably unknown to Calverley—was taking pills of extracts of the dreaded hops, to stimulate appetite. Her brother-in-law J. A. Power had

written to Calverley, saying that 'of course' the cyst was not ovarian. Evidence has shown that he was wrong.

Loo did call on Effie, who had written to Pauline on March 1st: 'What a fine noble creature Miss Mackenzie is, there is such a repose and power and depth about her at the same time. The other night at Sir G. Clerk's concert Lady Eastlake and I were admiring her fine head and calm expression through some hundreds of uninteresting ones. I think this year we shall see more of each other, and I shall deem myself happy if she likes me half as much as I am sure I should her. John is very busy now with his second volume of the *Stones*, his first comes out today as well as a pamphlet upon some ideas of Church Government which he calls *Notes on the Construction of Sheepfolds*. I am afraid you will not like it, but be sure and read it and tell us exactly what you think of it.'

And Pauline wrote to Loo: 'Effie is *quite* as much delighted with you as even I could wish, and she is *so* anxious you should like her. I was sure when you knew her you would be fond of her. She is so honest and true-hearted and loving, her manner does her injustice.'

Notes on the Construction of Sheepfolds was an attack on the Puseyites, an attempt to dissociate the Gothic Revival from them and the Roman Catholics. It was a mistake on Ruskin's part even to have tackled such a controversial subject. Volume 1 of the *Stones of Venice* came out at the same time; in spite of being such a major work it was not so well received as he had hoped. Pauline continued: 'I am not really hurt at people not liking my master's *Sheepfolds*. I think it is weak (besides, of course, not agreeing with its principles). I don't think it worthy of him, and so think also all his best friends here believe. It is a thousand pities he should go out of his own line, unless he has something better to say. I like his *Stones of Venice* exceedingly. It is full of beautiful things, it has been a great delight to me, lying in bed, to study it. The note in praise of Rubens is quite magnificent. I doubt if it will be a popular book, common readers will find it difficult (not that it really is so, it only requires reading with attention, and very few people nowadays ever *attend* really to what they are reading), and professional people of course will find fault with it. Still I hope there are a great, great many who will read and profit by it. I think *he* would be a great deal happier leading a quiet country life, but I agree with you that *she* would find it a trial at first.'

She always did her best to be loyal, whatever her secret misgivings. Dr. Brown was rather more forthright when he wrote: 'I read the

Stones carefully last week; it is a great work—in some respects his greatest—but his arrogance [in *Sheepfolds*] is more offensive than ever, and his savage jokes more savage than ever, and than is seemly or edifying, and his nonsense (and his father's) about Catholic Emancipation most abundantly ridiculous and tiresome. I once thought him very nearly a god; I find we must cross the River before we get at our gods.'²

In April the Ruskins went to stay with Whewell. The first days of May saw the opening of two events of importance in London, namely the Great Exhibition in Hyde Park and the Royal Academy exhibition.

The Pre-Raphaelite pictures shown at this last numbered six: three by Millais, including 'Mariana', one by Hunt, and one each by artists regarded as associates of the Brotherhood, Charles 'Convent Thoughts' Collins and Ford Madox Brown. *The Times* once more rushed into the offensive, and six days later Ruskin, signing himself 'The author of *Modern Painters*', counter-attacked with a long letter to the paper, at the instigation of Coventry Patmore, who was a mutual friend of his and Millais. A second, more measured, letter followed on May 30th, wishing the artists 'all heartily good-speed' and prophesying that as they gained in experience they might 'lay in our England the foundation of art nobler than the world has seen for three hundred years'. Shortly afterwards Ruskin and Effie went to call on Millais in Gower Street. And in August Ruskin published his further expanded views, with much about the glories of Turner included, in a pamphlet, *Pre-Raphaelitism*.

If the Great Exhibition did not excite Ruskin quite so strongly as the majority of his compatriots, its lure was very strong indeed for Calverley. First, however, Pauline had to be settled into Wallington. Then as soon as he dared, he hurried back to London to this 'Arabian Nights structure', as *The Times* termed it. He went every day. One has the impression that the Academy, the Sketching Club exhibition, and even the Horticultural Show were simply diversions. His diary was crammed with statistics and lists: nineteen acres, six hundred yards long, million square feet of glass, eight miles of table space; minerals, jewels, machinery, fabrics. 'American daguerreotypes. Gold service from California. Fine silver. Ore from Norway. Russian brocades, furs and knit shawls. Brussels lace.... Bavarian section: china, statues, jewelry, tea-set of cornelian amber. Austrian furniture....' At least he found time to say good-bye to the Ruskins, who were off to Venice once more.

Returning to Wallington, Calverley was pleased with the local doctor, who seemed to understand Pauline's case well. This doctor had a microscope. After dinner one evening they examined various animal tissues and some mud in which living organisms could be seen. In his curiously detached way Calverley was not averse to inspecting 'albumen and pus in discharge from P.'s bladder'.

By September Pauline was well enough to come to London, again with Laura in attendance. It was too tiring for her to pay many visits to the Exhibition, but Calverley again went daily. On October 1st he noted that 2,400 vehicles passed their lodgings (1 Wilton Place) in an hour, 900 being cabs and 480 omnibuses. On the 7th he recorded that on that day there had been 109,915 visitors.

Later in the month he went on his own to Nettlecombe, to inspect 'improvements' and newly erected cottages. A haunch of venison was sent to the Ruskin parents—a habit he kept up on each visit over the years. He paid a visit to Taunton Hospital, where a high spot was the sight of a preserved specimen of a 'large cystoid ovarian tumour successfully extracted from a girl', and this he duly sketched for Pauline's edification.

On September 22nd Ruskin wrote from Venice to his father, enclosing a letter from Pauline for him to read, with a reply for forwarding. 'If you knew how good and useful she was also you would be flattered by her signature to me—"your ever dutiful and affectionate Scholar".'[3]

In his note to Pauline he told her that he had been thoroughly tired out when he left London: 'We are in lodgings here [Casa Wetzlar, now the Gritti Hotel overlooking the Grand Canal]—so comfortable that I feel for the first time in my life as if I were really in my own house. I always considered Park Street as lodgings of the most disagreeable kind—and did not even trouble myself to arrange my books there. But here all my possessions are in order—down to my inkstand with One pen in it—no more—and my pencil case with three pencils in it and two brushes. And I am beginning to consider myself an exemplary person. As for Effie, I have no doubt she is a very exemplary mistress of a household; for she is scolding from morning till night; and is always discovering something wrong. Certainly there is a good deal of that to *be* discovered.' Pauline must have poked fun at him about *Sheepfolds*, and have said something about the behaviour of Pius IX, for he went on: 'So I am to fight out my quarrel with the Pope, am I, without saying anything about anybody else. Well, but then, are you Tractarians going to be quiet? You say you are down,

I had no idea of that, I thought you were in great strength and that there was a Tractarian curate *or* rector in at least three parishes out of seven over the whole country. I know that all my Oxford friends— with one exception, are divided between Tractarianism and liberalism —and are determined to let the Catholics have it all their own way, either because they love them—or because they don't care about religion at all. Such members of Parliament as they make! the men whom I used to have hot suppers with. They will give all England a hot supper, one of these days, if they don't take care. Meantime I am rejoiced that you like anything I have said about your pre Raphaelites, and that you are again drawing yourself. When you are *quite* well again, please tell me what you are doing—something very noble ought to come of those studies of trees.'

Thus it appears that Pauline had been praising the Pre-Raphaelites to him even before the opening of the Academy in May. It is not surprising that she should have leapt at the chance given by Dr. Brown on October 29th when he wrote to her: 'Bye the bye, I have been importuned by the gentle Findlay of the *Scotsman* to review *Pre-Raphaelitism*. I cannot do this.... Will you? giving a short account of your own estimate of the Brethren.' The fact that the *Athenaeum* and the *Art Journal* had attacked Ruskin for his attitude of 'infallibility' in the pamphlet and his 'Turner-*oratory*' made her all the more eager to accept.

Meanwhile she had first to accompany Calverley to Suffolk, partly to stay with the Capel Loffts, partly to see the new Ipswich Museum, where the fossils had been 'well and instructively arranged' by Professor Henslow. Calverley was extremely taken with its curator, David Wooster, 'Mrs. Loudon's former amanuensis', a very shy, unsmiling young man in his twenties, with dark hair and drooping blond moustaches—Mrs. Loudon being a successful horticultural writer and widow of J. C. Loudon the landscapist and architect. This encounter, indeed, was eventually to lead to a proposal that Wooster should come to Wallington, first to help with the arranging of Dame Jane's museum, and ultimately as Calverley's secretary—a proposal that initially does not seem to have pleased Pauline overmuch.

She wrote the review at Wallington, and Findlay was extremely pleased. It was published on January 3rd 1852. The opening was a brilliant summary of the conditions in the British art world that had led up to the founding of the Brotherhood:

'It is long since every thoughtful frequenter of our exhibitions of modern pictures began to feel a weary sinking of the heart, as, year

after year, those collections told him the same unvarying tale. There was the same display of pictorial skill, the same all-pervading prettiness, the same brilliancy of effect, produced in the self-same conventional manner, and the same absence of all lofty aim or original thought. Talent was not wanting, nor even genius. The system, not the men, was in fault—that something was wrong few people could deny; as to what that something was, or how it should be remedied, there were, and are, abundance of different opinions. The training of academies, the shallow criticisms of many who profess to instruct the public—the un-enlightened patronage of a large portion of those who purchase pictures—all have come in for a good share of the blame, and all, it would seem, have deserved it sufficiently—all, doubtless, have contributed to foster the production of works unworthy of the highest powers of the painters, and unimproving to those who admire and possess them. To these causes may be added the artificial state of society in which we live. The insatiable claims which it makes on the time and resources of the student, calling on him to paint pictures for profit, when he cannot rightfully spare an hour or a thought from severe study, gauging his respectability by his income, instead of by his merits. Under these circumstances, how much firmness of character, originality of thought, and determined self-denial, must it cost to break through adverse influences, to resist all temptations, and resolutely to adopt a course of severe study. To take nature as she is, and, rejecting all falsehoods (though permitted by long usage), to labour earnestly for truth alone, as the first and highest of all attainments. . . .'

And this was precisely what the Pre-Raphaelites had endeavoured to do, 'amid all the conventionalism and pretention' of the last London Academy exhibition. Agreed, she said, that their pictures were strange, even on occasions uninviting, but the artists—'young but determined minds'—were not concerned necessarily with beauty. Truth, whatever it cost them, was the most important thing, 'copying no pictures, but such as nature paints on the face of creation, and not heeding any rules, but what they can read in her works'. Like Ruskin Pauline looked to the future careers of these very young men with hope and confidence. She could not resist making fun of Ruskin's religious qualms: 'He is not without his fears for them, some strange enough, and, one may hope, needless enough too. Mr. Collins may not paint lilies in a convent garden, but the serpent is supposed to be hid under the leaves; and Mr. Millais cannot decorate Mariana's room in the Moated Grange, with some indications of the faith of her country, but the author of *Modern Painters* finds the Pope behind the curtain.'

All the same, *Pre-Raphaelitism* was 'full of thought and free from intolerance, and worthy of the generous spirit that dictated every line of it'.

On February 17th the Trevelyans were in Edinburgh. They went straight to the Scottish Academy, and by the 20th Pauline had written her very long critique, full of assurance and far more trenchant than previously. It is clear that she had thoroughly enjoyed writing it. The exhibition contained Millais' 'Mariana' and 'The Carpenter's Shop'. As she said, 'Mariana' was the subject of 'as much discussion and more vituperation than all the rest of the Exhibition put together.... People have forgotten to cry out even against the Turner which hangs near it; in their indignation at poor Mariana in her weary solitude.' It would have been so easy to have given her 'conventional simpering beauty'. Instead Millais had bestowed on it 'a poetical truth and deep feeling'. The picture was *painfully true*. 'We leave the merits of Mariana, without a shadow of misgiving, to the sure test of time and common sense.'

The Turner was a light-hearted one: 'Admiral Van Tromp, putting about in a stiff breeze, ships a sea, and gets a good wetting.' This enabled her to write a short obituary, for Turner had died on December 19th—'Our country has lost the greatest painter she ever produced.' William Bell Scott had sent in two watercolours, and she was a little hard on them. 'There is, in these works by Mr. Scott, a certain fire and poetic feeling, which attracts and interests us, in spite of the mistaken system in which they are painted. The want of models and of close study is glaringly apparent.' Words that were well and truly taken to heart by Scott, as she was to find out in the future.

All in all, the review was a triumph and Brown wrote on February 22nd: 'How delighted I was and am with yesterday's—everybody is.... Go on and prosper, and be as long and as wicked and as delightful as you like.'

CHAPTER SIX

A FATEFUL VISIT
1852–53

ON March 26th 1852 Calverley made the first of his wills leaving Wallington to Charles Trevelyan. It was of course a secret, and Charles himself was given no hint of the decision, which had partly been influenced by Pauline taking a liking to his black-haired son, George Otto, aged thirteen and recently gone to Harrow.

She was not well at the time, and was sitting in her wheel-chair under one of Sir Walter Blackett's hawthorns when the boy came riding up the drive, after a long journey in the fly from Morpeth station. They began talking and were at once friends. He had, regrettably, no interest in Art but possessed real literary flair, and she liked his liveliness and bright, eager self-assurance, more Macaulay than Trevelyan. He was also politically minded, which pleased Calverley. A very suitable future squire of Wallington therefore.

Alfred Trevelyan had been ruled out as an heir by Calverley partly because he was Roman Catholic (though this of course would not have worried Pauline). He was musical, which was something in his favour, and liked travel, but he was not particularly intellectual, and certainly not reliable. He did of course stand in line to inherit Nettlecombe, which was entailed—but Calverley had long ago decided that the possession of two such large estates was not only a burden but wrong socially. At the same time other important decisions were made about Wallington. Quite definitely it was to be the main home, not Nettlecombe. Pauline loved it, Calverley had been born there, it was reasonably near Edinburgh, where most of their friends (and her doctors) lived. And then there was the matter of Julia. . . . Also they had plans for altering the house. They were going to roof over the central courtyard and turn it into a 'saloon', perhaps filled with tropical plants. In William Bell Scott's words, it 'had been long found productive of only damp and cold'.[1] Dobson, the Newcastle architect, would be asked to do the work on this 'blind space', 'opening the walls into arcades and covering the whole by a coffered roof'. The room

would be warmed by hot water pipes, and the gallery upstairs would be used for hanging modern pictures and the collection of old masters from Italy.

Tradition has it that Ruskin suggested the roofing over. This could not have been the case. For one thing, he was in Venice when Calverley first discussed the work with Dobson in January 1852. Then the last time Pauline had seen Ruskin was in April 1848, when Maria was still in command. And finally, there is nothing Ruskinian about the design, except in one minor detail, as will be shown later.

It has also been suggested, and this seems much more probable, that the idea may have been influenced by Bridgewater House in London, where Barry had proposed a similar central saloon in 1849.[2] Without doubt the designs would eventually have been shown to Ruskin, possibly early in 1853, but by then all the major decisions had been taken. Dobson had altered many country mansions around Newcastle, and had advised the Trevelyans' friend and neighbour, Sir Charles Monck, on the construction of his superb Grecian building at Belsay. Although classical architecture was Dobson's real love, he had done plenty of Gothic work which Pauline had admired (not that the new saloon at Wallington was intended to be at all Gothic). Moreover, he was a teetotaller, and had agreed that only total abstainers should be employed on the work.

Calverley was still busy with improving the lot of his Cambo villagers. He put down a completely new drainage system for all the cottages, and founded a library. Most important of all for their moral well-being, he forbade the local inn, the 'Two Queens', to sell intoxicating liquor. A branch railway line was being planned, mostly at his expense, from Morpeth to Scots Gap, a mile away from Cambo.

A cousin, Spencer Walpole, was now Home Secretary in Lord Derby's Tory administration, and it was hoped that he might arrange a government grant to help in draining moorland. Such a suggestion might have seemed presumptuous, considering that Calverley again was under pressure, this time from Lord Grey, to stand for parliament as a Whig (for South Northumberland). However blood turned out to be thicker than politics.

Lifeboats, the Highland Emigration scheme, a bill to include alcohol in the law controlling sales of poison, objections to Knightsbridge barracks: these were some of Calverley's other preoccupations at the time. He was also a Deputy Lord Lieutenant of Northumberland, as well as of Somerset. He had not, as he had threatened, emptied the contents of the Wallington wine cellar into the Wansbeck, no doubt

to the relief of the ghosts of Fenwicks and Blacketts—for the house
had been famous for its convivial atmosphere in their day. 'Show me
the way to Wallington,' one drinking song used to run. And another,
more sedately: 'The wine of Wallington old songsters praise/The
Phoenix from her ashes Blacketts raise.' When Pauline won her battle
about a decanter of wine always being on the table for guests, Calver-
ley's conditions were that the wine should be of the cheapest quality
and that no more than two glasses should be drunk by any one person.

Pauline's particular love was the walled flower garden that lay some
distance from the house in a lush dell that contrasted marvellously with
the views of wild Northumberland hills. The garden around the house
itself was fairly plain, with the park in front divided by a ha-ha. To
the west and east there were woods, and the public road came up the
hill from the Wansbeck and Payne's bridge, almost as if it were a
private drive—this gave visitors a peculiarly welcoming sense. To
get to the flower garden one went through the East Wood and past
the China Pond, where there were water lilies and an island on which
were the remains of Sir Walter Blackett's rococo temple; then past
the Portico House, overlooking another pond, probably Capability
Brown's creation, and where greenhouses were being constructed for
avocados, guavas, mangoes and vines; and finally to the Owl House,
decorated with the owl insignia of the Calverley family. In order to
embellish the flower garden, Pauline had arranged a collection of
seventeenth-century Dutch lead figures—of Scaramouche, a Roman
Centurion, etc.—along the high wall. These had been at the Blackett
house in Newcastle. It was a sad blow when Calverley decreed that
some must be melted down as being indecent.

No further letters from either Ruskin or Effie to Pauline have been
discovered for the rest of their time in Venice. They left in June, and
were back in London the following month—once more missing the
Trevelyans, who had just returned to Wallington.

Life in Venice had been even more brilliant for Effie. She had at
last met Radetzky, who had admired her. There had been masked
balls, and she had shone at parties given by Hohenlohes, Trubetzkois
and Esterhazys. Ruskin, engrossed as usual in his work, had allowed
her to go out alone. Nobody seemed to mind his unsociability; he
was merely considered eccentric.

Ruskin had meantime been named an executor in Turner's com-
plicated will. The finished pictures had been left to the National
Gallery, but there were provisos attached. At first Ruskin was elated

by the possibilities, but, when he heard that the family was contesting the will, he renounced the executorship. All the same, he returned to London eager to discover what treasures could be unearthed in the old man's house.

The lease of the Park Street house had expired. Effie now had to face up to living in a small house at Herne Hill, half a mile from the old Ruskins at Denmark Hill. There could hardly have been more of a contrast to the gay life of the previous months. It was from there that she wrote to Pauline on July 25th: 'I have been a fortnight nearly in England, but what with moving into a new house, want of servants and quantities of workmen and other troubles, I have not been able till now to answer your kind note. That we left Venice after a year's residence there with much regret, you will easily believe. . . . Mr. Ruskin found so many interruptions in London to his work and quiet habits that, wishing to be nearer his Turners, he has taken a house in which we are now residing, about ten minutes' walk from his Father's house. He now intends to finish his second vol. of the *Stones* and third vol. of *Modern Painters* at his leisure. Much of his time is at present spent in Mr. Turner's house where he finds boxes and drawers *full* of most wonderful drawings of untold value which he is glad to look at now, as they will probably be sold. . . . But John is anxious to get rid of the executorship, as it might cause him a great deal of trouble if the case remains in Chancery—where if all Mr. Dickens says is true concerning that establishment [in *Bleak House*, coming out in monthly instalments], it is likely to remain some time. Thank you very much for wishing us to come to Wallington. You must really think us the most ungrateful of our species, but you know we have been such wanderers that we must stay a little at home. . . . I must confess every-thing . . . here looks hideously ugly after Venice, and the extreme cleanliness, squareness and precision of everything are perfectly painful after living in tumbledown Palaces with Tintorettos and Veroneses for furniture.'

There were messages to Loo. 'Workmen and other troubles' referred to the fact that Ruskin's parents had had the house done up 'cheaply and vulgarly', enraging both Ruskin and herself. In September she left, alone, for Bowerswell on a visit of seven weeks.

Most of 1852 is sparsely documented as far as Pauline is concerned. She met Millais in London, that we know, and of course she went to the Academy to see the Pre-Raphaelite pictures: an important collec-tion, including Millais' 'The Huguenot' and one of his most enduring

paintings, 'Ophelia', Holman Hunt's 'Hireling Shepherd', and Ford Madox Brown's 'Christ Washing St. Peter's Feet' and the 'Pretty Baa-Lambs'. The press and the public were on the whole enthusiastic. The tide had turned for the Pre-Raphaelites.

The Trevelyans enjoyed Mario and Grisi in *I Puritani* and Mark Lemon's *Mind Your Own Business*. Calverley saw much of the ageing Sir Henry Ellis, principal librarian at the British Museum, and was shown round newly arranged collections at the Museum, such as the Medieval and Nineveh. Sir Henry accepted four etchings by Pauline on behalf of the Museum: 'View in Ghent', 'Arch of Titus', 'Waterfall near Tintagel' and 'Turreted Gateway.'

By February 1853 the Trevelyans were back in London, after some while in Edinburgh. There was an invitation to the Ruskins', and Pauline sent this report, half tongue in cheek, to Loo: 'Last night [the 15th] we dined at my Master's. I am so thankful to find that I can worship him as entirely as ever, and also that he is as kind and loving as ever. What a blessing *that* is, when one has been several years without seeing one's idols. Not that one really doubts—but there are phantom fears (not about *you* though—if I did not see you for fifty years, I should feel sure of loving you just the same as now). I took the Master some drawings to look at. Oh, what a fright I was in! For he said he expected great things of me, and I was afraid when he saw what I had done, he would think I was a shocking bad scholar. Well, my love, he was not the least disgusted, quite the contrary, and said he was very proud of his scholar, and in fact I came to such glory that, as Phluff would say, I shall stand upon my head for the rest of my days. I am to go very often in the mornings to have quiet talks. . . . Effie Ruskin was very nice, she had a picturesque dress on, but it was quiet, and in good taste. After all, dear, if she is a little too fond of fine people and fine ways, there is a deal of truthfulness and trueheartedness in her.'

In the same letter, Pauline mentioned that Lord Cockburn had been entertaining the Nightingales at his house Bonaly, 'so I asked him a great deal about *your* Miss N., and he admired her as much as you could wish . . . one of the most striking and uncommon characters he had ever seen'. This was Florence, to whom Loo had become her 'Beloved Zoë', for by now Loo's main affection had been transferred from Parthenope. There are indications that Pauline was just a little jealous of Florence Nightingale.

Effie had been having a very dull time, and had now declared that she would not go out unless accompanied by her husband, who was completely absorbed with finishing off *The Stones of Venice*, vol. III

as well as II. It had been five years since Pauline had last seen the Ruskins. She must have been aware of Effie's discontent, and no doubt this was her real reason for the frequent visits, usually every other day. There were all Ruskin's daguerreotypes of Venice for her to see, and his collection of Turners. She was even able to be of some small assistance to him in his work. Whilst working on capitals, he appealed to her for a magnolia and she at once sent down to Nettlecombe for a selection of blooms. But then he decided that a magnolia flower was too divided for his purpose. He was really wanting something in the form of 'a ranunculus, rose or water-lily, or very open tulip'. As the season was wrong for these, she had to draw him a water-lily from memory and a wild tulip, *T. Sylvestris*.* And on his introduction she was taking drawing lessons from rugged old 'Birds' Nest' William Henry Hunt.

Calverley's activities were mainly in the British Museum, at Kew, at the Zoo where the new chimpanzee had now become the rage, and at the Geological Society where Captain Fitzroy of *Beagle* fame was much interested in Calverley's specimens of cryolite from Greenland. Like many another Calverley was exercised about the search for Sir John Franklin and his ships 'Erebus' and 'Terror', last heard of in July 1845, when they had set off on their bid to find the North-West Passage. Some traces of the expedition had been found in August 1851, and Calverley was now giving liberal contributions to search parties, in return receiving geological specimens for the Wallington museum.

Then there was all the controversy about table-rapping and clair-voyance, which had been sweeping fashionable London ever since the arrival of the American medium, Mrs. Hayden. Although mesmerism was under attack from such journals as diverse as the *Lancet* and *Punch*, Calverley still believed in its worth. He granted that chloroform had to some extent superseded the medical uses of mesmerism, but was nevertheless in favour of setting up a mesmeric hospital. Unfortunately, the 'Rappers' were helping to bring the entire 'science' into discredit, and he thoroughly disapproved of them. He also saw much of Charles Trevelyan: 'Charles at Treasury received application for a grant to erect a photographic room at Marlborough House [an offshoot of the National Gallery]'; 'Charles anxious about defence of country';

* *Cf. The Stones of Venice* II, *Works* 10, Plate X, 'The Four Venetian Flower Orders', facing p. 164, which has drawings that coincide with Ruskin's letter in reply. A footnote in *Stones* III, *Works* 11, p. 271, acknowledges Pauline's help with this plate.

'Charles preparing report on Civil Service.' This last was the report published in November 1853, in collaboration with Stafford Northcote (whose sister Cecilia, incidentally, was one of Effie's great friends), that aimed to destroy,—and successfully succeeded in so doing— patronage and nepotism in admissions to the Civil Service. Charles was becoming even more fearsome and zealous. Anthony Trollope satirized him as Sir Gregory Hardlines in *The Three Clerks*—he was 'something of a Civil Service Pharisee, and wore on his forehead a broad phylactery, stamped with the mark of Crown property'. As his grandson, G. M. Trevelyan was to write: 'Every weekday Sir Charles disappeared after an early breakfast, riding in from Clapham to Whitehall, to transact the nation's many affairs, with a sharp lookout against aristocratic jobbers and middle-class contractors, creating the standards of the British Treasury in the nineteenth century.'

Then there were temperance conferences to attend, and these brought Calverley into contact with George Cruikshank, a teetotaller heart and soul since 1847 and whose Hogarthian drawings for *The Bottle* had sold in thousands. However, Calverley basically was not the sort of person to feel at ease with him. Life for Cruikshank was always at fever heat, and it was said that he could have been a good actor if he had been capable of a moment's repose. As he was rabidly anti-Papist, he did not particularly appeal to Pauline, who was nevertheless an enthusiast for his drawings.

At the end of March 1853, Calverley had to go to Northumberland, partly in order to preside at a political banquet in honour of Sir George Grey of Fallodon, who had been Home Secretary under Russell and was now member for Morpeth. At this dinner, to every-one's surprise, Calverley snatched at the occasion to advocate tem-perance and to inveigh against 'absurd drinking habits which have been handed down from a barbarous age'. As a result, he said, he would announce the toasts, but would not ask people to raise their glasses or drink the contents. No wonder there were hisses. As he had the reputation of being a 'thoughtful and collected public speaker, who made every sentence he spoke tell, and who never wasted a sentence', the evening must have been dry in more ways than one.

Whilst he was away, Pauline stayed at Herne Hill with the Ruskins. She had already been there for a few nights at the beginning of the month. Calverley came back on April 3rd, and on his way to the Ruskins, ran into Effie and Pauline walking together along the road. During March Effie had been sitting to Millais for the wife in 'The

Order of Release'. So on April 5th, the Trevelyans were taken to his studio to see the picture. 'A fine one and deep sentiment,' remarked Calverley.

The two *Stones* volumes were in the press, and it was about the time of Pauline's visit that Ruskin, now relieved of work, promised Effie that he would go out into society in May, and that in June they would travel to Scotland, staying at friends' houses, including Wallington.

During April the Ruskins and Pauline continued to see a great deal of one another. Pauline had Effie and Loo photographed together for a stereoscope. On the 27th, the Trevelyans dined with the Ruskin parents, Millais being present.

Millais was tall, thin, fairly handsome, with large soft eyes and, as Holman Hunt called it, a 'cockatoo tuft'. G. P. Boyce found him rather egotistical, with his attention too easily distracted.[3] He was better off financially than the other Pre-Raphaelites and dressed in a conventional, strictly non-artistic manner. Effie was already suspecting that her father-in-law was trying to compromise her with him.[4] For all that, it was decided about this time that Millais should accompany the Ruskins on their trip to Scotland. Ruskin was so enthusiastic about his protégé that he felt that the impact of Highland scenery would have splendid and exciting effects on his genius. It was hoped that Millais' brother William and Holman Hunt, his best friend, would be of the party.

Pauline went with the Ruskins to the private view of the Academy, and returned there practically every day the following week. On the opening day, May 2nd, Calverley said there was such a crowd that it was impossible to see 'The Order of Release', let alone the other pictures. It was the picture of the moment. A guard had to stand by it to keep people moving. Some papers praised it extravagantly, some attacked it. Effie, of course, was very flattered as well as pleased about Millais' new fame. Other outstanding pictures shown at this Academy included works by Collins and Madox Brown, 'Claudio and Isabella' by Holman Hunt, and another by Millais, 'The Proscribed Royalist'.

The Ruskins took rooms in Charles Street. Effie seems to have made very little secret of her marital worries. On June 4th, Chichester Fortescue (the future Lord Carlingford, prototype of Trollope's Phineas Finn) came to breakfast and stayed talking until 2 p.m. Presumably he was one of the 'gallant rakes' to whom Millais was to refer at the end of the year when writing to Effie's mother about all the gossip circulating in London. Judging from Fortescue's diary,[5] not

only did she flirt with him, but she poured out her heart in a most indiscreet manner. This 'remarkable little creature', he said, told him that she had been watching him for years. She then spoke of her 'strange and painful history'. Ruskin, although a 'philosopher', was 'terribly wanting in the power of loving and appreciating a woman like her'. His two gods were his Art and his parents, and he allowed both to stand between him and his wife. She told Fortescue that she couldn't now help hating the name of Turner and feeling that it was her 'curse'. That Ruskin was enslaved to his parents, who idolized him and treated her like a rival, tyrannizing over her in a dark puritanical way. Ruskin senior and junior spent thousands on pictures and charities, and nothing on her. All this was recounted with a sweet and childlike naivety. She did her best, she went on, to combat her unhappiness with prayer, reading the Bible, etc. etc.

Just how innocent was Effie being? Whatever her motives for telling Fortescue all this, it pretty well summed up much of her predicament. Fortescue's sister, Harriet, who shared Ruskin's incipient interest in social problems, came to stay at Charles Street; when Fortescue spoke to her about these revelations, she said that she too had heard all about them. Effie had 'poured out all her heart'. Presumably Pauline must also have heard a certain amount whilst at Herne Hill.

In mid-May the Trevelyans went down to Seaton. Pauline, inspired by displays at Marlborough House, once more took up the cause of the lace-makers of Beer and sent the Director a collar made by two local women. It had involved a month's work, and she was charging £3 on their behalf. She complained that Government schools of design were sending down totally unsuitable patterns, with a want of feeling for the material. Her 'enemy' down there was John Tucker of Branscombe, who operated his lace business on the truck system—the workers receiving payment in goods from a shop, instead of money—and in her campaign against this she was aided by Calverley's sister Emma Wyndham, who was equally horrified by the fact that the system was used by farmers in Dorset, where she now lived.

Although Nettlecombe was such a short distance away from Seaton, Pauline did not feel like visiting it. By June 1st they were back at Wallington.

The alterations had been postponed until the distinguished guests had left. William Millais was coming, but not Holman Hunt who had work to do, namely finishing 'The Light of the World', after which he wanted to go to the Holy Land.

The two Ruskins and John Millais (whom Ruskin called by his second name, Everett) arrived on June 22nd. William Millais and Loo arrived on the 24th. On the 23rd, Ruskin wrote to his father: 'This is the most beautiful place possible—a large old seventeenth-century stone house in an old English terraced garden, beautifully kept, all the hawthorns still in full blossom; terrace opening on a sloping, wild park, down to the brook, about the half a mile fair slope; and woods on the other side, and undulating country with a peculiar *Northumberlandishness* about it—a faraway look which Millais enjoys intensely. We are all very happy, and going this afternoon over the moors to a little tarn where the sea-gulls come to breed.'[6] The description—taking into account that neither seventeenth- nor eighteenth-century architecture appealed to Ruskin—was rather at variance with the one he wrote retrospectively in *Praeterita*: 'Wallington is in the old Percy country, the broad descent of main valley leading down by Otterburn from the Cheviots. An ugly house enough it was; square set, and somewhat bare walled, looking down a slope of rough wide field to a burn, the Wansbeck, neither bright nor rapid, but with a ledge or two of sandstone to drip over, or lean against in pools; bits of crag in the distance, worth driving to, for sight of the sweeps of moor round them, and breaths of breeze from Carter Fell.'[7]

The party stayed until the 29th. On the face of it the visit was highly successful. In another letter, dated July 5th, Ruskin again wrote to his father, enclosing one from Pauline: 'The pleasantness of these people consists in very different qualities: in Lady Trevelyan in her wit and playfulness, together with very profound feeling; in Sir Walter in general kindness, accurate information on almost every subject, and the tone of mind resulting from a steady effort to do as much good as he can to the people on a large estate, I suppose not less than twenty square miles of field and moor. He has a museum at the top of the house containing a very valuable collection of minerals, birds, and shells, which was very delightful to me, as the days were generally wet. But we were out a good deal too, and Millais liked to watch Sir Walter with his bare head leading Lady Trevelyan's pony on the moor against the wind and the rain.'[8]

Calverley wrote of Millais' delight at the northern scenery, and especially the rocky streams. The two brothers went fishing in Rothley Lake and there were excursions to Shafto Crag and the Punch Bowl. Millais did sketches in watercolours of Effie and Calverley, 'very beautiful, rapidly done and good likenesses'. One June 27th the Trevelyans took Ruskin and Loo to Capheaton, where the Turners

were 'revelled over and admired'. 'Ruskin considers them some of the finest he has ever seen and so well selected.'

We turn now to an account of that visit, written a long while later by someone who by then considered himself an enemy of Ruskin: William Bell Scott. Ruskin, he said, had carried off Millais to Scotland to initiate him into the 'only class of painting he, Ruskin knew anything about or cared for, landscape'. Scott continued: 'Already apparently before they reached Northumberland, the handsome hero [Millais] had won the heart of the unhappy Mrs. Ruskin, whose attentions from her husband had it seems consisted in his keeping a notebook of the defects in her carriage or speech. More than that the lovers had evidently come to an understanding with each other, founded apparently on loathing for the owner of the notebook. Mrs. Ruskin used to escape after breakfast, and joined by Millais was not heard of till the late hour of dinner. Lady Trevelyan hinted remonstrance, took alarm in fact, but not caring to speak confidentially to the lady who acted so strangely in her house, got Sir Walter to rouse the apparently oblivious husband. Her quick eyes had of course discerned something of a telegraphic language between the lovers, and she was mystified by Ruskin's inexplicable silliness as she inadvertently called it to me. Sir Walter was also mystified, but having pretty good eyes of his own, was less given to forming conclusions or speaking of what was passing, he agreed however to take Ruskin into his confidence. But that innocent creature pooh-poohed him. Really he didn't *believe* there was any harm in their *pleasing* themselves. He could not see what harm they could do: they were only children! He had often *tried* to keep her in order! Years after when I could venture to talk over the affair with Sir Walter, I asked him how he explained this mode of taking the warning. He confessed to having thought over the matter, and was inclined to conclude that John Ruskin wanted to get rid of his wife; had it been any other man he would have so concluded, but then the individual in question did not know much about love-making.'[9]

The above has had to be included in this book, even though Scott has been discovered to have been maliciously inaccurate in many passages of his autobiographical writings. There is however no proof that he was wrong about the 'telegraphic language', and it is perfectly possible that there might have been some sort of declaration while the others, except William Millais, were at Capheaton.

It has been suggested that two drawings by Millais, both dated 1853, were inspired by events at Wallington. One is called 'Rejected', with a

subtitle partly erased, 'Good-bye, I shall see you tomorrow', and shows a pair of lovers preparing to part, with a carriage and groom in the background. The other is called 'Accepted': a moonlit scene on a lawn, a man kneeling with his face buried in a woman's hands whilst she looks fearfully back at the house, where dancing couples can be seen through french windows. The house is not Wallington, it was raining most of the time, and a dance would certainly never have been held there, but it is true that the setting has something of the atmosphere of the place.[10]

Dobson's plans for the alterations were as a matter of course shown to Ruskin, who thereupon made a suggestion for a small change, which was at once adopted. This was that the balustrade round the upper gallery, instead of the 'common gouty pilasters', in Calverley's words, should be copied from one at Murano, illustrated as figure 4 in plate XIII of *Stones of Venice* II.

Then there was Peter, Pauline's Skye Terrier. Ruskin, always a lover of dogs, was captivated by him. In the letter of July 5th to his father, he referred to this 'droll doggie with his hair over his eyes—who when he is asked if he is poorly lies down and puts out his paw to have his pulse felt'.

On June 28th Millais wrote to Holman Hunt: 'We are going to leave here tomorrow for Melrose Abbey.... The country is glorious like the Isle of Wight seen from the sea. On the moors I have seen many strange birds who lure one from their nests by running in front of you slowly to tempt you from the road to their young. These curlews and pee-wits have a melancholy cry which is very lovely indeed. Today I have been drawing Mrs. Ruskin who is the sweetest creature that ever lived; she is the most pleasant companion one could wish. Ruskin is benign and kind. I wish you were with us, you would like it. Goodnight old codger, yours affectionately.' He added that both he and William were suffering dreadfully from midge bites—'all my hands, arms, legs and face look as if I was recovering from smallpox'.[11]

Ruskin also mentioned this portrait in a letter written to his father on the day of their departure: 'We left Wallington this morning at eleven o'clock—to the great grief of our host and hostess as we very plainly saw—indeed we had been very happy with them and they with us—and Millais kept drawing all the while he was there—he could not be kept from it—first he made a sketch of me for Lady Trevelyan—like me—but not pleasing, neither I nor Lady Trevelyan liked it except as a drawing, but she was very proud of it nevertheless, then he drew Sir Walter for her, most beautifully—as lovely a portrait

and as like as possible—I never saw a finer thing—she was in great raptures with this, and then he drew Effie for her—and was so pleased with the drawing that he kept it for himself and did another for her— but he does not quite satisfy us yet with Effie. I made a sketch of a hawthorn bush for her—and she really therefore has some cause to be proud of our visit—She and Sir Walter are two of the most perfect people I have ever met with—and Sir Walter opens out as one knows him, every day more brightly. Lady T. kept us laughing all day long. . . .'

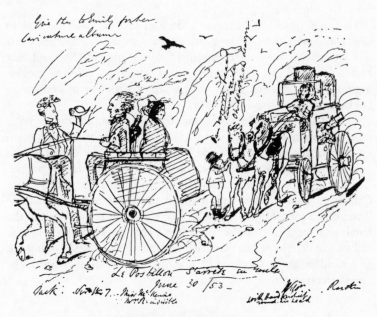

CROSSING THE BORDER, 1853
Sketch by William Millais

The party left in a 'tremendous north east gale over the moors'. Calverley and Loo accompanied their carriage in an open dog cart for the first nine miles, Calverley being without overcoat as always and hatless—'his hair driving back from his fine forehead as if it would be torn away'. Neither of them appears to have enjoyed the experience very much, as a drawing by William Millais makes plain.[12]

Effie wrote to Pauline on arrival in Edinburgh. She was hoping to see Simpson professionally, though he had been invited to meet them all by her uncle, along with Dr. Brown and the artists Noel Paton and George Harvey: 'John is awfully bored and would be thankful for an

express train to carry him to Callander. The P.R.Bs have behaved very properly, tell that darling Lulu, about Scotland. They admire it in their different ways. William Millais is always sketching or bursting into enthusiastic fits, abusing all the rest of the *world* and keeping us extremely merry, for as his brother says, he thinks if he were dying "that boy would make him laugh". The three went to the Calton Hill at ten last night, and came back immensely delighted, the Millais saying it was the only lovely city they had seen. Today they are going to look over the town and I shall remain in all day in hopes of a visit from Dr. Simpson.'

They had not liked Melrose, 'a decided take in', and had had to wait four hours there—'the gentlemen ate so much gooseberry tart and cream that they were extremely sleepy after it'. She said that Millais had told her that the three men who had made the greatest impression on him for 'beauty of feature or grandeur of head' were Lockhart, Manning and Calverley.

Pauline had evidently pulled some strings, for Simpson did see Effie, who thereupon wrote: 'I cannot thank you enough for procuring two visits from the little Genius.' He had prescribed olive oil rubbed all over at night 'to fatten me' and chloroform pills when she felt poorly. On July 3rd the party reached the hamlet of Brig o'Turk, near Callander, merely intending to spend the night there. Instead the Ruskins and John Millais remained four months, the first week at the hotel, and then in a tiny schoolmaster's cottage which they rented. Millais had determined to paint two portraits: one of Effie looking out of a window at the Castle of Doune, the other of Ruskin beside the stream that ran through Glenfinlas.

GLENFINLAS

1853

THE Trevelyans now moved out of Wallington, to make way for Dobson's builders. For the next year they were to live in a small house on the estate. Meanwhile they went on a tour of Cumberland, en route for Dublin.

Effie wrote again to Pauline soon after arrival at Brig o'Turk. The correspondence thereafter dwindled away, and Ruskin himself took over. From the end of August his letters came thick and fast. Effie's letter, written on. about July 7th, was addressed for the first time to 'Dearest Pauline'—hitherto she always had written formally, 'Dear Lady Trevelyan', just as Ruskin had always done and always would do over the years. No doubt this was in response to 'Dearest Effie'. Mainly she was reporting on her health, and there was more about Simpson, how 'he found the mucous membrane more diseased than formerly, the heart irritable and internal arrangements disordered'. However: 'I am so much better already that John Millais declares I do nothing but laugh and eat and grow fat, besides which my drawing goes on *he says* splendidly. I get a lesson of an hour and a half every morning. He sits by and watches my feeble efforts to draw poor William, who sits to me and is a perfect martyr. He gets so wearied and yawns and fidgets, upon which his brother gets up, and administering a box on the ear and a scold at the same time, gets him to sit still a little longer, and really his temper is so good and his delight in every thing so unceasing, that he is quite invaluable. He fishes a great deal on Loch Achray and often tells us some myth about a salmon which he was just on the point of catching but didn't.'

Perch well fried was popular for breakfast. The weather was very bad (and continued so all through their stay). 'My best regards to Sir Walter and a shake of the paw to Peter.'

The happenings at Glenfinlas have been written about many times, but they still remain an enigma, and an intriguing human situation. They were to have important effects on the future work of both Ruskin and Millais. The letters from Ruskin to Pauline that survive do not of

course mention the tragedy that was developing, even if Ruskin was aware of what was really happening. Their very reticence gives them a peculiar interest.

Ruskin's books throughout his career have a curiously uneven quality. Sometimes they are inspired, but occasionally they can be muddled and obscure. This is partly due to a chronic inability to stick to the subject, but more often than not the key lay in the particular circumstances of his life and the condition of his mind, even to the day.[1] The scandal following the Glenfinlas episode was to distress him directly or indirectly for many years and is thus important in any attempt to try and understand him.

William Millais remained in the hotel, but the Ruskins, Millais and Ruskin's valet Crawley were in the cottage. Millais and Effie slept in little cubicles, but Ruskin slept on a sofa. At first the state of general merriment continued. Effie was known as the Countess, because of all her grand talk about Venice one imagines. Millais' letters to Holman Hunt were still full of her praises, and Ruskin competed in the boisterous games of battledore and shuttlecock. Acland arrived and joined William Millais in the hotel; he was slightly perplexed by all the nonsense and 'chaff' that went on between the brothers, in contrast to Ruskin's basic earnestness. He said of Ruskin at the time that 'no labour of thought or work' was 'wearisome to him. . . . I had no idea of the intensity of his religious feeling before now.'[2] And Acland to Effie was 'very clever at all sorts of things with hard names'.[3]

At the time Ruskin was busy with the huge index for *Stones of Venice* III. He had also taken up Bible reading. Very shortly afterwards he became absorbed by his preparations for lectures on art and architecture that he was to give in Edinburgh. Millais said to Holman Hunt: 'Ruskin is extremely funny, placidly, alternately writing and drawing throughout the day.'[4]

Acland left on August 1st, and for a while the euphoria continued. Ruskin told his father how 'Millais is chattering at such a rate—designing costumes—helmets with crests of animals, and necklaces of flowers', and Effie told Pauline he was drawing houses made of ferns and heather. 'With huge herons and hares and swallows and mice and everything else the land produces.' 'His large picture of John,' she wrote, 'with a torrent bed goes on perfectly and very slowly, as he is doing it all like a miniature and about two inches a day is as much as he can do. William, the happiest being I ever knew, is also getting on very well with his oil picture, but leaves us next week to spend a couple of days at Bowerswell en route for London.'

But gloom was soon to set in, partly because Millais had heard that Hunt had determined to leave for the Holy Land. He must have been truly in love with Effie before she set out with his brother to Bowerswell, for he told her a year later that he had felt half frightened at the thought of seeing her again. Ruskin had suggested that Millais should go on that same trip to Bowerswell, but he had refused because, again as he said later, he considered that it was just a plot to get them further entangled.

When Effie came back, Millais started to sleep badly. He gave up the idea of painting her portrait at Doune. Sometimes he would rush off to the hotel for a few nights. He complained to Hunt of loneliness and wrote of 'Ruskin, his lady, and me, all talking whilst dressing'. Yet he continued to work on that extraordinary portrait of Ruskin, perhaps his masterpiece, now seen as so symbolic—the figure immaculate, urbane, clerical, set against the tumbling stream, life itself: a 'Déjeuner sur l'Herbe' in reverse. Then he fell ill.

On August 30th Ruskin wrote to Pauline, ostensibly to ask how she was getting on with her drawing, but really to get her help. He was making studies of plants for architectural purposes, i.e. for his Edinburgh lectures, and was turning to her because with anyone else he would be ashamed to ask the names of what might be very common plants. Thus he intended to post specimens to her, with dates when found, and she could post them back with the names written on them; she wouldn't even have to write a covering letter. 'I daresay some day I shall send you a dandelion—or something as common—but pray don't think I do so in jest, as I really don't know the right name of anything that grows.' As for his 'saucy little wife', she was painting in oil, 'just like a monkey, after seeing Everett do it', and succeeding very well.

Then he asked if she would obtain permission from the Swinburnes for her to copy a tree in their 'Bacharach' by Turner. He also needed it for a lecture. There were elaborate instructions. She complied, but in the end he didn't like the result. He supposed he hadn't remembered the original very clearly. Still, she would have done herself 'a great deal of good' by copying it. She had to be very patient.

He wrote a long letter on September 6th. He was glad she enjoyed Cumberland so much, he said: 'I hope you saw the pass from Wast Water into Borrowdale well, for there is really something sublime about it. Did you ride up any of the mountains? ... Neither Everett nor I are quite as well as we ought to be; he has headaches very often, and I am somehow or another, wonderfully lazy; I don't care about these

hills, and the long extents of morass make me as dull as their own peat holes—and I don't find the climate in the least bracing—as I expected —on the contrary, soft and damp—or blighting when it is dry: and the upshot of it all is that I never am up or out in the morning as I am in Switzerland. But all of us are as late at breakfast as if we were in London:—never before nine o'clock.—Then I generally have some letters to write or, till lately, some bits of index to correct, and Everett makes sketches in pen and ink of our last days' adventures—or idles over a bit of paper somehow or another—until about 12 o'clock when the sun is right for his picture and then we all go out to the place where he is painting—a beautiful piece of torrent bed overhung by honeysuckle and mountain ash—and he sets to his work on one jutting bit of rock, and I go on with mine, a study for modern painters vol. III, on another just above him, within speaking distance, and Effie sometimes reads to us, and sometimes holds the umbrella over one of us— and sometimes potters about the rocks and draws a strawberry leaf on her own account. At two o'clock, comes Crawley with our dinner in a basket—and there is a little rock table just above us on which it is laid out; after the discussion of which Everett goes on with his work in an impatient manner—always gobbling his dinner at a rate which is partly the cause of his headaches: but I lie on my back on the rocks and listen to the water above my head until I find myself going to sleep. And then I wake up and go to work again. At about half past four we give up, and set out for our walk or scramble which generally furnishes Everett with a subject for next day's sketch—and come home to tea when it gets dark, which I am sorry to say—it does, now, a great deal too soon. On wet days we have battledore and shuttlecock in the barn—and work at architectural designs which Everett is helping me with for Edinburgh.'

Would she be able to get over from Ireland in time to hear him in Edinburgh? Yet he was half afraid of her being there, in case he was a failure, got confused, or lost his voice. 'I am heartily glad you like the second volume of Stones. I am nearly sure you will be pleased with the third—which is more general in its subjects—and perhaps Cardinal Wiseman will like it too—as there is plenty of abuse of the Reformation in it.'

He was sorry about the cholera in Newcastle, he said in another letter, not dated. 'I have fancied there was something unwholesome in the air all the summer' (almost a bad joke). The third outbreak of cholera in the country had started recently at Newcastle and was causing great alarm. Within nine weeks 1,500 people out of a population

of 90,000 had died in the city. A misconception of the time was that the 'morbus' could be spread by poisoned atmosphere. (Calverley subscribed £100 to relief work.)

Ruskin either sincerely believed that Millais' despondency was due to Holman Hunt's imminent departure, or he was being curiously blind—or, as William Bell Scott and later gossips would have us believe, it was all part of a deep malevolent plot, to which the Ruskin parents were party. There must have been bad quarrels with Effie, for according to Ruskin's statement to his Proctor the following April, he was aware that Effie's feelings of affection for him were gradually becoming extinguished. About the end of September or beginning of October, she was reputed to have said to him that 'if she ever were to suffer the pains of eternal torment, they could not be worse to her than going home to live at Herne Hill'.[5]

On October 6th Ruskin was telling Pauline that Millais might not after all finish his portrait. And Effie scribbled a postscript saying: 'Dearest Pauline, I don't write now because I have much to do, and John and you carry on so steady a correspondence.' She cannot have been all that busy in the cottage with Crawley to do the work for them. Now Millais was becoming 'almost hysterical'.[6] He had phases of not eating, and was constantly restless. As he was to say later, it was Ruskin's sheer neglect of Effie, and his indifference to her comfort, that was mainly upsetting. He, of course, could not help being aware that Ruskin was not interested in sharing a bed with her.

Ruskin's last letter from Glenfinlas to Pauline was on October 19th. She had been ill again and perhaps had jokingly asked him to join an expedition to find Franklin:

'I don't at all like the thought of going to Greenland, even with you. It is getting very sufficiently frosty on these hills, and I don't like glaciers *at home*. It is only delightful to see them in strange countries, astonished and astonishing. You are setting Effie a worse example than usual in being ill so often—pray don't. . . . If I can help it I never will be out of a hill country in the autumn again—the colours of the ash (mountain) and fern, among the purple rocks are beyond conception or hope—and it is so delightful to have something that does *not* change. The rocks and lichens in their everlasting strength and delicate glory—and the dead leaves instead of being trampled into sodden heaps, sinking like flaky sponge under the foot—lying upon the rocks like spots of gold until the rain washes them down and the torrents take them away. And the harvest is yet standing in heaps in the level fields—the air clear and for the most part calm—the birds in

fuller song than in summer. And the bell heather coming out now bell by bell—but *still* coming out in the little sheltered crannies—and the withered russet of the past blossoms mingling with it in perfect harmony. I never saw anything so beautiful. I enclose two flowers—I am ashamed to send the common yellow thing—but I don't know it— and have drawn its *green* leaves a great many times—and Everett and I have quite quarrelled about its flower for just in the corner of my picture—in a lovely place—just finished—*out* came one of the nasty things one sunny day—and he must needs paint it in immediately and there it is—a bright yellow spot looking like a splash of gamboge. As if it couldn't have come out somewhere else!'

Millais must have been in utter despair, for the very next day Ruskin sent a letter to Hunt: 'I can't help writing to you tonight; for here is Everett lying crying upon his bed like a child . . . I don't know what will become of him when you are gone.'[7]

The Ruskins left Glenfinlas on October 26th, evidently in a state of tension. On one level Ruskin's behaviour had been 'provokingly gentle',[8] yet underneath he was suffering. Writing to his father about Effie, he said: 'When we married I expected to change *her*. She expected to change *me*. Neither has succeeded and both are displeased.' He also admitted that he had hoped to change Millais when he reached Scotland, but 'one might as well have tried to make a Highland stream read Euclid or be methodical'. Millais had thought he could make Ruskin 'like the Pre-Raphaelites and Mendelssohn better than Turner and Bellini', but he too had failed.[9] The portrait was unfinished.

Just how much had been a 'plot'? That is the crucial point, because it affects one's whole estimation of Ruskin's character. Most people nowadays would agree that it was very unlikely. He had admitted in Venice that he had felt proud when Effie had been admired, and had become fond of Paulizza for this reason (the episode was to be seized on by his enemies, who maintained that he had actually wanted Paulizza to live with them). It is possible that he felt a form of sexual excitement from the mere fact that Effie was being desired by handsome and virile men. In the same way, in 1855, one can point perhaps to the way he was stirred by Rossetti's love for Lizzie Siddal. When Millais returned to London, he told Effie's mother of the rumours that were buzzing around about the Ruskin marriage, presumably inspired by people like Lady Eastlake and Chichester Fortescue. Ruskin was generally considered a 'kind of milksop'. And what were those 'unwarrantable insinuations' at dinner parties?[10]

For all this, even after the collapse of the marriage Ruskin continued

to believe in Millais' genius. As he again told his father: 'I have led him to a kind of subject of which he knew nothing, and which in future he will always be painting.' And he also said: 'I have had a wonderful opportunity of studying the character of one of the most remarkable men of the age.' For the same reason he later took Burne Jones and his wife to Italy, ostensibly so that Burne Jones could copy Old Masters for him but really so that the younger man would have a chance of developing his powers as an artist.

Millais wrote two very frank letters to Mrs. Gray from London. He had by now conceived a real loathing for Ruskin, a 'plotting and scheming fellow', an 'undeniable giant as an author, but a poor weak fellow in everything else', and with a 'delight in selfish solitude'. The treatment of Effie had been 'sickening'. He also mentioned the business of Ruskin noting down Effie's 'defects'.

Admiral Sir William James, a grandson of Effie's, has also referred to the 'stream of unwholesome letters' from Ruskin's mother. To him the whole Ruskin family was a 'brooding selfish lot'.[11] That Ruskin was fundamentally narcissistic and selfish there is no doubt, and he himself was aware of it. Effie's duty was to 'attend' him. The writing of his books, his vocation, had to come before all else. It is amazing that a man who was to develop such a strong social and philanthropic sense should have been so foolish about human relationships. Even if there had been any ulterior motives for taking Millais up to Scotland, he was glad in the first instance that Effie and Millais got on so well (it could also be said that the actual fact of their going to Scotland was a compliment to Effie). If he had really intended that his wife and Millais should fall in love, he must have realized that he would have risked losing both: something he surely would not have wanted.[12]

The real, complicated truth will never be told. Basically, John and Effie Ruskin should never have married.

Calverley had to be in Manchester on October 26th for the first meeting of the United Kingdom Alliance, whose aim was 'to procure the total and immediate legislative suppression of the traffic in all intoxicating liquors as beverages He'. was elected President, an office he held until his death. The Alliance was based on the recent Maine Law in America, and its aims went far beyond those of the original temperance reformers. They had wanted teetotalism to be a question of 'moral suasion'. Calverley and his associates wanted absolute Prohibition.

It was a very successful and confident meeting. The sum of £900

was subscribed, and in the years ahead Calverley was accustomed to send over £500 a year to the Alliance. Naturally fierce arguments were to develop, but they are of no concern here. When a temperance hotel was erected at Manchester, it was called the Trevelyan Hotel. Once more Calverley came under pressure to stand for Parliament, so that the Cause could be represented in the Commons. Once more he declined—the first temperance M.P. being Wilfrid Lawson, who was elected in 1859.

By November 1st the Trevelyans were in Edinburgh, ready for Ruskin's first lecture. Millais had been unable to keep away. They all stayed at the old Royal Hotel. Calverley, always inclined to be irritated by Ruskin's dogmatism, wrote that day: 'In evening first lecture on Architecture—well attended—much good and beautiful and some absurd. Too sweeping in his denunciations of what he does not like [such as Greek architecture, which had no "truth to nature"].'

Ruskin himself thought it went 'capitally'. Over a thousand people were there, and perhaps it was on that occasion that several people fainted and had to be carried out. On the 4th Calverley recorded: 'Ruskin's lecture [the second on Architecture, mostly Decoration]— much of it very beautiful. Denounced Quixote.' Again Ruskin himself felt pleased, and he had tried to do his best, for as he said to his father: 'When I heard that Lady Trevelyan and others of my friends were coming hundreds of miles to hear me . . . I saw that I must do more than I at first intended.'[13] Perhaps he tried too hard, for the reporter from the Edinburgh Guardian found his elocution too much 'from the chapel reader'.

On the 5th Calverley left alone for London on 'Greenland business'.

THE SCANDAL

1853–54

RUSKIN developed a persistent 'roughness' in the throat after his second lecture, so the third, on Turner, had to be delayed. Effie was not well again either, and began a *tic douloureux* such as had troubled Pauline some years back—as it happened also five years after her marriage.

Millais left Edinburgh on November 10th, reaching London to hear that he had been elected an Associate of the Royal Academy. Thus he had become a member of that establishment against whose tenets the Brotherhood had originally rebelled. 'So now the whole Round Table is dissolved' is a much-quoted remark by Rossetti to his sister Christina. This was also in reference to the defection or failure of other P.R.B. members.

There were other ways in which Ruskin wanted help from Pauline. For instance, before the first lecture he sent an urgent message ('as my servant is out')—could she find him a bough of a tree five or six feet long, and give it to the bearer? A formidable request, this one. 'I don't know who has a garden or would let their trees be cut.' Somehow or other she obliged, and a branch of an ash had been duly produced.

Calverley was back in time for the third lecture. He wrote: 'Tea with Ruskins—then to his lecture on Turner. Much of it very interesting—tracing landskip through its various stages from the conventional exaggerated foliage of Giotto—the zany mountain and rock forms of Leonardo—trees drawn from nature of Titian—Pastoral school, Claude and Salvator—to truth of Turner. Characterizes the centuries: 14th—thought; 15th—drawing; 16th—colour. Interesting anecdotes of Turner—Altogether this was a much better lecture than his previous ones. It is a subject that he understands better and has studied longer, and has not such eccentric theories as he has on architecture.'

Ruskin felt pleased with the result himself. He told his father: 'Lady Trevelyan says everybody was alike delighted with the last, and that she heard a man whose time was valuable, muttering, near her, at

being obliged to wait for an hour in order to get a place, but saying afterwards that he would have waited *two* hours rather than have missed it. She and I got into some divinity discussions, until she got very angry, and declared that when she read me, and heard me, at a distance, she thought me so wise that anybody might make an idol of me, and worship me to any extent, but when she got to talk to me, I turned out only a *rag doll* after all.'[1]

On the 18th there was the final lecture, on Pre-Raphaelitism. This time Calverley wrote that he did not like it so well. First there had been the usual tea. 'Ruskin does not agree with me in thinking talent and labour thrown away by good artists in minutely finishing parts of pictures which in nature would not be observed—as background by Millais in "Huguenots" [a wall with ivy].' This waste in the 'The Huguenot' was a hobby-horse for Calverley. He was of course complaining about one of Ruskin's most fundamental dogmas: the need for absolute, uncompromising truth. He also found Ruskin's way of speaking 'too flowery'. And no wonder—no two people could have been more different in their manner of public speaking.

Loo and Effie called on the John Browns. 'Kitty [Mrs. Brown] likes you rather better than Effie!' wrote Dr. Brown afterwards to Loo. He added: 'Much and so she may; if Effie is a butterfly, you are a dragon-fly.' Now Effie felt free to join her family at Bowerswell, but Ruskin remained in Edinburgh for two more weeks. The Trevelyans had also left, to stay with Bishop Forbes, Pauline's close friend and another Tractarian, at Dundee. So Ruskin hopefully settled down to some quiet work on his *Modern Painters*.

Perhaps it was Pauline who had recommended that he should read the biography of David Scott. His reactions are worth quoting in view of a small drama between himself and William Bell Scott, its author, in the summer of 1855—'A poor bravura creature, one of the Greek worshippers: himself a mere bad imitation of the Germans, throwing heaps of muscles together and calling them men, and thinking a mass of vermicular attitudes composition. Writing vainly and sulkily all his life, as I did when I was twenty-two. . . . Really these roaring high art men are wretched nuisances. They should be well flogged and set to plough and porridge.'[2]

Edinburgh wanted to lionize Ruskin, but he was back in his anti-social mood. He wanted to work. This accounts for the petulant tone of a long letter he wrote to his father on November 27th, in which various friends of Pauline are mentioned. There was Lady Agnew, for instance, 'of the turning up eyes religious school', and Noel Paton,

who was famous for his fairy and religious pictures, 'the Genius of Edinburgh, more a thinking and feeling man than a painter'. Then: 'Mr. and Mrs. Dr. John Brown. Lady Trevelyan's particular friends, the Doctor at least—the lady I don't like—nor I think does Lady T. Wary. Black-eyed. Vicious expression like a biting horse. The Doctor my great supporter here, writes very friendly reviews. Called by his friends "the beloved physician", not in good health, and must be attended to.... Miss Mackenzie and Miss Sterling. Miss Mackenzie a romantic young lady—just on the edge of the turn down hill—Miss Sterling a romantic middle-aged spinster—an awful bore. Got in by mistake. Miss Mackenzie would be pleasant enough if she would come by herself. The other is her duenna. I shall keep them both out.'[3] Miss Mackenzie was Loo. All this was particularly hard, considering that by now he knew her quite well.

Ruskin joined Effie at Bowerswell. After travelling in the Glasgow area, they returned to Herne Hill. It was at this point that Millais wrote openly about his opinion of Ruskin to Mrs. Gray (who had been to Edinburgh for the lectures). He now gave his word not to see Effie again or to write to her—nevertheless he intended to carry on with the portrait. Meanwhile Ruskin was planning a trip abroad with his parents in May. They would cross the Channel with Effie, who would then go and stay with Cecilia Northcote, now married, in Germany.

The Trevelyans had seen Ruskin whilst he was at Bowerswell. On December 28th, in snowy and wintry weather, they called there again to see Mrs. Gray. The days had passed when Pauline could be considered a confidante by Effie or her family, so she would have heard nothing about the Millais affair. The next day the Trevelyans 'burrowed' their way into Edinburgh, where they meant to stay like 'two hibernating mice'.

At Herne Hill Effie made what she must have felt was a very great gesture. The letter she wrote about it to her mother on January 1st reads truthfully enough. Apparently she had told Ruskin that she was ready to do anything he liked by way of helping him with his work. It was patently a last attempt to patch up the marriage. But the offer had been ignored in a most unkind way. Worse, she said, Ruskin had actually gone so far as to tell her that the fact that they had married at all had been a 'crime'. From now onwards her mother must understand that 'you cannot expect I shall ever be happy'.

With this background of tension Ruskin, who was now visiting Millais' studio for further sittings (without Effie's name even so much

as being mentioned), wrote to Pauline on January 9th. He told her about a 'field day' at Hamilton Palace, where the Duke had shown him his magnificent MSS 'squeezed together on the shelves as if there were no room for them in the Palace'. Glasgow had been a 'somewhat disagreeable round of confused visitation', always a matter of arranging 'something to go somewhere', and he couldn't bear arranging, but liked to 'stop everywhere and go nowhere'. He went on: 'Effie is I think better—but is never happy here, which makes her ill, and I *must* be here; for I am hard at work on Modern Painters (and so delighted to get back to my Turners after these stupid stones). I shall have something to show you, I hope, when you come up in the interval between Northumbrian spring and summer—no—by the by, I forgot—spring in Northumberland is at the end of June; the hawthorns were just out.'

The Northumberland weather was now a favourite joke of his. 'I don't know where the summer can be—having nothing but a confused recollection of having been very cold last year all July and August.' He hoped, he said, that she would be in town by April, so that she could come and stay a little.

Effie was fast becoming desperate and working herself into a pitch of hatred against the whole Ruskin family. She wrote a disjointed, undated letter to Pauline, the last to survive between them: 'Dear Pauline, You are a dear good lady to be so kind as to write me two letters and also to be pleased with the cloak, which I think quite suited *you* and hope you mean to hire a carriage on purpose to pay little visits and be told that green and brown become you vastly and that you look so comfortable and warm in this cold cold weather. I am shriveled to a mummy and hardly able to bear this keen air. I have just been giving myself a dose of it by breaking a pane of glass at my back and getting Crawley, who is the comfort of my life, to patch brown paper across the place to keep Sophie [her sister] and I in the body. John has gone to Den Hill with his friend Newton [Charles Newton, archaeologist] who has come over from the Greek Isles [having been Consul in Rhodes] wearing a beard but quite the old man, talking Philosophy and Phidias, intermingled with remarks, I suppose for my benefit, of how all the women in Rhodes spin and make their husbands' clothes and how shocking it is to be waited on by a Greek lady in a satin gown and Parisian corsets who eats scraps after her Lord, occasionally gets a beating, and hands coffee to the guests. . . . ' The rest was a medley of social chit-chat and messages to Simpson.

Table-turning had reached Edinburgh, so in Calverley's diary we

find frequent sarcastic remarks about the effects of 'muscular exertion' in the seances. We also have mentions of lectures on fish manure, musical parties, temperance meetings and talks by Charles Kingsley on *Alexandria and its Schools* ('drawling manner, to save stammering, unpleasant') and Bulwer Lytton, 'that hummest of bugs', as Dr. John Brown called him—at the University ('too much blarney . . . pompous but not eloquent . . . utterance indistinct . . . learnt speech by heart . . . compliments on the beauty of the ladies!'). Charles sent him a copy of his Civil Service report, 'the bearing of which upon the efficiency of the public service, upon education, and upon Parliamentary and Electoral purity are most important'. So Calverley, also infuriated by the impending war against Russia, was hardly behaving like a hibernating mouse.

The Trevelyans in due course went to Wallington to inspect the alterations, and early in May, they reached London—by which time drawing-rooms were abuzz with the awful scandal of the collapse of the Ruskin marriage.

On March 7th, Effie had written to her father about the truth of her married life: 'I do not think I am John Ruskin's Wife at all.' She added: 'I entreat you to assist me to get released from the unnatural position in which I stand to Him.' She had also confided in Lady Eastlake, and no more delighted recipient of this news could have been found. For the Eastlakes had long been irritated by Ruskin's smugness and pontificating about Art, and in particular by his grand letters to *The Times* on such things as the cleaning of pictures at the National Gallery. A plot was hatched whereby Effie would escape on April 25th. Instead of going to Germany, she would go to Bowerswell for a holiday—and she would never return. Lawyers' opinions were secretly obtained. And Millais was writing to Mrs. Gray: 'Surely such a quiet scoundrel as this man never existed, he comes here sitting as blandly as ever, talking the whole time in apparently the most interested way.'

There was still no direct communication between Millais and Effie. All messages were passed obliquely through Mrs. Gray, or more directly through Effie's little sister Sophie, who would sometimes go to the studio. As the day approached, Lady Eastlake could hardly wait to spread the news. And now someone else was drawn in, Rawdon Brown, on a visit to London. As Ruskin apparently regarded him as a true friend, his deceit is one of the most distasteful aspects of the story. Ruskin even offered him the loan of Herne Hill whilst they were away in May—though maybe, judging from the embarrassment that this caused Effie, this was not quite so guileless.

Effie's train at King's Cross was actually seen off by Ruskin. Later that day his mother was sent Effie's keys, account book, wedding ring and a long letter. A citation was served on Ruskin.

Ten days before Effie's departure, Ruskin had written cheerfully to Pauline: 'I was delighted to have your letter and more delighted by the reading thereof—I don't know when I have had so refreshing a laugh, and then I was so glad to hear of your being well, and able to go and see machines dig [presumably she had sent some anecdote about agricultural machinery]: I was with John Millais today and informed him of Sir Walter's changes in his former subject—on which he said—"When he is about it, he ought to wear chain-mail at once; I never saw the man who would look the thing so well".... I have been doing nothing since I wrote to you—and yet have been always busy. To be sure, in the springtime I pass a good many hours in the garden looking at the buds, and throwing stones for my dogs to play with—and I have been drawing leaves....' He had also been cataloguing manuscripts at the British Museum, taking lessons from Bird's Nest Hunt and 'trying to paint a stone, to my great discomfiture'. And he had been 'several days standing on one leg to please John Millais—till I got such cramp and pain in the side that I have to give over, since which break down I have merely had to sit for four hours a day without moving my head and to look all the time out of the window at a particular brick in an opposite chimney without winking: in order to secure the expression.... What Effie has been about, all this time, I cannot exactly tell you: she has had a friend with her, a Miss Boswell—elderly rather, and stout,—and they went about town together seeing sights. Effie has been drawing a little—but I believe the drawing fit will die off, like the woodcarving one.' He then continued: 'And now—comes the worst business of all. We—that is to say my father and mother and I—leave London for Switzerland, God Willing, on May 9th. Effie will probably leave us for Scotland some days previously—so that if you and Sir Walter do not come before the beginning of May, you may miss *her* altogether—and perhaps find me—(unless for the first time in my life I fulfil my present intention of being ready with all things beforehand)—in a mere puzzlement of pack up. Pray come sooner if you can at all manage it.'

Lady Eastlake had set to work immediately. In his diary for February 5th Ruskin had referred to the Spanish word *zizaña*, a 'poisonous grass amongst wheat'; and now her behaviour exactly suited the other, more usual meaning to a Spaniard: troublemaker. She called on Mrs. Murray, the publisher's wife, who was unable to hold back her emotion. 'The

story was out in all its sad outline before I well knew what I said.'
Immediately Mrs. Murray burst into tears and buried her face in the
sofa.[4] At dinner parties people were saying Ruskin was mad and ought
to be imprisoned for life. No wonder Sir Charles Eastlake regretted
that the Glenfinlas portrait was not ready for exhibition at the
Academy.

On April 27th Ruskin wrote his statement to his Proctor. Its contents
have been touched upon earlier. Three other points should also be
mentioned, all questionable. He claimed to have married for com-
panionship and 'not for passion'. He said that he had been under the
impression latterly that Effie had been suffering from 'some slight
nervous affection of the brain': a statement which has been taken by
some as deliberate malice, though Effie's feverish behaviour may well
have seemed like madness on occasions. And he mentioned that if
need be he could prove his virility at once. 'But I do not wish to
receive back into my house this woman who has made such a charge
against me.'

Maddeningly for Lady Eastlake's set, Ruskin played it cool. He was
actually seen, still 'bland', at the Water Colour Exhibition, and *in the
middle of the day*. On May 5th he dared to write one of his ex cathedra
letters to *The Times*, as usual signed 'The author of *Modern Painters*',
in praise of Holman Hunt's 'Light of the World', which with 'The
Awakened Conscience' was on view at the Academy. His religious
stance—'one of the very noblest works of sacred art ever produced
in this or any other age'—was even more infuriating. How could he
behave so hypocritically, said his enemies. Lady Eastlake considered
the picture 'odious'.

Then the three Ruskins, as prearranged, left for Switzerland. Effie
told Rawdon Brown that she had heard from Pauline, who was
Ruskin's 'greatest admirer and friend'. 'She said she had not had a word
on the subject from himself or anyone but me.' And Millais said to
Mrs. Gray: 'Dr. Acland expressed deep sorrow and doubtless is of the
same way of thinking as Lady Trevelyan.' Acland had quoted St.
Matthew, Chapter Five, at him and had said that he was 'fully con-
vinced of Ruskin's fault'.

It is conceivable that at this stage both Pauline and Acland were
genuinely upset at the ending of a marriage between two friends, and
that at the same time neither was totally surprised that a break had
occurred. Pauline must have been horrified by the gossip and vitu-
peration against Ruskin when she reached London, for she immediately
became ill. The subject was as much discussed as the war against

Russia. She was told that people like Panizzi, expected to be Sir Henry Ellis's successor at the British Museum Library, had actually gone as far as to cut him. Possibly Effie had also written her a denigrating letter. Thus by May 18th, Millais was saying to Mrs. Gray: 'I am sure nothing will ever make Lady Trevelyan see J.R. in the wrong, and it will be almost useless trying to explain the wretchedness of her [Effie's] position with him [Acland] before this change.'*

Effie must have reported Pauline's refusal to condemn Ruskin to Lady Eastlake, who wrote back furiously: 'I should be glad if Lady Trevelyan came in my way. Mama always calls Sir Walter a "Hamadryad" which may have confused Lady T's notions of conjugal duty.' A hamadryad can either mean a wood-nymph living in a tree, or a cobra. It has been suggested that Lady Eastlake really meant 'hermaphrodite', which at that time was a synonym for homosexual.

Needless to say, not a word about the Ruskins appeared in Calverley's diary. Carlyle's view of marriage was that it was a woman's duty to suffer in silence, and that this applied to Mrs. John Ruskin. One can safely assume that in principle Calverley would have agreed with him. The difference was that Calverley, for all his qualities, was married to a woman who outshone him. It was William Bell Scott, who, looking back, described him as the 'most self-centred, unaffected, high-intentioned man' he had ever met, and who said that Pauline had become 'in many respects in perfect harmony with him'. He also added: 'She was a true woman, but without vanity, and very likely without the passion of love.'[5]

The fact that Pauline had had the strength of character to make a success of her own marriage must have coloured her attitude towards Effie. She probably did not want to take sides anyway. When a marriage breaks down, most people realize that one party has always been more of a real friend than the other and therefore needs support, whatever the supposed fault. Most people also hope that, after a painful interval, they will be back on the same easy terms with the 'opposite' side. Pauline also had strong religious convictions about the bond of marriage. Above all, perhaps, she believed it her duty to help a man, her close friend, whom she sincerely believed to be a genius, in spite of obvious weaknesses, and a man who was already prone to nervous

* On Sunday 14th Millais had met the Trevelyans coming out of Church. 'They stopped and spoke for a moment,' he told Mrs. Gray. 'Sir W. has had the bad taste to grow a pair of moustaches and looks quite different.' Calverley's lack of moustaches must only have been temporary. Not long afterwards Millais contemplated growing them himself (J. G. Millais I, p. 223).

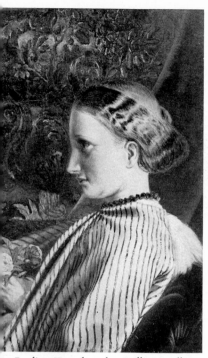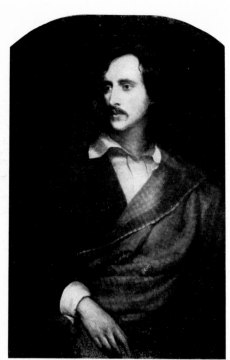

a Pauline Trevelyan by William Bell Scott, 1865. b Walter Calverley Trevelyan by
R. S. Lauder; oil begun in Rome 1839, finished in Edinburgh 1841

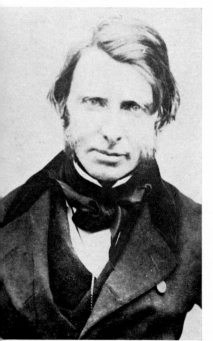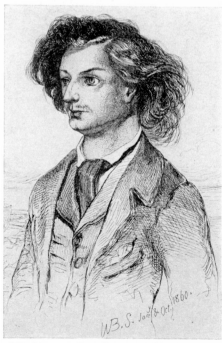

c John Ruskin, taken in 1856 by a student at the Working Men's College. Possibly the first
photograph taken of Ruskin. d Algernon Swinburne by William Bell Scott, 1869 (from
Autobiographical Notes, Vol. 2).

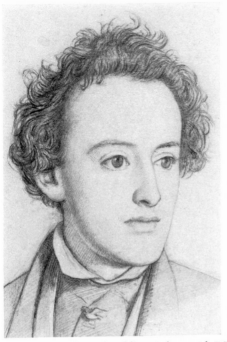
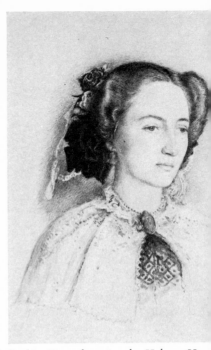

2a John Millais, after falling in love with Effie Ruskin, December 1853, by Holman Hunt (from a private collection). b Effie Ruskin at Wallington by Millais, 1853

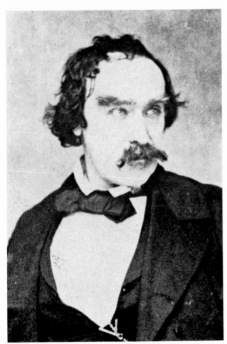
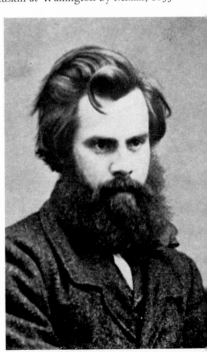

c William Bell Scott, 1861

d Thomas Woolner, 1860

depressions against the massive weight of destructive innuendoes and self-righteous gossip that had accumulated against him. Perhaps she was even a little in love with him. . . . She was standing by Ruskin, and, it did not mean that she was against Effie: but this was not good enough for Effie.

As for Loo, her feelings are also unrecorded. She was a little afraid of Ruskin, but no doubt followed Pauline's point of view. One can only quote from another letter from Lady Eastlake, on May 6th: 'She [Loo] was very *earnest* in manner and her eyes overflowed with tears. On her saying to me at first "Do you really think him so utterly devoid of feeling?", I said, "I think that you can need no further proof than that letter in *The Times* this morning. . . . What man of the slightest heart, losing even a bad wife, could have written that disgusting farrago not ten days after?" '

Soon afterwards Millais actually returned to Glenfinlas to finish the background of his picture. The figure of Ruskin was all completed except for the hands.

On May 30th Effie was examined by doctors in London and declared virgin. On July 15th she was granted a decree of nullity, the dread words 'incurable impotency' being included on the document. Effie returned the £10,000 which Ruskin had settled on her when they married. On July 21st, Millais at long last felt free to write to his 'Countess'.

Not everyone saw the affair as black or white, as a letter that Mrs. Carlyle wrote shows: 'I have always pitied Mrs. Ruskin, while people generally blame her—for love of dress and company and flirtations. She was too young and pretty to be left to her own devices, as she was by her husband, who seemed to wish nothing more of her but the credit of having a pretty, well dressed wife.'[6] While Mrs. Gaskell, who loved gossip and had been at Effie's school, twisted facts: 'Now don't think me hard upon her if I tell you what I have *known* of her. She is very pretty, very clever—and very vain. As a girl when she was staying in Manchester, her delight was to add to the list of her offers (27 I think she was *at*, then); and she never cared for any of them. . . . *Effie Gray was already engaged at the time she accepted Mr. Ruskin.* . . . Mr. Ruskin was spoiling Effie because he could not bear to thwart her . . . he had a very bad temper. I *know* he forgave her many scrapes in Venice.'[7] It was nonsense about the 'scrapes', but in a sense she had been right about Effie's beaux. At least one young man could have

considered himself engaged to her, though it had been no secret from Ruskin.

Mrs. Buckland claimed that in Scotland people made 'common cause with Mrs. Ruskin'. She said: 'They declare that her husband's taking a house in the Highlands, with the apartments so arranged as to afford every opportunity for his wife to ruin herself with Millais, render our poor friend an object of loathing. . . . Lady Chantrey writes that not a shadow of blame rests with Mrs. Ruskin. She is evidently a martyr in the set frequented by Lady Eastlake. . . . Her [Effie's] trials must have been heavy, dreadful, if she ever loved her husband with real human passionate love.' An exception to those views was that of Calverley's brother Arthur, who considered Effie to have been a 'goose' not to have given in to temptation at Glenfinlas.

And now we return to Ruskin's own letters. He wrote this to Pauline from Dover on May 8th: 'I received your little line with deep gratitude—fearing that even *you* might for a little while have been something altered to me by what has happened. I do not know what Effie has written of me. I am thankful that neither by word nor look of mine, at least voluntarily, any evil was ever spoken of *her*. She has now put it out of my power to shelter or save her from the consequences of the indulgence of her unchastised will. For *me* you need not be in pain. All the worst—to me—has long been past. I have had no wife for several years—only a shadow—and a duty. I will write you a long letter soon—at least to Sir Walter. There are only two people beside my parents whom I mean to acquaint with the whole circumstances of this matter—these are Dr. Acland, and your husband. The world must talk as it will. I cannot give it the edifying spectacle of a husband and wife challenging each other's truth. Happily I have long been accustomed to do without the world—and am as able to do so as I ever was. But I will not give my two best friends the pain of having to trust me in ignorance. I am very sorry you have been ill— but it was no wonder. I am sure you loved Effie—it must have been a cruel shock to you to receive her letter—whatever it said. . . . My earnest thanks for your steady trust in me—at a time when I most need it. For indeed Effie has said such things to me that sometimes I could almost have begun to doubt of myself—and what then might my friends do. I hope Hunt's picture will make you quite well again. It might comfort any grief, I think—I mean the "Light of the World".'

It is probably true that up till then he had never voluntarily spoken evil of Effie.

Then on May 17th Ruskin wrote to Calverley: '. . . I have too long delayed giving you further information on this unhappy subject. I have written a long letter to Henry Acland about it, and in order to avoid the pain of writing such another, I have asked him to forward it to you for your reading. . . . I send this . . . merely to tell you and Lady Trevelyan that I am quite well and working very happily on Rouen Cathedral. Tell Lady Trevelyan whatever you think fit out of the long letter. It will be very painful to her—you will know how much she can bear to know at present.'

Acland sent on the letter with a non-committal scrawl (he was once more very overtired): 'I must not trouble you with comments—nor indeed am I much minded to make them. I think the whole of this most distressing affair is the most striking example of "the naughtiness of this evil world" I have ever met, and a painful warning and lesson more than a hundred executions. The sadness and sorrow of it is irremediable and depressing.'

Unfortunately, whether or not Calverley thought fit to show the contents to Pauline, the letter must have been destroyed. On May 23rd, Millais told Mrs. Gray he had heard from Acland—'all groaning and lamentations', nothing else. Then the Trevelyans went to Oxford. Whilst they were there, Pauline received the following letter, written from Geneva on June 6th—the three *sentences* to which supporters of Effie would no doubt have taken greatest exception, apart from the question of cruelty, are in italics (the occasional italicized *words* were underlined in the original by Ruskin):

'Your kind letter received last night was one of great comfort to my father and mother as well as to myself. So far from drawing back from sympathy—and distrusting my friends—I never felt the need of them so much. I am only afraid of *their* distrusting me. For indeed that a young wife, in Effie's position, should leave her husband in this desperate way might well make the world inclined to believe that the husband had treated her most cruelly. It is impossible for people not to think so—who do not know me, and though I am as independent of the world as most people, I am not used to be looked upon as Effie will make some people look upon me, and am very grateful to my unshaken friends.

'Indeed I am most ready to admit I may have been wrong in several ways—about Effie—*but assuredly, I did all I could for her to the best of my judgement*—except where I must have sacrificed not only my own but my parents' entire happiness if I had yielded to her. As for

controlling her—*I never felt myself a judge of what was right for her to do or not to do*—and I had so much steady resistance to make to her in one or two great things that I could not bear to thwart her in less ones—I used to express my wishes to her very often, that she would be less with certain people, and more with others: but, except only with you and Miss Fortescue—it was generally sure that Effie would take a dislike to the people whom I liked best. I had no *capacity* for watching flirtations—I might as well have set myself to learn a new science, as to guess at people's characters and meanings. I should never have had any peace of mind, if I had been always thinking how far Effie was going—with this person or that. I knew her to be clever—and for a long time believed she loved me—I thought her both too clever—and too affectionate—to pass the bounds of what was either prudent for herself or kind to me. I also was induced to believe that her influence over several young men whom she got about her was very useful to them—I used to hear her giving good advice like an old lady—which I thought it possible—from the *young* lady—might be listened to. In the last instance (which indeed at present gives me the most anxiety of all things connected with this calamity) I trusted as much to the sense, honour, and principle of my friend [Millais] as to Effie's. The honour and principle failed not. But the sense did—to my infinite astonishment—for I supposed he must have passed through all kinds of temptation:—and fancied besides his ideal quite of another kind. But he lost his sense—and this is the worst of the whole matter at this moment. He never has seen Effie since November, but I don't know what thoughts may come into his head when he hears of this.

'The whole matter is strange—complicated—full of difficulty and doubt. I cannot in Effie distinguish art from blindness—when she said what was not true I never could tell how far she herself believed it. She never—during the whole course of our married life—once admitted having been wrong in anything. I believe she truly thinks herself conscientious—unselfish and upright. It is in this she was so like Miss Edgeworth's Lady Olivia [in *Leonora*, in which occurs: "Women of ability, if they err, usually employ all their powers to justify rather than to amend their faults"]. I do not know what she might have been had she been married to a person more of her own disposition. She is such a mass of contradiction that I pass continually from pity to indignation—and back again. But there was so much that was base and false in her last conduct that I cannot trust to anything she ever said or did. How did she make you believe she was so fond of me? and how, by the bye—came you to think that I was *not*

fond of her? I am not demonstrative in my affections—*but I loved her dearly. . . .*

'I have been made excessively uncomfortable for the last fortnight by finding *restorations* going on at Chartres, Rouen, and Amiens—the three best Gothic cathedrals, I believe in the world—I was like to have got quite ill—and was obliged to come away. The sight of the Alps has put me to rights again. I never thought them so beautiful. I am drawing vignettes, which I am rather proud of and which I think you will like. . . .'

Perhaps it was as well that Ruskin's enemies did not know of a remark he also made to Acland: 'My real griefs are about other matters. I could get another wife, if I wanted one, but I cannot get back the north transept of Rouen Cathedral.'[8]

Calverley's cough had been so bad that he was unable to preside at the annual meeting of the National Temperance Society. A few days later, George Cruikshank had burst in on him, in a state of indignation because the Crystal Palace company had applied for a licence to sell intoxicating liquors—he considered this to be a dreadful breach of faith.

The re-erected and redesigned Crystal Palace at Sydenham was due to be opened on June 10th 1854. The new building was on a larger scale, with a central apse of wrought iron instead of timber. It was to be a 'Palace of the People', with entertainments, sports grounds, a concert hall and 'courts' of an educational nature, mostly representative of the arts of other nations and past ages. In other, more high-falutin' words it was to provide, according to the prospectus, 'refined recreation, calculated to elevate the intellect, instruct the mind, improve the hearts of, and welcome the millions who have now no other incentives to pleasure but such as the gin-palace, the dancing saloon and ale-house afford them'.

Cruikshank's ire was therefore understandable, and he easily persuaded Calverley to join a deputation on June 1st, the more so because Calverley had been incensed by a 'flippant' and highly convivial dinner party that had been given there by scientist friends a few months ago—it had taken place inside a giant model of the prehistoric Iguanodon, to be displayed with other monsters on an island in the gardens. Alas, the directors were obdurate in the necessity of providing 'solid food' in the form of beer and wine for travellers from a distance; and there were other arguments 'equally feeble'.

If Calverley was convinced that the 'character, utility and benefit

of the institution' would now be ruined, he was obviously very intrigued by what he had seen of the new Crystal Palace. So much so that, on their return from two weeks in Oxford, the Trevelyans took lodgings for a fortnight at Sydenham. After the first visit of six hours, Calverley wrote in terms that for him were very enthusiastic. 'The Palace on the whole I think exceeded my expectations. The different courts were well arranged, the most beautiful I think the Alhambra, where the effect of the colouring is exquisite.' The Greek and Roman courts also appealed to him, but the colouring in Nineveh and Egypt was 'heavy and overdone'. The reproduction of the Parthenon frieze was, he felt, spoilt by being painted. 'The collection of Greek statues is very fine, and the mixture of sculpture and vegetation very beautiful.'

Thereafter there were daily visits, in the company of Laura Capel Lofft, who had come to stay with them. At the end, the Alhambra was still voted the 'most satisfying', but there are constant complaints in the diary about the treatment of the tropical plants, which, without the proper temperature, were necessarily doomed to die. As it happened, the Crystal Palace provided lessons for the central hall at Wallington, and the idea of having plants in the centre was abandoned.

The Trevelyans broke their journey north at Castle Howard. On the day of their arrival home, July 17th, Ruskin wrote to Pauline from his beloved Chamonix: 'I wish I could let you see the aiguilles this morning—pale and serene—intense in their strength and silence, in the morning light. And in the sky—I see—more and more lately, that I have never enough insisted on the great fact that the sky is not blue *colour*—but blue *light*. One ought to think of it as of a great lambent vault of blue flame, when one is drawing—else one never rightly comprehends its relations to the mud of the earth. . . . I think the Alps are growing.'

He rambled on pleasantly about pine-trees and Acland's belated conversion to Pre-Raphaelitism. Then: 'I was very glad to have your letter—for my friends are all aghast—one way or another—and don't know what to say, or whether to write to me or not—and decide not, at last. I was very glad to know that Acland had really begun *his*—and I have written to him to say that that will do, for the present for I am sure he will not know what to say. I shall write and thank Mrs. Buckland also, directly—but the less I write, the less I like writing, at present, for it puts me into painful trains of thoughts—and when I am at my pines and aiguilles, I am all right.' He ended with a suggestion that the Trevelyans and Aclands might join him the following year at Chamonix.

As it happened, he must have received Acland's long delayed letter
the very next day—the result obviously of discussions with Pauline,
though not necessarily in line with her own opinions. Millais had said
earlier to Mrs. Gray that he was not surprised by Acland's 'gentle,
fearful way of considering the subject', for he was 'exceedingly timid',
but that nevertheless he had spoken 'very kindly and was quite alive
to the misery such a life would have entailed to the Countess'. Then
on July 13th, Millais had enclosed a letter from Acland, because 'it
would give the Countess pleasure'. 'The few words he says upon
Ruskin are of quite a different nature to what he had first thought.'

Ruskin's reply to the letter he received shows that once again
Acland was concerned with the religious aspect of what had happened.
It also shows that, whatever criticisms were contained in the letter,
Ruskin's friendship for him was not at all shaken.* It began:

'I cannot rest tonight without thanking you for your letter. I hope
you have not been uneasy about it since thinking there was too much
sermonizing in it. Only I wish you would not be so *elliptical*. You
know I have always been as much tormented by your withholdings
of words as you have been by my rashness in words. And I do very
much wish that you had said—not "that you could not defend my
judgement" but exactly and plainly how wrong you thought me. I do
not think I have ever given you ground to suppose that I supposed my
heart such as I would have it before God—I have never possessed on
my own part—any condition of religious feeling whatever. I have
declared, as far as I saw it, what seemed to me to be the truth. But I
never announced myself as an example of right conduct. Nor have I
ever—during my whole life—been happy in my conscience, for
the principal reason that I at the best (at the *worst* doing what I knew
well enough to be wrong) managed to convince myself when I had
to act—that duty and inclination were at one. Whereas I often found
afterwards that they were two. I have always pursued what I wished,
done what I liked, served myself to the utmost of my powers—and
done what little good I could in such byeways as suited myself—and
in no others. There is as far as I know—nothing whatever estimable
in my moral character—except a certain feeling of honour—which
would make me very safe as a director of a savings bank or in any

* On August 18th Ruskin wrote to his Christian Socialist friend Dr. Furnivall:
'You are one of the *three* people who have been perfectly staunch to me' (White-
house, p. 28). The other two are usually assumed by biographers to have been
Pauline and Mary Russell Mitford.

post of trust whatsoever—and a certain instinct of kindness which makes me unwilling to hurt anything alive, if I can help it. I believe Robespierre had this last instinct quite as strongly, but it did not stand against his other passions—nor would mine, I suppose—at least I know if I saw a mob going to pull down a cathedral—and a park of artillery bearing on them—*they* would go down first. I don't think however that any temptation would make me false to a trust, except to God, whose trusts I abuse every day....'[9]

Again, Ruskin was no doubt right when he also said that he had never defended his moral conduct, and that he was even ashamed of some of it. An interesting aspect of this letter is that it confirms that 1854 marked the beginning of a period of religious scepticism in Ruskin's life—very different to the old, comfortable confidence of *Seven Lamps* in 1849.

He had to wait for a reply to this letter, for on August 6th cholera broke out in Oxford and Acland became the leading spirit in relief work. The epidemic lasted until October 30th, during which time 115 people died. As the outbreak occurred during the Long Vac, most of Acland's colleagues were away. Worse, the Board of Guardians behaved in an obscurantist way, and the Radcliffe Infirmary refused to accept patients. So a temporary building had to be put up, and, thanks to Dr. Pusey, the kitchens of Christ Church were made available to patients.

Acland's great work established him as an authority on hygienic and sanitary reform. His *Memoir of the Cholera at Oxford* was important in that it consolidated evidence about the connection of polluted water and the disease—most of the citizens of Oxford obtained their drinking water from the rivers into which sewage poured. It was to lead to his appointment to the Regius Professorship of Medicine in 1857.

On September 1st, Ruskin wrote in his diary: 'A letter from Acland relieved me from the anxiety which I have so long laboured under ... Deo Gratias Gloria.'

The next letter from Ruskin to Pauline was dated September 24th. It was from Paris and shows how many of his old ideas and shibboleths were being shaken. The letter was half meant to be flippant; nevertheless it does display the confused state of his mind, reflected eventually in the disjointedness of the remaining three volumes of *Modern Painters*. He began by reassuring her that 'I have got over my darkness now, thank God'. He was 'very very full of plans, and promises, and hopes', so much so that there would be no time for a visit to Wallington.

'I have been learning a good many things, and have convinced myself of some things which I had long suspected; for instance, that most Raphaels are not worth ten pounds apiece,—I settled that matter only yesterday in the Louvre; and you may tell Sir Walter I have great misgivings that the science of geology is good for very little. It never tells me anything I want to know. . . . I am rolling projects over and over in my head. I want to give short lectures to about 200 at once in turn, of the sign painters—and shop decorators—and writing masters —and upholsterers—and masons, and brickmakers, and glass-blowers, and pottery people—and young artists—and young men in general, and schoolmasters—and young ladies in general—and school-mistresses, and I want to teach Illumination to the sign painters and the young ladies; and to have prayer books all *written* again; (only the Liturgy altered first, as I told you), and I want to explode printing; and gunpowder—the two great curses of the age—I begin to think that abominable art of printing is the root of all the mischief—it makes people used to have everything the same shape. And I mean to lend out *Liber Studiorums* and Albert Durers to everybody who wants them; and to make copies of all fine 13th century manuscripts, and lend *them* out—all for nothing, of course—and to have a room where anybody can go in all day and always see *nothing* in it but what is *good*, with a little printed explanatory catalogue saying *why* it is good; and I want to have a black hole, where they shall see nothing but what is bad: filled with Claudes, and Sir Charles Barry's architecture, and so on— and I want to have a little Academy of my own in all the manufacturing towns—and to get the young artists—pre Raphaelite always—to help me. . . .'

And he was going to start writing on politics, 'founded on the Thirteenth Century'. He was glad to get away from the Alps, he said. The effect of 'perfect art' on the mind was rather curious after being 'a long time in wild nature'. When at the Louvre, after leaving Chamonix, he always went straight to the Veroneses:

'This time I had very nearly cried; the great painting [presumably "Marriage at Cana"] seemed so inexpressibly sublime—more sublime even than the mountains—owing to the greater comprehensibility of the power. The mountains are part of the daily, but far off, mystery of the universe—but Veronese's painting always makes me feel as if an archangel had come down into the room, and were working before my eyes. I don't mean in the *piety* of the painting, but in its power. I would go to Tintoret if I could, but there are no Tintorets in the Louvre except one—hung sixty feet from the floor—and after

Tintoret there is nothing within a hundred miles of Veronese. The Titian's and Giorgione's are, all very well—but quite *human*. Veronese is *super*human.

'I find Angelico's and Perugino's rather thin and poor work—after Alps. Or perhaps I am getting every day more fond of matter of fact, and don't care to make the effort of the fancy they ask of one. As I said, I have made up my mind that Raphael is a take in;—I must be a little cautious, however, before I communicate the discovery to the public.'[10]

The letter illustrates the mood that made Ruskin plunge with such enthusiasm into teaching at the Working Men's College later in the year. He also briefly referred to 'Acland's museum', which would entail an early visit to Oxford—but more of this great project later.

Ruskin and his parents returned to England on October 3rd. Later in the month, Calverley had to make one of his quick dashes to London and recorded that he had seen Ruskin in the Athenaeum. Pauline, in Edinburgh, wrote to Loo, her letter as usual undated: 'I can tell you *nothing* of Effie. Dr. John Brown fancies she is still at Perth—but he does not know. He thinks her conduct shocking. As for my master, Calverley saw him in London two days ago and thought him looking tolerably well. He is luckily very busy, preparing lectures and has no time to give way to sorrow. He says that the worst time is over and that now he can give his full time to other things. He is living of course with his father and mother. Calverley himself is very well again. I am quite proud of his looks. He looks stronger than he has done for a long time. I should like to show him to you.'

And her master meanwhile calmly returned to Millais' studio for his last sittings.

ENTER SCOTUS

1854-56

IN retrospect it might have seemed strange that Ruskin never mentioned the name of Rossetti in his *Pre-Raphaelitism*. Yet this is excusable, for Rossetti's first Pre-Raphaelite picture, 'The Girlhood of Mary Virgin', had been shown at the Free Exhibition in 1849, when Ruskin was on the Continent, and his 'Ecce Ancilla Domini!' had not been allowed to appear again in public after a disheartening exhibition the following year. Since then, until he began 'Found', Rossetti had been too lazy, or preoccupied, to tackle much grand-scale painting, mainly because of his infatuation with Elizabeth Siddal, the subject of quantities of drawings and sketches, done simply for his own pleasure.

Very likely Rossetti at that time meant little to Pauline either, which was all the more reason why she had not yet met his friend William Bell Scott, in spite of the fact that for the past eleven years he had been head of the Government School of Design in Newcastle. Scott now is considered one of the most controversial figures in the Pre-Raphaelite circle, mainly because of the outrageous remarks in his posthumously published *Autobiographical Notes*. Yet he had qualities, both physical and intellectual, which people—and women especially—found very attractive. His work as an artist and writer was uneven. He was a good book illustrator and now and then painted a portrait that was outstanding. Occasionally a poem would produce a spark of something special.

In October 1854 he was aged forty-three. Holman Hunt accurately described his appearance as Mephistophelean, with tufted eyebrows over penetrating grey-blue eyes. His hair was thick and brown, his voice was flat, with a strong Scottish accent. He had very little sense of humour, something which his friends found endearing. G. H. Lewes nicknamed him Duns Scotus, and this stuck. For a long while he was a popular member of the Pre-Raphaelite circle.

It had been his long poem *Rosabel* that had attracted Rossetti, who may have been inspired by it to paint. 'Found'. As a result of this

admiration Scott had been drawn into the Rossetti family circle, and it has been suggested by a romantically minded lady professor from Utah that not only was Christina Rossetti in love with him but that she was the 'Mignon' of his love poems.[1] Certainly it is true that he concealed the fact that he was married from the Rossettis for a long while. Indeed we are led to believe that his marriage was yet another *affaire blanche*. His wife had been born Letitia Norquay; it is also said that, on suffering some severe illness that had somehow incapacitated her during their engagement, she had offered to release him, but he had been gallant enough to insist that they must go ahead.

The publication of his *Poems of a Painter* that October had been the cause of his getting in touch with the Trevelyans. The reception of the book had been disappointing to him. As the *Guardian* reviewer had truly said, the poems were the 'composition of a man apparently at odds with the world and of an unhappy frame of mind, one whose aspirations and performances have not been altogether equal'. Thus Scott had decided to send copies of the book to as many influential people as possible, including Calverley, whom he had met earlier at the Newcastle Literary and Philosophical Society.

Calverley's reply was friendly, unlike that of Carlyle, who mistook 'Painter' in the title for 'Printer' and wrote back suggesting that Scott might do better sticking to his types and giving up metaphors. Calverley said that he hoped Scott would visit Wallington, once masons and plasterers had been 'banished'. For the collection of poems had many things in it that would have appealed to the Trevelyans: a requiem on the death of David Scott, a sonnet 'to the Artists called PRB', 'Lines written in the Elgin Marbles Room', and so on. Scott also showed ability as a ballad-writer, and ballads were one of Calverley's special interests.

It was to be eight months before Scott could come to Wallington, during which time Pauline had met others of his friends. The visit turned out to be the beginning of a long and close association between Scott and the Trevelyans, and was also to be useful to him in producing a much desired introduction to Ruskin.

Ruskin saw 'Ecce Ancilla Domini!' in the month that Effie left him. He had been immediately enthusiastic, so much so that Rossetti had been rather amused by his effusions. 'In appearance,' Rossetti told Ford Madox Brown, 'he is an absolute Guy—worse than Patmore. However, he seems in a mood to make my fortune.'[2]

Rossetti's colour combinations and methods of grouping appealed

especially to Ruskin, who persuaded the nouveau riche purchaser of 'Ecce Ancilla Domini!' to commission another picture—the subject chosen being one of the artist's favourite themes, 'The Virgin in the House of John'—later also to be of importance to Pauline. When the Edinburgh lectures were published, an appendix was added on the Pre-Raphaelites, in which it was questioned whether 'even the greatest men of old times possessed more exhaustless invention than either Millais or Rossetti'. Thus, on his return to England, Ruskin went immediately to see his new protégé; he also gave him financial help —accepted in a rather cynical manner by Rossetti.

The discovery of another genius to enthuse about became more important to Ruskin when he received a final snub from Millais. It was ingenuous to think that they could remain on good terms after the Glenfinlas portrait had been finished. Nevertheless, when at last the picture was hanging on a wall at Denmark Hill, he wrote a warm letter of appreciation, signed 'faithfully and gratefully yours'. In due course, Millais replied breaking off 'further intercourse'. Ruskin was extremely hurt. His father was furious, threatening to destroy the picture.

There was another emotional release for Ruskin: the proposed new Natural History Museum at Oxford, which meant much corres- pondence with Acland. Even more important was his involvement with the Working Men's College, founded by Frederick Denison Maurice and fellow Christian Socialists. The ideals of the College, in Red Lion Square, did not then exactly coincide with Ruskin's own, but they suited his mood. With enormous energy and considerable personal generosity, he began teaching art there, not he said in order to turn working men into artists but to make them into better men. Rossetti was persuaded to assist him.

It is not surprising, with all these preoccupations on his part, that Pauline should come up with one of her complaints about a lapse in correspondence. She wrote on December 11th: 'It is such a very long time since I heard from you. I suppose you know I wrote last? And if you are busy with lectures to workmen, I am busy with lectures to workwomen. Soap and scrubbing brushes and brooms are my subjects, which are quite as necessary as letters with scriggly tails, for we have been for three weeks trying to make the big house habitably clean, and the more it is cleaned the dirtier it seems to get. And though there may be an end to most earthly things, there is no end to dusting. . . .'

There then followed what might now seem a surprising passage about the Crimean War, especially when one takes into account the

fact that she was the wife of a near pacifist. The charge of the Light Brigade and the battles of Balaclava and Inkerman had recently taken place; the toll from the cholera had been frightful; the muddle out there was still bathetic. Yet Pauline—in this respect so typically of her time—chose to see glory in the bloodshed and in what was essentially disaster. When war had been declared earlier in the year, it had been welcomed by nearly everybody as a chance of proving that the British, after nearly forty years of peace, were still capable of self-sacrifice.

She therefore continued: 'I hope you are insane about the War. You are perverse enough to say that you don't care about it, just out of malicious wickedness. Pray don't. It is such a wonderful thing and will do everybody such a quantity of good, and will shake up the lazy luxurious youth of England out of conventionalism and affectation into manhood and nobleness. What a comfort it is to find. . . . no one has yet succeeded in laughing England's chivalry away! Whatever comes out of it we may be thankful for ever, for Alma and Balaclava.'

Ruskin replied at once to this 'noble piece of passion'. At that precise moment he had just written his friendly note to Millais and would have been waiting for a reply. He sent her, he said, a 'line of echoed cheer' about the war, 'this glorious woe', much as he regretted the 'agony of the poor friends and lovers and mothers of the men who have been sacrificed to misunderstood orders' and general confusion— 'insuperable, impenetrable Donkeyism, Moleism, Gooseism, Slothism, and if there be any animal that has no eyes, nor feet, nor brain, nor ears, that animal-ism'. But the great news for him was that Acland's museum was to be Gothic, and that the architect was to be a friend of his, Benjamin Woodward, an Irishman, who—inspired by *Seven Lamps*—had already adopted the Venetian Gothic style for his new library at Trinity College, Dublin.

As Acland and Pauline had a habit of lending each other letters from Ruskin, no doubt she had already read the delighted letter in reply to Acland's telegram about the decision: 'I hope to be able to get Millais and Rossetti to design flower and beast borders—crocodiles and various vermin—such as you are particularly fond of—Mrs. Buckland's "dabby things"—and we will carve and inlay them with Cornish serpentine all about your windows. I will pay for a good deal myself, and I doubt not to find funds. *Such* capitals as we will have!'[3]

Alas, a week later there was no question of employing Millais. For that matter, Rossetti—though he was seduced to work in Oxford— had other commitments when the time came. But Pauline, Scott and

other 'Pre-Raph' friends became involved, especially in the designing of the capitals in the central court.

The Trevelyans arrived in London for a short visit in January. Pauline had not been well again, and Ruskin wrote suggesting lunch at Denmark Hill. 'I wish,' he said, 'you had told me *how* ill you have been—instead of saying in your quiet way "I have been ill", for I don't know what that means, and it makes me anxious.'[4] Would she bring Peter with her? 'I should like to show him to my good little Wisie, as an example of what sulky dogs are like.' Wisie was Zoë, Effie's dog that she had left behind. And would they mind coming late, as old Mr. Ruskin wanted to meet her? 'I think I can hold you in play until my father gets home.'

All went well and Pauline reported to Loo that 'Master' was well and 'very loving and nice, but I thought there was effort in his cheerfulness'. She had been given three drawings as a New Year's present. A 'high spot' in London, she added, had been her visit to Alexander Munro the sculptor, 'so dark and handsome and poetic and poor'. Munro had a reputation for waywardness and indiscretion that was readily condoned by his many friends, who included not only Louis Blanc and Mazzini, but Rossetti, Scott and Arthur Hughes, with whom he shared a studio. It was he who had told a journalist the dreadful truth about the meaning of the initials PRB that had so enraged the art critics. Pauline was so fascinated that she determined to get him up to Wallington as soon as possible. She also bought his plaster group that had been shown at the Great Exhibition, the 'Paolo and Francesca', perhaps his most sensitive work.

She was not quite so fascinated by the thought of young David Wooster coming up to arrange Calverley's museum. 'I have had to give in,' she said to Loo, 'but he is not the sort to meet every morning at breakfast.' He arrived in time for the great day for moving into the house, January 29th 1855. There was snow outside and it was very cold, but this did not worry the hardy Trevelyans, and Wooster was expected to 'acclimatize' himself.

The new hall, as an adaptation, was very successful, and in spite of the dun-coloured walls, had considerable grandeur, not at all competing with the eighteenth-century magnificence of the outer rooms. The question now was how to introduce colour and fill in the big blank spaces between the lower arches. . . . Altogether the alterations, including the innovation of water closets, had cost Calverley more than £4,000.

Ten servants were now employed. There was a lot of work for Pauline all the same. Nevertheless on February 17th, she settled down

to one of her long teasing letters to Loo about delays in correspondence:
'I was just going to ask you if you were still alive, and if not, whether
you had remembered me in your will. . . . Effie is at home and I ought
to tell you that I had a very nice account of her from some friends of
ours who have taken a cottage near Perth. They say she is quiet and
good, devotes herself to the teaching of her little sisters, dines early
with them and walks out with them like a governess, and is kind to
poor people. I am so glad. I hope she will keep good. I shall always
have a great regard for her. With all her faults—which are horrid—
she has some noble qualities. Millais has taken a lodging and studio
at Langham Place, and is working diligently. Mr. Munro told me he
thought one of the pictures he is about ["The Blind Girl"?] is far finer
than anything he has done. . . . I hadn't time to go and see him. I
don't like his picture of my Master and the waterfall. Of course
it is beautifully painted, but the face is detestable. The figure is
admirable.'

Calverley had attacks of gout, and Pauline was losing weight.
Wooster began on the fossils. The man was extraordinarily silent and
shy. Pauline called him Woosie, and that somehow cheered him up,
and they began at last to be friends. Then rats began to be a nuisance
in the house. Ruskin wrote that he was sorry about this, 'but have never-
theless some sympathy for the beasts' in their battles with Pauline.
The cold weather continued. An organ was placed in the new hall and
Wooster had to do the pumping while Pauline played vigorously,
'to scare off the creatures'.

Ruskin's own letters were hurried and short, as he was busy with
Modern Painters IV. Rossetti, he said, was helping him 'gloriously' at
the College, and the men were 'all so happy and getting on so wonder-
fully' (and indeed Ruskin was very popular with them). He was
worried now about the 'mawkish amiability' in his writings. 'It
plagues me more than I can tell you, in spite of all you said. Perhaps
if you come to town you might succeed in irritating me a little and
something might come of it!'

For once Pauline had to miss the Academy, because of more illness.
Instead, recuperating at Berwick-on-Tweed, she had to content herself
with Ruskin's new yearly venture, his *Academy Notes*—penetrating,
uninhibited comments on selected pictures, so uninhibited that they
created a kind of uproar among artists. The face of Eastlake's 'Beatrice'
for example, he said (and no doubt rightly, though he was on very
dangerous ground), indicated 'little piety and less wit'; whereas he
described Millais' 'The Rescue' as 'immortal' and 'the only great

picture exhibited this year'—carrying, it must be confessed, fairness
and generosity to too great lengths, for it was a poorish work.

Ruskin sent her a copy of the *Notes*. He was ailing himself—in point
of fact at the beginning of a long period of depression—and had gone
to Tunbridge Wells to recuperate. The Empress Eugénie was to blame
for his illness, he said; he had stayed out in an East wind 'to look at her
over the garden palings'. Still he knew the dangers, and spoke alarm-
ingly of hoping to carry on 'without another breakdown'. Now that
his mother had taken up the carpets at Denmark Hill, he had never
felt so homeless in his life. 'I would come and play hermit crab with
you and Miss Mackenzie if I could but I am like a dog turned out of
the drawing room and tied to the door scraper.'

He was sorry to hear that he had missed Calverley in London: 'I was
a good deal surprised at his thinking it possible to introduce that Maine
law among us: I have no opinion or judgement on such matters myself
—having no knowledge—all I feel about it is that there is a certain
poetry in Beer—and a peculiar, racy, Shakespearian odour of non-
sanctity in a Tavern which I should be sorry to lose. . . . I have still a
certain Sir Tobyish sympathy with the Cakes and Ale, which makes
me believe in their perpetuity.'

Meanwhile his obsession with Rossetti was continuing. He had been
shown drawings by Lizzie Siddal, and had been overcome with
admiration. But she was so frail and so ragged, and Rossetti's love was
so intense and so sad. Within three weeks of seeing the girl Ruskin had
settled £150 a year on her. Then he wrote to Acland to beg him to
give her medical advice.

Lizzie was sent to Oxford, and the dons and wives she met were one
and all enchanted. Acland's conclusions seem to have been that her
troubles were mostly psychological, arising from her prolonged
engagement to Rossetti. In a curious, morbid way she appeared to
like being worshipped by her handsome Latin, as his unattainable
love-object, the incarnation of the medieval idea of the dame lointaine.

So we have the spectacle of Ruskin, after his own experiences the
previous year, urging marriage and hinting that he would help them
financially if this happened. The truth was that he was lonely and
longing not only for friendship but to be *of use*. Unfortunately,
however, he was out of his depth in the bohemian world of Dante
Gabriel Rossetti, and constantly found himself being let down. Thus
when he told Mrs. Acland that he had known five geniuses in his life—
Turner, Watts, Millais, Rossetti, and now 'Ida', as he called Lizzie—
he added that he 'didn't know which was or which is wrong-headedest'.

In her special way, Lizzie was also a catalyst, in spite of the opposite impression one gets from that wan, generally unsmiling face in Rossetti's portraits. Forty years later Algernon Swinburne wrote those words, already quoted: 'Except Lady Trevelyan, I never knew so brilliant and appreciative a woman,' and added: 'So quick to see and so keen to enjoy that rare and delightful fusion of wit, humour, character-painting, and dramatic poetry.'

William Bell Scott now deemed it time to remind the Trevelyans of the earlier invitation. The day fixed for his visit was July 2nd.

And here we come to one of those little inaccuracies, in the form of a single word, in Scott's *Autobiographical Notes*. Deliberate or not? One can excuse the lapse of time, but the twist does help along his story. 'It was fortunate,' he said, 'that I had Lady Trevelyan these few *days* all to myself, Sir Walter being so difficult to become acquainted with.' 'Not,' he added, 'that he drew a line round himself as many do whose only recommendation in the world lies in their belongings, but he was a man of few words, and many unacknowledged peculiarities . . . for . . . a philosophical leveller in some respects by inclination, the inherited habits of thirty generations were not to be cast aside.'[5]

As it happened, it was not a question of 'days'. Calverley, who had been in London, returned to Wallington the next day, July 3rd. However, the whole passage has been seized upon by the aforementioned professor from Utah, who became convinced that a love affair sprang up between Scott and Pauline either then or during his later visits, over which she says Scott draws a 'decorous curtain'. 'One can only guess at the precise nature' of their friendship. At least there was a chaperon at Wallington that fatal night of July 2nd: Woosie Wooster. The phrase 'without the passion of love' does rather spoil the professor's argument, as does the comment by Scott that Pauline, in spite of differences in age and temperament with her husband, 'became in many respects in perfect harmony with him'.[6]

Apart from news of friends killed in the Crimea, Calverley had had an enjoyable time in London. He saw Charles Kean in a lavish production of *Henry VIII*, dined at the Athenaeum, once more saw his favourite Alhambra Court at Sydenham, visited Moussy at Cowley and Mrs. Buckland at the Deanery, saw Charles Trevelyan, and went to the Royal Academy. 'Slept a short time in Newcastle; and after shopping etc. to Morpeth. In gig to Wallington, where I found Mr. Scott, a very interesting, clever, poetic mind.'

The same gig had also met Scott at Morpeth. We reach now the description of Pauline quoted at the beginning of this book, a description which continues with comments on her appearance and her way of seeming to sum you up at once, 'seasoned with mild satire'. And why, said Scott, should anybody mind this teasing, 'innocent on the tongue of the amiable, mild in the hands of a lady who knew reply was out of court, and beneficial too from so trenchant an observer as the possessor of those hazel eyes that saw through one and made him careful to avoid affectation of any complexion. . . . ?'

Later in *Autobiographical Notes* he described Pauline, in a sentimental passage joyfully clutched at by the Utah professor: '. . . Pauline, my never-to-be-forgotten good angel; small, quick with restless bright eyes that nothing in heaven or earth escaped; appreciative, yet trenchant; satirical, yet kindly; able to do whatever she took in hand, whether it was to please her father in Latin or Greek, or herself in painting and music, intensely amusing and interesting to the men she liked, understanding exactly how much she could trust them in conversation on dangerous subjects, or in how far she could show them she understood and estimated them. This was intensified by the want of humour and imagination in Sir Walter, which must have been a grievance, but was only perceptible as a secret amusement to her. When I first knew her, I was not learned in the female character, my own wife being the most difficult of human creatures to understand. She soon saw through me. . . .'[7]

On arrival that day at Wallington, he had been immediately whisked off to the flower garden, and within half an hour they were 'old friends'. 'She had asked many questions, and received the directest and truest answers.' She showed at once, he said, that she approved of his plain speech, which she recognized as 'genuine and unconventional'. Then she pointed out to him various nooks which she liked to sketch, and made him row her across one of the ponds.

In all the above it is possible to divine the peculiar fascination of old Scotus's character. In a plodding way he was honest; but jealousy too often got the better of him, and then his honesty would become submerged in rancour. Of this he was quite aware, for in another passage about Pauline he said: 'Always amiable and often complimentary to strangers, towards me she had the appearance of severity, rating me for pride, for ignorance of the world, for conceit in things below my mark.' Pauline's own nickname for him was, significantly, 'Mr. Porcupine'. He stayed at Wallington until July 7th. And here it is necessary to quote from him yet again—a passage often mentioned

in books and articles about the Ruskin marriage, in spite of its self-evident inaccuracies: 'At the very time of my first visit to Wallington they [the Ruskins] had separated. Every other day Lady Trevelyan laid certain letters aside; these I believe were from Mrs. R. [Effie] beseeching sympathy with the painful position of a wife, who, for the first time in her life knew what love was, confessing that John was loathsome to her, and that at any pains and penalties of exposure and shame she must from him be separated. I could not even appear to wish to know the feeling which these letters called up, but it was evident enough that the action of the wife was repudiated, and that Lady Trevelyan would not reply to them, or even I think read them.'[8]

Effie married Millais on July 3rd 1855, the day after Scott's arrival at Wallington.

A kind of postscript can now be inserted. Effie and Millais apparently lived happily ever after, until their deaths in 1897 and 1896 respectively. They had eight children. Millais rose to fame and was created a baronet and President of the Royal Academy. However, the quality of his painting became uneven. That old fire dwindled, and this may well have been because he was driven to earn money to support his family. Effie was certainly keen on cash, and Agnew is reported to have said that she was the second best businessman he had ever met.[9]

On December 23rd 1857 the Trevelyans went to a party given by Baron Marochetti in Onslow Square, and they were confronted by Effie. Pauline put out her hand, but Effie refused to take it. Millais described, in a letter to Mrs. Gray, how Effie came home in an excited state: 'Nothing could have been better for Effie than dining there and being made so much of by the Marochettis in the sight of the Ts, who must have felt ashamed of themselves and occasioned the clumsy attempt at reconciliation.'[10]

Queen Victoria would not agree to receive Effie at Court, and this was something that would have always rankled. However, at Millais' deathbed wish, she did see her privately at Windsor.

Scott had one criticism of Pauline, and that was that with all her discrimination and knowledge of artists she had not risen above the Turner mania. 'And the exponent of Turner, Mr. Ruskin, I soon found, held an overpowering influence over her. . . . She had taken his part before, and was now prepared indignantly to stand by him again.'

There is a passage in *Autobiographical Notes*, dealing with Scott's subsequent visit to Ruskin, at Pauline's behest, that once more twists round the facts in a half-convenient manner. As the encounter was a

failure and Scott conceived such a dislike for Ruskin, it is interesting to piece together the documentation.

Pauline wrote to Ruskin on July 5th to ask, 'if you can without inconveniencing, show your Turners to our friend Mr. Scott', who would be staying with the Rossettis. 'He is very amiable, so don't ill-treat him.' To which Ruskin replied briefly: 'Why do you make speeches in your letters? You know I haven't anything else to do than to see people who have got anything to say to me. I write to Mr. Scott forthwith. I am quite well, thank God. Ever yours J.R. (going to town).' And he duly wrote a formal note[11] to Scott inviting him to dine at Denmark Hill at 5 p.m., to go to the College afterwards.

As Scott put it, he willingly accepted Pauline's suggestion that he should visit Ruskin, 'expecting much pleasure, if not also advantage, from listening to the most eloquent writer and enthusiastic hero of this or any age'. However, on receiving Ruskin's invitation, he felt—so he said in the *Notes*—that it would be unwise for him to go to the College, since it 'repudiated every point of the curriculum of the Government system' in the Schools of Design, and there was 'an impertinent jealousy in every one of the teachers'. This reluctance again cannot have been quite true, as he must have known what Pauline had said in her letter. According to Scott once more, Rossetti volunteered to acompany him self-invited, in order to provide moral support.

'There are natures sympathetic to each other's,' Scott wrote, 'and there are others antipathetic. I endeavoured to be very modest, and tried to be agreeable, but it was of no use. I had sent him my little volume of poems at the lady's desire, and D.G.R. asked him what he thought of the book; he pretended to be surprised it was mine. His late visit to Edinburgh led us to talk of Scottish artists, when he mentioned David Scott, some of whose works had been pointed out to him. He thought they possessed some quality in colour, but nothing else, though he believed the artist had valued himself on quite other qualities! "Scott's brother, you mean," suggested D.G.R., whereat he again simulated surprise. This was still followed by some other supercilious pretence, and I could bear him no longer.' So Scott thought he would try a 'good-humoured reprisal', which was to make fun of Turner's character and Cockney way of speaking. 'At this Gabriel laughed, and asked him if Turner really talked in that way, and how he got over that sort of thing. The poisonous expression of his [Ruskin's] face was a study.'[12] The visit to Red Lion Square was just as disastrous. Scott was appalled to find the men being set to make pen and ink

drawings of pieces of sticks encrusted with lichen. He left feeling that 'such pretence of education was in high degree criminal'—intellectual murder, no less.

Ruskin's comment to Pauline was: 'I liked Scott very much—but he is languid, and not to be got out in a hasty single chat. You never told me he was David Scott's brother. I came out with something (luckily not so bad as it might have been) about David Scott in the middle of dinner—and was very sorry.'

Scott had a more difficult task in reporting his impressions. He knew he had to be sincere, but he could not risk offending his influential new friend. He wrote on August 25th, having just returned from the Exposition Universelle in Paris: 'Truth to say he is not a person to be quickly understood or lightly characterized.' He was afraid of having appeared 'too positive or energetic' for Ruskin's 'clear cold eye'. He went on, as if to change the subject: 'The evening after meeting Mr. Ruskin I spent with Mr. Carlyle, the most extraordinary contrast to each other, Mr. Carlyle's view of art being expressed in a volunteer manner by himself thus—"Airt, airt, what is it all about? I've never been to the Exhibition [at the Academy] all the time I've been in London, and don't mean to go, and more than that I believe if all art, except good portraits, faces or great men well done, if all art but these was swept out of the world we would be all the better!"'

Guests at Wallington that summer included Munro and two exhausted professors: Acland, 'like a tired horse with a cartload of drawing things', and Whewell, who had been worn down by the controversy over his *Plurality of Worlds* and the ensuing mockery of some friends, including Brewster. Recently Whewell had been forced to give up his Professorship of Moral Philosophy at Cambridge, and this had been upsetting. He had also been deeply involved in the struggle to reform the University, of which he was about to be reappointed Vice-Chancellor. And his wife was dying.

Mrs. Scott had not yet been to Wallington, the plea of her mysterious infirmity keeping her at home. Nevertheless, Pauline would not allow Scott to forget the fact that he was a husband; in her letters she usually sent messages, which obliged him to send some back from 'my good little lady'. He tried so hard to keep up a jocular tone.

Naturally Pauline wanted to go to the Paris exhibition, where among other things, the Pre-Raphaelites were making their first appearance abroad. Munro was accompanying Rossetti, who was longing to see his Lizzie again—Ruskin had paid for her to have a winter abroad. The Brownings were in Paris too. Munro could introduce

Pauline to them. Why didn't she make her visit coincide with his and Rossetti's? In the event the Trevelyans did not arrive there until November 1st, by which time Munro was back in London again. They would not have seen much of Rossetti anyway, for 'he was every day with his sweetheart of whom he is more ["foolishly" deleted] fond than I ever saw lover', as Munro told Scott.

The exhibition was Napoleon III's answer to Hyde Park in 1851. Needless to say it received the same exhaustive attention from Calverley, over a period of three weeks. He was especially delighted with the Minton exhibits, which he considered quite equal to Sèvres and the old majolica. A method for breeding leeches artificially fascinated him. Pauline—apart from the art sections—concentrated on such things as lace, silks, photography, porcelain and pottery. We have no record of her feelings about the pictures they saw, but Calverley singled out Decamps as the greatest artist and Moreau as having most in common with the Pre-Raphaelites. On the whole, he deplored the taste of the French for 'large canvases covered with bloodshed which it is by no means desirable to perpetuate'.

As soon as they returned to London, they rushed to see Munro's medallion of Pauline, a strange, rather morbid work, reminiscent now of the death-mask of the Inconnue of the Seine: a mixture of fun and pathos Dr. Brown called it and still to be seen in the hall at Wallington. Arthur Hughes was at the studio, working on his 'trembling' girl in 'April Love', that Pauline could well have urged Ruskin to buy when she dined at Denmark Hill on December 5th.

At Oxford Calverley read the draft of Acland's cholera report, which included a reference to himself as having provided model sanitary flooring for cottages at Cambo. He also arranged a £10 prize for the best essay on methods of introducing and rearing fish in the Cherwell and Isis, visited the Mendicity Institution and the Littlemore Asylum for pauper lunatics—'good situation and seems to be well managed, though ventilation did not appear to be sufficient'. Pauline, for her part, went to see the 'Syrian boxes' belonging to Holman Hunt, who had recently returned from Palestine. She managed a glimpse of the long awaited 'Scapegoat', and was at once enthusiastic, though others, including Holman Hunt's dealer, Gambart, were horrified.

Once she was back at Wallington, the correspondence with Scott resumed. He had been reading *Modern Painters* III. 'How beautiful and discriminative a great part of it is,' he wrote guardedly. 'Yet there is more play than work, more luxurious than nutritive fare in it.' To which Pauline, who was not to be caught, replied: 'We think it is

excellent, and he is much less vituperative, and more grave and calm.'
She was as warm and intimate in her correspondence as ever. Then
came an invitation for Scott to stay for Easter—but with his wife.

For Scott that visit in March 1856 was one of the key points of his
life. He must have talked to the Trevelyans of his frustrations at the
School of Design, his disappointments in the art world and his longing
for travel. The drawback of having Mrs. Scott—who turned out to
be boringly garrulous—to support would also now be quite apparent.
His sincerity would have touched both Pauline and Calverley, and
their reaction would have probably been spontaneous. Would he help
with the decorating of the central hall? Together they could turn it
into a glowing, splendid Pre-Raphaelite showpiece: eight large
canvases of scenes from Northumbrian history between the arches,
tall plants such as foxgloves and bulrushes on the pilasters, spreading
foliage of native trees such as oak and elm, with perhaps vignettes,
on the spandrels below the Murano balcony. This would only be a
beginning. And Pauline would help with the flowers and foliage. One
can imagine the enthusiasm and the planning. St. Cuthbert, Bede,
Grace Darling would be possible subjects for the canvases. . . .

On his return to the 'cool regularity' of Newcastle, Scott wrote a
delighted letter to Pauline. A great load was obviously about to be
lifted from him. However, he had been to see Dobson about elevations,
and had been alarmed by the possibility of the architect interfering
over colour schemes. Indeed he was terrified, 'poor desponding wretch'
that he was, that some 'dark hand' might 'rise between me and all
this'. In other words he was wanting reassurance.

The reassurance came. There was no hurry though, she said, and
certainly Calverley would not allow Dobson to 'meddle'. They had
picked up some ideas about colours when they were in Paris. But
she found it hard what to advise about whether or not to stay on at
the School of Design. 'It seems to me a noble vocation enough—
what you have got—and perhaps none the less so that it involves so
much abnegation of self. And if a person is naturally inclined to be
desponding, and to be profoundly dissatisfied with their own doings,
and to feel that *they* themselves are very much better than their own
achievements, it seems to me to be much for their ease and comfort to
have an honourable calling marked out for them, which needs only
energy and perseverance to fulfil it, such a calling and such a round of
duties as yours are now.' The most important things to Scott were
that at last he had received material recognition and badly needed
encouragement as an artist. His chance had come.

THE CIRCLE GROWS

1856-57

'NOTHING can be more degradingly low, both as regards art and manners, than the whole tone of this pamphlet.' Thus, in a forty-eight page tirade, wrote the anonymous reviewer of *Academy Notes* in the *Quarterly Review*. Some good slashes at vols III and IV of *Modern Painters* were also included. Malice, it was claimed, lay behind everything that Ruskin wrote, not to mention 'false assumptions, futile speculation, contradictory argument, crotchety views and romantic rubbish'.

The secret was soon out. The reviewer was Lady Eastlake. 'One of the great prose-hymns of hate,'[1] her effort has been described: a real hatchet job, an argument if ever there was one against anonymous reviewing. It was noted that when still Elizabeth Rigby, she had attacked *Jane Eyre* on publication ('total ignorance of the habits of society, a great coarseness of taste, and a heathenish doctrine of religion').

Needless to say, she succeeded only in enhancing Ruskin's literary reputation. And in point of fact, the need for humility—in addition to self-knowledge and self-improvement—was intended as a theme for vol III. George Eliot considered his work as among the highest writings of the age. The youthful William Morris and Edward Burne Jones (his name not yet hyphenated) wrote a counter-attack in defence of Ruskin in the *Oxford and Cambridge Review*.

Five years later, in 1861, that termagant of a woman, as Carlyle called Lady Eastlake, took Effie to hear Ruskin lecture—the subject being 'Tree Twigs'—'on purpose to disconcert him'.[2] This they succeeded in doing, for he broke down half way through.

When Ruskin went to lecture to the workmen at the Oxford Museum, Acland was alarmed by his state of depression and 'cracked' talk about wanting to write on political economy. If only, he said, Ruskin would stick to regions where he was pre-eminent, like style

and taste. 'But barring these things, I love him more and more.' Nevertheless Ruskin's views on paternal socialism were to dominate much of the rest of his life. They were to cause far more of a furore than his *Sheepfolds* ever had.

It had been decided that the first panel at Wallington should depict St. Cuthbert on the Farne Islands. Pauline would paint plants such as poppies, ferns and rushes on the pilasters of the hall, and help with the lower spandrels. First, however, she wanted Ruskin's imprimatur and forced Scott to write to him for an opinion, something he did with 'strong misgivings'.

Ruskin's off-hand reply from Amiens, where he was staying with his parents, outraged Scott, who dredged it out in *Autobiographical Notes*. He recommended 'all Nature' for the spandrels instead of arabesques, in other words foliage of trees similar to the tops of the iron columns at the Oxford Museum. However, he told Scott, he really knew as little as he did about interior decoration. 'So get on that I may have plenty to find fault with, for that, I believe, is all I can do. Help you I can't—But am always, truly yours.'

His excuse was that he was very tired, which was true. Pauline and Scott did get on during the summer, but there was no hope of having anything to show in October. She chose campanulas as her first subject. The plan was to paint in tempera direct on the stone, so as to show up the roughness underneath. Every detail, every shade was discussed. Then Laura Capel Lofft came to stay, and she was allocated two pilasters, hollyhocks and foxgloves being her subjects. Gradually Scott came to be consulted less and less, and for a while he did not dare object. Then there was Calverley, who was doing the paying. He had to approve every step. Rosettes? He wanted them to be copied from snow crystals. Scott's so-called Pompeian motifs were entirely wrong—he had confused them with Etruscan designs. Tragic and comic masks? Certainly not. They must have heads of Roman emperors connected with Northumberland: Agricola, Hadrian, Severus and Constantine.

For all this, the hall today does display a kind of illogical unity. It is extremely individual, and at the same time so unabashedly mid-Victorian. Any visitor must be aware of the planning—not to mention the anxieties, the excitements, the enthusiasms—that lay behind its creation. Pauline was probably disappointed by some of Scott's panels. She intended each to let in the 'breezy sunlight' but some turned out quite claustrophobic. Two panels are now famous: 'The Roman Wall', a favourite illustration in popular history books, and 'The

Nineteenth Century', Scott's chef d'oeuvre that entitles him to a secure place in the Pre-Raphaelite canon.

There is a sense of strength, or—to use one of Pauline's favourite words—manliness, about the whole place. That 'lofty aim', which she mentioned in her *Pre-Raphaelitism* review, is very evident. The only light-hearted touch, significantly, is in 'The Descent of the Danes', which includes herself in the guise of a distraught native, clutched by her Faussett foster-daughter, also distraught, and with the dog Peter's shaggy head by her side. Nobody could have complained about the set of panels having a 'want for models and close study'. Every figure was taken from a living person. Even a piece of Roman Wall was obtained to provide Scott with the right inspiration.

Scott was in the habit of sending calotypes of the pictures to Rossetti, who genuinely praised them, as both Madox Brown and Woolner confirmed. 'St. Cuthbert' had 'all the qualities that yield high enjoyment in historic art.' The 'vivid freshness' of the background was admired. One had the feeling, he had said, that the painter had really seen the incident take place—there was a 'simple truth' about it. Rossetti was particularly flattering about 'The Roman Wall': 'As a piece of life and teeming invention it is altogether glorious, and could only be produced by a true poet.'

The *Academy Notes* for 1856 almost looked like a victory for Lady Eastlake. 'Ruskin has praised some of the worst pictures in the place,' wrote Woolner, who quite liked him, to Mrs. Tennyson. 'He has made such a mess of it that his enemies are dancing for delight.'[3] What the 'little despot' needed was to go without money for a year, and then he would be more careful about condemning other people's work. Calverley, becoming less and less tolerant of Ruskin's vagaries, considered the *Notes* 'flippant and in great part untrue'.

Ruskin certainly did not like 'The Scapegoat', which was on display at the Academy. Indeed, he said, as a landscape or a composition it was a total failure. Pauline said she didn't care. She thought it 'wonderful', though—as she admitted to Loo—it was too painful to live with, 'at least for anyone who is deeply moved by pictures'.

Ruskin suggested that Hunt should now paint pictures with 'less feeling' and more 'handling'. As for Millais, he thought—and posterity would now agree—that his 'Autumn Leaves' was the 'most poetical work he has yet achieved', though many at the time felt quite differently. But even Millais' friends must have regarded Ruskin's opinion as exaggerated when he described 'Peace Concluded' as one

of the world's masterpieces. Few today, however, would fault him for singling out for praise Hughes's 'April Love' and Wallis's 'Death of Chatterton'.

When Pauline heard from Scott that Thomas Woolner had said that all people with titles were 'maggots', she determined to 'tame' him, which she swiftly did. Soon, not only was he sending her long gossipy letters about Tennyson and Carlyle, but he accepted an invitation to Wallington. She liked his 'alert' look and had admired the early version of his poem *My Beautiful Lady*, which had appeared in the *Germ* in the days of the Brotherhood's 'universal artistry'. (Swinburne, it has been said, picked up something of Woolner's style in *Queen Yseult*.) It had not taken 'long for Woolner to realize that he was primarily a sculptor. Indeed he had conceived a longing to create statuary on the grand scale; but when his luck failed he had left England in disgust, in 1852, in search of fresh fortunes in the Australian goldfields. His departure is supposed to have been the inspiration for Madox Brown's 'The Last of England'. Alas, no gold was forthcoming, and he had been obliged to make a living out of portrait medallions of prominent Australian citizens. He had returned to England two years later.

He went to Wallington with Munro, and it was a great success. 'O, such a place to luxuriate in!'[4] The sculptors went fishing, just as the Millais brothers had done three years before. They had been taken to Capheaton to see Sir John Swinburne and the 'marvellous' Turners, kept in a folio which his daughter Julia now always carried with her when she travelled. Sir John was 'as fine a picture as any drawing, only more so'. The old fellow was ninety-six, 'and as cheerful as any man half that age'. As a special favour, Calverley took them on a tour of the Wallington cellars, originally the lower part of the Fenwick's tower and containing the old refuge for cattle in times of Border raids. There, all neatly ranged out, was the famous collection of wines, untouched since Maria's departure. It was like going round a museum. Here was port laid down at the time of Culloden. Here magnums of hock acquired by the fourth baronet on Sir Walter Blackett's death in 1777. There tokay bought from Edward Wortley in 1752. . . . When a bottle of especially ancient malmsey sack was produced, Woolner was bold enough to suggest that it might be opened, 'as an experiment'. Two glasses each were allowed per sculptor and declared 'perfect', and the rest was poured away. No one else, Woolner would claim, was ever allowed such a privilege.

As old Dean Buckland had at last died (to be followed a year later

by his wife, worn out with caring for him), his almost equally eccentric son, Frank, came to stay. Frank was the author of amusing articles in the *Field*, to reappear, slightly refurbished, in 1857 in the first of his best-selling *Curiosities of Natural History* volumes. He coincided with Professor Sedgwick, in a state of shock after quarrels with Murchison and the Geological Society. Pauline thought Frank might cheer the Professor up and pushed them off on a walk together. Not a bit of it— on his return Sedgwick was so upset by the experience that he had to go straight to bed. Apparently they had reached a spot where midges had been particularly abundant. Frank had at once thrown off every stitch of clothing so that Sedgwick could count how many midge bites one could get in thirty seconds.

Then came Benjamin Woodward, 'beautiful in face and character',[5] with news that he had now been commissioned to design the Union debating rooms at Oxford. He looked pale. Perhaps Pauline realized that the 'shadow of an early death' was already 'stealing over him'. She found him 'a sort of mystic' and at once set about drawing him out of his reserve. There was much talk of course about the Museum, which Ruskin claimed was 'literally the first building raised in England, since the close of the fifteenth century, which has fearlessly put to new trial this old faith in nature'.[6] Some Irish labourers, notably the O'Shea brothers, had been imported, brilliant in a sense but apt to take advantage of the adulation they received as 'medieval' craftsmen. F. G. Stephens thought the Museum a triumph, and in a curious, rather endearing way—and for some of the same reasons as at the hall at Wallington—it is just that.

Calverley, who had given money to the Museum and was later to donate geological specimens and birds' eggs, agreed to work out a botanical sequence for the capitals. Then Pauline had an inspiration. Calverley wanted to develop Seaton. Why not employ Woodward as architect? They could put Venetian Gothic terraces all along the seafront, build a Gothic school and a Gothic fire station. It would be a model watering place, a showplace (a mid-Victorian Portmeirion?). Then Woodward must design a villa for them; on Ruskinian principles it would be built entirely of flints and other local materials. The bannisters of the staircase would be wrought iron, copying a design at the new Paddington Station.

After Wallington, Woodward went to stay with Scott. All went 'very comfortably', in spite of differences about ways of teaching Art. Scott was conscripted into helping over the Museum capitals. After-wards, Woodward returned to Dublin, where he was joined by Munro.

All in all, a happy little group of friends was beginning to form round Pauline.

Not, it appears, that staying at Wallington was all that cosy, if Augustus Hare is to be believed. He found artichokes and cauliflower to be a staple diet there. The house was 'only partly carpeted and thinly furnished with ugly last century furniture'. Pauline, surrounded by female acolytes, did not appear to bother about running the house, 'which is like a great desert with one or two little oases in it, where by good management you may possibly make yourself comfortable'. Hare thought his bedroom 'quite horrid' and had to push his dressing table against the door to keep it shut.[7]

Pauline was now forty. She still preferred sitting on the floor. Sometimes she would leap up to write a book review, always published anonymously. If friends persuaded her to review their works, they had to beware. She was no Lady Eastlake, but she refused to praise anything that she did not think worth while.

As soon as Ruskin announced his return in September, the Trevelyans came south to London. He was better, but neurotically concerned about his health. They saw a great deal of him. At long last the complications over Turner's will had been sorted out, not altogether in accordance with the artist's own wishes, it must be admitted. All the pictures, drawings and sketches, however, were to be the nation's property, and Ruskin at once offered his services for cataloguing them. He even volunteered to frame a quantity of drawings at his own expense and supervise their display. But there was so much jealousy at the National Gallery that his offer was refused. Instead the Trustees chose thirty-four paintings, which they had cleaned and framed themselves, for display at Marlborough House.

Pauline went with Ruskin to Marlborough House, but found it 'shamefully dark'. At a dinner party at Denmark Hill on December 12th she met Morris and Burne Jones, those 'redhot young Ruskinites' as Woolner called them. The talk was of Elizabeth Barrett Browning's poem *Aurora Leigh*. Ruskin was 'in a state of perfect rapture over it'.

It was Woolner who had introduced Pauline to the Brownings. He wanted her to see Rossetti's 'Dante's Dream', which was on loan to them. Pauline had liked Robert Browning especially, but Mrs. Browning was suffering a 'severe hollow cough, most distressing to her', as a result of 'this vile weather'.[8] Would she now be inviting them to Wallington, Scott hopefully asked? 'We *did* entreat [them] to come and see the Borderland,' Pauline replied. 'They said they should like

it very much and would do it, if ever it were possible, but her health cuts their summer visits to England very short.'

Then there was a round of artists' studios: to John Brett, to see his Rosenlaui glacier picture ('excellent' said Calverley, to whom the precise geological detail appealed); to Madox Brown, to see 'An English Autumn Afternoon' ('uninteresting'); and to Rossetti ('in colouring and feeling he outshines most other of the young artists'). Pauline found Rossetti 'fascinating'.

The old jealous Scotus kept rearing up in correspondence. Really, didn't she think Woolner's adulation of Tennyson excessive? 'Gardener's daughters and sixteen year old Mauds with murdering lovers, as well as consumptive music masters and donkey poets making mannerless love to proud ladies, are very closely allied to things silly.' He was at once put in his place. Obviously, she said, he had not read *In Memoriam* properly, or he would have no doubts about Tennyson. 'It seems to me to grow greater and deeper every year.'

In spite of Scott's feelings towards Ruskin, he was anxious that Pauline should ask him to paint one of the pilasters. A lily perhaps? 'Let us add his initials to the hall.' Of course, it was important that Scott's name should not be mentioned in this manoeuvre.... 'He will know me by degrees.' To which Pauline was able to reply that Ruskin himself had 'spontaneously' made this very proposal, though his choice of plant had not been mentioned. She then, at the end of her letter, dropped a little bombshell: 'Sir Walter has settled to give up having plants in the hall, and we are to have a bit of sculpture there, which we have asked Mr. Woolner to undertake. We have laid our three heads together about a subject, but quite in vain.... It must be definite and complete in itself ... a crown and centre of all that the pictures tell.'

Considering Scott's nature and the fact that once more he had not been consulted, one might have thought that he would have shown annoyance over this decision. Not a bit of it. For a change, he was extremely pleased: 'The best news I have heard for a long while and would go a long way to ensure a grand completion of our labours.' Woolner was in need of proper recognition. Indeed, as Scott said in his autobiography, the Trevelyans' commission was the beginning of Woolner's immense success.

Scott at that moment must have been in a charitable phase, for when Pauline wrote to him saying that she had met Gabriel Rossetti's brother, William, at Mrs. Loudon's and thought him 'beautiful', he replied: 'He *is* beautiful and one of the best informed and balanced

minds I have had the luck to know. . . . I absolutely love him although should not think of telling him so.'

Admiration was reciprocated by William Rossetti, who was also very pleased about Woolner's commission—'It is beginning to be high time he should take up his proper position,' he told Scott. He had not actually had much time to talk to Pauline, 'but she seems particularly frank, unaffected and good-humouredly willing to be pleased'. He had talked more of Calverley: 'A fine-minded man, of both natural and acquired dignity. He would do well for Don Quixote —not the Don of the caricaturist, however.'[9]

Unfortunately the commission lost Scott a friend: Munro. 'He jumped to the conclusion,' wrote Scott, 'that but for me being inter-ested in a brother poet, Woolner would never have stepped in.' But this must have been a much later development. Certainly Munro's subsequent letters to Pauline show no diminution of his affection for her, and as it happened Calverley was always ready to lend him money. Munro was still seeing Scott in 1861, and Scott would refer to him in such terms as 'that good sensible soul'. He also came to be very well represented in the hall.

At the end of their stay in London, the Trevelyans were able to see Holman Hunt working at the Crystal Palace, where he was copying details in the Alhambra court for his 'Christ in the Temple'. And scribbled in pencil in Calverley's diary is the word 'Swinburne', perhaps his first reference to Algernon Swinburne, then aged nineteen.

On December 12th Acland had written: 'My dear and very naughty friends. I. 1. Where are you? 2. When are you coming? 3. What are you doing? 4. What have you been doing? 5. What shall you be doing? 6. What is Ruskin doing? 7. Where is the classification of the Museum capital carvings? 8. Do you spend Christmas with us? . . . II. 1. Sarah is not very well. 2. The children are very well. 3. They have 130 objects for a Christmas tree. 4. I am not so fat. 5. The Museum is roofing over. 6. Woodward answered a question the day before yesterday!!! . . .'

It was unlike the Trevelyans to have been dilatory, but perhaps Pauline's state of health was the excuse. In one way it was as well that they did not come for Christmas; Acland's old tutor, Henry Liddell (of the Liddell and Scott lexicon, and father of Alice in Wonderland), had become Dean of Christ Church and had fallen seriously ill. It was decided that he must recuperate in Madeira, and the Dean had absolutely refused to go unless accompanied by Acland himself. This

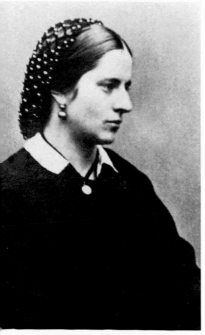

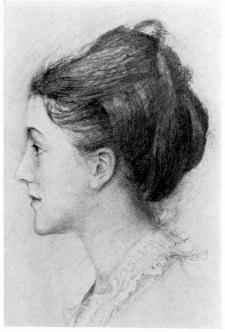

3a Louisa Stewart-Mackenzie, later b Constance Hilliard by Ruskin, 1870
Lady Ashburton, c. 1858

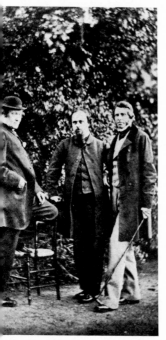

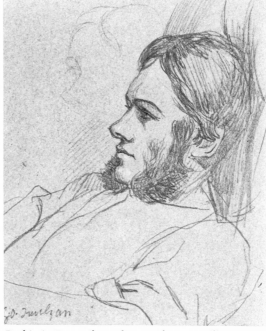

W. B. Scott, D. G. Rossetti, John Ruskin in Rossetti's garden at Cheyne Walk, 1863.
A controversial photograph taken by William Downey. d George Otto Trevelyan by
George Howard, c. 1864

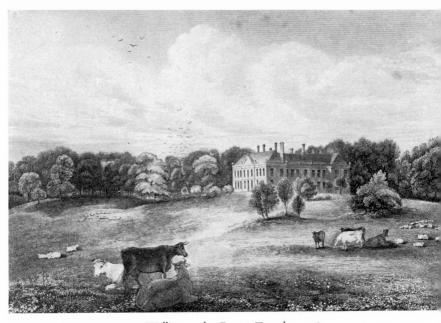

4a Wallington by Emma Trevelyan, 1832

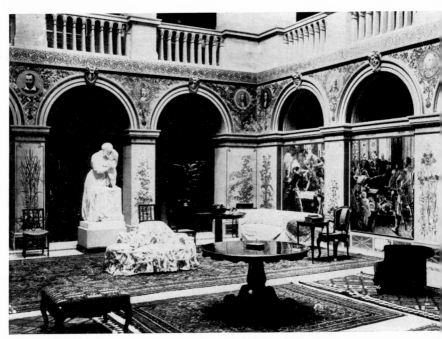

b The Central Saloon at Wallington, c. 1880

had come to pass, but Acland on the way back had been shipwrecked and nearly drowned.

He had been immensely courageous. 'Everyone says: "I suppose you were much frightened",' he told Pauline. 'It is curious, as illustrating the difference between reality and imagination, that that particular state of mind never entered. I felt my end was possibly at one time probably near. It was solemn—but not sad. . . . All self was extinct— until on landing I found her [his wife's] Bible and prayerbook and picture were wet in the seas that had immersed the boat, and I burst into tears and fell down on the beach. . . .' Ruskin writes in *Praeterita* how at the height of the storm Acland 'astonished and scandalized' his fellow passengers by appearing in full morning dress from the saloon announcing that breakfast was ready. Friends subscribed to a presentation to Mrs. Acland, namely a bust of her husband by Munro, to commemorate his escape, and it was Pauline who was chosen to make the presentation.

'Your pet,' Woolner now told Pauline, 'begins to look very old and more odd-looking than ever.' He was referring to Ruskin. 'His forehead looks stronger and the eyebrows grow raggedly, hanging over much like Peter's.' When Ruskin spoke in public, he seemed to sneer, 'I suppose with the energy of his intentions.'

As it happened, some good news soon lifted Ruskin's spirits a little. Thanks to the influence of Palmerston, it had at last been agreed that he could go ahead with his work on the Turners, though this could not start until the autumn. As he himself put it to Pauline, 'the National Gallery people are fraternizing at last.' 'Overtures—through Mr. Wornum [R. N. Wornum, the Keeper], even from Sir C. E. [Eastlake]! —declaring Lady Eastlake never wrote Quarterly Review. I behave in as conciliatory a way as I can. It don't do anybody good to quarrel— and if Sir C. wants me in future to look at him as an opaque instead of a transparent body—I will, only I won't say he can paint.' He even agreed to stay at Wallington after lecturing at the Manchester Art Treasures Exhibition in the summer.

The Exhibition opened just as the Indian Mutiny broke and the sepoys were cutting down all Europeans on sight in Delhi. The siege of Cawnpore was about to begin. Later Pauline said she felt it 'almost wicked' to have been there at that time. The Exhibition was one of the greatest events of its kind in the second half of nineteenth-century Britain. It had cost £24,500 to erect the main building. The treasures exhibited were mostly from private collections—'all that in England

comes under the name of articles of *vertu'*: sculpture, pictures, engravings, works in ivory, enamel, jewelry, majolica, Manchester had been selected not just because it was wealthy and prosperous, the boom town of Victorian England, but 'for the effect on Manchester itself', i.e. on its future manufactures. The Pre-Raphaelites were represented by such favourites as 'Convent Thoughts', 'April Love', 'The Death of Chatterton', 'Autumn Leaves', 'The Awakened Conscience' and 'The Hireling Shepherd'. Titians, Van Dycks, Gainsborough's 'Blue Boy' and Turner's 'Wreck of the Minotaur' were also shown. Woolner sent his bust of Tennyson. Calverley lent two pictures: 'Worms' and 'Caterpillars' by Van Kessel.

Nearly a million and a half people visited the Exhibition. The general opinion was that it was too overwhelming, too rich, and that after all Manchester was not the ideal place for such a thing. The Trevelyans came for a long stay, hoping to remain until Ruskin gave his projected lectures. They too found the first impression bewildering, and as Pauline said to Scott, she felt 'a kind of despair' until luckily she met 'dear Dr. Wellesley [Henry Wellesley, Principal of New Inn Hall, Oxford], who had a day's start of us, and was beginning to get settled in his mind again, and he helped me to my senses [he had lent several drawings]'.

Unfortunately all plans were upset by a double bereavement. Only a few days after their arrival news came that Calverley's sister, Emma Wyndham, was dying. He had had to set off south by the next train. It was a dreadful shock, as she was his favourite in the family. The wretched woman had lain for five days with none of her numerous relatives near her, except her youngest daughter, who was 'either too frightened or too unconscious of the danger' to write to anybody.*

* Emma's eldest son, William Trevelyan Wyndham, was an eccentric, almost the family skeleton. He was said to have inherited his red hair from his father and a Jewish look from his mother. Quick-tempered and apt to be excitable, he went as a youth to relatives in Queensland, where his uncouth manners and dislike of personal cleanliness caused some distress—though not as much as his habit of going to live with the aborigines for weeks on end in the bush. He returned to England and his mother, more or less on her deathbed, made him swear to marry the daughter of her best friend. The girl was certainly to be pitied. Eventually she was taken out to Australia, but had to escape home, with her six children, from his drunkenness and cruelty. Two daughters, however, returned to him, and he boarded them out in a brothel. Wyndham lived with a series of aborigine 'wives' and begat several children by them. On market days he would be seen in the local town with his beard tied up with purple ribbon.

One of Emma's daughters, tradition has it, was the first person to die under

Then Pauline heard that old G.B.J., her erratic father, Dr. Jermyn, had died in Sardinia on March 2nd. 'May God bless my children and forgive me my sins' had been his last words. It appears that much of his last years had been spent in 'tilling the soil'. No reason has come to light as to why none of the family had ever visited him. Perhaps it was just a question of expense. Pauline was distressed to hear that he had been refused burial at Maddalena; his body had been taken to the island of Santo Stefano, then carried across the isthmus to the small cemetery at Calo Marina.

The subject of Ruskin's lectures was 'The Political Economy of Art', in due course to be published as *A Joy for Ever*. The second lecture lasted an hour and three quarters. He was received rapturously, though in that year of serious commercial crisis few members of his audience seemed to understand quite what he was getting at. The rich industrialists of Manchester did not get their congratulations either. Ruskin considered the keynote to be his phrase 'soldiers of the ploughshare as well as soldiers of the sword', one that was to be repeated later in the more inflammatory *Unto This Last*. He was concerned largely with education. Everyone should be educated according to the extent of his capabilities. It was the right of each human being to be cared for and educated when a child, and to be recompensed and, if necessary, also cared for, in old age.

On July 15th he reached Wallington. Scott was already there, the Roman Wall painting having been rushed to the house the day before. It was probably on this occasion that Ruskin first met Algernon Swinburne, who was staying with his grandfather at Capheaton. On September 17th he was back again, and on the 18th Calverley recorded that he began to paint in the hall.

And here Scott once more takes up the tale: 'Ruskin, who had not been there since his eventful visit with his wife and Millais, at last accomplished his visit to paint one of the pilasters. Lady Trevelyan had kept for him the great white lily, commonly called the Annunciation Lily, but the modesty of the professor would not allow him to take that sacred flower. No; he would take the humblest—the nettle! Ultimately wheat, barley, and other corn, with the cockle and other wild things of the harvest-field, were selected, and he began, surrounded by admiring ladies.'

The account continues, with the usual number of subtle inaccuracies.

gas in the dentist's chair. It is also said that when Emma died, her husband told the children: 'Now that your mother is dead we can have the terriers in the house.'

'At dinner we heard a good deal about the proficiency of the pupils at the Working Men's College, and next morning he appeared with his hands full of pen-and-ink minute etchings of single ivy leaves the size of nature, one of which he entrusted to each lady as if they had been the most precious things in the world. He took no notice of me, the representative of the Government schools. I could stand by no longer. He had been giving lessons on drawing, had set Miss Mackenzie [Loo] to draw a table, prohibiting her to make a preliminary general sketch, but directing her to begin at one corner and finish as she went on; this being next to impossible, she had applied to me, but I had declined to interfere. Now I could not remain silent, so I gave them a little lecture on the orthodox method of teaching. . . .' Whereupon Ruskin 'grinned in contemptuous silence', and the 'subject was dropped'.[10]

Under the circumstances, it is surprising that Scott did not relate a story handed down in the Trevelyan family. Ruskin believed that he was painting oats and corn-cockles on his pilaster. On being contradicted and told that he was painting cornflowers (which are blue) not corn-cockles (reddish-purple), he lost his temper and refused to continue.

It was to be six years before Ruskin visited Wallington again.

Early in October Scott brought William Rossetti to stay. Again there were happy expeditions to Rothley Lake. Calverley, whom William Rossetti now described as 'an elderly thin man with a very high nose', startled everybody by eating 'funguses which no one else would touch'. William was however persuaded to accept a dish of some of them, 'which I remember with a modified degree of pleasure'.[11]

It had been hoped that Christina Rossetti might have come too. Her biographer from Utah considers that she refused to visit Newcastle because of the 'shattering blow' of her discovery of Scott's 'attraction towards another woman': Pauline. She points out that this is the significance behind Christina's poem *Introspective*, written while Scott was 'basking in the luxury of gracious country living' and being 'petted by pretty women', i.e. Pauline again and 'her young house guest, Miss Capel Lofft' [aged fifty-three and no beauty]. 'The three of them formed an intimate and congenial circle.'[12] Swinburne called at Wallington during this visit by William Rossetti and Scott. Now that he had reached adult years, Pauline was to play an important part in his life.

POETS AND LOVE
FRUSTRATED
1857-58

ALGERNON Swinburne had been coming regularly to Northumberland since at least 1853, the year in which he had been removed from Eton. It had been decided then by his parents that the vicar of Cambo, John Wilkinson, should start preparing him for Oxford.

Swinburne as a youth was small, pale-skinned, seemingly fragile, with a large head and a mass of tousled red hair. We are told that he ran wild over the moors on his long-tailed pony. He grew to love the vast Northumbrian scenery, the great rolling cloudscapes, the copses, the heather, the streams, the knowledge that the sea lay just beyond the hills. He also loved the sea-coast, especially in rough weather. And he had fallen under the spell of his gallant old grandfather. Scott recalls seeing the 'little fellow' (he grew to no more than five foot four) hurrying along the road on his pony. 'He had the appearance of a boy, but for a certain mature expression on his handsome high-bred face . . . on his saddle was strapped a bundle of books like those of a schoolboy.'[1] Then one day Scott saw the mystery figure kissing his hand to Pauline at the front door of Wallington, and was told who he was.

Presumably this happened during the autumn of 1855, Scott having first visited Wallington that summer. In January 1856 Swinburne went up to Balliol. It is sad that the Trevelyan archives do not provide details of those early meetings with Pauline, for traditionally she is regarded as the first person to have recognized his genius and actually to have encouraged him to write verses. Swinburne and she used to sit under one of Sir Walter Blackett's remaining hawthorns, or in the big drawing-room, while he declaimed, back rigid and hands fluttering. She was ready to listen to his ambitions and ideas, and read the books he was enthusiastic about. As he was also to find later, she was difficult to shock and in that way even more untypical of the average Victorian of her class. Like Swinburne she was a republican, albeit a 'mild one'.

Then of course she was probably responsible for making him aware of Pre-Raphaelitism; or as one of his biographers, Lafourcade, put it, Swinburne at Wallington 'breathed the air faintly laden with Pre-Raphaelite incense'.[2] Swinburne himself was to say that 'there never was a shadow between us'—as with Scott, Pauline was his 'good angel'.[3]

One would have loved to find some comment by Calverley on this passionate, voluble youth with the flaming hair. Their relationship had its crises, but even so Calverley would never have dreamt of stopping Pauline from seeing him. For one thing the Trevelyans and the Swinburnes were too close to one another; Calverley had been at school with Swinburne's father.[4] Looking back years later, Swinburne himself wrote of Calverley with obvious affection as an 'admirably good and really able man of learning and unvaried eccentricity', with 'valuable collections of literary and other curiosities'.[5] One of their great bonds was, quite simply, their love for Northumberland. Then Calverley was among the greatest experts on the Border ballads, which fired Swinburne so much and which he began to rewrite in 1858. Indeed Calverley was the first to introduce him to a particularly gruesome specimen, *The Fair Maid of Wallington*.

In one of Swinburne's own ballads, *A Jacobite's Exile*, he referred to the little river he loved, more or less dividing the Wallington and Capheaton estates and over which he would ride to and from Cambo:

> 'The Wansbeck sings with all her springs,
> The bents and braes give ear:
> But the wood that rings with the song she sings,
> I may not see or hear:
> For far and far thae blythe burns are,
> And strange is a' thing near.'

Scott, in the unfortunate *Autobiographical Notes*, wrote how Swinburne delighted in the French language, his 'only success at school or college', and was childishly proud of a prize for French that he had won. The next paragraph in his book must be quoted, since it was the one which apparently aroused the most ire in Swinburne: 'A few days after my first meeting him he appeared with the prize-book, entering the saloon where we were all at work hopping on one foot, his favourite expression of extreme delight. It was a large edition of *Notre Dame de Paris* gorgeously bound, with illustrations by Tony Johannot; but the exuberance of his delight was so comical that even Lady Trevelyan could not resist a smile, and Miss Capel Lofft, a very nervous person, begged him to sit down quietly and show her the prints. For my part,

not yet recognizing in this unique youth the greatest rhythmical genius of English poetry, I looked on with wonder as at a spoilt child. The whole forenoon that book was never out of his sight. If it lay on the table his eyes were always wandering to it. The fascination of first love was nothing to this fascination; and when we all adjourned for an interval to the garden, there it was tightly held under his arm, while he ran on before backwards and ran back to us again, and the sharpest of eyes were fixed on him with their amused but maternal expression.'[6]

When Scott died, Swinburne wrote an affectionate ode in his memory. But when *Autobiographical Notes* appeared, Swinburne called him a 'lying, backbiting, drivelling, imbecile, doting, malignant, mangy old son of a bitch'. He also said this: 'Here . . . is a man whose name would never have been heard . . . but for his casual and parasitical association with the Trevelyans, the Rossettis and myself.'[7]

As the winter approached, and Pauline's health was not improving, it was felt that sea air would help. A letter from Acland contains the sinister words: 'I am sorry to hear that you think the tumour enlarged.' She must have decided that she could not bear to undergo the ordeals of 1850–1 again. And Calverley, having achieved satisfactory prizes for his shorthorn herd in Northumberland, was also now anxious to turn his attention to his Somerset estates. First, however, the Trevelyans joined Ruskin for a week in Oxford, in order to support Acland in his candidature for the Clinical Professorship.

Acland had recently been appointed Regius Professor of Medicine, and was also Reader in Anatomy. It was thus felt by some in Oxford that a double professorship would constitute a dangerous monopoly. The result, however, was a victory, and Pauline described the scene to Scott on November 12th, after reaching Seaton: 'The end was very picturesque. In University elections, before the numbers are declared all the voting papers are burnt. It was dark when this election ended, and there was only one lamp where the Vice Chancellor etc. sat, counting the votes. Then a great tripod was brought in to the Convocation house—and the mass of papers were thrown into it and blazed up. The dark old building and crowd of eager faces, anxiously watching . . . were really very pretty in the blazing flickering light.'

As things turned out in the future, few could have complained about the result, for Acland immediately plunged into important reform work. Among other things he remodelled the method of medical examination. He was also the great influence behind the Health and Sanitation Act of 1858.

The Museum had of course been inspected by the Trevelyans. Calverley had caused some consternation by announcing that he now considered carved capitals to be a mistake and distracting to students. Pauline's main interest, however, had been in that extraordinary, doomed enterprise, the decoration of the Union debating room by Rossetti and his band of enthusiasts, including Munro, Hughes, Morris and Burne Jones. Scott had been invited to help, but had shied away; and just as well, for he would have been as out of place as Calverley amid all that jollity, noise, cork-popping, paint-sloshing, and general larking about. The venture was important, as marking Pre-Raphaelitism's second birth, a new type of revolt against comfortable Victorianism. It was a tragedy that the frescoes were to fade so soon. Pauline's comments on what might have been a kind of masterpiece have therefore all the more interest.

She went to the Union every day. In that same letter to Scott she described the 'adored' Gabriel's 'glorious piece of colour,' like 'flowers or fruit with the fresh bloom on them'. As for the little angels' heads surrounding his Guinevere, 'I don't think anyone invented more divine ones.' She was not so keen on Morris's dark colours and northern grotesques of twining serpents. His 'fair Yseult' was 'so hideous that even the P.R.B.s themselves can't stand her'. She loved Burne Jones's enchantress with a lute enticing Merlin into a wood, and Hughes's Sir Bedivere throwing Excalibur into the moonlit lake. To her the quiet of the moonlight seemed 'reposeful' after all those blue skies, red-haired ladies and sunflowers.

Alas, there were to be misunderstandings with the University about payment, and after a while Rossetti lost interest. The portrait of Guinevere was intended to be of the absent Lizzie Siddal, becoming ever more petulant and jealous of Rossetti's infidelities, but her place was taken by a sultry new 'stunner', Jane Burden. Even William Rossetti was not allowed to see his brother's work because it was 'in a muddle'. Algernon Swinburne, however, went there. It was his first meeting with Rossetti, 'Topsy' Morris and 'Ned' Burne Jones, and the result was explosive.

'Now we are four not three,' Burne Jones had said, and Swinburne had become the group's 'dear little Carrots'. All the lush imagery, the semi-mystic sexuality, the symbolism, not to mention the rowdiness and general high spirits of these new-style Pre-Raphaelites, appealed to the newcomer at once. Morris read him some of his poetry, which had an immediate effect on him.

Ruskin had been baffled by the antics at the Union. 'The fact is that

they are all the least bit crazy,' he had said. He is supposed to have sought out Swinburne during the time of Acland's election, and perhaps went to call on him with Pauline. Her enthusiasm for her protégé also inspired Acland to try to see more of this extravagant young man with the amazing conversational powers. The result was disastrous. Acland simply annoyed Swinburne by 'goatishly' trying to share in the 'orgies and dare-devilries' of the group. When he gave a party, Swinburne and the others fled to London for the night in order to escape it. Burne Jones complained that Acland's pulse was 'only really quickened when osteologists were by, who compared their bones with his till the conversation rattled'; and Gosse has recorded that 'on one occasion, when Dr. Acland was so kind as to read aloud a paper on sewage, there was a scene over which the Muse of History must draw a veil'.[8] So much for the hero of the Oxford cholera epidemic.

As soon as Pauline reached Seaton she set about helping her lace-makers, for Woodward was too preoccupied to start on his plans for the Gothicization of the village. She was determined to get her friends to put in orders for the lace and had a plan for setting up a kind of agency in Northumberland. As she wrote to Loo: 'I have been so busy. . . . I am very fond of the poor people here. Their poverty strikes me painfully after the north, though they are rather better off than usual, mackerel having been abundant. In a regular sea-going population like this, where the men are rather daring, there are so many widows and such touching stories. The spirit of the Drakes and Raleighs still leaves some vestiges on this coast.'

In December the Trevelyans were back in London. There was some anxiety about selling diamonds belonging to Loo, who was also complaining about the 'monotony' of her life—Pauline was getting worried about her. Naturally they went to see Ruskin, 'up to his ears in Turners'—'I never saw such a wonderful sight in my life.' They also had another glimpse of Holman Hunt's still unfinished 'Christ in the Temple'—'highly illustrative of scripture history', wrote Calverley approvingly; 'wonderful', said Pauline. They saw Woolner's sketch for the Wallington group (having heard in advance that Rossetti liked it).

The subject chosen for the group was of course very serious: a mother teaching a child to say the Lord's Prayer. Beneath it there would be a pedestal, around which would be carved vignettes of scenes of violence: a savage mother feeding her child with flesh at the point of a sword; Druids offering their enemies in wicker cages to the gods; a warrior cutting down enemies with the scythed wheels of his

chariot; another savage mother praying that her child should become ferocious and destroy all its foes. The title of the whole composition would be 'Civilization': the vignettes and Scott's paintings were simply leading to this one simple scene of reverence and mother-love.

However Calverley's main distraction at this time was the writing of a thousand word open letter headed 'Indian Mutiny and Massacre', which he had printed and circulated among as many friends and influential people as possible. He had been horrified by the country's howl for revenge after Cawnpore and the resulting atrocities. England, he said, had forgotten that it was supposed to be a Christian country. (So Woolner's choice of subjects for his group had been all the more appropriate.) It was true that Nana Sahib had committed a loathsome crime, but there was no need for indiscriminate murder in return. Calverley wrote this in spite of the fact that his own niece, one of Emma's daughters, and her husband had died at Cawnpore.

Apart from a short visit to Edinburgh in June the Trevelyans were to remain at Wallington from mid-January until late September 1858. Now there was a shock. Loo became engaged; and not only this, the news reached Pauline in a roundabout way, through an acquaintance. Pauline wrote somewhat stiffly to Loo on February 3rd: 'My darling, pray read the enclosed and put me in a position to answer the questions, "*how* did they first meet?" and "when is the marriage to be?" I always thought you and L. [Louisa] Yea mere kindred spirits, but Caly and I both think it rather hard that you should have taken her so deeply into your confidence, before us. Your conduct requires explanation. I pause for a reply.'

The fiancé was the extremely rich William Baring, second Lord Ashburton, whose first wife, Harriet—the friend of Carlyle and object of Mrs. Carlyle's jealousy—had died in May 1857. He was aged fifty-nine, Loo being nearly thirty-two, an even greater distance in age than there was between Calverley and Pauline. A shy man, he 'lacked boldness', which meant—it was said—that his abilities were insufficiently appreciated. Now Loo would be the châtelaine of the Grange, the Palladian mansion near Alresford, and Bath House in Piccadilly. Her days of so-called poverty were over. No wonder Pauline added: 'Don't fidget so about paying me [to do with selling the diamonds]. It looks as if you wanted to cut and have done with me.'

Loo, needless to say, was to find some prejudice against her from friends and relations of the Barings. Carlyle described her as a 'bright vivacious damsel, struggling fitfully about, like a sweet-briar, and with hooks under her flowers, too, I understand: for they say she is much of

a coquette, and fond of doing a stroke of "artful dodgery".[9] Lord Stanley told his wife that Loo was 'full of bad taste, ostentatious and courting publicity'.[10] He also revealed that she had 'thrown over' Landseer in order to marry Ashburton.

Pauline soon forgave Loo, who—rather oddly—invited her to come on the honeymoon trip to Egypt.

Otherwise the time passed quietly enough at Wallington. In April Hugh Jermyn, now an Archdeacon, had arrived from St. Kitts, wretched in health and hard up. His wife was left in the West Indies, and he and the children spent most of the summer in Northumberland. When the Rector of Nettlecombe died (as it happened another of Calverley's brothers-in-law), it seemed an ideal solution that Hugh should take his place. So his wife was sent for, and he remained at Nettlecombe until 1870.

Whilst at Wallington Hugh saw much of someone who was to have a considerable effect on his life. This was Alexander Forbes, the Bishop of Brechin and son of Lord Medwyn, with whom Pauline kept up a close correspondence on religious matters. They had known each other years ago when Hugh was at Forres. Their friendship now increased, during what was a very trying period of doctrinal troubles for Forbes, and when Forbes died in 1875 Hugh was 'unanimously chosen by the clergy and laity' to succeed him. In 1886 Hugh was elected Primus of the Church of Scotland.

From time to time there was the customary letter of news from Woolner. Millais had 'sneaked' into a dreadful mess with Agnew, 'a keeper of a print and curiosity shop'. A small matter of £500 was involved, Agnew having paid this sum for a picture which eventually was returned to Millais for touching up. So Millais had painted a copy which he had sold to Gambart the picture dealer. Just another proof of this once great artist's extreme avarice, Woolner said. All good meaty stuff, such as Pauline enjoyed.

Calverley, for his part, was taken up with plans for the new single-track railway to Scots Gap (a name redolent of Border raids). It was to be known as the Wansbeck Railway, and he was contemplating investing £10,000 in it.

Arthur Hughes, whom Pauline called 'Cherry', arrived and painted dog-roses on a pilaster. Then on June 1st Mrs. Scott and Christina Rossetti came for the night. And so we return to the hypothesis of the Utah professor, Mrs. Packer. Although nothing can be proved about Christina's love-life in the mid and later fifties, it is of course conceivable that Christina had been jealous of Pauline, whom she

had never met. Mrs. Packer produces evidence of Christina's love for Scott in the poem *Love from the North*, originally called *In the Days of the Sea-Kings* and written in December 1856. Here the lover's eyes are of a 'dangerous grey', and it is true that Scott did have peculiar light grey eyes. When Mrs. Packer says that Pauline was in the habit of calling Scott a 'sea-king', she is on more unsafe ground. The only occasion when Pauline can be traced as saying this was in October 1860, and it was meant to be in mockery: 'You are a sort of fat peaceable sea-king.'[11]

In *Look on this Picture* Mrs. Packer sees Pauline in the role of the wicked temptress. She also finds significance in another poem, *Triad*, about three women in love with one man, all different but none of them adequate: the lush mistress, apparently Pauline (a 'fattened bee'), the dim wife (a 'tinted hyacinth') and the love-sick virgin.[12] Mrs. Packer evidently did not know about Christina's visit to Wallington during this time of 'ordeal'. No doubt Christina said all sorts of typically caustic things about Pauline afterwards, but the encounter must have dispelled whatever jealous doubts there may have been, for thereafter they were quite friendly; such prosaic topics as lace, help for penitentiaries, and a translation of the psalms drew them together.

There were walks in the garden and park. Then Scott came out in the mail-cart to take the two women back to Newcastle, described by Mrs. Packer as a 'quaint and staid old Northumberland town'. Picnics followed, not always in good weather. In the train back Christina wrote *Good-bye*: 'Parting after parting/All one's life long:/It's a bitter pang, parting/While love and life are strong.'

A little while later Christina wrote one of her shaft-like letters (undated) partly to thank Pauline for two lace collars. Every word in the letter was as polished as in one of her poems. There was a dig at poor Arthur Hughes (whom she later came to respect): 'It must be a privilege to know the artist of "Nativity", yet I fancy that when one has gone a certain depth, one will fail to find a deeper still, intellectually of course.' And then: 'Anna Mary Howitt [author of *An Art Student in Munich* and painter of "Faust's Margaret"] called the other day: good-naturedly toiling under fruit and flowers for our benefit, in addition to her palette. She looked fagged and in want of freshening up, a process now I hope going on in Jersey whither she has adjourned for two or three months. Not a word did I hear of spirits or mediums [Miss Howitt being an enthusiast for table-rapping, which was also interesting Gabriel Rossetti]. . . . Hope Peter is well and waggish, pray believe me, Very truly yours.'

During Hughes's visit mention had been made by Pauline of her

longing for a picture by Rossetti. Thus on August 15th he wrote to say that he had heard accidentally from Rossetti himself that he was engaged on a water-colour of the Virgin in the house of St. John, and suggested she should try to obtain it. However a version of this very subject had been commissioned two years previously by Ellen Heaton, a rich, brash but well-meaning spinster from Leeds; Ruskin, who advised her on buying pictures, had said that it was 'one of his [Rossetti's] finest thoughts'. Some delicate bargaining therefore followed. Presumably Pauline agreed to pay a larger sum than Miss Heaton, who was persuaded to accept a replica. The whole business sounds suspiciously like Millais' manoeuvres with Agnew, taking into account the fact that Pauline was not even happy about there being a replica at all.

The fee was a hundred guineas. For Rossetti the commission had come at a very convenient time, for he was desperately short of 'tin'. The Oxford frescoes had had to be abandoned, and Ruskin's American friend, Charles Eliot Norton, had been made to pay in advance on an unfinished picture. Pauline had invited him to stay in September, when Munro was expected, but he refused. With the cash shortage he had to work, and the unfinished Oxford work was nagging at him.

On August 17th Swinburne came to stay for a few days. There was a large house party in progress, of all ages and mostly family, including Laura and a Northumbrian neighbour, Annie Ogle, who had written a novel much admired by the Brownings. Wooster had had to rush down to London, because of Mrs. Loudon's sudden death, and had brought back the daughter Agnes, all in a state because a Mr. Spofforth had actually dared to propose to her *within a month of her mother's death*. Worse, she had found herself accepting. But then she would have otherwise been left with an income of only £100 a year. . . . She arrived just before Swinburne came for a second visit. Pauline seems to have been in a wheel-chair for a certain amount of the time.

Swinburne, with his father, had been to dine at Wallington two days before. No doubt it was decided then that he would sleep at Wallington whilst the rest of the family was at Capheaton—he must have ridden backwards and forwards a great deal, for a letter dated September 15th to his friend John Nichol is written from Capheaton. He stayed exactly a month. The business of Agnes Loudon's impending marriage hung maddeningly over the first days. She was forever rushing upstairs with Pauline to choose flounces for her crinoline, and there would be sudden glooms. Swinburne however quite impressed her: 'He is clever and writes quaint ballads,' she told her diary. 'And he reads his poems, which are very nice.'

Did he read her *Yseult*? 'She laid out before him there/All her body white and bare,/Overswept with waves of hair.' Presumably not, though maybe Pauline heard it in secret. At any rate, the poems of Victor Hugo, his passion of the moment, must surely have been read out to the assembled guests. Over the past months Swinburne had not seen so much of his Pre-Raphaelite friends, which was probably why he had been able to take his Mods with second-class honours in June, and indeed why he was able to stand semi-teetotal Wallington for so long. At Easter, according to Gosse, he had been taken by his parents to Paris, and 'handsomely agreed not to endanger the Empire by any overt act', in spite of the fact that his 'republican spirit boiled within him'.

Swinburne's early life is full of puzzles and contradictory dates. Was Gosse in fact right about this trip in 1858? In January 1861 Swinburne was to write to Pauline from France: 'I am still in love with Paris—you know I never saw it before.' Still, Gosse does produce some convincing stories in his biography. For instance, there was an incident in the Champs Elysées when Swinburne refused to stand up and take off his hat as the Emperor passed. Certainly in 1858 'the Beauharnais' was his pet hate. Swinburne would practise his 'ingenuity in inventing tirades against him, sometimes full of humour and splendour, at other times grossly absurd', and Pauline, always ready to enter his mood, 'used to assist him'. Indeed she was so amused by his exploits in Paris that, according to Gosse, she painted a water-colour drawing of him, 'stripped to the waist, his red hair flying out like the tail of a comet, with a blunderbuss in either hand, striding across the top of a Parisian barricade'.[13]★

Calverley and Swinburne, it is worth noting, in view of allegations about incompatibility, went for several walks on the moors together. Before going south to London, Swinburne went to Newcastle and called on Scott, who was again charmed. Scott wrote three undated letters to Pauline about him—letters, it is true, which could conceivably (as some suggest) have been written the following year after another encounter. On 'Wednesday morning', he wrote: 'Is not young Swinburne a regular trump? Sara Gamp, Pre-Raphaelite hair and also his poetry took me rather by surprise. I rather think he *is* a poet, not merely by instinct of imitation with Morris and others. He read to me

★ Scott's version is slightly different and exactly tallies with a drawing now belonging to John S. Mayfield and reproduced on the front of his *Swinburneiana*. The drawing shows Swinburne addressing the people on his way to the guillotine and is dated 1861 by Scott (who once owned it); in the background there is an equestrian statue of Napoleon III, with 'Je suis le neveu de mon oncle' beneath.

the ballad of a lady turned into a dragon [*The Worm of Spindlestone-
heugh*], and his tragedy [*Rosamond?*] so far as it is gone. His ballad really
is a ballad, not a fantastic mystical modern invention, and his play
characters talk like reasonable or rather unreasonable people.'

On 'Friday morning' we have: 'Algernon's going off so soon is quite
a disappointment, he spoke of being in these quarters until the end of
the month. Must I give him up? Is he gone already? I must have a
red-haired Northumbrian in my picture.' And on 'Sunday evening':
'I enclose a letter from Algernon in the most cramped handwriting.
I have not been able yet to make every word out so hope there is
nothing *improper* in showing it, which I do because of sundry messages
to you. . . .'

And now comes some mischief.

In January 1948 there appeared an article called *Unpublished Swin-
burne* by Randolph Hughes.[14] The sub-heading included the words 'an
unnoticed love-affair' and the article began with an incomplete poem,
originally in T. J. Wise's collection and now in the Brotherton Library
at Leeds University. Hughes recorded that the 'huckster' Wise was
responsible for the poem's heading, *An Epistle in Verse: Addressed to
Lady Trevelyan*, and for the sentence at the end: 'This "Epistle" was
written by Swinburne at Oxford and was addressed to Pauline, Lady
Trevelyan, then touring in Italy'—described by Hughes as 'absolutely
and impudently gratuitous . . . a pure invention of Wise's interloping
fancy'. The poem begins:

'I write these words for you, before the moon
 Sows with waste silver half the saddened sea:
While one weak wind, the prisoner of some tree,
 Flutters its wings and weeps, unhappiest
Of all the late year's plumeless brood that rest
 A summer through, then tremble and awake;
With its keen sobs the grieved grey poplars shake,
 Angering the water-shadows; and a cloud
Across the narrowest rim of hill is bowed
 Like one who listens. Are you sad tonight
With dear Italian distances in sight
 To comfort in despite of rain and foam?'

Apart from the fact that Pauline had never been to Italy since 1842,
surely—one might think—this poem need not necessarily signify a
love-affair? It is certainly true that, as Hughes says, there is 'no scrap of

evidence of any kind that they were addressed to this elderly [?] friend of the poet'.

Lafourcade, in his two-volume work on Swinburne, quoted Louis Gillet in the *Révue des Deux Mondes* as saying that Pauline represented 'la seule intrigue de la vie de Swinburne'.[15] He regarded this statement as 'risible', and so it is. Hughes saw a resemblance in style to Swinburne's prize poem *The Death of Sir John Franklin* (1860) and also regarded it as a sequel to another poem, *By the Sea-Side*, which definitely is a love-poem: 'And so tonight I have you, and tomorrow/Long miles will sweep between us. . . . Will you remember when the days are fair/In the far southern lands. . . . Tomorrow! Well you go then, it is said./New faces there will smile.' This last poem is pin-pointed by Randolph Hughes as having been written in February 1860, but the person to whom it was addressed has not so far been identified. Perhaps both poems were to Mary Gordon, the cousin whose cipher letters on flagellation have become well known through J. O. Fuller's biography.

Pauline did represent a kind of ideal woman for Swinburne, and it is of course conceivable that he may even have imagined himself to be in love with her for a brief moment. A theory, however, that she was really the Yseult of the poem of that name, and that Wallington was King Mark's Castle, is certainly carrying things to risible extremes — especially as Yseult is made to pick up Tristan in her arms and carry him to her bedchamber. Granted that 'such great love had made her strong'; but the vision of five foot Pauline, just out of her wheel-chair, carrying Algernon is pretty comic.

And there is yet another theory about Pauline, somewhat more harmless: that she was in part the original of the Lady Midhurst who appears in Swinburne's novels *A Year's Letters* (otherwise known as *Love's Cross-Currents*) and *Lesbia Brandon*. It has also been said that Calverley was caricatured as Ernest Radworth in the first novel. Since both books — we know this time for certain — were begun later, they will be considered in their proper context.

On September 27th Ruskin wrote, after long silence. He had finished his work on the Turners in the Spring, and in May had temporarily given up the Working Men's College. He had then gone to Switzerland and on to Turin, where he had stayed some seven weeks, admiring Veronese and going through a process of 'unconversion', as he was to call it: a reaction against his Puritan upbringing and even against mountains and detailed painting.[16] 'I think for once in my life I am a little penitent. I am not quite sure about it — for I believe penitence makes people uncomfortable, and I feel quite comfortable. I've been

enjoying my journey very nicely. I got out of everybody's way and answered no letters. I had great satisfaction in looking at the great heap of letters in my box—and thinking how much tiresome work I hadn't done. . . . No. I'm not coming north—nor going anywhere— and I don't feel much inclined to *do* anything. . . .'

He must have soon gone to see Rossetti, who wrote to Pauline in an undated letter: 'Ruskin saw your drawing here on Saturday, and he is pleased with it I think, as far as it is gone.' When Pauline came to London, she took Loo to Rossetti's studio. It was a great moment. The sense of excitement is now obvious, but one realizes that something was not quite right. Rossetti was to do some more work on it. Perhaps the criticisms came from Calverley, who said of the visit: 'There is much feeling in some of his work, but great P.R. extravagance in many.'

Certainly there was no extravagance about this picture. The model for the Virgin was Ruth Herbert, Rossetti's new discovery. It was a twilight scene, the dark blue hills seen through the window. The Virgin had risen from her spinning-wheel to light the oil lamp, symbolically placed in the window frame in the form of a cross—the lamp being depicted where Christ's head would have been. St. John is said to have been modelled on H. W. Fisher, the father of H. A. L. Fisher the historian.*

It is surprising to discover that Pauline left London just before Loo's wedding. She had decided that her health would not stand going to Egypt. Her verdict on Lord Ashburton was muted: 'thoroughly kind, good and high-minded, a true gentleman in all his ways', but 'not at all clever or strong in character'. It was clear who was going to wear the trousers.

Pauline wrote enthusiastically to Scott from Seaton about Rossetti's picture, 'as grand and deep in feeling as anything he has done'. She could not help feeling glad that it was not another 'Blue Closets' or 'Tunes of the Seven Towers', 'which have no meaning except a vague medievalism, very chivalrous and fine once in a way, but not what one wants to see him spending years of his life on'. This picture was something in the old, true Pre-Raphaelite spirit. The only snag was that Calverley was refusing the final payment until the picture was completed.

* The picture is now at the Wilmington Society of Fine Arts, Delaware, U.S.A.

THE LIONS AND THE
LIONIZED

1858–60

'MILLAIS' wife is going to oblige him shortly with another baby, which doubtless will please his paternal soul, for he thinks there never were such babies as his babies.'

Woolner was writing one of his chatty letters to William Bell Scott. He continued: 'Lear called on me today [November 18th 1858], for he starts on Saturday for Rome, not daring to risk an English winter, being troubled with asthma. Of self nothing particular, working steadily at Trevelyan group, but being so large a work of course at present cannot make much show. One of my chief difficulties is the obtaining of suitable models, for really those one can get are so ugly that all ideas of beauty are driven away at a single glance of the de-nuded horrors: I wish art was in such a high spiritual state that lovely ladies could sit for their figures without entailing scandal upon them-selves. . . . "They waste their sweetness on blank chemises". You see I grow poetical.'

Not that Calverley would have contemplated a denuded lady in the central hall at Wallington. The letter also praised the Rajah of Sarawak, Sir James Brooke, 'a born king'. The 650 copies of Carlyle's first edition of *Frederick*, vols I and II, had sold out, Woolner said. The second edition would number 950 copies.

Pauline down at Seaton, had read *Frederick* too, and being herself a hero-worshipper, had loved it. '*Majesty stripped of its externals*: yet not a *jest*,' Christina Rossetti had described it. The Rajah was also one of Pauline's heroes just now. She considered him both victimized and maligned over the question of Borneo pirates, and indeed had sub-scribed towards his expenses on a lecture tour round the major British cities. Her vehemence in his defence rather alarmed Scott. Was it the sea air, or too much sewing that made her thus, he asked? Certainly her 'lace people' were worrying her; for she had told him that the moment she had arrived at Seaton they had rushed down to see her, pathetically begging her to buy their work or find orders. In spite of being mostly

in her wheel-chair, she had thus been kept very occupied, another task having been the laying of the foundation stone for Calverley's new school. A further cause for her belligerence might have been that at last, after all those years, she was having to return to Nettlecombe, for her brother Hugh's induction as Rector.

Archdeacon Hugh, now sporting a beard right down to his chest, did not have an easy time with Pauline's sisters-in-law. He immediately had a row with Maria Ellison, widow of the ex-Rector, who seemed to have taken after her mother in character. She refused to pay one penny of the £700 needed for repairs to the Parsonage, all of which was morally and legally her responsibility. It took at least a year for Julia to 'accept' him. By the time he left Nettlecombe, however, Julia's veneration for him had become quite a matter of amusement in Somerset. Everyone knew that she had remembered Hugh in her will, so that he would be able to pay off a loan from Calverley. When she died, it was discovered that the legacy consisted merely of her 'wearing apparel'. So there was more joking in the county.

The Nettlecombe parish contained a population of 350 and was thus hardly a lucrative post. Thanks to Pauline's help Hugh became editor of *Weldon's Register*, which had its main office in London. She wrote book reviews for him and persuaded friends to write articles without remuneration. It was an ill-fated venture though, since he had to employ a manager who was 'too occupied with fads of his own', and as Hugh's son wrote later, the head clerk 'turned out to be an unmitigated rascal, who not only appropriated valuable books that were sent for review but opened letters and stole cheques by the score'. The result was a financial loss, which rebounded on Pauline. At the time it seemed as though Hugh would have as little luck in life as his feckless father.

It was not until December 28th that Calverley could be made to agree that Rossetti's picture was 'much improved'. The remaining money was therefore paid. That same evening the Trevelyans dined at Denmark Hill where Ruskin was 'trying to get at the mind of Titian; not a light winter's task'.[1] They were staying at 3 Porchester Terrace in Bayswater, an elegant little building still of particular interest, having been built by J. C. Loudon in 1824 as the fore-runner of so many thousands of semi-detached villas that spread over the suburbs of Victorian England. It was here that Calverley wrote on New Year's Day: 'Expected Algernon Swinburne to dine, but he came not.'

On January 11th Calverley had a letter from Charles, with a great piece of news. He was to be Governor of Madras.

The post could not have delighted Charles more. All during his years at the Treasury he had never ceased to be interested in Indian affairs, and his advice had been especially valuable in the Charter Act of 1853. Of course there had been a few qualms about acceptance, but from a strictly personal point of view only. . . . The letter was typical of the man: 'I have been offered the Government of Madras, and have accepted it because those whose opinion I was bound to respect in such a case told me that it was my duty to do so. The domestic sacrifice is tremendous. From the moment I began to think of accepting it, I determined that Hannah should remain to keep on our happy home for George [Otto] and Alice [their unmarried daughter]. I shall aim at a full and painstaking performance of all the duties of government rather than entering upon an avowed course of reform. Perhaps you and Pauline will pay me a visit there. . . .'

As Charles had determined views about breaking down social barriers between British and Indians, it was hardly likely that he would avoid 'reform'. He did not mention the effect of his decision on his brother-in-law, Macaulay, who in his bad state of health was far from delighted at the prospect of losing Hannah. Charles, Macaulay said, was as elated and unfit to be reasoned with as if he had drunk three bottles of champagne.[2] For it was a fact that champagne was his one great weakness, and within a fortnight one finds that he was already making inquiries about its availability in Madras. As for Calverley, he was exceedingly proud of Charles and kept all the newspaper cuttings. A *Times* leader congratulated the Tories, and Disraeli in particular, on the appointment of such a man when he was known to have been a steady Liberal in politics. Generally posts like these were the 'prerequisites of the peerage'; not only was it a 'graceful act of homage to the spirit of administrative reform', but an 'encouragement to the class from which Sir Charles was drawn'. *The Times* also saw the appointment as a sign that the Government was determined to do its best for India irrespective of politics.

In the event Hannah stayed behind for a few months. 'Another sharp winter will probably finish me,' her brother said gloomily. And he died as the year ended, on December 28th 1859.

During a subsequent stay at Oxford the Trevelyans managed to see a certain amount of Swinburne. To quote Gosse once more, his conduct was now generally considered by the authorities to be 'turbulent and unseemly', even dangerous. Calverley in his diary says that Swinburne took them to the Union. This of course may simply have been to see

the frescoes, now so sadly abandoned by his friends; but it could well have been the occasion when Lord Sheffield heard him 'reading excitedly but ineffectively a long tirade against Napoleon, and in favour of Mazzini'. Later the Trevelyans went to Swinburne's room. 'Has curious old plays etc.,' noted Calverley, for Swinburne was engaged yet again in rewriting his play *Rosamond*, about Henry II's mistress, and researching for another, *The Queen Mother*, about Catherine de Medici.

By Easter the Trevelyans were home, Pauline triumphantly bringing her Rossetti. Meanwhile an event had occurred which to Scott was 'as important in my life as Wallington, infinitely more so'. On March 18th 1859, as he was painting 'Bernard Gilpin' for the hall, he had a visitor, a Miss Alice Boyd of the recently restored Penkill Castle in Ayrshire, 'a lady some few years over thirty, ill and weary from watching by the death-bed of her mother'.[3] She told him that she was searching for a new interest in life and hoped to find it in art. Immediately Scott decided that she had the most beguiling face and voice he had ever heard or seen. And so 'from day to day the interest on either side increased'.

Pauline was informed of this encounter on May 31st: 'I have got acquainted with such a delightful new friend! Miss Boyd an Ayrshire lady who came to me about learning to paint, and whom I have in a friendly way been doing my best to make an artist. She can scarcely walk about, so weakly, but full of spirits, and enthusiastic about the new pleasure she has discovered in painting. Such an amiable good soul she is, and such a sweet candid expression she has!'

It is hard to keep silent when one has fallen in love. Mrs. Packer at once divines that Alice Boyd was destined to be 'a more formidable rival than Lady Trevelyan had ever been'.[4] And certainly there is no doubt that, despite discreet references in contemporary accounts to a 'platonic' relationship, Miss Boyd became Scott's mistress. Mrs. Packer sees it all in terms of a development from Christina Rossetti's so-called final renunciation of Scott; it was a 'hasty substitution of another woman' by a 'vain man who has been rejected'. Nevertheless Christina was quite prepared to come up to Newcastle in October (of which Mrs. Packer seems again unaware).

What about the unshockable Pauline's reactions? A faint feeling of disapproval and concern for Mrs. Scott exudes from the correspondence. At any rate she did agree that Miss Boyd's cousin William Losh, should come to stay; and, whether she liked it or not, Miss Boyd became one of the chief models in 'Grace Darling' and possibly two other pictures. As for Mrs. Scott, she had no option but to accept the situation, and after a while a ménage à trois began at the charming

and cosy little Penkill Castle. When this fact was established, Pauline was prepared to end her letters sending regards to both women.

On July 28th Swinburne came for a night or so. On August 10th he was back, and on the next day was carried off by Calverley to inspect the caterpillars of the turnip fly. The Ashburtons and the Aclands were staying too, the latter no doubt not so welcome to Swinburne, who complained that he caught a cold from reading French novels on wet grass—escaping from the house therefore? The young George Otto Trevelyan, fifteen months his junior and up at Trinity Cambridge, arrived: not a very successful encounter either, for—as George Otto was to tell Edmund Gosse—'we were not to each other's purpose', though there was no special 'liking or disliking between us'.

Indeed the two young men were almost absurdly different in character, without a taste or pursuit in common, in spite of the fact that George Otto had won the English Prize Poem at Harrow three years running. But as George Otto said, Pauline was 'catholic enough' to be in sympathy with both of them. George Otto read Thackeray, *Tristram Shandy*, the novels of Albert Smith and Theodore Hook, 'to all of which the poet was indifferent'. Swinburne was devoted to Aeschylus and Catullus, George Otto to Aristophanes and Juvenal. 'No author existed for me,' said George Otto, 'who was not a favourite of Macaulay, and though that gave me a large field of choice, it must be allowed that Macaulay's reading did not lie among the same lines as that of Gabriel Rossetti's circle. Moreover, I was always eager to be after the blackcock and partridges, although I shot much less well than Algernon Swinburne wrote poetry.'[5]

Four years later Swinburne told Monckton Milnes how in 1859 Pauline had 'a dark project of passing me off upon Madame Sand as the typical *miss anglaise emancipée* and holding the most ultra views'. Evidently she did a drawing of him, and 'we made no end of a history of it'.[6] One cannot imagine George Otto joining in this kind of fun.

An invitation from Scott to stay in Newcastle meant a chance for Swinburne to get away. 'There seem only two people in the world to him,' Scott reported to Pauline, 'Topsy [Morris] and Rossetti, and only those books or things they admire or appropriate will be entertained.' A very real friendship grew up between the two disparate men, and Swinburne used often thereafter to come to stay with the Scotts. In *Autobiographical Notes* Scott described how Swinburne would lie in front of the fire 'with a mass of books surrounding him like the ruins of a fortification, all of which he had read, and could quote or criticize correctly and acutely many years after'.[7]

On September 5th both Swinburne and Scott stayed at Wallington for two nights. Afterwards they went on an expedition to the Long-stone lighthouse, to get material for 'Grace Darling', and Pauline's brother Powley Jermyn (now a naval commander) went with them. The sea journey was pretty rough, and Scott as usual was sick, but Swinburne loved the tossing of the waves. As Scott said, the sea was 'as a nursing mother' to him. Soon afterwards Swinburne returned to Oxford, where he got himself into more trouble. Non-attendance at morning chapel was one of his great crimes in the eyes of college authorities. Lord Bryce told Gosse how he and some friends went to console Swinburne after he had been 'gated' by the Dean, only to be greeted with a 'wonderful display of vituperative eloquence'. It was that fine 'sweet-blooded' character Benjamin Jowett, Regius Professor of Greek and a fellow of Balliol, who took him in hand and quietly arranged that he should leave Oxford for a while to study modern history with the vicar of Navestock in Essex.

'Is it not delightful Hunt turning up in this way?' wrote Scott on September 22nd. 'Such capital anecdotes he has.' He proposed bringing him out to Wallington by mail gig.

Holman Hunt was escaping from London as his ex-mistress Annie Miller was trying to blackmail him for breach of promise.[8] He and Pauline got on well. There is a good description of him around this period: 'A very genial, young-looking creature, with a large, square, yellow beard, clear blue laughing eyes, a nose with a merry little upward turn in it, dimples in the cheek, and the whole expression sunny and full of boyish happiness.'[9] A result of the visit was that he promised to do a flower painting on one of the pilasters. The next to come was Madox Brown, possibly not quite such a success as Pauline knew that he disliked Ruskin. For Scott the visit was important, since he wanted Brown to help over an exhibition of the completed Wallington pictures in London. Brown declined to paint a pilaster.

On October 22nd the Trevelyans had to be in Newcastle and brought Christina Rossetti back with them. Then, after the usual procrastina-tions, the 'scamp' Munro—'overflowing with happiness and looking so well'—came on November 7th. And William Rossetti arrived, with Scott, at the end of the month.

Calverley had now taken to reading improving literature to the assembled villagers of Cambo once a week. Guests at the big house were also expected to attend. No doubt these guests also had to listen to Calverley fulminating about his new bugbear: the war in China.

'Glad to find that Lord Grey takes the same view as I do,' he put in his diary, i.e. that British traders had behaved with inexcusable brutality. 'As a profoundly Christian and civilized people we ought to be deeply shamed,' he had written to the Press. 'Our eyes should be opened to the enormities which have been perpetrated . . . a character which we have but too well-earned in the East, of being reckless murderers and plunderers, and faithless in our engagements . . . not to mention the enormous wickedness of the course we pursued in India—which led to the terrible destruction of life and property there.' He was also irritated by all the drum-beating going on about Napoleon in Italy, and the forming of rifle corps throughout the country, in case of a French invasion of England. When, in December, he was summoned to attend a rifle corps meeting at Morpeth, the organizers received a stinging retort. He certainly would not dream of coming, when the Government was putting its existing military forces to criminal ends: the war in China. As for a possible invasion, 'we should look to our costly army and navy for our protection'.

Curiously, Pauline was an ardent supporter of the rifle corps movement, and was not afraid to say so to her husband. But for the moment his mind was focused on problems to do with flint instruments in pre-historic caves.

Pauline and Ruskin must have corresponded about his *Political Economy of Art*, for he told his father that he was pleased with her comments.[10] During February 1859 he had lectured again in Manchester, to be confronted afterwards by Miss Margaret Bell, headmistress of Winnington School in Cheshire, with a bevy of schoolgirls who had immediately captivated him. He had already met and corresponded with Miss Bell, and she now invited him for a weekend at Winnington. It was the beginning of a long, happy association.

Not long before, Ruskin had met the ten year old Anglo-Irish girl, Rose La Touche (whose father as it happened the Trevelyans had met on the train to Limerick in 1849). That he eventually fell in love with her, in spite of a thirty years' difference, and asked her to marry him when she still was not of age, is well enough known. Mrs. La Touche had originally written to ask him to recommend someone to give Rose and her elder sister drawing lessons. Soon the two girls were going regularly to Denmark Hill, not so much for lessons but for games. Unfortunately Mrs. La Touche herself fell in love with Ruskin.

Pauline may have seen Rose, but for a long while there is no mention of her in letters. Van Akin Burd, who edited *The Winnington Letters*,

sees the girls of Winnington as a kind of substitute for Rose when she and Ruskin were separated, and this interpretation would seem correct. When Ruskin left Winnington, that 'nursery for the young females of the governing class',[11] after the first visit, he behaved as though he had fallen in love with all thirty-five 'Birds', as he called them, together.

An odd letter to Pauline would seem to date from just after this visit—odd because it enclosed a letter originally intended for his father but not sent, as it 'would scandalize my mother too much':[12]

'It may amuse you a little—though it will only confirm you in your unfavourable impression of Miss Bell—for the present—but I'll get it out of you—for it is quite wrong. That letter you read of hers only seemed to flatter me so ungracefully because she knows how much at present I need the strongest expression of praise to keep me merely alive. She knows how disgusted I am with my work and myself—and how hopeless and that I have not vitality enough to understand reserve, or care for it,—that I must be fed with fat all sorts of unwholesome meat things—merely to get me to feed at all—for a little while.'

The potentially scandalous part of his father's letter ran: 'What strange creatures girls are—I only wish I could have had Gainsborough to paint one of them on Friday and Sunday afternoons. On Sunday in her plain printed dress—very intent (at least apparently so, and I believe really so) on her chant—looking as saintly as our charity girl of Hunt's [in "The School-girl's Hymn"], and rather short of stature: and altogether inconspicuous—subdued—gentle and childlike. On Friday, this same girl—not quite 16, played me the principal lady character in Molière's "Précieuses Ridicules"—with four or five of the other children for the other parts. It convinced me at once for one thing that the costume of Reynold's time—artificial as it may seem— is beyond all yet invented for giving dignity and brilliancy to women —even the plainest of the girls became striking in it. The rest acted well, but felt that they *were* acting. But *this* one peculiarly simple looking child, *became* actually a quite dazzling "Grande Dame"—her fan—her hoop—her towering hair, all managed as Lady Waterford would have managed them—and her character assumed with absolute mastery—or mistress-hood, ease, and good taste. No French actress could have been more piquante—no French princess more graceful. Miss Bell is a good deal frightened for her, as this peculiar gift of external bearing is a terrible power and temptation if it is not associated with very sterling qualities—and it will be very difficult to give this child due balance within for her without. But Miss Bell has long known practically the truth of my great educational principle—that

whatever a child's gifts may be—you cannot educate by repressing—
but by guiding their exercise—nor can you change them for others.'

He had told Pauline that he felt 'fatally listless' and 'gloomily
depressed'. This state of mind had gone on for a long time. Under the
circumstances, perhaps, it is not all that surprising that he fell under
the spell of the innocence and unaffected high spirits of Rose and the
girls of Winnington School. What was more, there was the delight of
finding out their individual 'gifts' and guiding them to perfection.

After his *Academy Notes* (in which he had praised Millais' 'Vale of
Rest', otherwise almost universally criticized in the Press), Ruskin had
gone abroad with his parents. A letter from Pauline came chasing after
him, a 'funny little note' he called it, for yet again she was at him
about his rudeness in not writing: 'I have long lamented the mistaken
economy of your parents in not paying the extra twopence a week for
"manners" when they sent you to school.' He replied from Hanover,
describing the trip. He found German architecture 'interesting though
barbarous'; Cologne cathedral was an 'absurd failure'; if 'that fellow'
Overbeck were tied to a millwheel on the Rhine and made to go round
on it for a thousand years it wouldn't work 'the least particle of his
conceit out of him'. All in all, as he was to say in his next letter,
Germany had made a 'calamitous impression' on him.

The Trevelyans did not leave Wallington until February, and even
then it was only for a fleeting visit to London, when they dined at
Denmark Hill. Either Pauline or Ruskin must have been in a poor
mood, for some time afterwards he wrote, rather disturbingly, after
a rather schoolmasterish lecture about how to paint light and shade:
'My mother says she thinks you really were a little displeased with
me for not having written to you for so long. . . . After all—one main,
unconscious reason of my not writing is that I do not quite understand
your feelings about many things—and about many very serious things
do not care to tell you always what I am thinking—I am much changed
in many things since you first put up with me—and I am little afraid
—sometimes of not being put up with much longer.'

On January 3rd 1860 Scott told Pauline: 'Who do you think has
just come in? Algernon, on his way home, prepared to read Hugo to
you till you confess him the greatest genius that ever lived, or at least
since Shakespeare.' Swinburne had been corresponding happily with
Scott from his seclusion at Navestock. Three weeks before he had sent
him a long letter, with messages for Pauline: 'I have got the immortal
Whitman's Leaves of Grass, and there are some jolly good things in it

[Scott had been an early admirer of the book]. Do lend yours to Lady Trevelyan. Also entreat her to abstain from Hugo's Ratbert till I come and read it to her.' And, with an allusion to *Martin Chuzzlewit*: 'Give Lady Trevelyan my filial respects and tell her I have been living in a raging vortex of Popery but remain free as a winkle of my country in his shelly lair, or the still mite in his house of cheese.'[13]

Obviously this friendship with Swinburne, and the fact that so many London friends were glad to come north to see him (even if a visit to Wallington was an additional attraction), had done a lot to improve Scott's self-confidence. A more relaxed and jocular tone is evident in his letters to Pauline. It was in this month that he began sketches for the oil portrait of Swinburne that now hangs at Balliol— the clouds and sea behind the figure presumably inspired by the visit to the Longstone in September. Rossetti never liked the picture, 'too hasty' he thought, but its strangeness and freshness do have an impact. Scott himself always thought of it being like Uccello's head of Galeazzo Malatesta in the 'Battle of Sant'Egidio' at the National Gallery.

Swinburne came for a week's stay at Wallington on the 16th. He read Pauline his new scenes from *Rosamond*. Now he was interested in Mary Queen of Scots, and Calverley was able to show him all sorts of books about her 'of the most exciting kind, down to an inventory of her gowns'.[14] This research was eventually to lead to his poem *Chaste-lard*. Soon afterwards he began work on the Sir John Franklin poem. A prize had been offered for the best poem on this very topical theme, and the winner would be invited to read out his own work at the meeting of the British Association, which in 1860 was to be held in Oxford.

The truth about Sir John Franklin's fate had become known in October, when the yacht 'Fox' had returned home from the Arctic with definite proof of his death. The commander of the 'Fox', Captain McClintock, had published his sensational diary two months later.

The 'Fox' had set out from Aberdeen in June 1857, entirely under the auspices of Franklin's widow, who had raised subscriptions from friends—including Calverley (£40), Pauline (£10), Sir Thomas Acland (£100), Murchison (£100), Swinburne's father (£30) and Thackeray (£5). The total subscriptions had come to £2,981-8-9, and the cost of the expedition was £10,412-19-0, the balance being paid by Lady Franklin herself. Captain McClintock's story had created a very great stir. The Trevelyans returned from London in February, in order to attend a lecture in Newcastle by the Arctic explorer, W. Parker Snow, who was going to produce relics of the expedition.

During the lecture Snow said that he believed that some of the crew of the 'Erebus' and 'Terror' might still be alive. Pauline was so taken by the man's personality that she invited him to Wallington. It was then that Snow put forward yet another theory: valuable scientific papers might also be found, if only another expedition were forthcoming. Soon a plan was hatched whereby a new subscription would be got up to enable Snow to conduct this expedition, the ultimate aim of which would be to pierce the North West Passage itself.

The end of the matter was that Pauline made a slight fool of herself. With great ardour she started writing round for subscriptions, her own contribution being £50. Calverley likewise gave £50. No wonder Snow was to write: 'As Lady Franklin was to the previous Expedition, so you, dear Lady Trevelyan, are to this attempted new one.'

It was decided that Snow must read a paper to the Geographical Section of the British Association. Murchison would be approached for support. Calverley would write to professional friends at both Oxford and Cambridge. He would also write to the Prince Consort.

Snow was not without some literary and scientific credentials, and it seems that once he had done work for Macaulay. One important snag was that he was chronically in debt. Over four hundred letters from him to the Trevelyans survive, and those to Pauline are nearly all effusive. The early ones deal with his plans, the hiring of ships, lecture tours to raise cash. Calverley did write to the Prince Consort, and Snow did read his paper at the B.A. Subscriptions were a little slow, but he hoped to leave in late Spring the following year. Then, at the end of 1860, came disaster. His three year court case against the South American Missionary Society for unjust dismissal went against him, leaving him penniless, and Snow had to flee to New York to escape his creditors.

Calverley's nephew Alfred Trevelyan was married on February 15th 1860. His bride, Fanny Monahan, a 'first rate musician', was a Roman Catholic, a fact which did nothing to make Calverley want to change his will, even if she was the daughter of the Lord Chief Justice of Common Pleas in Ireland. All the same, the marriage had some importance, for Alfred was still the only descendant of the fifth baronet likely to produce a Trevelyan heir.

The first child, however, was a girl. She was tactfully christened Pauline. Then came another girl, and another. In all there were six daughters, and no sons. Thus it became likely that for the first time the baronetcy would not follow in the direct line.

On their honeymoon Alfred and Fanny came to look at the progress of 'Grace Darling' at Scott's studio. As it was the penultimate picture in the series, the time had come to decide what precisely the last, 'The Nineteenth Century', should represent. Scott wanted the Armstrong gun and shell, which were in the news, as their inventor, a Northumbrian, William Armstrong, had recently been knighted. Having seen Calverley's letter to the Morpeth rifle corps, he did not dare make the suggestion himself. So the presumably unsuspecting Alfred was deputed to put it across to his uncle. The effect was disastrous from Alfred's point of view. Calverley's rage was such that he and Fanny had to flee from Wallington. Better a gin palace than such a monstrous thing.

It was to Scott's credit that he decided to do battle with Calverley. If he had to illustrate Progress, he said, in other words the manufacturing industries of the Tyne, how could the iron works be ignored, and especially the latest inventions? 'Fortitude, endurance, heroism, self-sacrifice . . . are no doubt parts of War, as well as the destructive passions, and the Armstrong gun and shell are simply engineering inventions.' In order to convince Calverley, Scott arranged for him and Pauline to be conducted round various Tyneside engineering works by his friend James Leathart. This was a subtle move, as Leathart, who owned some important lead works, had already been a guest at Wallington and was an avid buyer of Pre-Raphaelite pictures. Thanks to Scott he had been acquiring some of Rossetti's work; he was also the owner of such famous paintings as the 'Pretty Baa-Lambs', and in due course he bought 'Autumn Leaves' and 'The Hireling Shepherd'. So it was presumably he who finally swayed Calverley. The final picture was not *of* the Armstrong gun, but it did include it. The result was the most important and interesting picture of the whole series, though obviously derived from Madox Brown's style.

A large canvas by Scott, 'Una and the Lion', had been accepted by the Royal Academy in London. It was not, however, well received. The picture of the year was Millais' 'The Black Brunswicker', which was sold to Gambart for 1,000 guineas—a very welcome sum for Millais and Effie, with their growing family. On the other hand, the subject was vapid and execution slick. 'The Black Brunswicker', despite its expertise, is generally regarded as marking the end of the best of Millais' creative career*.

* The Millais marriage continued very successfully. Effie's letters to her husband were full of encouragement, with details of prices of other people's pictures, etc. On July 13th 1859, he wrote to her: 'Take walks and keep yourself fine for I will *gobble* you up when we meet', and on July 16th: 'I think I shall go to bed with

Another picture, not at the Academy, far outstripped even 'The Black Brunswicker' in popularity. This was Holman Hunt's 'Christ in the Temple', which Gambart had bought for no less than 5,500 guineas, the highest sum ever paid for the work of a modern artist. It was put on display at the German Gallery, where up to six hundred people a day visited it. The *Manchester Guardian* hailed the picture as the summit of Pre-Raphaelitism. Holman Hunt's fortune and reputation were now assured.

The other piece of Pre-Raphaelite news, not of general interest but just as sensational for some, was that Rossetti had married Lizzie Siddal. The decision had been taken suddenly, surprising even his own family. It was assumed that the marriage had taken place partly out of guilt on Rossetti's part, partly out of pity for Lizzie's wretched health, which seemed to be made worse through sheer jealousy. But disaster lay ahead. Scotus, wise after the event, said: 'Knowing Gabriel better than his brother did, I knew marriage was not a tie he had become able to bear.'[15]

Loo Ashburton was at Bath House and about to have a child—she had suffered a 'mishap' the previous year. She went with the Trevelyans to see Holman Hunt's picture, and Lord Ashburton took Pauline to see the great Volunteer Review in Hyde Park, a fantastic sight, with the trees full of men and boys, and all the roofs and balconies of the surrounding houses covered with spectators. Whewell came to London with his second wife, a rich widow who had snobbishly decided to retain her previous married name, Lady Affleck. Woolner, still worried about not having found the ideal face for the Wallington group, was working on a bust of Sedgwick. Holman Hunt came to dinner, 'very well and jolly' and diligent about his rifle drill.

For some months Loo had been urging Pauline to meet Mrs. Carlyle. At last Pauline had written from Wallington to say that she would do so, 'since you wish it—though I have a presentiment that I am not at all what she would like'. She added: 'I think I *could* get on with him very well.'

Mrs. Carlyle, by now exceedingly frail, had confessed to friends that she had been 'completely vanquished' after her first meeting with Loo, though she had quite resolved not to like her. She found that she spoke like an 'unaffected Highland girl'. Indeed most of the Ashburtons' set was coming round to the 'new Ladyship'. Henry James was to say

you whatever hour I arrive and not get up for 24 hours, I am so greedy for you.'
Pierpont Morgan Library, M.A. 1485 R-V.

(some years later) that she 'seemed always to fill the foreground with colour'; this 'brilliant and fitful apparition' would greet you with 'a kind of traditional charmed, amused patience'.[16]

The meeting between the Carlyles and the Trevelyans took place at Bath House on June 24th. Calverley was even able to provide a helpful piece of information for inserting in *Frederick*, concerning a Barbara Wyndham who had sent the King £1,000 in 1758 (duly to be documented by Carlyle in vol. VIII). Not that the Sage of Chelsea found Calverley all that stimulating to meet: 'a strangely silent placidly solemn old gentleman', he told his brother Alexander, whom the Trevelyans already knew in Edinburgh. He added, surprisingly, and wrongly, 'in lengthy black wig'. Pauline, on the other hand, was described as 'a kind of wit, not unamiable and with plenty of sense'.[17]

Although Pauline admitted that she had been put off by the effusiveness of Mrs. Carlyle's letters, the two of them became friends immediately.

The British Association now beckoned, and by the 27th the Trevelyans were with the Aclands in Oxford. Snow had meanwhile lectured in Newcastle, and Scott received one of those letters from Pauline to which he dared not reply in like manner: 'Now I do conjure you by all you believe in—by misty philosophy, by gooseberry pie, and tobacco smoke, and anything else equally sacred to you —do go, do make other people go, do puff and ventilate the subject.'

Scott, she said, must tell everybody that we couldn't allow 'any old flag' go first round the world by the Arctic route; 'that odious Stars and Stripes' would be before us 'as sure as fate is fate if we don't mind'. Be that as it may, Scott seems to have managed to escape any embarrassment by retreating to Penkill.

Earlier Acland had invited Calverley to take the Chair of the Natural History Section, but this had been declined, rather to Pauline's disappointment, especially as the meetings were to be held in the Oxford Museum itself. As the date approached, it was realized that the B.A. was going to be something rather special this time, for that explosive volume *The Origin of Species* had been published six months back and would inevitably be discussed. Darwin's opponents were already formidable, and included Herschel, Agassiz (now the very eminent Professor of Zoology and Geology at Harvard), the Bishop of Oxford, Sedgwick and Owen. The last two had written particularly savage anonymous reviews, Sedgwick having described the book as a 'dish of rank materialism cleverly cooked'. Henslow and Jenyns were among those cautiously in favour. Huxley was a main supporter.

The first round was after an address on *The Sexuality of Plants* by the 'large-browed, square-faced' Professor Daubeny, who was in favour of Darwin.[18] A furious attack by Owen on Huxley, concerning gorillas, seemed to bode excitement for the next day, when an American professor was to speak *On the Intellectual Development of Europe, considered with reference to the Views of Mr. Darwin and Others*. Owen was to have presided at the American's lecture, but he failed to turn up, and his place was taken by an 'unclerical looking man in black', namely Henslow.[19] The younger Hooker and Huxley—who had been on the point of going to London, but were persuaded to stay on by Robert Chambers—were on the platform.

Pauline went with the young new wife of Sir David Brewster (now seventy-nine), but found that the attendance was so huge that the meeting had had to be moved from the Museum's library to the main lecture room. After a tedious, drawling prelude by the American, the atmosphere suddenly became boisterous. 'Soapy Sam' Wilberforce, the Bishop of Oxford, strode in, trampling his way through the crowd, to ask Huxley the famous question, whether he was descended from an ape on his father's or his mother's side. And Huxley demolished him by saying that he would rather have an ape for an ancestor than an intellectual prostitute like the Bishop. Next appeared the Roman-nosed Admiral Fitzroy, who had been captain of the 'Beagle' but now disowned Darwin. He began waving a Bible, shouting 'The Book! The Book!' At which point Lady Brewster swooned, and Pauline had to help her out. In fairness to Lady Brewster, it should be recorded that she had just become pregnant. In January she delighted her husband, who had become an octogenarian, by producing a daughter.

Pauline admired Huxley, 'both mind and looks—such thick black hair', and later bought a photograph of him taken by Lewis Carroll during the B.A. meetings. Quite how much she and Calverley supported him and Darwin at that particular stage is uncertain, but in due course both were 'converted'. And in parenthesis it may be added that later generations of Trevelyans became connected by marriage to the Darwins and Huxleys.

Then it was farewell to Acland, who was going to Canada with the Prince of Wales, and Pauline and Calverley were off to Seaton, where Pauline promptly became extremely ill again. She managed to write, though almost in delirium, to congratulate Loo on the birth of a daughter, to be called Mary Florence, after Florence Nightingale.*

* Florence Nightingale wrote to Loo on July 16th 1860: 'Dearest, If you wish to call your daughter after me as a token of my affection for her, as your child,

But, as usual suddenly, she made a recovery, and Calverley took her down to Penzance for a change of scene.

With Calverley out geologizing on farms he owned in the neighbourhood, Pauline 'plunged' into letter-writing. One letter was to Christina Rossetti, who replied in that special style of hers:

'Your letters are always so kind that it is quite a treat to receive one. How charming your Cornwall surroundings must be; in spite of cold and rain even I should enjoy them: a less grand scenery must however content me this year as Mamma feels by no means at home amongst precipices, and next week we hope to adjourn to either the South or East coast. At the seaside one never failing pleasure awaits me: to plod along the shingle and search for precious stones, weeds, and monsters in general. Gabriel and his Lizzie are returned from abroad, and staying for the present at Hampstead. His marriage would be of more satisfaction to us if we had seen his bride; but owing I dare say in great measure to the very delicate state of her health, we have not yet met. She suffers much from illness. Some years ago I knew her slightly: she was then extremely admired for beauty and talent. I hope we shall be good friends some day. . . .'

Pauline never attempted to see Lizzie Siddal because of stories about her 'unattractive manners'. Other recipients of her letters were Holman Hunt and Woolner. Yes, replied Hunt, he still looked forward to painting at Wallington—that lily perhaps. And Woolner gave the latest news about Tennyson, who was thinking of going to Constantinople for a few weeks, 'but he never definitely makes up his mind what he will do until the last'.

Woolner's letter was written on August 5th, so it was a surprise nearly three weeks later to receive, when back at Seaton, another postmarked Tintagel of all places. What was more, he revealed that he was with Tennyson, awaiting Francis Turner Palgrave's arrival 'amid solid drenches of rain, howling wind and general desolation'. Hunt and Val Prinsep were also going to join them later. They had of

and of yours for me, it cannot but be very grateful to me. But if you have any superstitions, I don't think you would like my fate for your child. Not but that I think it a very happy one. God has given me a larger measure of usefulness than I had ever expected—of usefulness which *is* happiness, which *is* success. He has given me the "roc's egg", which I had never dreamed of, as some do. But bitter have been my disappointments—heart-breaking. And not the least of them is the failure of my·health. Not followed so soon by death, as the doctors had told me and as I had hoped, which now limits all usefulness.' And Ruskin wrote to Pauline: 'Mary Florence—Santa Maria del Fiore—I hope she will be nice and pretty.'

course come to Tintagel because it was 'supposed to be the birthplace of the great King', Arthur. It was sad that they would be missing the Trevelyans at Penzance.

Mrs. Tennyson had asked Palgrave not to let her shortsighted husband out of his sight. She was fearful that he might become so absorbed by the composition of new stanzas that he would walk too close to the edge of the cliffs. Tennyson himself was afraid that his presence in Cornwall might get into the local papers and that he would then be 'lionized'. So he asked his friends to avoid calling him by name in public. Not that he could have been anything but a distinctive figure, in his slouch hat, large cloak and flowing hair and beard.

In the end Holman Hunt and Prinsep caught them up in the Scillies. Woolner then had to go back to London, but the rest of the party moved to the Lizard. Tennyson and Palgrave talked poetry incessantly, and one result of the trip was that *The Golden Treasury* emerged the following year. But Palgrave's strict attention to Mrs. Tennyson's instructions began to prove irritating. When the Bard tried to escape, Palgrave would go rushing after him shouting 'Tennyson, Tennyson', like a 'bee in a bottle making the neighbourhood resound' and simply courting the lionizers. So there was no option for Tennyson but to flee to London. Even then Palgrave pursued him.

Tennyson made his way up to Lincolnshire to collect his family. Woolner's plot was that Pauline should now lure them up to Wallington before they returned to the Isle of Wight. It failed, largely because Calverley refused to leave Seaton until the school was finished. He had found that the builders did precious little work unless he himself was on the spot. Woolner was very disappointed: 'I know Mrs. Tennyson would have liked it, for I have heard her say how much she should like Alfred to know you and Sir Walter. When I was with A.T. at the Scilly Isles he was grumbling that he had to go home to entertain guests; he was always asking me about Sir Walter, and seemed to take a great interest in him; I think that wild Trevelyan legend of the White Horse fascinates rather and makes him wish to see the descendant of such a favoured man [the legend was that the first Trevelyan swam ashore to Cornwall on a white horse as Lyonesse was being submerged].' In a way Pauline seems to have been relieved that they did not come. The whole manoeuvre had smacked too much of the dreaded lionizing, that 'special sin of the age' as Hunt had called it.

SACRED AND PROFANE
1860-62

A BRIDGE across the River Axe, a new branch railway line, these were but two of the expensive projects that kept Calverley at Seaton until February. The chance of getting Hunt to paint a pilaster at Wallington was therefore lost for·ever.

Scott had been staying at Penkill, and Pauline, who had been writing about the universal bad weather, could not resist teasing him. 'I suppose it was all sunshine with Miss Boyd,' she said. Then, because of Alice Boyd being one of the models in the picture: 'Is Grace Darling finished? Is she fearfully and wonderfully ugly?' And: 'What are you doing now? Smoking and getting fat in your studio? I expect to find you fearfully fat and stupid when I get home!'[1]

As for the Sir John Franklin poem, she told him: 'Algernon Swinburne did not get the prize. A very mild washed out young man [O. A. Vidal] with whitish hair and weak eyes, and a poem to match, got it. I went to hear him recite it.' She was afraid that they would not be seeing much of Algernon now that his grandfather, Sir John Swinburne, had died. 'It seems ridiculous to feel as if a man of ninety-eight had died too soon, but he certainly has, for he enjoyed life and added to the enjoyment of many other people.'

Scott told her that Algernon had been staying with him for some days after the funeral (Gosse, erroneously, says that Algernon went to Wallington), and was intending to go with his family to the South of France for the winter. It was on this visit that the Balliol portrait was finished. The other bit of news was that *The Queen Mother* and *Rosamond* were about to come out together in book form, paid for by Algernon's father—which was magnanimous, considering that he was so annoyed with Algernon for not sitting for his finals at Oxford.

In point of fact Algernon seems to have been in a fairly docile state during much of 1860. He had had a riding accident and consequently had to have treatment in London. Burne Jones being also now married, Pre-Raphaelitism was going through a period of domesticity. The

Morrises (William Morris having married Jane Burden) were in
London, and by the year's end Lizzie Rossetti was pregnant. Algernon,
it is said, saw few people outside these three families. Otherwise he
was 'studying and writing, generally alone, with feverish assiduity'.[2]

Originally Benjamin Woodward had been excited about the idea of
developing Seaton. But he was now obviously very ill indeed. Woolner
had warned Pauline that he was 'as weak as a little candle in the open
air', though uncomplaining as ever.

Woodward had sent some ideas in advance of his visit to the Tre-
velyans—high roofs with gables facing the street, for instance. Never-
theless it is unlikely that he was even capable of much constructive
discussion. For he had consumption. Perhaps it was Pauline's idea that
he ought to winter abroad, as six weeks later he was in France.

We know now that damp sea air is the last thing to help someone
suffering from lung trouble. Woodward went to Hyères, became
worse and in May 1861 decided to return. He never got further than
Lyons, where he died on the 15th.

So Seaton did not get its Gothic Marina. Succeeding generations
thought this a blessing, but looking at the present architecture along
the sea-front one is not so sure.

Ruskin had been in Switzerland, where he had been busy with his
articles on political economy for *Cornhill*, to be published eventually
in book form—as usual with an obscure title, this time *Unto . This
Last*. He considered it to be his best, and indeed, as Kenneth Clark
has said, it is one of the great prophetic works of the nineteenth
century.

A copy of *Modern Painters* V had been sent to Pauline by Ruskin's
father, to be followed soon after by the first *Cornhill* article. 'The
editor [Thackeray],' Mr. Ruskin wrote, 'albeit eager to have anything
from John, rather shrunk from appearing to sanction the sentiments—
so to relieve him from the opprobrium of seeming to approve of any-
thing kind liberal or just towards the working classes I let my son's
initials go to the end of the article.' Which is just one piece of evidence
of Mr. Ruskin's continuing dominance over his son's career.

Mr. Ruskin expected 'slaughter' in the press. He had been charmed
with the article, 'though little complimentary to my vocation [as a
business man]' John had done well, he said, 'to drag the merchant
princes from their pedestal and place them on a lower and more
appropriate shelf'. There was indeed a hullaballoo. If Ruskin were not
checked, 'a moral floodgate may fly open and drown us all', wrote the

Manchester Examiner reviewer. Even Dr. John Brown told Ruskin's father, after reading the onslaughts in *Blackwood's* and the *Scotsman*, that he was vexed and unhappy 'at such a bye stroke'. But old Mr. Ruskin, ill though he was, was ready enough to defend his son's reputation. 'I do not at all vex myself,' he wrote to Pauline. 'The Blackwood articles did at times annoy me because they mutilated his paragraphs in quoting, and even that gaunt personage Lady Eastlake with her article in the *Quarterly* does at times haunt me, but this *Scotsman* critic though I daresay clever enough is of no higher notions in Political Economy than those distinguished members of the mercantile community in my country Scotland, who deal exclusively in red herrings and penny candles.' He wisely added: 'In place of being vexed I am obliged to the *Scotsman* for a column of large print, always a mark of consideration whether for praise or abuse.'

Evidently Pauline approved, though with some reservations. Ruskin on his return in October, had said to her: 'If you look at my political economy of art you will see what to do with your coalmerchant. The price of coals is to be fixed by the guild of coalmerchants; the carriage to be paid like postage at a uniform rate, and coals of given quality delivered anywhere at one price,—for certain freed periods—but I can't enter into details yet for a long while—till I've corrupted people's minds more extensively.... I'm very poorly, philanthropy not agreeing with me, as you very properly say it shouldn't. . . .' He was 'in for a rest' anyway, as he had finished his 'last incendiary production' (for November), and Thackeray—fearing for the magazine's reputation—had said it must be the last.

All during the year Ruskin had been corresponding regularly with the girls of Winnington, his 'dearest Birdies'. There had been joint 'Sunday Letters' on religion, with stray references to his Rose, who he hoped might even be sent to the School. He had also expounded some of his ideas on political economy—often above their heads but the Birdies were after all the daughters and future wives of influential people; a seed or two, if well sown, might sprout satisfactorily later on.

The weather became extremely wintry. Pauline and Calverley went to London for a 'jolly' fortnight before Christmas. On their return to Seaton, she had a letter from Woolner in which he told her that Holman Hunt's great picture 'Christ in the Temple' had had a narrow escape from fire. It had only been saved by the glass which covered it: 'A quantity of dust had collected on the bar which supported a curtain, and on moving the curtain some of the fluffy dust fell on the gas jet

and was instantly ignited, and some flying up communicated with the main body when the whole place was instantly a sheet of flames. They at once removed the picture, but not before the heat had attacked it and changed the colour of the sky down to the doves which are flying into the Temple. Therefore the sky will have to be repainted, and this is a part on which he took infinite pains to get it luminous. . . . Gambart would not like it to be talked of much as it might prejudice picture owners against lending their property.'

Hunt himself expands on this story in his memoirs. The curtain, he said, had been erected to prevent the dresses of spectators being reflected in the glass, and a row of gas lights had been placed just above. Though the morning was freezing, some people complained of excessive stuffiness in the room, and 'while attention was being given to the question' the curtain caught alight. The flames spread rapidly. Only one pail of unfrozen water could be found. The terrified crowd escaped, but a lady snatched off her valuable Indian shawl so that it could be thrown over the fire, which was 'happily overcome'. 'The lady, although advertised for by the proprietor [Gambart], never came forward to receive compensation from the Insurance Company for the destruction of the shawl by the gracious act she performed. Years later I heard she was the wife of Sir Walter Trevelyan.' Arthur Munby, in his diary, said that the name given had been Lady Seaton.[3]

By this time it would seem that a model had at last been found for Woolner's group: Fanny Waugh, who became Holman Hunt's first wife in 1865—'one of the grandest creatures I ever saw,' Mrs. Tennyson had been told. A price had also been at last fixed with Calverley, £1,500.

When news came that Charles had been recalled from Madras under a temporary cloud, and was in London, Calverley immediately rushed to see him. Not that Charles was in the least bit ashamed. He, of course, regretted being removed from a 'field of action which was suited to me and where I felt I was doing good', but he had no misgivings about the line he had taken. On arrival in Madras he had at once plunged into administrative reforms. Unfortunately, he had behaved in a way that was considered by some to have been both patronizing and overbearing, and had not concealed the fact that he was contemptuous of the Central Government. His mistake had been to publish, in 'an access of chivalric recklessness' a minute of protest on a financial matter. As his son George Otto said later, if Hannah had been in India at the time, this never would have happened. 'The discipline of the Service demanded his recall,' and Hannah arrived just too late—to find that

she was having to make the long uncomfortable journey back to England almost at once.[4]

Charles was preparing a statement of justification, intended to 'throw some light upon our wonderful Eastern Empire'. He was to be the subject of a long debate in the House of Commons, when his independence of character was greatly praised, and his friend Sir Charles Wood drew up documents showing that he had 'in all other respects been of great service' in Madras. The result was that there would soon be a startling reversal of fortune, with Charles back in India.

Now Calverley was struck down with such severe gout that he was unable to go to an Alliance meeting in Liverpool; he sent a message about his affliction being 'the inheritance of three generations of wine-drinking ancestors'—a joke rare for him. In May, however, he was able to return with Pauline to London, in connection with her lace stall at a Kensington bazaar the next month. He also wanted to find out if Turkish baths would relieve his gout—and apparently they did, judging by all his visits, not only then but on later trips to London.

Pauline is one of those credited with having made the fateful intro-duction between Algernon Swinburne and Richard Monckton Milnes. In actual fact she did not reach London until May 17th 1861, and Milnes is known to have invited Swinburne to his house on May 5th. All the same, there were many reasons why Pauline might have thought the two would have got on well. Milnes himself was a poet and a brilliant and witty speaker; he belonged to the Hogarth Club, was a lavish host to literary people both in London and Yorkshire, and a member of Parliament to boot. She probably thought he would be just the one to appreciate Swinburne, not simply as a young man of promise but as an individual with real genius, and that he would be able to give him some useful introductions—all of which came to pass. Various writers on Swinburne have seen Milnes's influence in a light very different, presumably, from that visualized by Pauline: 'mephis-tophelean' (Praz), 'le cosmopolite blasé, le cynique parfait' (Lafour-cade); while Humphrey Hare has said that Milnes's behaviour was a 'piece of calculated corruption'. In actual fact Milnes had plenty of attractive qualities. If he did introduce Swinburne to an 'enfer' of 'tous les livres les plus licencieux qui peut fournir la littérature euro-péenne',[5] he also—as James Pope-Hennessy has pointed out—cleared the way for the 'great upsurge of lyrical poetry' in the crucial year of 1862.[6] In short he gave Swinburne self-confidence.

Swinburne had recently returned from Italy, whither he had gone

after what had proved a very unsuccessful visit to the South of France. At the time he met Milnes he was feeling at a loose end, as is shown in a long letter, written to Pauline partly in the language of Mrs. Gamp on January 19th. He was then in a state of great disgust about the Riviera scenery:

(*Maison Laurenti*) *Mentone*

'My dear Lady Trevelyan,
(Which a nice place it is to date from)

Many thanks for your letter, which a comfortable letter it was, but creates violent wishes to get back to England. For of *all the* beasts of countries I ever see, I reckon this about caps them. I also strongly notion there ain't a hole in St. Giles' which isn't a paradise to this. How any professing Christian as has been in France and England can look at it, passes me. It is more like the landscape in Browning's Childe Roland than anything I ever heerd tell on. A calcined, scalped, rasped, scraped, flayed, broiled, powdered, leprous, blotched, mangy, grimy, parboiled country *without* trees, water, grass, fields—*with* blank beastly senseless olives and orange-trees like a mad cabbage gone indigestible; it is infinitely liker hell than earth, and one looks for tails among the people. And such females with hunched bodies and crooked necks carrying tons on their heads and looking like death taken sea-sick. Arrrrrrr. Grrrrrr.

'Wal, I feel kind of better after that. But the aggravation of having people about one who undertake to admire these big stone-heaps of hills and hideous split-jawed gorges! I must say (in Carlylese) that "the (scenery) is of the sort which must be called, *not* in the way of profane swearing, but of grave earnest and sorrowing indignation, *the d- sort*"; (I would rather die than write it at length).'

Then came a reference to *The Queen Mother and Rosamond*, published in December and a complete failure commercially:

'I am very glad you like my book; if it will do anything like sell I shall publish my shorter poems soon; they are quite ready. I have done a lot of work since I saw you—Rossetti says, some of my best pieces: one on St. Dorothy and Theophilus (I wanted to try my heathen hands at a Christian subject, you comprehend, and give a pat to the Papist interest) also a long one out of Boccaccio that was begun ages ago and let drop. Item—many songs and ballads. I am trying to write prose, which is very hard, but I want to make a few stories each about three or six pages long. Likewise a big one about my blessedest pet which

her initials is Lucrezia Estense Borgia. Which soon I hope to see her hair as is kep at Milan—"in spirits in a bottle" [a Gampism].

'Which puts me in mind of a favour I want to ask you. In the beginning (probably) of Feb. I am going to Venice and through all the chief towns I can and perhaps to Florence *if* I could find out whether Mr. Browning is there. Now there is nobody within reach who knows as much of art as a decently educated cockroach; and I want you to have the extreme goodness to tell me what to go to and how to see Venice—buildings especially as well as pictures—before it gets bombarded—out of the British tourist's fashion. If you are not awfully busy would you write me a letter which I could get say by the week after next? considering I have read no books and am not content with the British Murray.'

Next followed his cri de coeur about the uncertainty of the future:

'—I wish I *had* anything to do' besides my proper work if I can't live by it. Which it's very well to pitch into a party like brother Stockdolloger [a reference to Sala's *Colonel Quagg's Conversion*] but what *is* one to do? I can't go to the bar: and much good I should do if I did. You know there is really no profession one can take up with and go on working. Item—poetry is quite work enough for any one man. Item—who is there that is anything *besides* a poet at this day except Hugo? And though his politics is excellent and his opinions is sound, he does much better when he sticks to his work and makes Ratbert and Ruy Blas. *I* don't want to sit in rooms and write, gracious knows. Do you think a small thing in the stump-orator [political] line would do? or a Grace-Walker [again a reference to Sala]? Seriously what is there you would have one take to? It's a very good lecture but it's not practical. Nor yet it ain't fair. It's bage [Gampism].

'*Have* you heard the report that old Landor is going to republish *all* his suppressed libels in verse and prose and more new ones? Isn't he a marvel of heaven's making? I suppose a British public will bust at once if it's nipped and frizzled and churned up to an eternal smash any more: which by the by America seems to be at this writing.

'I am in love with Paris—you know I never saw it before. What a stunner above stunners that Giorgione party with the music in the grass and the water-drawer is ['Le Concert Champêtre']—that Gabriel made such a sonnet on. Then that Stephen preaching of Carpaccio! I never heard a word of it; but it seems to me lovely, with wonders of faces. Item the Velasquez. Item things in general. Item the little Uccello up at the top of the gallery.

'My parents would no doubt send all proper messages, but are probably in bed, and, (let us hope) enjoying a deep repose. For the hour is midnight. On this account I will now conclude, with my duty and respects to Sir Walter; and am Your most sincerely, and with a filial heart, Al. C. Swinburne

'I wish to goodness you would send me out some eligible companions. I shall have to go alone to Turin. For the English here are mainly false friends. Don't you think we shall yet live to see the last Austrian emperor hung? Is Garibaldi the greatest man since Adam, or is he not?'

At this stage it should be remarked that very few, precisely eight, letters from Swinburne to Pauline have survived the years. After her death Calverley is supposed to have destroyed the rest as being indecent or scandalous.

On June 5th Swinburne was again at Monckton Milnes', where he met Richard Burton, who with his revelations of sexual life in the East soon became another important influence on him.

In style Ruskin's letters of the period, still full of gloom and self-pity, could hardly have been more of a contrast to Swinburne's effusion from Mentone. His parents were really worried now about his low spirits and relative unproductivity. Mrs. Ruskin had broken her thigh, which had not improved the tenor of life at Denmark Hill. Although Mr. Ruskin had mellowed a little—Mrs. Burne Jones talked of his dignity and simplicity—he still dominated his son to a most extraordinary degree.

Ruskin wrote to Pauline in March about his listlessness. He felt he was boring people, he said. There was nobody who could really help him. He brought up the question of marriage: 'I don't quite see my way to anything in particular, as the purpose of the downhill road of life: I shouldn't care for an old wife—and a young one wouldn't care for me;—or if she did, I should be always pitying her, and wondering what she would do with me when I got quite old. Besides, though I'm out of heart just now, I fancy I've got some plans in my head rather too rough for a wife to help me in carrying out: and freedom is a grand thing—though a gloomy one.' His father followed up with another letter shortly afterwards: 'John is in Cheshire since 18th March, I suppose endeavouring to compensate to his Mother who is at times uneasy at his frequent visits to Carlyle by performing the part of chaplain at Miss Bell's Winnington Hall in getting thirty or forty young ladies and children through their Bible lessons.'

Before Ruskin left Denmark Hill he had packed up sixty-one of his Turners with the intention of presenting them to Oxford and Cambridge Universities. Even they, his once beloved Turners, had begun to pall on him. 'Seriously however,' his father continued, 'I am not sorry for this—I had indeed told him that his costly decorated walls and large accumulation of undivided luxury did not accord with his doctrines. I am now paying for my speech.' 'Romps and rest' were what Ruskin looked for at Winnington. 'You needn't think I am in love with any of the girls here. . . . Rosie's my only pet,' he told his father on March 26th.[7] Afterwards he went to stay with Palmerston at Broadlands, where perhaps he again met Mrs. Cowper ('Egeria herself!'), who became one of his great confidantes as the Rose La Touche affair developed. On April 19th there was the notorious 'Tree Twigs' lecture, and the Winnington Birds, still kept up to date with news of Rose, were told how he 'fairly broke down'—though not of course that this was caused by the presence of Effie and Lady Eastlake.* Then Rose came back briefly to London. In June and July Ruskin went to Boulogne for another rest. He was undecided, so his father told Pauline, whether to go to Switzerland or to Ireland, where he had been invited by the La Touches. 'His cold is gone and his health I hope returned, but he has been saddened by the death of Mrs. Browning.' Could Pauline help to 'allieve' his sorrow with a letter? For once, she had been a bad correspondent.

It seems probable that Ruskin knew that going to Ireland was a temptation to which he probably ought not to give in, and that the consequences might easily be dangerous for him. But he did succumb, and he made his way there by stages across England and Wales, almost reluctantly, as though he was ashamed.

Pauline went to stay with the Ashburtons at the Grange. Before returning north, she had seen Mrs. Carlyle, whose letters to Loo were becoming more and more extravagant, being usually signed 'Yours devotedly', 'Yours entirely' or 'Yours wholly'. Any reference to the baby would be decidedly embarrassing—'like a pearl in an oyster-shell in her pink and white basket'. And her Amazonian correspondent

* A letter from Effie to Millais, written from Edinburgh early in 1859, gives a clue as to why she found the prospect of a lecture on such a precious subject as tree twigs irresistible. She described how she and her uncle 'went into fits' when confronted with a picture by 'J.R.' 'This diminutive absurdity is four inches square . . . with a very tiny twig of a tree with 3 very petite buds the size of a bead!' Pierpont Morgan Library, M.A. 1338 R-V.

also received such effusions as: 'O my darling! My darling! I know the effect a letter from *you* has now always on *me*; it makes me long to take you in my arms and hush you to sleep, as if you were a tired wee child, and kiss off all tears from your eyes.'[8]

All this seems doubly remarkable, when one remembers how bitterly jealous Mrs. Carlyle used to be about her husband's affection for Loo's predecessor at the Grange. Not that Carlyle was by any means neglected by the Ashburtons, or even resented this tremendous unleashing of her affection. It was still Loo's habit to show all Mrs. Carlyle's letters to Pauline, who sometimes seemed in competition for her love. 'You know very well,' Pauline would write, 'that if God took *you* from me, darling, Baby would be one of the dearest interests of life to me, and nothing would comfort me so much as being of the least bit of use to her.'

Meanwhile Scott had been taken by Rossetti to Little Holland House and wrote about its 'charming' society, 'to an artist most attractive'. There he had met the dark- and flashing-eyed Julia Margaret Cameron, 'a very fantastic individual who boasted she had Tennyson's new book in her pocket—and that it was next to the Bible'.★ As all the Wallington pictures were now finished, he had arranged with Gambart to show them in London.† The secret hope, of course, was that there would be as much excitement as with 'Christ in the Temple'. Calverley however disappointed him by not offering to pay the carriage from Newcastle or any other expenses. Indeed the Trevelyans left London before the pictures were even hung. It was July, a bad month for critical attention, and as Millais put it in a letter to Effie, there was a 'smash in the picture trade in consequence of the uncertainty in America',[9] where the Civil War was still in its early stages.

Then Scott quarrelled with Gambart, who treated artists 'as a jockey does race horses'. There were some good reviews, but a very hurtful one by an ex-PRB brother, in the *Athenaeum*. The Trevelyans were relieved to have their pictures safely back in the peace of their hall.

On July 1st 1861 Calverley wrote in his diary: 'Good old dog Peter chloroformed out of this life.' Only a few months before Dr.

★ Mrs. Cameron, Virginia Woolf's great-aunt, began her famous photography in 1863.

† Earlier Rossetti had written encouragingly to Scott in an undated letter: 'We are hanging our new rooms here with pictures in oriental profusion—one room is hung all round with my wife's drawings, and in another is a chief feature in the frame containing your photographed pictures, which I took away from the Hogarth.'

John Brown's second volume of essays, *Horae Subsecivae*, had been published with very great success—so that he was now being hailed as the Scottish Charles Lamb. And the section in it called *Our Dogs* had been dedicated to 'Sir Walter and Lady Trevelyan's glum and faithful Peter'.*

Friends sent their commiserations. Christina Rossetti hoped Peter would soon find a worthy successor. 'I have read no obituary', wrote Mr. Ruskin to Pauline on August 23rd, 'that has lately affected me more than your letter containing Peter's death. During the last drive I had with John only last week, our conversation fell on the short lives of dogs proving one of the minor trials of life.' He said that John had said that he would never keep another dog, 'so much has he felt the loss of one or two now gone'.

Mr. Ruskin continued: 'My son paid us rather an unexpected visit of ten days. . . . He spent one evening at Chelsea with Carlyle and Froude and is now at Llangollen on his way (somewhat circuitous) to Harristown Ireland where he has been coaxed to go by Rose La Touche a spiritual little creature of thirteen. I believe she figures with her sister Emily in last week's (17 Aug.) Punch.** I will not answer however for his yet finding his way there as he seems a little in the Hamlet mood.'

It is easy to laugh at Ruskin's obsession for Rose, but the story as it developed over the years, far beyond Pauline's lifetime, is essentially a tragic one, both for himself and the girl. Rose has variously been described as ethereal, fragile, wraith-like and saintly, and yet in those early days of incipient love she was also 'wild', typically Irish. 'I sometimes wonder if she ever will be a civilized being,' her mother wrote to a friend. 'All day long she is in and out let the weather be what it may, and not one single thing that girls do does she do.' Rose called Ruskin 'St. Crumpet', and she was his 'Rosie posie' and her sister 'Wisie', after the dog that had died. In actual fact two or three years were to pass before his love for this 'Mouse-pet in Ireland' was to become overwhelming, and he could write that she 'nibbles me to the very sick-bed with weariness to see her'.[10] At this time too, in the autumn of 1861, Mrs. La Touche probably regarded Ruskin's visit simply as a diversion from the philistinism of her neighbours. When

* Ruskin, writing to thank Brown for a complimentary copy, wrote: 'To me, at the time, the most available part was that dedicated to poor dear old sulky Peter, monumentum aere' (Forrest, p. 294). Both volumes of *Horae Subsecivae* and Brown's equally famous *Marjorie Fleming* (1863) were best-sellers in Britain and the United States. ** See p.174.

she eventually realized that Ruskin was in love with her daughter and wanted to marry her, she was furious.

The nearer he got to Rose, the more despondent Ruskin became. He wrote to Pauline on August 26th, from Holyhead; he was 'as sulky as ever, a little less viciously and more weakly and sorrowfully so'. All he was doing was to read natural history and Greek grammar, 'patiently, not caring for either, because one must do something', and gather shells and 'disgust' himself. He had given up philanthropy 'as well as pastry'. He couldn't draw. He was bored with scenery and of course Turner.

A NICE GAME FOR TWO OR MORE
"—Fixing her eyes on his, and placing her pretty little foot on the ball, she said, 'Now, then, I am going to croquet you!' and croquet'd he was completely." (*From Rose to Emily.*)
Punch, August 17th 1861

Two days later he wrote with a little more spark, having had a letter from her: 'I have today your illegible note, for which many thanks. I shall have nothing particular to do on board the Dublin steamer and I daresay in the course of the four hours passage, I may be able by diligence to make it out. It has been to Dolgelly, and as it always rains in Wales, the leaves of it are stuck together, of course—and it looks like a beautiful fern impression of the coal formation. It is not a bit the less legible than originally however, I can see that. . . . What an awful gossip you are getting to be. Why shouldn't heads of

colleges marry whom they like? Frances Strong will write Greek beautifully. But I'm glad she's done with her drawing.'

In the last sentence he was referring to the marriage of dour Mark Pattison, aged forty-eight and the new Rector of Lincoln College, Oxford, and Pauline's young friend, the twenty-one year old Francis (not Frances) Strong, whom she called Piggy. Francis's drawings had been shown by Acland to Ruskin, who had recommended that she should study at the South Kensington School of Art. The Pattisons have been held up by some as the true models for Casaubon and Dorothea in *Middlemarch*; and later in her life, after Pattison's death, Francis became Lady Dilke. But more of them later.

Ruskin next wrote from Harristown on September 4th. His health was improving, he said what with all the scrambling and wading he was having to do, Rosie being 'half squirrel, half water-ouzel'.

'You would have liked the picture she made the day before yesterday, standing beside an old Irish piper ordering tunes of him—he nearly an ideal of road-side musician—worn and pale, but full of sweet sensitive-ness—though sixty five: sadly ragged like all the Irish (but not dirty;) and very happy in pleasing the child; and she listening with intense seriousness—all the deeper for squirreline faculties at rest—the pure wild-rose-colour of the face braided with its auburn hair (clear gold in sunshine) and a background to both of waterfall and wild dark rock— a piece of glen in the Wicklow Hills.

'We have had a nice evening tonight—papa and mama were going out to dinner. I wouldn't go; so they left Rose and her sister (Rose's just fourteen and Emily—wiser somewhat—shortened to Missie and transmuted complimentarily to Wisie—nearly seventeen) and school-boy Percy (their brother) at home for holidays—fifteen—to take care of me. Rose ordered dinner—and we had all the house to ourselves with only the old butler to wait, we turned ourselves into lords and ladies—Lady Emily and I were very grand at head and foot of table— Percy and Rose for quatrefoil. Then, plenty of music—a game or two of chess (Rose and Percy in council against me)—and a canto of Marmion.

'I've just come upstairs at eleven—sorrowfully: but in good humour enough to be goodnatured and write to you. . . . If you have anything spiteful or disagreeable that you particularly want to say, you may write—for a week—care of John La Touche Esq. . . .'

Wallington was full of guests all autumn. On September 1st Swin-burne arrived from Fryston Hall, Milnes's house in Yorkshire, where

a medley of talent seems to have been gathered—Carlyle, Kingsley, Froude, Holman Hunt, Palgrave, Burton and bride—and where he had been shown, before Church on Sunday, some choice volumes from his host's library of erotica. He stayed on at Wallington until the 18th, Woolner and Scott being there part of the time.

Before reaching Wallington Swinburne must have told Scott about a short story he had written 'at immense length' whilst in France. It was about 'a twin sister of Queen Victoria kidnapped on her birth by consent of the late Sir R. Peel and Lord Chancellor Eldon for political reasons—to remain a rival candidate for the throne—grows up an indescribable [prostitute], is discovered in the Haymarket by the Lor Maire [Lord Mayor] on a profligate excursion, is informed of her origin, claims her rights, is confronted with the Queen, Queen swoons, the proofs of her birth are bought up and destroyed, the archbishop of Canterbury solemnly perjures himself to the effect that she is an imposter, and finally, the heroine, consumed by an ill-requited attachment to Lord John Russell, charcoals herself to death'. Scott had to return to Newcastle after a day or so, but on his return to Wallington he found Swinburne 'master of the situation' and telling the absurd story to Pauline, who was 'on a high stool'.[11]

There is another anecdote about Swinburne, ascribed by Gosse to 1860 when Sir John died—impossible of course, as Swinburne did not go to Wallington then, though it could have belonged to his visit in December 1862 just as easily as the one in 1861. As usual, in that September of 1861, Swinburne held court to the ladies in the middle of the saloon, declaiming his verse with one foot curled under him—his intonation and emphasis very different from the way in which George Otto's friends would read Byron and Keats to one another in their rooms at Trinity, Cambridge. 'Unfortunately,' said Gosse, 'these symposia were often more completely to the taste of the hostess than to the host.' One morning Calverley came into the saloon and found— of all things—a French novel lying on the table. He asked how it got there, and was told that Algernon had brought it as a gift. 'It was nothing worse, I believe, than a volume of the Comédie Humaine.' (Or could it have been something picked up at Fryston?) Calverley thereupon threw the book into the fire 'with a very rough remark'; and Swinburne 'marched with great dignity out of the house', going straight to the Scotts' in Newcastle. Luckily 'the alienation was not permanent, and Swinburne was soon on the old affectionate terms with him'.[12]

Swinburne was now working on Chastelard, his play about Mary

Queen of Scots, eventually to be published in 1865. He had not yet been allowed to see de Sade's works, but told Milnes he was becoming mad with curiosity. Meanwhile he was also writing *Charenton*, celebrating the Marquis, the title taken from the asylum in which he died.

Augustus Hare, then Madox Brown and William Rossetti were among the next visitors to Wallington. Calverley showed the two 'Pre-Raphs' his paper on the 'supposed borings of lithodomous mollusca'. One hopes they found it edifying; it was not published for another ten years. They also were taken round the 8000 acre estate adjoining Wallington that he had just bought for £26,500—and this on top of the improvements at Seaton and the Wansbeck Railway.

'What do you let your house be full of tiresome people for?' Ruskin wrote to Pauline from Lucerne. 'I've turned everybody out and am all the better for the change.' His spirits were obviously rising, for he could now write: 'I never saw such a ruby sunset on Alps in my life as yesterdays—and I never saw autumn before. Fancy all the beechen groves—*tall* beeches—80–100ft. high—in their now thin gold—with the sun shining intensely through them in multitudes—and backgrounds of purple mountain, dashed with filmy blue-greens of the indescribablest loveliness. I see what autumn was made for, now,—I couldn't make it out before a bit. Rosie says it's only peoples being hopeless that makes autumn wretched to them. It is enough to make one hopeful, to see what it can be—sometimes and in places meant for it. I've promised Rosie she's to go and see you when you come to town next—mind you tell me when you're coming.'

He then told her that Rose had been ill. 'The doctors say she mustn't do anything.' Indeed she had been exceedingly ill, possibly with a nervous breakdown, and Ruskin had even to tell his father that it was nothing to do with him—which would seem to have been very unlikely, for it stands to reason that a highly-strung adolescent girl would have been pretty disturbed by the more than average interest of a middle-aged, famous man. Being also religious, Rose may have been upset by his confession to her mother that he was losing his faith and the fact that Mrs. La Touche had had to make him promise that he would not publish anything on the subject for ten years. For his part, Ruskin initially seems almost to have been made happier by her illness, for it made him feel more confident of the nature of her love for him. 'You say', he wrote to Dr. Brown, 'that you have heard of me from Lady Trevelyan—that I am busy and well. I suppose she knows.'[13] At any rate she had guessed it, and correctly.

He wrote again to Pauline on December 28th. He was in Paris, on his

way home, having arrived at 5.30 a.m. after seeing the sun set on the Jura: 'The early winter has been, they say, (in Alps) singularly beautiful: whether it has been singular I cannot say: but beautiful it has been beyond conception. Nothing that I ever saw in summer is comparable to the frosty day among the pines. Tuesday before Christmas day I was far up Pilate—the entire mountain looking like one of those precious Benvenuto Cellini jewelleries in the Louvre—frosted silver pines—purple shadows leagues long—and divine calm in the air.'

He referred again to Rose and to his religious doubts, which appeared to have intensified: 'You wonder I stayed so long in Switzerland? Well —even with all that you can generally allow for absurdities of mind—I suppose you can't fancy my having to stay there partly because I wanted too much to go home? At least—the little work that I'm now good for, goes on a good deal better by Lake Lucerne than it would have done if I had been within a walk of my little Wicklow blossom— What will she say to me now—that I'm half Heathen to half nothing, and can't talk about good things any more! However—I'll take care and not hurt her by letting her see why. Seriously—it is sorrowful work enough this, turning oneself upside down, like a cake on the hearth—when one is within seven years of fifty. Partly because it is worse confusion—and still more because it is hard to lose one's hopeful thoughts of death just when one is growing old.'

Pauline was very ill during December with congestion of the liver. She recovered enough to travel to London for a short visit in January, when Ruskin took her to the National Gallery to see the Turners and introduced her to the La Touches.

After her return Woolner wrote about a meeting with Robert Browning, who he said had been chatty and almost cheerful until 'something however distant touched near the dark place of his memory'. When Browning gave him a photograph of his wife, 'the way in which he turned his head aside was enough to break one's heart'. The letter ended: 'I dare say you heard of the death of Rossetti's wife—she took an overdose of laudanum—was buried yesterday. It was a frightfully sudden shock to the family.'

Lizzie's death is the most dramatized incident in the whole Pre-Raphaelite saga, and the matter of whether she did or did not leave a suicide note can still arouse controversy. She had been to dinner with her husband and Swinburne at the Sablonière restaurant in Leicester Square. Rossetti had gone out again afterwards, some say to seek the favours of Fanny Cornforth, others to visit the Working Men's College, and had returned to find her dying.

For a while, especially since the birth of a still-born child, Lizzie had been addicted to laudanum, so it is quite possible—if she had been tipsy—that she would have swallowed too large a dose. Scott's mention of a suicide note has been proved by Helen Rossetti Angeli to have been a total fabrication. Rossetti was distraught, and with a typically Latin mixture of theatricality and real grief, placed the only manuscript of his poems—which he considered to be the cause of his neglect of her—among the famous golden-red tresses in the coffin. Seven and a half years later he had the body exhumed, so that the poems could be removed, dried out and published.

Swinburne had become very attached to this still beautiful woman. He read to her and they played around together 'like a pair of angora cats'. She was to him a 'wonderful as well as a most lovable creature'. Others simply saw her as a remote, rather elegant figure. Georgiana Burne Jones found her affecting; the whole atmosphere in that house was a mixture of romance and tragedy. If one is to believe Scott, there must have also been terrible depressions and tantrums.

Reputedly Swinburne, who was also at work on some of his most famous poems, had not yet been initiated by Milnes into the 'mystic pages of the martyred Marquis'. However William Hardman has described a 'social reunion of artists and literary men' before Lizzie's death at Rossetti's, where he held up de Sade as 'the acme and apostle of perfection', such tirades being received with 'ill-concealed disgust' by the company, though he was treated throughout the party like a spoilt child. Hardman remarked on his nervous twitching, not unlike St. Vitus's dance:[14] a fore-warning of the fits from which he later suffered.

As William Rossetti and Scott were planning to go to Italy together, they hoped Gabriel might join them. Both Swinburne and Ruskin had also offered to take him abroad. Not that Ruskin's offer would have been considered, Gabriel being annoyed with him for his lack of enthusiasm for both the manuscript of Christina's *Goblin Market* and his own poems, now to all intents lost to the world for ever.

'But a new aspect of the affair,' Scott told Pauline on March 1st, was that Gabriel would not stay any more in 'his Blackfriars place', where he had lived with Lizzie, and 'William and he are to take house together and Algernon is to live with them. . . . So the continental tour [with Gabriel] is abandoned.' The three moved into Tudor House, Cheyne Walk, in October. Fanny Cornforth mostly looked after them as housekeeper, and for a short while George Meredith was an inmate, along with a menagerie of wombats, peacocks, armadillos, kangaroos and hedgehogs.

CHAPTER FOURTEEN

A HOUSE AND ITS INHERITANCE

1862–63

THE International Exhibition was the outstanding event of 1862 for Calverley and Pauline. The building, designed by Captain Fowke and known officially as the Palace of Art and Industry, was on the site of the present Natural History Museum and Imperial Institute. A curious conglomeration of styles, part Renaissance, part Romanesque, part fantasy, it was as ungainly and unpopular as the Crystal Palace had been graceful and beloved. Ruskin wrote from Denmark Hill; he had been seeing Rose ('getting horrid'), and told Pauline that he was delighted to hear that everyone was abusing the building.

Dr. Brown had once more been responsible for persuading the *Scotsman* to let Pauline review the pictures at the Exhibition along the lines of her performances in 1851 and 1852. It was an especially important assignment, for the galleries at the Exhibition were visualized as being a nucleus for a new National Gallery—if South Kensington, or rather Brompton, was not 'too far out'.

She began with the French section, rather than 'lose' herself in the 'enormous wilderness of British pictures', and the article was as lively and provocative as ever. It was a relief, compared to Paris in 1855, she said, not to have to suffer the icy chill that 'nearly froze the blood in one's veins after a whole morning spent among the great works of M. Ingres'. French soldiers 'swarmed' on the Exhibition's walls. Of course an essentially military nation would take delight in these representations of contemporary exploits, even though there were some curious revelations, such as the fact that the British Army had never apparently been in the Crimea, let alone taken part in the Alma or other battles. All the same, the display was not quite so bad as on that other occasion, when the 'goblin dance of blue-coated, red-legged warriors pursued one for hours, from victory to victory'. She did realize, however, that most people would find it difficult to appreciate the true greatness of some of these French pictures.

Findlay of the *Scotsman* was 'highly satisfied'. In all she had written some 17,000 words. The series reminded him in several ways of Hazlitt or Thackeray. But for some reason she never completed her review of the British pictures, which was a pity as many Pre-Raphaelites and their allies were represented.

Woolner's work was also to be seen there, and became the subject of a scandal. Earlier he had written to Pauline to ask her to put in a word with Hannah Trevelyan about persuading a committee in Cambridge to choose him, rather than Marochetti, as the sculptor for Macaulay's statue. Pauline had at first pulled his leg. She would not do so until he had finished her group, which she knew had barely progressed beyond the modelling stage. 'I feel I shall grow into an Annunciation Lily before it is finished,' she said. Nevertheless she did write to Hannah, and although by now she had become on quite affectionate terms with her and Charles, she was rebuffed. Charles had written back to say that Hannah had an 'insurmountable objection to involving herself in any kind of memorial', which had to be 'perfectly spontaneous and independent'. So that was that, and the decision about the sculptor still had not been resolved by the time of the opening of the Exhibition.

When the authorized handbook, written by Palgrave, appeared, Holman Hunt saw at a glance—as he wrote in his memoirs—that the 'author's prejudice against all other sculptors but Woolner was rampant, and his admiration of him riotous'. All very well, but Hunt felt this would arouse resentment against Woolner, which it certainly did. Munro, for example, had been described in the handbook as 'grotesque and babyish', whilst Marochetti was not only said to be ignorant of the rules of art but guilty of 'colossal clumsiness'.

Then came a long scathing letter to *The Times* by 'Jacob Omnium', Matthew Higgins, revealing the terrible fact that Woolner and Palgrave actually lived together in the same house. Watts and Millais plunged indignantly into the battle, while Hunt wrote trying to save Woolner's reputation. It was one of those major newspaper affrays such as the Victorians revelled in. No wonder the Cambridge committee postponed its decision about the Macaulay statue for a month.

Pauline attempted some peace-making. She went to see Munro and invited Palgrave to stay at Wallington. In the end Woolner did get his commission, but it was this incident that caused the final break between him and Munro, who had suffered a bad blow to his reputation. Holman Hunt had to admit that in the end the Macaulay group was a disappointment. 'Ideal groups', like the one for Wallington,

were Woolner's real forte. This was also Pauline's 'secret' opinion. And, after all, the very aim of the group was to symbolize 'all that is reverential and noblest in human life—the simple truths that we are, or ought to be, striving for'. The thought does also arise that the symbolism of a mother and child meant something even more to her, being childless.

Whilst in London Pauline had, as a matter of course, called at Denmark Hill. She must have known already that Ruskin was becoming increasingly irritated by his father, who in turn was feeling that—at the very end of his life—they were drifting away from one another in a bewildering manner.

On July 20th Ruskin wrote from Milan to thank her for her 'nice rambling letter'. As by now she was with the Aclands, the contents of his reply would inevitably have been discussed with them.

'You ask if I have been ill—I wish I knew. . . . I know my father is ill—but I cannot stay at home just now—or should fall indubitably ill myself also, which would make him worse. He has more pleasure if I am able to write him a cheerful letter than generally when I'm there—for we disagree about all the Universe—and it vexes him—and much more than vexes me. If he loved me less—and believed in me more—we should get on—but his whole life is bound up in me—and yet he thinks me a fool. That is to say—he is mightily pleased if I write anything that has big words and no sense in it—and would give half his fortune to make me a member of parliament if he thought I would talk—provided only the talk hurt nobody—and was all in the papers. This form of affection galls me like hot iron—and I am in a state of subdued fury whenever I am at home which dries all the marrow out of every bone in me. Then he hates all my friends—(except you)—and I have had to keep them all out of the house—and have lost all the best of Rossetti—and of his poor dead wife who was a creature of ten thousand—and others such—I must have a house of my own somewhere.'

He then went on to talk of the Burne Joneses, with whom he had been travelling. Waiters in hotels were puzzled to know whether Ned could be his son or Georgie his daughter. 'I really didn't think I looked so old.' But he liked the young couple very much. 'What a funny thing a mother is. She had left her baby at home in her sister's charge—and she seemed to see every thing through a mist of baby. I took them to see the best ravine in Mont Pilate—and nothing would serve her but her husband must draw her baby for her on the sand of the stream.

I kept looking up massacres of the innocents and anything else—in that way—that I could—to please her. . . .'[1]

He wrote again on August 17th from Mornex in the Haute-Savoie. As an experiment he had rented a furnished house, 'preparatory to fastening down post and stake'—in other words to finding a permanent home in the district. He had a small garden, 'with espalier of vine, gourd, peach, fig, and convolvulus—shade of pine and sycamore—view over valley of Bonneville to the Savoy mountains and Mont Blanc summit', and above 'like Malvern Hills, the rocky slopes of the Salève in front, a dingle and rich wood of Spanish chestnut and pine, strewn with blocks of the tertiary glaciers, granite and gneiss, moss covered'. He had also been reading Faust and 'going dreamily back to my geology, and upside-down botany [grouping flowers by colours]'. He spoke of his parents, who had been told of his decision to live in Switzerland.

'I'm very sorry for them at home, as they will feel it at first—but no course was possible but this, whatever may come of it. I trust they will in the issue be happier, they will if things go right with me, and they won't see much less of me—only I shall be clearly there on visit, and master of my own house and ways here—which, at only six years short of fifty, it is time to be. The father has stood it very grandly hitherto; I trust he will not break down. I could not go home. Everything was failing me at once—brain, teeth, limbs, breath—and that definitely and rapidly.'[2]

Pauline replied immediately, and what she said pleased him, for he sent her letter to his father, asking him to pass it on to Mrs. La Touche.

'And have you really set up that dreadful house in Switzerland', she wrote, 'which I always used to hope would blow over?. . . Everyone knows their own affairs best, and I trust now you really are at peace you will get well; and besides I have such faith in your perverseness that I have no doubt when you don't live in England and have nothing more to do with it you'll begin to like the poor old Country and think she was not so bad after all, and also that having satisfactorily got rid of all your friends, set up your hermitage, locked the door, and thrown the key down the well you'll begin to think you like us, and that *we* aren't so bad after all.'

As it happened, Mrs. La Touche had originally suggested that Ruskin might come and live on their estate in Ireland. The scheme had fallen through, because she was afraid of gossip among neighbours. All this contributed to Ruskin's restlessness. By the time he had received Pauline's letter, he had decided he must move from the house

he had rented, as it was in the village and 'not solitary enough'. Now he had in mind that he might take a room in Tudor House, Cheyne Walk. From which idea the new landlord, Rossetti, was tactfully to dissuade him.

It was a busy season for guests that autumn at Wallington. George Otto, intent on his snipe-shooting, arrived, followed shortly afterwards by Whewell and his Lady Affleck. It is not clear whether George Otto and the Whewells coincided. If they did, Pauline no doubt thought she was helping George Otto who, having failed for his Fellowship to Trinity, was making a second attempt in October. Very likely George Otto escaped from the house, for the dislike between him and the 'despotic' Whewell was mutual, Whewell believing that he was lacking in deference. Whilst at Wallington Whewell told Pauline that the young man 'must not expect' to be elected, 'as so many men of the previous year were in'. Later, when George Otto— to his intense disappointment—failed again, she told him what the Master had said. He was furious. It was 'a farce and an insult'. Why had he been *allowed* to compete? 'It is a most cruel thing to call an examination a competition, and then to give the prizes by seniority. Never again will I put my reputation in any hands but my own.' As it happened, in 1885, when he was famous as a politician and writer, he was awarded an honorary Fellowship to Trinity.

The Pattisons also came over to Wallington, since they were staying nearby at Bamburgh Castle for three months. Francis had a great deal in common with Pauline, and not only because of her drawing and the fact that there was a large difference in age between her and her husband. She too was witty, unconventional, a Puseyite, a good linguist and interested in lace design. She even took to art criticism and addressed Ruskin as 'Master'. Some of her friends had been shocked by her 'fearless advocacy' of the necessity of drawing from the nude, encouraged by Mulready, to whom Pauline had introduced her.

A 'lace friend', Mary Anne Eaton, had sent on a letter from Francis at the time of her engagement: 'Do you remember,' Francis had written, 'saying one day how passionately you thought I should love if I ever did [get married]? Well you were quite right in your conjecture. I am really becoming a little mad I think by our happiness.' Alas, this great love was all too soon to turn to revulsion on Francis's part. Mark Pattison was a fine scholar, but prickly and to many people unapproachable. His silences and stony glares were famous. He became known as the lizard with a drip on his nose.

Much has been written about this marriage, which certainly was far from a case of non-consummation. There is no doubt that Pauline soon became not only an example to Francis but a confidante. After all, she had turned her marriage into a success. As a hostess she was just what Francis aspired to be. One is not surprised to learn from Sir Charles Dilke's memoir that Francis kept a locket with Pauline's portrait in it until the end of her life.*

In spite of misgivings about the discomforts of Wallington, Augustus Hare could not resist another invitation to this unusual household, so baffling to ordinary county folk in Northumberland and liable to be full of artists, writers, scientists, prelates, American visitors and eager, intelligent ladies. He was also collecting material for his Murray's handbook and realized that Calverley's erudition could be of very great use to him.

Hare knew how to make a good story. In his diary, obviously refurbished for *The Story of My Life* (1896), he complained about 'awful noises being heard all through the night'. Footsteps rushed 'up and down the untrodden passages'—and they belonged to none other than Calverley's mother, poor old Maria, who had been a 'miser'. He described Calverley as 'a strange-looking being, with long hair and a moustache, and an odd careless dress'. Calverley, he said, had never been known to laugh. Pauline however was 'cheerful' and 'light', with sparkling eyes. 'She . . . imports baskets from Madeira and lace from Honiton, and sells them in Northumberland, and always sits upon the rug by preference.' He continued: 'There is another strange being in the house. It is Mr. Wooster, who came to arrange the collection of shells four years ago, and has never gone away. He looks like a church-brass incarnated, and turns up his eyes when he speaks to you, till you see nothing but the whites. He also has a long trailing moustache, and in all things imitates, but caricatures, Sir Walter. What he does here nobody seems to know; the Trevelyans say he puts the shells to rights, but the shells cannot take four years to dust.'

The next day was a little easier. 'Even Sir Walter is gruffly kind and grumpily amiable. As to information, he is a perfect mine, and he knows every book and ballad that ever was written, every story of local

* The question of whether the Pattisons were the Casaubons in *Middlemarch* has been hotly argued. See *Dorothea's Husbands* by Richard Ellmann in T.L.S. February 16th 1973 and subsequent correspondence; *Mark Pattison and the Idea of a University* by John Sparrow, Cambridge 1967; *Poor Mr. Casaubon* in *Nineteenth Century Literary Perspectives*, ed. C. de Ryals, Duke University Press, N. Carolina, 1974.

interest that ever was told, and every flower and fossil that ever was found. . . .' His conversation was so curious that Hare followed him about everywhere, and took notes under his nose. 'Lady Trevelyan is equally unusual. She is abrupt to a degree, and contradicts everything.' Her eyes twinkled with mirth all day long, and she chided him for not admiring a 'miserable little drawing by Ruskin'. And Calverley on a day of fog and rain forced him to wade through the Wansbeck.

From Wallington Hare went to the Clutterbucks at Warkworth, a charming sunny old house, 'the most perfect contrast to Wallington'. But, he added, 'if Sir Walter saw his house papered and furnished like those of other people's, he would certainly pine away from excess of luxury'.[3]

At the end of October Calverley received a dramatic letter from Charles, with the announcement that he had just accepted the office of Finance Member of the Council of India, the very job that he had originally criticized. George Otto was going with him as his Private Secretary. 'To me,' Charles wrote, 'the appointment is very acceptable as restoring me in an honourable and suitable manner to the public service and enabling me to devote to it the remainder of my strength and health. As a mark of confidence nothing could be more complete for it involves the management of the entire finances of India, Income Tax included.'

So the family honour had been saved. Calverley decided it was time to tell Charles that a few years back he had decided to leave his Wallington estates to him and, ultimately, George Otto. 'I feel satisfied,' he said, 'that it would be well bestowed, and I should be glad to think that you may, after your labours are over, be able to enjoy some years of rest in a place which I think you will like and where you, I have no doubt, would carry out some of the improvements and reforms which I have commenced.' He had long come to the conclusion that it was 'bad for the country' that one individual should hold possessions separated so far from another, and that the Devon, Cornwall and Somerset properties were quite enough for one person (Alfred) to 'enjoy profitably and properly to manage'.

As this communication was in a postscript to a long letter otherwise about the evils of alcohol in medicine, it was indeed something to 'liven up the breakfast table'. The Wallington estate now comprised 23,000 acres. Two years later a reporter on the *Newcastle Daily Chronicle* reckoned that its value had gone up sixty to seventy per cent since 1846. Calverley was thought to have spent £25,000 on deep drainage;

he had 'quite changed the character and appearance of the property', and his tenantry was 'enterprising and prosperous'—once Charles had complimented him on the Wallington estate being like a well-run Government department.

Now Charles wrote back, naturally overwhelmed by such 'kindness' and 'confidence'. The only return he could make was 'in some degree *to endeavour to deserve it*'. He pointed out that as he was already fifty-six, and Calverley only ten years older, there was always the possibility that Calverley might survive him, 'so that the great benefit will be to my son'. He and Hannah had 'bestowed all the care in our power' on George Otto's 'moral and intellectual training', and the boy had not disappointed them. 'He has an affectionate disposition, strong reasoning faculties, and considerable attainments suited to enable him to perform a useful part in social and political life.' Thus Charles felt it would be best not to tell him about the inheritance until he got back from India. The disappointment at not obtaining the Fellowship had turned out to be beneficial, in that it had helped to make the boy's character 'more sober and solid'. 'He feels now that his future depends upon his strenuous exertions at this crisis of his life, and is braced up to work hard with me and under my guidance.' It was vital that nothing should now unsettle him. He must acquire 'a habit of close application to practical business'. There followed diplomatic assurances that Pauline would be cared for if Calverley died first.

They arranged to meet again in London before Charles and his family left late in December. Pauline anyhow wanted to hurry back there, for Ruskin had arrived for a few weeks. On November 26th there was an 'evening tea' at the Carlyles', where they found both Ruskin and Burne Jones, the discussion being mostly about Bishop Colenso and Charles Spurgeon, who had just become Minister at the new Metropolitan Tabernacle.

Colenso's *The Pentateuch and the Book of Joshua Critically Examined* was the book of the moment, to some people the last straw after the *Origin of Species*—'heretical', 'blasphemous', 'abominable', 'the instrument of Satan'. He was a friend of Miss Bell and had been to Winnington, where he had left his five children. Miss Bell had been shown at least part of the *Pentateuch* manuscript in advance and the Birds had copied out some of it for Ruskin, who had told Pauline to watch out for this 'nice pan of fat in the fire'. Later, to the horror not only of his father but of Mrs. La Touche, Ruskin had publicly affirmed that he 'stood by' the Bishop, the crux of the book being that the

Pentateuch included post-exile forgeries—which was to lead to Colenso's deposition as Bishop of Natal and his subsequent excommunication.

On the same visit to London Calverley went to Exeter Hall, to see Cruikshank's huge painting 'The Worship of Bacchus'. Cruikshank, old now and poor, was 'highly gratified' by Calverley's interest, for the hope was that 'this work might aid in staying the mighty evils arising from strong drink'. Later Calverley was instrumental in helping to send the picture on tour, with however disastrous effects for Cruikshank, for the expense was crushing and the public response small. As a result, since publishers were not interested in commissioning works on Temperance matters, Cruikshank became practically destitute. It was Charles Augustus Howell, regarded now as the jackal of the Pre-Raphaelites (and incidentally the supervisor of Lizzie's exhumation in 1868), who eventually was the chief organizer of a public subscription to help Cruikshank, under the aegis of Ruskin and Calverley.

On December 2nd Swinburne had written to Pauline from Fryston, his cryptic letter being headed 'Anniversary of the Treason of L. Buonaparte':

'I am leaving here next Monday and want to know if you could have me then [at Wallington], as you was so kyind as ax. I believe Gabriel Rossetti is or will be at Scotus's, so that haven is presumably barred. William Rossetti is here, and desires to be remembered and cetrer to you. I have Quaggified an eminent Saturday Reviewer who before had seen no merit in the great Sala, but is now effectually converted to the Grace-Walking religion, which hitherto he allays licked. I have to run down into Sussex this week to attend my grandmother's funeral: but am coming back here for a day or two at the end of the week to meet other eminent men. . . . Please let me know if I am to turn up.'

It had been a tumultuous visit to Fryston, we know now, with everyone there stunned by Swinburne's recitations and screams of laughter.[4] Thanks to Milnes, he was contributing to the *Spectator*, but this association was soon to come to an end, after he had written a review of a book by a fictitious French poet named Félicien Cossu, author of such imaginary works as *Une Nuit de Sodome* and *A Quinze ans je ne suis plus vierge*.

Pauline's reply to Swinburne must have been misunderstood, or else she just could not bear to leave London while Ruskin was still there,

for on the 15th he had to write to her, in some desperation, from the Turf Hotel, Newcastle:

'I hope you are prepared for one thing, the natural consequence of your unnatural conduct, viz., to come and bail me out when the hired minions of oppressive law have haled me to a loathsome dungeon for inability to pay a fortnight's unlooked for hotel expenses. Nothing on earth is likelier, and all because I relied with filial shortsightedness on that fallacious letter of invitation which carried me off from Fryston. If I had but heard in time, I should have run down to London, and come up later. As it is I see Destitution and Despair ahead of me, and have begun an epitaph in the Micawber style for my future grave in the precincts of my native County's jail. If by any wild chance—say by offering the head waiter a post-obit, or a foreclosure, or a mortgage, or a bill payable at three months, or a Federal bond, or an African loan, or a voucher, or something equally practicable—I can stave off the period of my incarceration so as to get to Wallington on Wednesday, I shall take the train that leaves Morpeth at 2.15 and gets to Scotus's Gap at 2.50. But I cannot disguise from myself, and will not from you, that this contingency is most remote. It is far more probably that posterity will appear, a weeping pilgrim, in the prison-yard of this city, to drop the tear of indignant sympathy on a humble stone affording scanty and dishonourable refuge To The Nameless Dust of A.C.S.'

A full week passed before he could leave Newcastle. Presumably Pauline did pay his bill. Whilst he was at Wallington he wrote two letters to Milnes, both addressed to 'Mon Cher Rodin', Rodin being the maître de pension in *Justine*, and signed 'Frank Fane', the name of a schoolboy in his poem *The Whippingham Papers* and elsewhere. The Trevelyans would certainly have been surprised if they had known what 'indecencies' were being written under their roof.

Calverley had influenza most of the time. On January 5th, his first day out of bed, he wrote baldly in his diary: 'Alg. Swinburne went.' Scott has described how Swinburne suddenly arrived at his house in Newcastle, having posted from Wallington early that morning. 'Why so early? he could not well explain; just thought he had been long enough there! he wanted letters at the post but had not given his address! I could inquire no further; there appeared to be some mystery he did not wish to explain.'[5] No clue as to the cause of this behaviour has so far been unearthed. It could, of course, have been due to that incident when Calverley threw the 'Balzac' into the fire. If so, Swinburne was hardly likely to have kept silent about the matter to Scott. Maybe he was just bored, or craved alcohol, or had had words with

Pauline, or had been fed up with all the Sunday piety the day before. The Scotts, who were just off to Tynemouth for a holiday, found themselves accompanied therefore by Swinburne. As they walked along the beach he declaimed his *Hymn to Proserpine* and *Laus Veneris*, 'two of his most lovely performances, never to be forgotten when recited in his strange intonation which truly represented the white heat of the enthusiasm that produced them'.

According to Gosse, Swinburne whilst in Northumberland at this time wrote his love poem *The Triumph of Time*, after being rejected by a girl, identified as a certain 'Boo' Faulkner, who in turn has been identified as being precisely only ten years old.[6] Thus Boo (*pace* Rose La Touche) must be ruled out as the love object. In any case the poem appears to be addressed to a person about to get married or who was going to be tied to someone else.

So, on the face of it, Swinburne's precipitate departure for Newcastle might also have been to do with this disappointment. However recent biographers have shown that the poem might actually have been written at the beginning of 1865 to Swinburne's cousin, Mary Gordon, then shortly to marry Colonel Disney-Leith.

Whatever the truth about his leaving Wallington there appear to have been no hard feelings between Swinburne and Calverley, for the two of them, with Pauline, travelled down together by train to London on January 14th.

During 1862 Swinburne had been writing his novel *A Year's Letters*, later known as *Love's Cross Currents*, which contains the two characters Lady Midhurst and Ernest Radworth, claimed by some to have been based on Pauline and Calverley. 'Based on' is certainly far-fetched; 'owes something to' is a possibility, especially in the case of Calverley. Like George Eliot and the Casaubons, Swinburne would simply not have been interested in direct representation.

His Lady Midhurst was born in 1800 and described as a beautiful old woman, clear-skinned with pure regular features and abundant white hair. She was broad-minded (as Pauline was), but had a gift of sarcasm which could get her into trouble. At the sight of her smile a curate would become 'hot and incoherent, finally dumb'. She adored her grandson, Reginald, who indeed owed something to Swinburne, and encouraged his verse-making. Ultimately, however, she was a Machiavellian and destructive character. In a typically Swinburne manner she could say to Reginald: 'Upon my word I should like of all things to give you a good sound flogging. It is the only way to manage

you'; and to her daughter about Reginald: 'It is simply the canon of our church about men's grandmothers which keeps me on platonic terms with our friend [i.e. which prevented her from committing incest].' By the time she reappeared in Swinburne's next novel, now known as *Lesbia Brandon*, she had become a venomous old beauty, a heathen, capable of good turns as well as evil, etc. etc., and far from bearing any resemblance to Pauline.

As for Radworth, when young he had shown a 'singular taste and aptitude for science, abstract and mechanical'. So far so good. He had kept himself aloof from all other learning, and had allowed himself little rest or relaxation. 'His knowledge and working power were wonderful; but he was a slow, unlovely, weighty, dumb, grim sort of fellow, and had already overtaxed his brain and nerves, besides ruining his eyes.' He scarcely went out at all (certainly unlike Calverley). And 'there was always a strong flavour of the pedant and the philistine in him, which his juniors were quick to appreciate'.

Both Calverley and Pauline were unwell during the early part of 1863. George Otto's enthusiastic, vigorous and informative letters from India were therefore all the more appreciated. He told them about visiting places associated with the Mutiny, how extraordinary it was that memories were glossed over so soon—even the notorious well at Cawnpore had been filled up, and it was difficult even to know where it had been. 'The chief traces of the Mutiny, however, are not material but moral. It is no longer the fashion to show the slightest interest in the natives: the "confounded nigger" style is the thing nowadays. The Englishmen who do not belong to the Government Service behave too much like the Orangemen in Ireland. Every day there is a ferocious article against the natives in one or other of the Calcutta papers.' Then he wrote about how he and six others were just off to Nepal for a fortnight's tiger-shooting. They would be using eighty elephants. . . .

George Otto's gift for letter-writing was soon put to more lucrative use, and he began contributing articles in letter form under the title of *The Competition Wallah* for *Macmillan's Magazine*.

On May 12th Calverley and Pauline set out on 'a voyage of recovery' to Paris and the Auvergne.

CHAPTER FIFTEEN

TEMPTED TO
IN-CONSTANCY

1863–64

'OH MY HEAVENS!' wrote Mrs. Carlyle to Pauline. 'How I wish that he [Ruskin] may not break down again on Friday evening, that the shadow of his last disastrous lecture may not fall upon this one! I suppose there is no hope of Lady Eastlake or Mrs. Millais, or both being laid up with smallpox or scarlet fever?' She was referring of course to the 'Tree Twigs' lecture, and the fact that Pauline had written from the Ashburtons' in Paris to ask her to wish Ruskin luck with another, on 'The Stratified Alps of Savoy', at the Royal Institute on June 5th.

Mrs. Carlyle herself was in a wretched state. People were shocked by her frailty. She suffered from insomnia, and during the summer had developed agonizing neuralgia in her arm. She became convinced that her death could not be far off. Yet she still managed to conceal her misery from her husband, who was in the depths of the last pages of his *Frederick*.

Pauline had told Loo that Calverley had decided to go ahead at once with building the Seaton villa, based on Woodward's designs and therefore '*very* modern'. He was giving it to her as a present. Loo, who obviously was soon to be widowed, impetuously decided that she too must have a villa there—even if she had never been to Seaton—and Calverley was made to agree to sell her a field on the cliff next to the proposed plot.

The trip to the Auvergne had been a 'success in all conceivable ways'. Ruskin had been amazed to hear that Pauline had managed to climb the Puy de Dôme, nearly 5,000 feet. 'I should like to know where you'll go next,' he wrote on June 17th. 'From coals in Northumberland to cinders in Auvergne, and pretending to enjoy them.' The letter was cheerful enough, considering the press attacks on his *Fraser's Magazine* articles (eventually published as *Munera Pulveris*) and the fact that the publishers of the magazine, alarmed by the outcry, had said that there

could be no more. Geology was now an important preoccupation for him—hence the Royal Institute lecture. The battle over James Forbes's theories on glacier motion was still in progress; Forbes had been attacked by Huxley and Tyndall, who had opposed Whewell's suggestion that he should receive the Copley medal, on the ground that his work had been anticipated by Agassiz's former assistant Desor. Ruskin was very much against Huxley and Tyndall in this matter, and defended Forbes (bitterly hurt by an article in the *Quarterly Review*) in lectures and letters to the press. 'Our friends the glaciators are still locked in mortal strife, you see,' Pauline told Loo.

In mid-July 1863 the Trevelyans collected Pauline's niece, Constance Hilliard, aged eleven, and returned to Wallington, to prepare for another visit from Ruskin. Dr. John Brown had also been invited.

Scott now wrote to announce his return to Newcastle. He had been spending a week with Rossetti at Cheyne Walk and had enjoyed it very much. 'It is an emancipated menage, and the furnishing of the house is really astounding. Gabriel is at present in great force and plenty of commissions, so he is serene in this respect. Algernon was there.' Whilst in Italy Scott had been taken very ill. It seems likely that this was the occasion on which he was struck by *alopecia arcata*, a disease which resulted in total loss of hair. Thus he was forced to wear a wig. Rossetti, who was addicted to limericks, wickedly wrote:

'There's that foolish old Scotchman called Scott,
Who thinks he has hair, but has not.
He seemed too to have sense,
'Twas an equal pretence
On the part of the painter named Scott.'

There were other, more hurtful variations. Naturally Scott was extremely sensitive about his affliction. All credit therefore to Miss Boyd, that her love for him never dimmed, especially in view of the suggestion that the disease was accompanied by hypopituitarism, loss of sexual drive.

During the week at Cheyne Walk two photographs of Rossetti, Ruskin and Scott were very likely taken in the garden by William Downey: Rossetti pallid and ill at ease; Ruskin confident and elegant, with walking stick and velvet-collared coat; Scotus, sans Mephisto-phelean eyebrows and Vandyck beard, but with a kind of bowler to keep his wig in place, very much the odd man out, in one photograph looking like a truculent John Bull, in another with eyes meekly

downcast and a foot on a chair. Since these photographs were bitterly commented on by Ruskin in his quarrel with Scott nine years later, it is worth mentioning the magnanimous letter Ruskin wrote on September 18th to his father: '. . . The broad-hatted individual I always forget to tell you is Scott, the painter of Lady Trevelyan's hall— a very good and clever man, and one of the honestest and best scions and helpers of the best part of the Pre-Raphaelite School.'[1] He had no reason therefore, he said, for being ashamed of his company. But Scott's own dislike of Ruskin, it becomes quite clear over the next weeks, had not diminished by one iota.

The house-party at Wallington was kept in suspense about Ruskin's date of arrival, for he insisted that he must first visit his Birds at Winnington—he wanted to take Ned and Georgie Burne Jones there too. 'As I have a remnant of character still to lose to Winnington,' he wrote, 'and none at Wallington, I think it will be best to keep my word to the schoolgirls, who still believe it a little. But I want to see Dr. Brown very much, and if you can get him to stay over Monday I'll come to Wallington on Monday 10th.'

There followed another letter, also undated, mostly about train times and whether or not he could arrive in time for dinner. He added: 'This place [Winnington] is very pretty just now in its perfect green—lovely park and dingle foliage: and the girls are out of doors all day at some mischief or other (what it is called a "School" for, I can't think) and look mightily pretty glancing in and out among the trees by threes and fours.'

He finally arrived on August 11th. Scott, who was still being kept waiting about a commission to paint the upper part of the hall, had been summoned to Wallington by Pauline four days before. 'As far as I can judge,' he had told his 'dearest goodie', Alice Boyd, 'there is nothing whatever in the wind, only gossip seems to be the motive for her wanting me. She wants to hear all about the Cheyne Walk household, which she thinks must be fun, she says. I must keep a wary tongue in my head.' Like Ruskin later he fell under Connie's spell: 'one of the few perfectly delightful children I ever met'.

Obviously Scott was on edge about people's reactions to his eight pictures, ranged round the hall like a 'diadem of Pre-Raphaelite jewels', a gushing American visitor had said. To his intense boredom, however, he had been forced to spend much time with a young Miss Perceval, a Trevelyan relative who wanted to know how to paint; she was described to Miss Boyd as 'a botanical lady of uncertain age and with

the highest nose in creation'. As for her brother Charles Perceval, Lord Egmont to be, he was 'a cub of seventeen who I think never said a word to anyone all the time I was there, but disappeared after breakfast (a blessed fact) for fishing and shooting'. Very different from the boy's lively first cousin, George Otto.

As it happened, Ruskin arrived in time for tea on the lawn, an event which always remained an unforgettable experience in his memory; little Connie acted the hostess—she had sent letters of invitation to every member of the household. She was just Pauline all over again, he told his father, and 'glittered about the place in an extremely quaint and witty way'.[2]

The teapot was enormous and Connie could hardly hold it. Uncle Calverley arrived late and was immediately rebuked severely. Such daring behaviour on her part at once made the conversation languish, at which Connie ordered everybody to continue talking. Ruskin wrote to Lady Waterford about the exchange that followed: ' "Why don't you talk, properly?"—"My dear Miss Hilliard—(I began) you do not consider how a stranger must be at first oppressed by your presence—" (Miss interrupting) "There—there—I don't want any more of that." '[3]

The next afternoon Brown and Scott left, taking Connie with them as she was to spend some days by the sea. In the morning there had been a walk on the moors—Brown, Connie and Ruskin—when as Ruskin said in *Praeterita* 'it dawned on me, so gradually, what manner of man he [Brown] was.' Thus, as the years went by and he began to recognize Brown as 'the best and truest friend of all my life', the 'dearness' of Wallington became more deeply founded in his memory.[4]

In his letter of August 13th to Alice Boyd, Scott had admitted that Ruskin had been 'very good and sweet and kind to everybody, myself included, dancing to amuse little Constance, and playing at croquet standing behind the ball before him like a woman'. So, he added, 'I suppose one ought to be delighted with him; yet he is a little nauseous.' In another letter, dated the 16th he told how he had overheard 'something concocting for after breakfast'. After a while he had made his way up to Pauline's boudoir: '. . . and there came upon a sweet scene. Lady T. and Dr. Brown sitting in a wrapt almost devotional attention opposite a row of Turner drawings Ruskin carries about with him, displayed on chairs, the thin figure of the critic moving fitfully about seeing that they were properly exhibited, and pointing out the "wondrous loveliness" of each. Of course I joined in and cried "Oh, what a glorious treat!" '

After Brown's departure Ruskin descended into gloom. He told his father that he had been given the beautiful room hung with the tapestries done by Julia Calverley, Sir Walter Blackett's mother, and was sleeping in a bed with fluted columns and hung with crimson damask. The weather had changed, the wind was howling, everything was grey and wretched. Still, Pauline was in great spirits, 'better than ever I knew her'. He could not go out, because he was still finishing 'some weeds [the corn-flowers] at the bottom of the coin [quoin] I did six years ago'.

Eventually he left Turner's painting of Schaffhausen for Pauline to study and copy, but on condition that her new dog Tiny, which he hated, should not 'wrap his cutlets' in it. The nights of the 18th and 19th were spent in an inn at Coldstream, and he wrote to Pauline how the Tweed was 'intensely lovely and makes me utterly miserable'; it sighed and moaned like a human creature and seemed 'more senseless than Tiny' and was 'as black as his nose'. To his father he said that the river was like the Tay; 'it makes me feel as if the air is full of ghosts', a reference to Bowerswell and Effie.[5]

As soon as he was out of the way, Scott was anxious to know what he had thought of the hall at Wallington. He was sure he could not have liked 'The Nineteenth Century', 'somehow identifying labour with squalor and ugliness'—which only went to show that he had not done his homework on Ruskin's political economy theories. He complained that 'at first he questioned me as if I had run my head blindfold against the canvas', and admitted that 'meeting Ruskin is always a sort of stab to me'.

Pauline replied more frankly than he even perhaps expected, with the usual teasing twist that must have left him guessing. Ruskin considered the pictures to be 'in the highest sense of the word great works', and he thoroughly admired them; indeed he had said that he 'does not believe that we could have got them so well done, take them all by all, by any other living man'. He had found 'some wonderfully skilful dexterous things', but 'he does not *enjoy* them, because the colour is not pleasant, and one colour is left quite uninfluenced by another, and the unnecessary bits of ugliness and vulgarity annoy him as cruelly as they annoy me (perhaps worse, though I doubt it)'. And it could have cost her some effort to say this.

She was pleading with Ruskin to return. Connie, she told him, was back at Wallington too, and she would make Scott come out specially. . . . Was she really trying to be wicked?

'You know,' Ruskin replied, 'no human creature (masculine and so

deceivable) could stand such coaxing like that—and the sacrifice of the hair and all [i.e. Scott's baldness].'

So he came, on August 22nd, with his friend the Rev. W. Kingsley of Thirsk, and arrived four hours late at Scots Gap. He only stayed two nights, then was off to Winnington again. He did a little more work on his pilaster; even though it was still unfinished and he never touched it again, it remained, and still remains, the most graceful, indeed the outstanding piece of work artistically in the hall. The reason for his escaping was to avoid the opening of the British Association, which was to be in Newcastle that year. Calverley was one of the Vice-Presidents and had hoped that Ruskin would show his diagrams of Mont Blanc to the glaciators. But Winnington was the longed for tonic to revive Ruskin. 'I'm glad you miss me a little,' he wrote eventually to Pauline from there. 'So do I you and Con—though I have some nice "Lilys" and Isabelles and Mays here to tempt me to in-Constancy.' And he sent Constance 'all kinds of devotion'.

On September 8th he was off again to Savoy.

Connie had had a special letter to herself from her other admirer, Dr. Brown, whom she called J.B., or Jeye Bee, to distinguish him from Ruskin, J.R., or Jeye Err in the Scottish accent. She and Brown had been 'playing houses' at Wallington, she being the wife, he the husband. Although she treasured the letter for the rest of her life, it disturbed her at first. It was written mostly in an ornamental script and decorated with little drawings of the type that had been delighting his Edinburgh admirers (p. 198).[6]

He addressed her as My Own Dearest Little Wifikie (and persisted in doing so in later letters), and ended Your

SATURN TIGLATH-PILESER

Later Connie seems to have become accustomed to being his Wifikie. She sent him her photograph. He thanked her: 'It is so "awfully" (as young people now call very) good and like ... and the sly, prim, droll, quaint, queer, dear, funny, sunny, look all over, which is EURZ.' All this was against the tragedy of Mrs. Brown's last illness. He wrote to Pauline on the day of the funeral, and necessarily his letter to his 'dear, dear friend' was in great contrast, showing that she must have sent him a note full of characteristic affection and warmth.[6]

Meanwhile George Otto's letters arrived regularly from India, lively pendants to his *Competition Wallah* articles, which were circulated with pride among friends in Northumberland. Charles was said to be overworking, 'sheer madness during the hot weather', and up until the small hours. On August 2nd 1863 George Otto wrote from

Ootacamund, having received from Calverley some improving litera-
ture on temperance for the soldiers. It was like paradise up there after
the burnt plains of Madras. 'You cannot imagine the pleasure of
drawing a blanket over oneself at night and awaking in the morning
to a tub of cold water, after long long nights of sleeplessness, and
mosquitoes, and prickly heat, and quarrelling with the punkah-puller.
My mother enjoys herself intensely. . . . She drives around in a pony-
chair.' Needless to say his father was receiving some opposition from
civilians of the old school, but for once he was being 'patient and
cautious' and 'so considerate'. This time there was no fear of 'diffi-
culties'; 'he keeps everyone to his work, prevents much speculation
and more extravagance, and infuses spirit into every branch of the
public service'.

On November 13th George Otto wrote from Delhi. It was to be
his last letter from India before returning home. 'I have very grave
news here. Lord Elgin [the Governor-General] is dying, and our force
in the mountains has met with a serious reverse [the Ambela Campaign].
With our usual pugnacity we have sent an army at the beginning of
winter into the middle of the snows to subdue an enemy who might
be put down by a neighbouring tribe for a bribe of a few thousand
rupees. In consequence we have sustained a disaster, drawn upon
ourselves an apparently interminable war, and, as a culminatory
misfortune, there are alarming reports of a general sedition among our
Sikh regiments: which God avert! Then at this precise moment, Lord
Elgin dies [he died on the 20th] and the Government devolves to a lazy
good-natured old philosopher, Sir William Denison, who knows as
much of northern India as a pig does. . . .'

All this stirring stuff would have a considerable effect on his father.
On the way home George Otto began to adapt and revise his articles
for publication. He had a consuming desire to tell people in Britain the
truth about his compatriots' behaviour in India. 'I entreat adverse
critics,' he wrote in his preface, 'to show that I am wrong in my facts;
that the Europeans settlers cherish a kindly feeling towards the children
of the soil; that they speak and write of them as equals in the eye of the
law—as fellow-men and fellow-subjects; that they do not stigmatize
them as "niggers", and treat them little better than such; that they do
not regard as execrable hypocrisy the sentiment that "we hold India
for the benefit of the inhabitants of India". '

No wonder Charles began to encourage him to get into Parliament,
and 'give up his whole life to public affairs'.

It had been Woolner who had told Pauline the sad story about Mrs. Carlyle, how she fell while avoiding a cab as she got on to an omnibus, 'in the midst of city roar and traffic,' and lacerated the tendon of her leg. For weeks, he said, she could scarcely be moved from bed. 'When I last saw her, she could just bear her foot on the ground; and yesterday by aid of a stick she could walk across the room. But her spirits are pretty good, though she looks almost a ghost in gauntness.'

However Pauline, on her way to Seaton, could not manage to call on her. It was pathetic to see the poor woman's tortured handwriting in her letters to Loo. It seemed that desperate efforts were being made to hide the worst from the Sage himself, but Mrs. Carlyle was often in such pain that she literally was afraid of losing her reason. 'They say I shall get well *in time*,' she wrote, 'but I don't believe it.'

No doubt Swinburne had been writing to Pauline. If so, all his letters in 1863 (and for that matter 1864) must have been consigned to the flames. For instance, on January 21st, 1863, he had written to Milnes: 'Have you read Salammbô? I have just written Lady Trevelyan a brilliant account of it. The tortures, battles, massacres and Moloch-sacrifices are stunning.'[7] Maybe he had sent her *Chastelard* and some of his poems, about which Ruskin had been very discouraging. To publish them, Ruskin had said, would only win him a 'dark reputation', and had intimated in his exquisite way, as Swinburne put it, that 'genius should simply devote itself on behalf of humanity to overthrowing its idols'. Nevertheless Swinburne continued his work with frenetic energy, and that autumn began *Atalanta in Calydon*.

Life at Cheyne Walk, thanks to Swinburne, was becoming more emancipated than people had bargained for. As Gosse says, Rossetti was finding his 'little Northumbrian friend' a tempestuous inmate.[8] Indeed on occasions it was pandemonium, sliding naked down the bannisters being only one thing to which Rossetti objected. Alcohol made Swinburne violent. Worse, his contribution towards the rent became overdue, and epileptic fits were becoming frequent. It is not surprising to learn that early in 1864 he was asked 'with all possible apology' to leave Cheyne Walk.

Ruskin's letters from Chamonix were slightly more cheerful than they must have been to, say, Mrs. La Touche, who declared to George Macdonald: 'I don't care what becomes of me so long as anyhow he can be brought back to some sort of happiness and life.'[9] To be sure self-pity was not absent. 'I can't bear *myself*', he told Pauline in a flood of anguish, 'and hate everything I do and say, and it seems to me as if

everybody *must* tire of me in a little while, and if ever I've let myself get the least bit fond of people, something always goes wrong, and it hurts so; and yet, if people really did want me I'm sure they're welcome, if only they could be sure of themselves, and promise not to tire—there are Ned Jones and his wife for instance, you never saw such sweet letters as they write me, but the moment I'm near them I feel sure they're liking me less every minute; then they see that; and have to tell me they aren't tiring of me—and that must tire them, you know. But I've told them and the Winnington children, who really do cry a little sometimes when I'm going away, and whom I really do love very much (fifteen or sixteen of them at least, not all); that they may do what they like with me, only now I'm all at sea again and don't know what to do with myself.'

Pauline had commented on something connected with his Political Economy theories, presumably to do with the fact that there were people doing 'unpleasant' jobs who would be unhappy if taken away from them. 'How funny you are,' he replied, rather more calmly, 'as if I hadn't thought of all that! You are just like a bad patient with a doctor. . . . Don't you see that every bit of that work of mine points to a radical change in the aims of human life—and in every custom of it therefore?'

Then Rose fell ill with a 'brain attack', and he became desperately worried. 'I am so puzzled with everything and dead to everything,' he told Macdonald. He thought she was being driven mad by religion, and indeed she did believe she was being 'guided': it was all 'a sort of clairvoyance'. Suddenly in November she recovered a little, though she could not read or be read to. So communication between her and Ruskin became impossible.[10]

He went to see Pauline at the Hilliards' 'little rectory home' at Cowley. It was then that he first met Connie's brother, Laurence, aged eight and already showing signs of being a considerable artist. 'I never saw anything approaching that child's work, except Turner's, in perfectness of manner,' he wrote afterwards. Some thirteen years later Laurence Hilliard became his secretary, and his mother was in due course counted one of the most 'important among my feminine friendships'.[11]

Down at Seaton Pauline busied herself with her lace people and Calverley plunged into multifarious plans for the town's improvement —drainage, a sea-wall, a temperance hotel, public baths, committees for modernizing the fourteenth-century church. An architect named

Edwards was summoned from Axminster, where he had designed a bank and a police station, both Gothic and 'good'. All this was exciting and creative, but otherwise it was a time of gloom.

On January 7th Woolner wrote to say that Mrs. Carlyle looked more 'like a dark ghost than a mortal in the flesh'. She had sent word on New Year's Eve that she wanted to shake hands with him. 'When I did she said, "Tomorrow is the first day of the New Year you know," and she seemed to imply that she thought it would be the last she would ever see. Carlyle pulled me away, so that this was all she said.' On March 3rd Mr. Ruskin, 'that dry antique little man',[12] died, and his son replied to Pauline's letter of sympathy: 'I knew well enough how you would feel. I could have given you darker words, even when I wrote that former note, but wanted to soften the shock to you a little. My mother has borne it hitherto—by unspeakable sweetness and strength of heart. I think she is now, for the time, safe.'

Pauline sent Mrs. Ruskin a present of lace, very much appreciated. In another, again undated, letter Ruskin wrote: 'We are getting on pretty well. I should be very well if I could work. . . . My mother is quite herself. I think if I were to get rid of all my Turners I should be better—they torment me so because I can't get any more. . . . Rosie's so ill—you can't think—her mother sent me two photographs yesterday—and she's so wasted away—not that there was ever much of her to waste—but there's less now—and the face full of pain—and she looks about thirty-five—and she can't eat anything but children's meat—and she can't write me a word. Everybody's dying—I think—at least—they would be—if one were sure one had ever been alive. How long are you going to stay at Seaton? You couldn't come—could you—and look after the house and the gardeners for a day or two, while I go to give a lecture at Bradford? No—it wouldn't do—my mother would bore you—or feel as if she did. . . .'

Pauline certainly would have gone had not Loo begged her to come to the Grange at once, for Lord Ashburton had pneumonia and was probably dying too. Young George Otto had just arrived from India, and it seems that he also was invited—not a very cheerful prospect for him. They reached the Grange on March 17th, to find Loo's mother already there. On the 21st they left, and on the 23rd Lord Ashburton was dead.

A flood of loving letters reached Loo from Pauline. 'I cannot tell you what I feel at hearing from everyone about you, my Beloved, how nobly and Christianly you have been bearing your terrible grief.' All the same, no time was lost in getting on with designs for the villas

at Seaton. By the 30th the two sites had been marked out. On the next day Edwards arrived. Loo's house was to be in timber and concrete and would cost about £700; the stable and coach-house would cost about another £100. 'Ours is to be of flint and concrete—in squares— which will cost if anything a little less.' Flint was chosen because it was the 'material of the country'.

Pauline's strange gabled house was destined to be known as Calverley Lodge, and later as Check House because of the squares. It was indeed very modern for those days, one might say avant-garde. The legend at Seaton is that Ruskin was the architect—of course untrue, though it is perfectly possible that Woodward's plans would have been shown to him for approval and comment, as had been the case with Dobson's when the hall was roofed over at Wallington. Loo's house, Seaforth Lodge, seems to have been mainly designed by Henry Clutton, as for some reason she rejected Edwards' work. It was finished by the end of 1864, over a year before Pauline's.

Scott had retired from the Newcastle School of Design. Partly as a result of lessons learnt from the 1862 Exhibition, it had been decreed that there should be a complete change in the organization of all the Schools, and their heads were given the option of retiring on small pensions. Scott had taken up this option so that he could live in London. As it transpired, Alice Boyd decided that she had never cared for Newcastle society and would have to come south too. So a happy little arrangement was made: she would stay with the Scotts in London during the winter, and they would stay with her at Penkill in the summer.

Whilst house-hunting in London, Scott sent Pauline news of Cheyne Walk: 'The other day I saw at D. G. Rossetti's all the Art-workmen [Morris and Burne Jones] and Swinburne [hoping to be readmitted]— a sort of business dinner, Swinburne and I retiring to read his poetry while the *firm* discussed affairs. Algernon is not much different, only developing some singular conditions of vanity, and otherwise inter- larding his discourse with ferocious invectives against Browning.[13] Rossetti is making an incredible lot of money and number of small works, so he is adding to the masses of curiosities in his home—a set of blue china of 130 pieces for instance which cost him the other day £50. He went out with me to show me the old curiosity shops where bargains can be got, and invested in another set! E. B. Jones is now painting wonderful pictures in invention and colour. Really wonderful in Mediaeval spirit, and showing the highest instincts in colour. And

yet in the planning of the design and in the drawing quite like an amateur's work. Of course also, one sees the derivation of his scheme of art from Gabriel, but then he goes further and elaborates greater things.'

Pauline had at last agreed to spend some time at Nettlecombe. She pressed Scott to join them there, and he came alone. He was enchanted. 'This place and county is, I think,' he wrote to Leathart, 'one of the most lovely I have ever seen or imagined. An Elizabethan mansion in a hollow of emerald green park with hundreds of fallow deer and the finest ashes, oaks, cedars in England. A hall with a fireplace as large as a room and an oriel with a window twenty-five feet high. Endless family portraits. Magnolia trees in full bloom with white lily-shaped flowers as large as one's head!'[14]

Pauline was in splendid form. She found herself greatly enjoying Nettlecombe. Scott began a portrait of her holding camellias (from plants bought in Portugal in 1846?)—possibly the best likeness of her in existence. She was in profile, her 'anterior development' very apparent, her hair like folded wings on her head. Her dress was white with silver and amethyst stripes, and she was wearing an amethyst necklace. She looked twenty-eight instead of forty-eight. Scott also designed a dining-room table, à la William Morris; Calverley found a splendid broad plank for it hidden in the stables, only to be told by the factor that the piece of wood had been 'put by' for his coffin. . . . Pauline was delighted when her lace designs won first prizes at the Bath and West show.*

Before the Trevelyans left for Wallington, Pauline had a letter from Woolner. He had some wonderful news to tell her—'I am going to get married!!!!!!' There had been terrible work with the girl's parents, he said. He continued the letter in his funny staccato style, so typical of him in later years: 'Did not think me religious enough; soon settled them on that point; but had to promise to go to church twice on Sunday, which, considering what most sermons are, I thought no trifle;—thought the girl far too young; which I by no means agreed to, and so they were obliged to give up the point;—thought me much too old;—said I was very sorry, and would be glad to be younger if I could; and as they could not suggest as to how this was to be done, they had to give this up likewise. Then it was dubious as to whether I was rich enough. . . .'

This explained why they had not seen much of Woolner recently,

* Pauline's prize-winning bobbin lace handkerchief, with a design of ferns, is now on display at the Victoria and Albert Museum.

and why such slow progress was being made on the group. He des-
cribed the girl as gentle, with a 'lofty cast of spirit', no great beauty
but with well-formed features and an 'exceedingly refined expression'.
Her name was Alice Waugh, and she was the sister of Fanny, the future
Mrs. Holman Hunt, who was once to have been the model for the
group (though in the end only her hair was used), and in whom he
had once appeared to be more interested.

The marriage was on September 6th. Fanny died in 1866, a year
after her marriage and after giving birth to a son. In 1875 Hunt married
the third sister, Edith. Evelyn Waugh was their great-nephew.[15]

George Otto was one of the first guests at Wallington that summer.
Indeed during the next months he had the 'free run of the house'. For
some while he had been looking for a suitable constituency where he
could stand as an Independent Liberal. As his son, G. M. Trevelyan,
was to put it, socially he was a Whig, but in politics he was a Radical.
He revered John Stuart Mill at a distance, but found him 'a bit of a
bore' at close quarters. 'It was John Bright who touched some chord
in his moral nature.'[16] Lord Grey, being the Lord Lieutenant, had been
approached by Calverley about a possible seat in Northumberland.
He had been rather dampening, even about the Liberals' prospects in
the country. It seems more likely therefore that it was because of Sir
George Grey, who was member for Morpeth, that George Otto was
suddenly approached by a Liberal delegation from Tynemouth outside
Newcastle. At first George Otto was very wary; he was 'determined
not to be made a cat's paw of'. Tynemouth was a 'small borough of
old world character' where the Tories had always been entrenched,
thanks to the influence of the Duke of Northumberland and the big
shipowners. But the challenge came to excite him, and eventually he
agreed to be the Liberal candidate. So, when he was not after the
blackcock on the moors around Wallington, he was apt to be 'tearing
off' to Tynemouth, to 'get on with the nursing'.

He had much in his favour, besides youth and self-assurance. Not
least of course was the fact that he was Macaulay's nephew. His
Competition Wallah had been mostly well received. The Prince of
Wales was known to have been a personal friend of his at Cambridge.
But, asked his detractors, could he really claim to be a Northumbrian?
True there was the Blackett connection in the background, but did
not the Trevelyans boast of being Cornish and was not their main
seat in Somerset, where George Otto's father had been born? And
apropos of Calverley, what was George Otto's attitude to temperance?

House parties were honoured with readings from George Otto's new book *Cawnpore*. Pauline was very excited about it and wanted Ruskin to come and listen too. But, Ruskin simply countered, what about 'nice girls', were there any for him to play with in that 'square well' of hers, all full of 'nettles and weeds' (meaning the pilasters)? She presumably had to admit that there were no girls available of the age he liked. 'The idea,' he had then replied, backing out, 'of my coming down there among those peewits and snipes.' And as if for an excuse: 'I go to the Brit. Museum every other day and live with the (Egyptian) Gods.'

He had become quite rich since his father's death, and now that he had found a secretary—none other than that splendid bounder, Charles Augustus Howell—to take over, as he thought, some of the burden of routine work, he was able to indulge himself in some of his newer interests, such as Egyptology and Octavia Hill's housing schemes for the poor. He was also (no longer being inhibited by his father's disapproval) writing a spate of letters to the press on political economy. A young cousin, Joan Agnew, in due course his ward, had been found to look after his mother.

On September 9th Scott arrived at Wallington, still without any clear idea about whether he was going to be asked to paint the upper spandrels or not. 'Dearest, I kiss you in fancy all over,' he wrote to Alice Boyd. 'This young fellow George Trevelyan says he wonders how anybody can be moping and dull. There are so many things to interest one, and so many books to read, and Lady T. with the sparkle in her eye calls out, "Oh yes, I can't bear people who don't enjoy life, and moon about"—then after a moment—"except fat parties, who can't expect to be very lively, you know Mr. Scott!"' There were so many well-bred young ladies around, all wanting to paint, that Scott could hardly get a minute's peace. 'When my birthday came round, I told them all at breakfast and got nicely chaffed for it. However Lady T. proposed something should be done to celebrate it, and we had a game of croquet or something.' One of the young ladies was Francis Pattison, 'A beauty, her hair en toupie like the Queen Anne time, with two loose ringlets hanging from the back of the ears in front of the shoulder'. She was 'tremendous in anecdote and conversation' and considered a 'pet' in Oxford. He ended by thinking that she was so artificial and heartless that she was a 'kind of monster'. Thus he decided that he hated her 'like brimstone', and thought Pauline did the same.

Scott could not have been more wrong about Pauline and Francis,

who was busy painting great bold sunflowers on a pilaster. Francis wrote afterwards to say that her visit was the 'highest bit in her Northumbrian recollections'. In her biography *Lady Dilke*, Betty Askwith believes it was Pauline's example that now prevented Francis from trying to escape from a marriage that she knew positively to have been a mistake.

At the very last minute before his departure Scott was taken off his tenterhooks, and Calverley agreed that he should decorate the upper spandrels with scenes from the ballad of Chevy Chase, though 'not to do yet but to design and prepare for'. Yet another austere subject, indeed a gory one, and rather strange for a pacifist household. About eighteen small pictures would be required, and the aim was to make the series 'a true tragedy with the award of punishment sufficiently pronounced'.

On October 10th, at two in the morning, Pauline suddenly became alarmingly ill. Calverley thought she was dying and telegraphed for two doctors, one being Dr. Howison, who had treated her in the old days but was now in practice at Darlington. There were still guests in the house, but Wooster was sent to Morpeth to stop the tiresome Louisa Yea from coming.

By the 18th there were three doctors in the house. Nevertheless Calverley was able to write that day in his diary: 'Howison gave us hope which God grant.' The words were underlined. On the 21st he wrote to inform Loo. The danger had passed, he said. Principally the illness had been a 'bilious fever', more complicated and difficult to treat than on previous occasions. Pauline was still so weak she could hardly hear any letters read out to her, and for a while she had not even been able to speak.

Ruskin was at Winnington when he heard how ill she had been. Although busy with lectures he told her that he intended to write every day until he knew she was properly recovered; and she was not to answer, or he would immediately stop. Judging by the number of short letters that have survived it would seem that he kept his promise.

The lectures were to be 'Of King's Treasures', on the influence of books, and 'Of Queen's Gardens', on women's education. Both these were eventually published as *Sesame and Lilies*. He also in due course published *The Ethics of the Dust*, based on his talks to the children of Winnington.

Ruskin's letters were full of lightness and charm, ideal for an invalid.

Inevitably some of the remarks about his Birds cannot but raise a smile when—wise after the event—one reads them today: '. . . I've been having such a game at blind-mans-buff (at which *I'm always* blinded—because they say the game is blind-mans, not blind-girls) in the schoolroom—and they laugh at me so because I never can remember, if I try ever so—who it is that has "got on" what. Then the ones that have their hair tight let it loose—and the ones that have it loose tie it into knots—and they put on each other's brooches and bracelets—and they plague me out of my poor little halfwits.'

'I think I gave them a tolerable piece of talk last night—some bits strong enough even—perhaps—to have done *you* a little good—if you had been there to hear them—if anything could in the least amend you. Perhaps—if you had been there—the sense of intractability might have been too much for me. I had some of my schoolgirls there—they sat very quiet and made no faces at me—wasn't it good of them?'

'I've been saying everything likely to be beneficial to society in general in my lecture—and don't feel as if I had any didactic remnant in me for you—not that anything would do you any good of course—but it's too provoking to lose a day's lecturing of you when you can't answer. . . . Lily and Isabelle having been rolling me round the room on the floor, and pulling my hair over my eyes, and curling it afterwards—and pinching a great deal out.'

'I'm going to read his [De Quincey's] Joan of Arc to the children tonight. I think you would have liked to see the pleasure of a little Puritan girl of about fourteen who was "very good" when she came to school four years ago—and whom I've been trying to take the goodness out of, ever since. She came into the gallery today all aflush—she had written to her father and mother to come to Manchester to take her to my Wednesday lecture—and they've promised to come, to please her—and she's in a great state. And I've some other nice little pets, one Irish dark-eyed Lily—very precious in her own way—but nothing any of them like my old pet—and she's still ill—and cares only for her horse and dogs.'

'How stupid I am—this afternoon. I've been having a violent romp, and am giddy—how strong schoolgirls are! or at least are here—where they spend more time in playing cricket than anything else.'

'I haven't a minute—I've had so many goodbyes at school today and the girls are so pleased with my lecture on girls that they've kissed me all to pieces—the prettiest of them make their lips into little round Os for me whenever I like—as if they were three years old.'

Pauline was very moved by Ruskin's attentions and, when she was

better, wrote to Dr. Brown to tell him so. How frightened, Brown replied, he had been by her illness. 'It was good of you to write—quite as good, let me tell your convalescent Ladyship, as Ruskin writing you, any way. Why shouldn't he? and what else has he to do? I am sure he has wings under his flannel jacket; he is not a man, but a stray angel, who had singed his wings a little and tumbled into our sphere. He has all the arrogance, insight, unreasonableness, and spiritual "sheen" of a celestial.'[17]

Then, at last, Pauline was able to leave. She yearned for the sea air of Devon. A few days were spent in London, and Calverley took her to see the architectural sensation of the moment—Edward Barry's new hotel and station at Charing Cross, on the site of the old Hungerford Market. He also went to Heal's to inspect modern furniture, with the furnishing of the new 'cottage' in mind.

On December 28th he wrote in his diary: 'To Seaton via Colyton where Lady Ashburton's carriage met us.' For much of January and February Pauline had to be confined to her wheel-chair. Yet she was very cheerful, and on January 5th Ruskin was writing back: 'That is indeed all nice news—your letter came pleasantly today, a diamond among a wheelbarrow full of gravel delivered by the postman in form of begging letters.'

TROUBLE WITH ALGERNON

1865–66

> 'Who's come to Tynemouth, full of grace,
> With big black whiskers on his face?
> Who fancies he can go the pace?
> The Wallah!'

THIS was a jingle 'by a Chum' that, with several other verses, was being circulated in the Newcastle area about George Otto. There were digs about his fancying himself 'a second Clive', being 'self-satisfied' and wishing to keep 'poor harmless men' from 'drinking now and then'.

George Otto now kept a permanent room at the Star and Garter at Tynemouth, and it was here that he finished his *Cawnpore*. His answer about temperance had been that he would be glad to see a Bill passed prohibiting the sale of spirits provided that the 'majority of ratepayers were in favour of such a measure'. He was 'too jealous of personal liberty and private judgement to be dogmatic about the matter'. The jibe about not being a true Northumbrian was however more worrying.

Suddenly it was suggested that his success at the next election would be assured if he bought the Chirton estate on the edge of the constituency. But the sum needed was staggering: £62,000. George Otto realized the advantage at once, and tried to take it all with calm. He wrote frankly to Calverley. His own available cash came to £9,000, and he knew his father would help substantially. The Town Clerk of Tynemouth had said that he would lend £10,000 and a mortgage could be raised. But £16,000 would be outstanding. Could Calverley help towards this sum? There was no doubt that the acquisition of Chirton would prove a splendid investment.

Possibly even before Calverley had had time to react, another letter came speeding to Seaton. George Otto had had second thoughts. He had written in 'terror and uncertitude'. He was willing to pay a deposit, but had decided he would tell the vendors that he would not contemplate buying Chirton until he knew whether he was to be

member for Tyneside or not. 'I would rather lose the election, and come out of the matter uninvolved, with a good reputation, and minus a sum which I can well afford than be mixed up with such a perilous business.'

When G. M. Trevelyan wrote his father's biography he misunderstood the details of this transaction. He thought that Chirton was bought before the election (in July 1865) and sold immediately afterwards, 'having served its purpose'. Such behaviour was difficult to explain away. 'The fact that my father of all people first entered Parliament by such a road—indicates how little of a Radical he then was, and what were the limits of the electoral reform that had then been affected in 1832.'[1] He also gave the impression that most of the £62,000 had been provided by Calverley. In point of fact the purchase was not completed until November, and George Otto's views were essentially Radical even before the estate was offered to him. Calverley only put up £10,000. And Chirton was sold when George Otto abandoned Tynemouth in 1868, after the constituency had been reorganized as a result of the new Reform Act and he became member for the Scottish Border Boroughs.

Pauline was gathering strength slowly. It seems as though she may have had a stroke, for Scott wrote to Alice Boyd about an alteration in her face: one eye was a little twisted and half closed. Her temper had also been affected, and she would flare up in an unpredictable way. Loo's villa, Seaforth Lodge, was not only finished but habitable. Fairly grand it was too, in a conventional way. There was certainly nothing Gothic about it, though she had evidently incorporated some William Morris tiles and 'bits of glass'.[2] It was simply a place for holidays.

Loo had invited the Carlyles to Seaforth Lodge. First, however, the dread *Frederick* had to be finished, so life meanwhile was dull, not to say dismal, at Cheyne Row. Mrs. Carlyle, now a little better, wrote to Loo that 'Mr. C. is working as hard as if his life depended on being done by January. Naturally! the last mile of a journey is always the worst—and the last mile of such a journey as *his* has been—! Ach! And he always speaks as if the next thing to be done after finishing were to go to Seaton. As for me it is my own bit of blue sky at present, that *Seaton*!'

Sure enough, *Frederick* was finished on January 16th, 1865, and volumes V and VI of the opus were published in March. On March 8th, at last, the Carlyles arrived. Loo had thoughtlessly sent an open

carriage, and Mrs. Carlyle had to be wrapped literally from head to foot in rugs and shawls. The Trevelyans were now staying at Seaforth Lodge, as two days later Loo was having to leave for Cornwall on business and Pauline was expected to play the hostess.

In her now shaky handwriting Pauline told Scott how much of an effort it had been to abandon her easy chair. But with Loo away, she had had to go through with it. 'So we were left in charge of them. I never knew him so perfectly delightful, and to have him all day long is an unspeakable happiness. He and Sir Walter take long rides and walks together, and have endless talks. Mr. Carlyle likes this pretty primitive country and the fine air and clear streams and old villages, and is able to enjoy the resting after his twelve years of hard work upon Frederick.'

To Loo she also wrote every day, mainly about the baby May. 'Mrs. Carlyle likes to drive whether it rains or not, and Mr. C. will ride in his leather overalls.' In the evening Carlyle would read aloud from Tacitus. Mrs. Carlyle was sleeping well and seemed happy. Unlike Ruskin she loved Pauline's dog, Tiny, and had said that herh abitual 'horror of the sea' had quite passed away. It would appear that Carlyle found his very long excursions with Calverley a mixed treat. Calverley records that they spoke about temperance (needless to say), and that Carlyle told him of some 'boyish reminiscences' of drowning and being chased by bulls. On one ride Calverley lighted upon a 'curious variation of *scolopendrion vulgaris*', a grass, which was duly posted to Hooker at Kew, but which was by no means something to appeal to Carlyle, who years later wrote: 'Sir Walter and I rode almost daily, on ponies; talk innocent, quasi-scientific even, but dull, dull!'[3]

On March 15th, Loo being back, the Trevelyans moved out, and Woolner and his bride took their place at Seaforth Lodge. In the evenings the Trevelyans would come back for more readings, Goethe now. Then Mrs. Carlyle became immensely attracted by an empty house near Axminster, up for sale at £2,000: 'A Devonshire Craigenputtock [her family estate in Scotland where they had once lived], complete with pine trees, heath and black bog, a hundred acres in all, and a house in the "style of a convent".' Loo thereupon arranged a picnic on the terrace of the house, and Woolner overheard Carlyle say that if he were ten years younger and 'able to enter a new kind of life' he could not wish for a happier looking spot. What wrecked the speculation, however, was a dialogue relayed to Mrs. Oliphant: 'Carlyle, "I fear you would die of solitude in six months." Mrs. Carlyle, "Oh no! For I will keep constant company." '[4] So Loo tried

to persuade Woolner to buy the house instead. She would lend him as much money as he liked. Wisely he replied that a 'big house to me would be like buying a pack of hounds'.

The party finally broke up on April 3rd. Meanwhile Pauline had obtained an early copy of Swinburne's *Atalanta in Calydon*. 'What a grand poem!' she had said to Scott on March 13th. 'It seems to me most beautiful, and of the very highest kind of beauty. I am astonished and delighted with it—I do hope the public will appreciate it, they are stupid animals if they don't.' She asked him to forward a letter to Swinburne.

The public did indeed appreciate the 'blaze and crash' of *Atalanta*, and Swinburne had at last found fame. Ruskin thought it the 'grandest thing ever done by a youth, though he is a demoniac youth'. He added: 'Whether ever he will be clothed and in his right mind, heaven only knows. His foam at the mouth is fine meanwhile.'[5]

Swinburne replied at length to Pauline on the 15th. Her letter had given him 'the greatest pleasure I have yet had with regard to my book'. He had hoped that it would find favour with her, 'as I think it the best executed and sustained of my larger poems'. It was begun, he said, 'last autumn twelvemonth, when we were all freshly unhappy [after the death of a sister], and finished just after I got the news in September last, of Mr. Landor's death which was a considerable trouble to me, as I had hoped against hope or reason that he who in the spring at Florence had accepted the dedication of an unfinished poem would live to receive and read it'. In spite of the funereal circumstances, 'which I suspect have a little deepened the natural colours of Greek fatalism here and there, so as to have already incurred a charge of "rebellious antagonism" and such like things, I never enjoyed anything more in my life than the composition of this poem, which, though a work done by intervals, was very rapid and pleasant'. Allowing for a few insertions made later, it had been the work of two afternoons. 'I think it is pure Greek, and the first poem of the sort in modern times, combining lyric and dramatic work on the old principle.'

A paragraph was no doubt read out at Seaforth Lodge. 'I am raging in silence at the postponement from day to day of Mr. Carlyle's volumes. He ought to be in London tying firebrands to the tails of those unclean foxes called publishers and printers. Meantime the world is growing lean with hunger and ravenous with expectation. I finished the fourth volume last May in a huge garden at Fiesole, the nightingales and roses serving by way of salt and spice to the divine dish of battles and intrigues. I take greater delight in the hero, who was always a hero

of mine and more comprehensible to my heathen mind than any Puritan, at every step the book takes. . . . I must say Frederick's clear cold purity of pluck, looking neither upwards nor around for any help or comfort, seems to me a much wholesomer and more admirable state of mind than Cromwell's splendid pietism. And then who would not face all chances if he were convinced that the Gods were specially interested on his side and personally excited about his failure or success? It is the old question between Jews and Greeks, and I who can understand Leonidas better than Joshua, must prefer Marathon [*sic*, Thermopylae] to Gilgal. Besides, as a chief and a private man, Frederick is to me altogether complete and satisfactory, with nothing of what seems to me the perverse Puritan Christianity on the one hand, or on the other of the knaveries and cutpurse rascalities which I suspect were familiar at times to the greater, as always to the smaller, Buonaparte. I only draw the line at his verses.'

The letter ended with a comment on Tennyson's new collection of poems. He particularly admired the one on Boadicea, 'the highest if not the sweetest of all the notes he ever struck . . . the yellow-ringleted Britoness is worth more many score of revered Victorias'. He signed himself 'Yours (in spite of ill-usage) most filially'.

What Pauline had apparently not noticed in *Atalanta* was an antireligious strain. In a letter to Scott Swinburne had said that he was glad that this 'one virtuous daughter' of his had given satisfaction to them both, but that he observed 'with due joy that neither of you seem to object to what the unwise Christian slaves of faith and fear characterize as blasphemous rebellion against their Supreme Being'.

George Otto took a break from Tynemouth to stay at Seaton. He had brought news that his father, after an illness, was shortly to arrive home for good. Sleeplessness, once again, had been a cause of Charles's collapse. When he had gone up to the mountains for a change of air, in an attempt to regain his health, Sir John Lawrence (Elgin's successor) had said: 'You have lost all your *vice*. Do try and come back as vicious as ever.' A forlorn hope. At least Charles would return to England in time for the election.

Cawnpore was finished and the entire book was read out in two sittings to Calverley and Pauline. George Otto knew well, he said, that it would give offence to many of his Anglo-Saxon readers. For he had tried to 'imbue it with a spirit of tolerance towards the natives'. Certain passages might seem deliberately provocative—'. . . the truth was that it mattered very little to them [the Sahibs] whom they killed, as

long as they killed somebody. After the first outbreak of joy and wel-
come the inhabitants of Cawnpore began to be aware that the English
were no longer the same men, if indeed they were men at all. . . .'

There were protests of course, but the book remained in print for
many years, indeed decades. What he was trying to say was com-
pletely in line with Calverley's own opinions at the time. Not that he
hid details of the mutineers' own excesses. Sensitive friends of Pauline
wrote how they had wept at his description of the inner apartment of
the ladies' house at Cawnpore: '. . . ankle deep in blood. The pilaster
was scored with sword-cuts: not high up, as where men would have
fought; but low down, and about the corners, as if a creature had
crouched to avoid the blow. . . .'

On Charles's return Calverley insisted that he and Pauline must at
once go to London. They found him indeed 'very much done up'.
Before Pauline left Seaton she had had an affectionate letter from Mrs.
Carlyle, delighted to hear from Loo that Pauline would soon be at
'Paddington House'. She was saddened, however, to hear that Pauline
was still 'not so well'. She of all people, having suffered so much,
'must even more than the generality of people who love you' long to
see her improved, 'even to the dear wee thin arm'.

'But where is Paddington House? At Paddington I presume; but
perhaps I should need a trifle more of specification, to find it? I have a
Brougham and Black Horse (christened Bellona) in which I *fire* about
three or four hours every day, so I can go to see you with perfect ease
and take Tiny a drive whenever he liked.' Then: '. . . What do you
think Mr. Ruskin says with perfect gravity? That "he never in the
whole course of his life saw two women so absolutely like each other
as you and *me*?!!!!" No wonder I like you he says, he knew it could
not be otherwise, before we had ever met! Oh my Lady! What a
thing to have said of you, by one of your most intimate friends, after
having been *what you are* and for so many years! But I never did put
much faith in Mr. Ruskin's *Judgement*!'

It would appear that Paddington House was simply the Great
Western Hotel. In any case Pauline soon called on Mrs. Carlyle, and
they went driving together. Pauline reported to Loo that 'she seemed
very poorly, and oppressed with the heat'. She was also afraid that she
was 'going to overwork herself' with moving Carlyle's books in his
absence, and 'painting and papering the house'.

On the 30th the Trevelyans left for France, taking Pauline's sister
Moussy Hilliard with them. They were away for nearly two months,
travelling to the Pyrenees by way of Chartres and Bordeaux and back

through the Dordogne, altogether rather surprising, in view of Pauline's weak condition. What is even more surprising, and would have amused Augustus Hare, is the rich food she apparently ate, especially for somebody who had lately been suffering from a bilious fever: côtelettes de homard aux truffes, salmis de perdreaux à la Royale, paon jeune. By the time they reached Wallington again, the election was over and George Otto had had his triumph.

Electioneering had been 'real slavery', George Otto had written on July 1st. 'The Tories are wild with anger and I have been attacked in every manner. . . . It is hard to keep in view the noble goal through this mist of trickery, virulence and self-seeking.' He also told Pauline that, whilst in London, he had seen much of the Prince of Wales, who had written him a letter about *Cawnpore* in his own handwriting. He and the Prince had been playing whist together at Marlborough House. 'He is very good natured and really clever,' though 'seriously grieved by my principles.'

Charles and Hannah had arrived at Tynemouth for Polling Day, which had been on July 11th. Although Gladstone had been 'excited and gushing' about the result, which he had said was the 'most surprising victory of the election', the actual figures were not high: George Otto polled 494 votes, his opponent 438. But then the district had a large working class population, and the second Reform Bill was yet to come. Charles was very proud of his son. Two of his qualities had especially impressed him: his power of extempore reply, and the way he had of 'conciliating the good will of persons of every class'. 'The whole town,' he said, 'seemed animated by an immense enthusiasm in his favour.'

Swinburne is mentioned by Calverley as having been at Wallington by September 15th. Whilst he was in the house, Pauline wrote to Scott, who was at Penkill and working on some frescoes on the main stairway: 'Algernon is howling because you do not come sooner . . . [he] has repeated and read to me some *very* fine things, *splendid, I think*, and *one* thing which I can't endure. I thought at first that he was a great deal improved in himself—but I am afraid that was a mistake. He is as touchy in his vanity and as weak of temper as ever. The way he goes on at Browning etc. is too silly, and I see, with other people, that he is out of humour the moment he does not get as much admiration as he wants. It is such a pity. I wish he was more manly.'

Such behaviour was a common matter for complaint in London now. Munby described Swinburne as an 'intolerable little prig', who also did much harm to Rossetti by his constant 'toadying'.[6] In December

that year Lord Houghton, as Monckton Milnes had now become, was annoyed by Swinburne's discourtesy at a party arranged especially for him to meet Tennyson—conduct which was considered to have been a public insult.

Scott was at Wallington by the 15th. The Aclands, Annie Ogle and the famous Dr. Gully of the Malvern water cure were also there. Then on the 27th Woolner suddenly turned up, on his way south, 'as dogmatic, as loud, as egotistic, and seemingly as well received as ever', wrote Scott of his old friend.

Scott and Woolner went south by train to London together, followed soon after by the Trevelyans. Calverley recorded that he, Pauline and Hannah went to call on Rossetti at Tudor House. The massive collection of blue and white china seems to have made an impression, and may well have been the inspiration behind Pauline giving Scott a commission to find her some similarly coloured Delft tiles. After a week they left for Seaton, where 'dear little' Munro was convalescing after a bad illness. Pauline was never to see Wallington again.

The letters from Swinburne to Pauline in December 1865 are invariably quoted in his biographies. It has usually been assumed that Scott was responsible for 'betraying' him to her, out of jealousy. And judging from a letter written early in November it does appear that he had something of a guilty conscience: 'Did you see A.S. and give him a good advice? He was to have come out here on Sunday evening by appointment with Simeon Solomon. I hope he has not jumped to the belief that I was your informant—though the unhappy fact is so patent that anyone might have told you.'

Very likely she had had no time to see Swinburne whilst in London. However stories not only of arrogance but of wild and drunken behaviour were becoming more widespread (jumping on a row of top hats at the Arts Club being the least innocuous). After all, since *Atalanta* he was now a public figure. As Scott had once said, though the work had 'peculiarities', its paganism and licence were 'quite right in this classic subject'. When his next book *Chastelard* was published, some reviewers still hailed him as a genius, but others were horrified. 'The book was "morally repulsive" said *Atlas*, 'a lamentable prostitution of the English muse' declared *John Bull*.

It happened that, about the same time as Scott had written to Pauline, she had also received a letter, full of lurking innuendoes and without mentioning names, from Josephine Butler, wife of the Rev. George Butler, Vice-Principal of Cheltenham College, and famous in

future years as a moral reformer.* The gist of the letter was that Pauline might like to know that one of the persons whom she habitually invited to Wallington had a deplorably vicious reputation; people were talking and she had therefore better be careful. . . . Pauline naturally was annoyed, so was Calverley, So much so that they both wrote letters, not to Mrs. Butler but to her husband. One is not surprised to learn that Mrs. Butler became very unwell and had to retire to bed with 'rheumatism in the head'. Dr. Butler wrote on November 9th, apparently having been unable even to discuss the matter with her. As she said, 'I have no doubt Mrs. Butler wrote a letter to you about the author of *Atalanta*, of whom she heard much that shocked her about a week ago, when she was at Clifton.'

The person who gave her the information, he said, was an eminent professional man, 'as eminent as Henry Acland, and as incapable of lying as he is'. Butler admitted that he had not heard the extent of the charges and probably would have advised his wife not to write. He knew she had done it in good faith and not from any malevolent reason. Still less would she have wanted to cause Pauline or Calverley pain. He also would have thought that Swinburne was in danger of ruining himself socially. 'But I cannot help thinking that anyone who possesses the gift of poetry in so high a degree—and with it, of course, the power of influencing others, if not immediately indeed, at least in thought—is more than other persons bound to restrain himself in what he *says*, no less than in what he *does*.'

In his next letter he actually admitted the name of someone whom he had heard talking of the 'licentiousness' of Swinburne's poems, 'especially the unpublished ones'. This was Mrs. Myers, Whewell's sister-in-law, at the Master's Lodge, Trinity.

Pauline must have written to Scott more or less along the same lines as she had done when Swinburne was at Wallington, for his reply dated 'Saturday morning' ran: 'I do think you could do A.S. very much benefit by seriously writing [to] him. The remark you make on his behaviour at Wallington I believe I quite understand, he suffers under a dislike to ladies of late—his knowledge of himself and of them increasing upon him. His success too is certainly not improving him, as one might easily suppose with so boundless a vanity.' When she read *Chastelard*, he told her, she would see 'the total severance of the passion of love from the moral delight of loving and being loved'. This might give her a 'text' when writing to Swinburne. 'With all his

* In 1896 Josephine Butler published her *Personal Reminiscences*, which was attacked by Swinburne in a 'cruel and indecent manner', as she put it.

boasting of himself and all his belongings he is very sensitive about society, and I certainly think you will do him the very kindest of actions if you can touch his sensibility or his vanity a little sharply. Of late he has been very much excited, and certainly drinking. Gabriel and William Rossetti think he will not live if he goes on as lately without stopping. He says he is to leave town, however, for a long while, in a few days, and we hope he may quiet down.'

'Dislike of ladies' might have been a hint of homosexuality. Simeon Solomon was certainly a homosexual, and letters have survived showing that he assumed that Swinburne knew everything about his tastes. At the time of course Swinburne was preaching all kinds of sexual freedom, and lesbianism was a frequent theme in his poetry. Yet when, some years later, Solomon was arrested for soliciting, he was dropped by Swinburne, who then expressed horror of the whole subject.

It has also been suggested that the phrase might have had something to do with the forthcoming marriage of Mary Gordon. Or else it could have been a reaction from polite society as a result of his new habit of visiting 'whipping ladies' in Circus Road, St. John's Wood.

Whatever Pauline eventually said to Swinburne, it must have been very tactfully and affectionately phrased. He was quite knocked back. 'I know not how to thank you sufficiently,' he wrote on December 4th, 'for the kindness of your letter. I cannot express the horror and astonishment, the unutterable indignation and loathing, with which I have been struck on hearing that any one could be vile enough to tax me, I do not say with doing but with saying anything of the kind to which you refer. The one suggestion is not falser than the other. I am literally amazed and horrorstruck at the infamous wickedness of people who invent in malice or repeat in levity such horrors.'

He could only imagine, he said, that 'the very quietness of my way of living as compared with that of other men of my age exposes me, given up as I almost always am to comparative solitude, to work at my own art, and never seen in *fast* (hardly in *slow*) life—to spitefulness and vicious stupidity', and that 'as you say I must have talked very foolishly to make such infamies possible'. All he could ever recollect saying 'which *could* be perverted was (for instance) that the Greeks did not seem to me worse than the moderns because of things considered innocent at one time by one country were not considered so by others. Far more than this I have heard said by men of the world of the highest character.' This reference to the Greeks makes it seem all the more probable that Pauline had hinted at rumours of homosexuality. He went on: 'Once more, I cannot think how,—and I would fain try—

to thank you enough for the great and undeserved kindness which impelled you to write as you did. It consoles me under the horror of knowing what unscrupulous and shameless enemies one may make without knowing or deserving it, to remember how unlike to these are others—and if the one sort are my enemies the other are my friends. If you could write me a single word to say that you believe me and are satisfied by this hurried answer, it would be a fresh and almost as great a proof of kindness. I dare not undergo the pain of reading your letter again, and will endeavour to forget the cruelty and horror of such reports in their absurdity; but your goodness to me on the occasion I never shall. Believe me for ever, Yours most gratefully and sincerely, A. C. Swinburne. I do not ask who spoke to you against me as having *heard* me say things I never did.say. If you thought it right to tell me as a warning I know you would.' This letter and another following it the next day, from the Arts Club, were held back by the aged George Otto from Gosse and Wise when they wanted to publish them in 1918.

Swinburne had written again because he was not sure whether he had sufficiently thanked her. 'I only wish to heaven that at any time or in any way I could—not repay, which would be impossible, but—express to you otherwise than by inadequate words my sense of your goodness to me. Six hours ago, I was so utterly amazed, horrified, agonized and disgusted, that I could hardly think of anything but the subject of your letter. Now I can hardly think of anything but your inexpressible kindness in writing. I *cannot* thank you enough. That is nothing to say. And if I now try to say anything more I feel I shall begin to talk more wildly than ever. Only I do entreat you to believe in my gratitude. Nobody in my life was ever so good to me as you have been. You must know what pain any man would feel on hearing what you tell me—what shame any man must feel who was conscious that, in however innocent and ignorant a way, he had (I will not say deserved, but) exposed himself through rashness and inexperience to such suffering as I underwent in reading what you wrote. I know I have not deserved to feel pain—and shame I do not feel, because I have not deserved it. The pain I feel no longer—and what I do feel is a gratitude, and even a sort of gladness that anything should have happened to make me know so fully how great and noble, how beyond all thanks and acknowledgement, your kindness could be. I repeat it, upon my honour, this and this alone is what I now feel. I can think just now of nothing else. For years I have regarded you—as I trust you know or believe without words of mine—with a grateful affection

which I never could express. Now I can say less than ever how deep and true is my sense of obligation to you. You were always kinder to me (when much younger) than others—now you are kinder than I could have dared to think of. I am amazed beyond words at people's villainy or stupidity—but yet more at people's goodness.' He ended his letter: 'I am sure I have written at random, and "spasmodically"—but I will not read over my note, and I cannot but send it this evening. I am sure my first was too incoherent, and dealt too much with the matter at hand, to be properly grateful. But I hope you knew, and do know, with what gratitude and affection I must be Always yours, A. C. Swinburne. P.S. I see this is *too* chaotic—but please excuse it. I never do cry, and never did I think much as boy or man for pain—and this morning when I wrote I never felt less tempted—but this time I have really felt tears coming more than once.'

Pauline's reply has survived and is dated December 6th: 'My dear Algernon, Your letter is a great comfort to me. I am so very glad that you disdain indignantly any such talk as is attributed to you. Now that you know how people take things up you will be more guarded in future I am sure. I suppose when men get together and take what Sir Walter's protégés call "alcoholic stimuli" they are apt to say more than in their wiser moments they would like to remember. And their listeners may carry away dim notions that much more was said than was ever uttered. Perhaps some of the solid older heads among your friends would tell you loyally if you ever do lay yourself open to misconstruction, if you ask them about it. I dare say there is a great deal of truth in what you say, that your leading a reserved studious life is not any protection to you, but the reverse. People are more ready to believe any monstrous report against a man they never saw than against one they have met and conversed with. Now—(don't laugh at me for saying it) do, if it is only for the sake of living down evil reports, do be wise in which of your lyrics you publish. Do let it be a book that can be really loved and read and learned by heart, and become part and parcel of the English language, and be on everyone's table without being received under protest by timid people. There are no doubt people who would be glad to be able to say that it is not fit to be read. It is not worth while for the sake of two or three poems to risk the widest circulation of the whole. You have sailed near enough to the wind in all conscience in having painted such a character for a hero as your *Chastelard*, slave to a passion for a woman he despises, whose love (if one can call it love) has no element of chivalry or purity in it; whose devotion to her is much as if a man should set himself to

be crushed before Juggernaut, cursing him all the while for a loath-some despicable idol. I suppose people would say that Chastelard was a maniac and ought to be sent to Drs. [Forbes] Winslow and·[John] Connolly [both leading authorities on insanity]. Don't give people a handle against you now. And do mind what you say for the sake of all to whom your fame is dear, and who are looking forward to your career with hope and interest. I ought to tell you that to one person who wrote to us (a person I don't suppose you ever saw) and who wrote sorrowfully but not unkindly Sir Walter wrote a most kind and firm letter on your behalf. But it is horrid for your friends ever to have to decry such things.'[7]

The book that was being prepared for publication was *Poems and Ballads*. Now it was the turn of Ruskin to write on the subject, on December 8th. He had been a poor correspondent during 1865. Unfortunately the last part of his letter is missing, perhaps destroyed by Calverley or George Otto. 'I went to see Swinburne yesterday and heard some of the wickedest and splendidest verses ever written by a human creature. He drank three bottles of porter while I was there—I don't know what to do with him or *for him*—but he mustn't publish these things. He speaks with immense gratitude of you. Please tell him he mustn't. . . .'

And Swinburne wrote back to Pauline on the 10th, this time from Dorset Square and again thanking her, also Calverley, for defending him 'against the villainy of fools and knaves'. Next there followed a passage which George Otto at first wanted to cut out altogether from the Gosse and Wise publication:[8] 'Since writing to you, I have been reminded of things as infamous and as ridiculous inflicted upon others as undeserving as even I am. Two years ago, for instance, I was in-formed (of course on the best and most direct authority) that a friend of yours as of mine had boasted aloud of murdering his own illegiti-mate children. That they never had existed was of course nothing to the purpose. Fortunately, in this case, I was cited as a witness—and did pretty well, I believe, knock that rumour on the head. I cannot but suppose that all these agreeable traditions arise from one infamous source. When it is found out, we may hope to suppress it once for all. Meantime, upon the double suspicion, I have refused to meet in public a person whom I conceive to be possibly mixed up in the matter. At all events, I know that I have done the man no wrong—for a more venomous backbiter, I believe, never existed. . . .'

He could have been referring to an affair known as the Rossetti 'Imbroglio', when he was rumoured to have said that the procuring of

abortions was an 'everyday amusement' for Rossetti. The 'venomous backbiter' could therefore have been the unfortunate Holman Hunt.[9] The letter then went on: 'As to my poems, my perplexity is this; that no two friends have ever given me the same advice. Now more than ever I would rather take yours than another's: but I see neither where to begin nor where to stop. I have written nothing to be ashamed or afraid of. I have been advised to suppress Atalanta, to cancel Chastelard, and so on till not a line of my work would have been left. Two days ago Ruskin called on me and stayed for a long evening, during which he heard a great part of my forthcoming volume of poems, selected with a view to secure his advice as to publication and the verdict of the world of readers or critics. It was impossible to have a fairer judge. I have not known him long or intimately; and he is neither a rival nor a reviewer. I can only say that I was sincerely surprised by the enjoyment he seemed to derive from my work, and the frankness with which he accepted it. Any poem which all my friends for whose opinion I care had advised me to omit, should be omitted. But I never have written such an one. Some for example which you have told me were favourites of yours—such as the Hymn to Proserpine of the "Last Pagan"—I have been advised to omit as likely to hurt the feelings of a religious public. I cannot but see that whatever I do will be assailed and misconstrued by those who can do nothing and who detest their betters. I can only lay to heart the words of Shakespeare—even he never uttered any truer—"be thou as pure as ice, as chaste as snow, thou shalt not escape calumny". And I cannot, as Hamlet advises, betake myself "to a nunnery".'

Nevertheless his luck was 'looking up in the beautiful literary world of publishers and readers'. He had already had the 'wildest offers made me for anything I will do'. Moxon had asked him to 'do' Byron for a series on poets, 'as well as Landor'. He was sorry that Pauline had not liked Chastelard personally. 'I meant him for a nice sort of fellow. . . . I think it was George Meredith who once told me that, considering his conduct to the Queen, I had produced in him the most perfect *gentleman* possible. It is rather a "trap" to send you these proofs at the end of a long letter—but I didn't mean to entrap you into writing or returning them till you have nothing better to do; and then you know what pleasure you will have given me.' It has been assumed by some that 'proofs' referred to *Poems and Ballads*, but the publication of that book was much too far ahead.★

★ Gosse specifically says that she 'read and commented on' the proofs of *Poems and Ballads*. There is nothing to substantiate this, but it might of course eventually have been possible.

Pauline appealed to Scott to ask Rossetti to intervene with Swinburne, but it was no use, Scott said. 'He has for weeks been talking against Rossetti in a very unhappy way.' So she must have turned to Ruskin, who wrote in one of his undated letters: 'Thank you for the long talk about Swinburne. I shall take sharp and energetic means with both him and Rossetti. I have some right to speak to the whole set of them in a deeper tone than anyone else can.' But this was just bravado, for Ruskin's relationship with Rossetti was also under strain, Rossetti having wrongfully accused him of selling his pictures, when all the time they were simply on loan to Winnington, and suspecting that in any case he was now out of sympathy with his work.

Ruskin, with Carlyle, was now fully engaged in support of Governor Eyre in the controversy over the violent suppression of a Negro revolt in Jamaica, which had included the summary hanging of a political opponent, a mulatto—a controversy that was to continue over three years. Tennyson, Dickens and Kingsley were on their side.* Their opponents included George Otto, Huxley, John Stuart Mill and Tom Hughes—with whom Calverley and Pauline sympathized. George Otto had this to say on the subject to Calverley on December 5th: 'I feel far too deeply on the matter to trust myself to speak of it in public. By the time it comes before me as one of the judges I shall be in a state of white rage from constant repression. At present we only have Governor Eyre's defence: and one likes to hear what can be alleged against a man before one condemns him. Those however are the facts. A chronic political discontent: something resembling Chartism in England: a riot: the mob, irritated at being fired on, commit an outrage about half as bad as what happened last year in Belfast: and then follows the resisted massacre of the population of a large district; torture; plunder; chapel burning—May God forgive us!'

At least a thousand houses had been burnt down, five hundred Negroes killed and several more flogged. But the white population of Jamaica regarded Eyre as their saviour and hero. Ruskin wrote letters to the papers on the subject and contributed money. However his involved arguments, in favour of loyalty and order, against Liberal cant and hypocrisy, and his insistence that so-called white emancipation should come before black emancipation, are not within the scope of this book. Memories of the Rajah of Sarawak were revived in the press.

In September Woolner had told Loo that he had felt that Carlyle did not seem to be in the 'great Niagaran flow of spirits as he is wont',

* Ruskin also provided money for the cause. Embarrassed by the size of his inheritance from his father, he was engaged in giving away a large portion of it.

and had added: 'I think the almost entire want of intelligent notice of his great work now completed must make him fell depressed.' By December the situation was very different, for in recognition of *Frederick* Carlyle had been elected the new Rector of Edinburgh University in place of Gladstone. It was a great honour, with great prestige, and marked the zenith of his fame.

At Christmas Ruskin had written to Pauline and had told her that Rose La Touche was in London. The garden at Denmark Hill had been especially tidied up in her honour. 'She stole two crystals from the bottom of my primrose pool—for which her mother says she has "no conscience". She is nearly well again; only must be in the open air nearly all day, or the bad symptoms return.'

It was such a short note that Pauline must have complained. Therefore he wrote back: 'I fancied you didn't care about Rosie or I should have told you of her sometimes. She is very terrible just now—for at least she has *lost* nothing in the face, except spoiling her lips a little with winter and rough weather (for she's out all day long:) and she's tall, and the kind of figure I like best in girls—and the dressmakers make the dresses so dreadfully pretty for girls just now . . . so that the end of it is that I dare not go west end way (above all not near Rotten Row) above once in a fortnight or so—only I had a peep at her yesterday; and she was out here last Thursday and stole some stones out of my brook and loosed Lion whether I would or no, and petted the calf in the stable till she drove me wild: and I'm to have her to take down to dinner on her birthday next week.'

Her birthday, her eighteenth, was on January 2nd. Exactly a month later, on February 2nd, Ruskin asked her to marry him. Her reply was that he must wait for another three years, when she would be of age. Before long her parents had forbidden her to communicate with him again.[10]

By now Ruskin was truly, frantically, in love. The time had passed when he could take Pauline into his confidence. He turned to Mrs. Cowper, as a friend of Mrs. La Touche, and unburdened himself in such a way as he had never done with Pauline: '. . . I want *leave* to love: and the sense that the creature whom I love is made happy by being loved: that is literally all I want. . . . I don't care that Rosie should love *me*: I cannot conceive a thing for an instant—I only want her to be happy in being loved:—if she could tread upon me all day— and be happy . . . it would be all I want.'[11]

Meanwhile Pauline had had another bad bilious attack, 'with an entire inability to take food,' she told Loo who was in France. She had been reduced to a skeleton, and—in spite of Calverley—had

subsisted solely on sips of champagne. Her brother, Archdeacon Hugh, had been sent for. Next Moussy arrived to look after her, and because of her having to be away from home Connie—'rising fourteen and a dainty little vetch of a girl,'[12]—went to stay at Denmark Hill.

On February 24th, at long last, the Trevelyans moved into Calverley Lodge. Pauline's room was under the largest gable, and through her narrow trefoil windows she could see Loo's house smokeless and empty, with a view beyond of the Beer cliffs and the pounding sea below. Every small detail had been lovingly thought out, from mouldings on doorways to the entwined wrought iron lilies on the staircase, and this made even more of a contrast with the hastily built Seaforth Lodge. For some days she could not move further than the glass-covered verandah, unless the weather was really fine, when she would be wheeled among the young pines and tamarisks to a bench (Gothic) on the cliff-side. George Otto came to stay, then Scott, and after him Charles and Hannah. There was no doubt that George Otto had found his vocation. He was brimming with enthusiasms— 'he finds something new every day', Pauline told Loo. Scott helped her to paint flowers and quatrefoils on the new sideboard. As he said later, he thought he noticed a change in her which he 'dared not believe', though that 'brave commanding spirit' was still there.

It was Scott who urged Charles Augustus Howell to invite Calverley to be Vice-President of the Cruikshank testimonial fund under Ruskin. The committee included such names as Houghton, Browning, Rossetti, Holman Hunt, Swinburne, Woolner, Millais, du Maurier and Whistler. That grand old fellow Cruikshank was now aged seventy-three and as Scott said was still 'working hard for his daily bread'. Swinburne wrote again to Pauline on March 22nd, and told her that if Cruikshank were to die he would not leave his wife 'enough to live upon'. He was very sorry, he also said, to hear that she had been ill again, like his mother. 'That both my maternal relatives should be so ill at once is too much for a filial heart. Pray set a better example in future.'

At about this time he had received congratulations from Ruskin on his Byron selections. Obviously he found the letter odd, so he wrote back: 'I am glad you like my little essay, and gladder to hear that you think of coming to look me up [Ruskin having written to Pauline on February 25th: "I have not seen Algernon again. I was hopeless about him in his present phase, but I mean to have another try soon."] But I do not (honestly) understand the gist of what you say about myself. What's the matter with me that I should cause you sorrow or suggest the idea of a ruin? I don't feel at all ruinous as yet. . . . You speak of not

being able to hope enough for me. Don't you think we had better leave hope and faith to infants, adults or ungrown? You and I and all men will probably do and endure what we are destined for, as well as we can. I for one am quite content to know this, without any ulterior belief or conjecture. I don't want more praise and success than I deserve, more suffering and failure than I can avoid; but I take what comes as well and as quietly as I can; and this seems to me a man's real business and only duty. You compare my work to a temple where the lizards have supplanted the gods; I prefer an indubitable and living lizard to a dead or doubtful god. . . .'[13]

In truth, the letters from Ruskin to Swinburne were to become even more odd. When, in the autumn of 1866, *Poems and Ballads* was being abused almost everywhere in the press, and the book had to be withdrawn by the publisher, Ruskin was one of those who defended him. Swinburne, he said was 'boundlessly' beyond him 'in all power and knowledge'. The trouble was that his 'whole being' was still 'crude and miscreate,' with the divinity in the heart of it 'sputtering in the wet clay—still unconquered'. While to Swinburne he said: 'I should as soon think of finding fault with you as with a thundercloud or a nightshade blossom. All I can say of you, or them—is that God made you and that you are very wonderful and beautiful.' He also added: 'You are rose graftings set in dung. . . . I cannot help you, nor understand you, or I would come and see you. But I shall always rejoice in hearing that you are at work, and shall hope some day to see a change in the method and spirit of what you do.'[14]

Now Ruskin wrote to Pauline again to say how much he loved having the company of Connie, who had become very fond of his young cousin Joan Agnew. Suddenly, he said, he had had the urge to 'run to Venice and back in six weeks', and to take the girls with him, 'to look at a Titian or two'. Perhaps Moussy would accompany them. 'It would be approximately proper—wouldn't it? As far as running away with a clergyman's wife can be proper.' Would Pauline let him know what she thought. Perhaps they would leave at the end of April.

The real truth was that Rose was going back to Ireland on April 2nd, and he could not bear the agony of being left alone in London. What he did not expect was the burgeoning Prussian–Austrian war, which was to involve the surrender of Venice to the newly unified kingdom of Italy.

For some while Loo had been urging Pauline to meet her on the Continent. Why not at Lake Maggiore? And so it was that Pauline proposed that instead of Moussy she and Calverley would come with

them, at least part of the way. Ruskin must have at first been amazed that she could even contemplate such a journey; but he was delighted nevertheless. It was a 'glorious' idea, he said. 'You will be amused with my cousin, who is wonderfully capable of all childish enjoyment—and bringing out Con, in the character of Duenna and Chaperone—which is exquisite. And then to see Con herself—the first time in France! She is a dear little thing—but she's awfully old—and chaffs me fearfully about Rosie.'

Then the excitement of the planning began. Calverley suggested some places to visit; Baveno, Lugano, Monza, Luini. Ruskin assured Pauline that if she felt ill on the way she would find Joan a 'helpful, willing and loving nurse'. Obviously Pauline's spirits were rising and she had started to tease, for he wrote: 'What do you want to quarrel with me for? I am quite, quite down.' It was then that he decided to draw up a kind of manifesto:

'I've been thinking over this plan, now that I'm getting back my senses a little. . . . First of all, I'm not going to drink nasty French river water to please Sir Walter—so he needn't think it—and he's not to make faces at me at dinner. . . . I mean to be comfortable. Perhaps I shall even take a hamper of old Sherry with me. Secondly (and this is an inconvenience, on your side and his) I am of course liable to be called home at any moment if my mother got ill for want of me—and then I should have to leave those brats behind, for Sir Walter and you to do the best you could with. I don't think this will happen—but it's of course on the cards. Then—and this is the main article of treaty we've got to sign—you know—as long as I can stay (and all the while therefore, I hope) the said brats belong to me and not to you; and I'm to have them when I want them, and you're not—and I'm to be their papa in all respects just as if we were travelling alone. And accordingly, I mean to have my own set of rooms comfortably and you and Sir Walter are not to bother me to come to table d'hôte and the like. I hate talking at all times, but chiefly when I'm eating, because I can't chew. And I hate meeting people whom one half knows—again and again, and I hate whole-knowing them worse. So there my rooms will be—and I'll have them big enough—and tidy, and if you and Sir Walter like to come and dine with us and sit with us and be sociable—it's all right and if you won't you'd better say so at once and I won't go. And you shall pay for your own dinners, and we for ours—and you shall pay for your own bedrooms and we for ours; but I mean to have the sitting room under my own control, that there may be no worry about it anyhow, and if I get one with too many windows in it, for I

love windows, you shall draw the curtains when there's too much light.' He then told her that Joan had gone off to Ireland with Rose, but he could get her back whenever they wanted her. As it happened, Rose's brother Percy fell in love with Joan, and subsequently jilted her —but that belongs to another story.

On April 17th Pauline wrote her last letter to Loo. The plan was still to meet by Lake Maggiore. 'Mr. Ruskin wishes for short days' journeys as much as I do, and the two girls will find everything delicious. . . . Seaton looked very pretty when we came away. The fresh green leaves and the quantity of flowers were very lovely.' Then for a change she talked politics: 'The Government seems quite sure of a small majority on the Reform Bill. Sanguine people talk of twenty. The Prussian Austrian mess seems almost to supersede Reform in public interest. . . .' As it happened, her prediction turned out to be wrong. In spite of Gladstone's great speech, the Liberal Government was eventually defeated. A new Tory administration was therefore formed under Lord Derby, with Calverley's cousin Walpole as Home Secretary for the third time.

Tuesday April 24th was finally fixed as the day. The story repeated in nearly all biographies of Ruskin is that on the afternoon of their departure he called on Mrs. Carlyle with his usual bouquet of flowers, only to learn that she had just died. He then is said to have rejoined his friends, and the party crossed the Channel gaily, in spite of what they thought was rather a cloud over him. 'At Paris they read the news. "Yes", he said, "I knew." But there was no reason why I should spoil your pleasure by telling you.'[15] This story however is not quite accurate. Mrs. Carlyle's death occurred 'in trying to save her little dog', Tiny, and according to at least one source the dog was Pauline's Tiny, which had been given to her.[16] This is not quite accurate either.

Carlyle had left for Edinburgh with his friend Professor Tyndall on March 22nd, leaving Mrs. Carlyle looking 'pale and ill'. On his way north he had stayed at Fryston, where Huxley had been another guest. His inaugural address, with Sir David Brewster by his side, had been a 'perfect triumph', so Tyndall had telegraphed Mrs. Carlyle. At the time of her death he was still in Scotland.

Judging from a letter from Carlyle's brother John to his other brother Alick, the Tiny that ultimately was the cause of her dying was 'a small terrier, left to her care by a friend (Mrs. Chapman) who died lately (in March) of consumption. . . .'[17] A letter of March 16th from Louisa Baring to Loo says: 'Enter Mrs. Carlyle with a little black dog!

A new acquisition,' and on the following day Woolner told Loo how his wife had called at Cheyne Walk to find that Mrs. Carlyle had now a 'new dog left her by a dying friend'. But in her letter of April 17th to Loo Pauline herself had said: 'Tiny set off yesterday to travel 300 miles [to Wallington] in his little basket. All this valuable news for May!' Thus the evidence would seem to be against Pauline's Tiny being the culprit.

The accident actually happened on Saturday the 21st, three days before the Trevelyan–Ruskin party left. Ruskin might indeed have called that day and kept quiet. A telegraphed message was sent to Dr. Brown in Edinburgh and the news reached Carlyle via Alick. The announcement of her death was in the papers on the 23rd. It is of course possible that *The Times* had been kept away from Pauline, already upset by the recent death of Whewell, and that she only heard or read of the news in France.

Needless to say, all Loo's intimates rushed off letters on the 23rd in order to be the first to break the news to her. Louisa Baring's letter was one of the most correct: 'I write to tell you what I know will give you great pain to hear. Poor Mrs. Carlyle died suddenly last Saturday afternoon. She went out driving in a brougham she had hired by the month, and was as well as usual. On starting her dog was run over by a carriage and killed [*sic*, only slightly hurt]. The Coachman drove round and round the Park wondering why she didn't tell him to go home, and at last looked in [when they reached the Achilles statue] and saw her dead. He then drove to St. George's Hospital. *She was quite dead.*'

Before breakfast on the 24th Calverley was down at Charing Cross checking about tickets. Mr. Hilliard and Connie came to the hotel, and off they went to meet Ruskin and Joan at the station. Calverley wrote in his diary: 'We steamed out at 1.15 p.m.—a bright sunny day—John Hilliard taking leave of us—and had a pleasant journey to Folkestone and across the Channel to Boulogne, which we reached about 6 p.m. and put up at the comfortable Hôtel des Bains, in a more picturesque and busy situation than the Pavillon where we went last year.'

THAT LOVING, BRIGHT,
FAITHFUL FRIEND

1866

SHE should never have gone abroad of course, but she had set her mind on the journey. It was almost pathetic to notice how happy she was on the Channel crossing, even though it was so rough, and how she enjoyed watching little Connie's excitement. The morning of the 25th was spent wandering round the old town in Boulogne, and at 12.15 the party took the train for Paris. 'The fresh spring vegetation and bright sun,' Calverley wrote, 'made the journey through a monotonous country very pleasant.' They stayed at the Hôtel Meurice, listed as a hôtel de luxe, Pauline's room being on the second floor facing the Tuileries Gardens. Before breakfast Calverley was out walking in the Gardens. Ruskin spent the morning in the Louvre. 'Joan listless,' he wrote, so in the afternoon he went back on his own whilst the others drove down Haussmann's new boulevards to the Bois—a great success as the Longchamps races were in progress and they saw the Emperor in his carriage for several minutes close to. In her journal Pauline described the effect of the shadow of the leaves, with the sun shining through the trees; it was to be the last thing she ever wrote. 'Tired,' Ruskin put in his diary.

The next day the girls were taken to Notre Dame and the Sainte Chapelle. Pauline did some shopping. Then more sightseeing. She was determined, in spite of the disapproval of Calverley (and perhaps Ruskin), to see some pictures by Courbet and Manet, though this was never possible. Calverley was particularly impressed by a fifteen ton steam roller, 'used in rolling and smoothing the newly metalled roadways'. 'We are in this respect behind the French,' he noted.

On the 28th she was taken ill. After a while Calverley sought out an English doctor, who told him that 'No dew falls on the Paris sulphate of lime basin—consequently the dry atmosphere affects mucous membrane of air passages, and the limestone water affects other organs [i.e. the liver].' Kreusnach water and a concoction made

from green walnuts were prescribed. The doctor seemed a 'careful and judicious person'.

It was decided five days later that Pauline was still too weak to join an expedition to Chartres. Calverley wrote to Loo that during all this time he did not think that Pauline had been able to take more than half a dozen ounces of food. However, in her extraordinary way, she rallied soon afterwards, and he was able to get her to Sens, where they met the others at the Hôtel de L'Ecu. Ruskin told his mother that the trees in blossom along the Seine had been 'glorious'. Pauline by this time was so cheerful that on May 4th they went on to the Hôtel de la Cloche at Dijon. Here Ruskin wrote his letter of condolence to the stricken Carlyle, whose eventual reply showed that, in spite of the party's high spirits, Ruskin at the time was still secretly depressed. '... You are yourself very unhappy, as I too well discern—heavy-laden, obstructed and dispirited.' 'But', Carlyle reminded him, 'you have a great work still ahead.'[1]

For the next two days Calverley took Pauline for 'botanizing' drives outside the town, Ruskin sometimes accompanying them, for he was making notes for his *Proserpina*. Ruskin spoke of that time in *Praeterita*, of Calverley's 'unfailing knowledge of locality' and the way that Pauline, frail though she was, rejoiced in the progress of his book. They drove down a long canal lined with poplars on the Plombières road, and in some hills discovered Calverley's favourite *Veronica prostrata*. On the 6th they found themselves in a 'sweet valley', as full of nightingales as the Denmark Hill garden was of thrushes, Mrs. Ruskin was told, 'with slopes of broken rocky ground above covered with the lovely blue milk-wort, and purple columbines, and geranium and wild strawberry flowers'. The children were 'intensely delighted'. Pauline made a sketch, again her last.

The hotel, though comfortable, overlooked a noisy street, which probably made Ruskin decide to catch the 6 a.m. train to Neuchâtel the next morning. It was too much of a distance for Pauline, so Calverley fixed that he and she would have to break their journey at Pontarlier. They therefore left later in the day, and he wrote in his diary:

'Route through a flattish alluvial valley till Mouchard, where the cuttings into the Jura lime commence. But there my dearest Pauline frightened me with such an attack of illness, that she was obliged to be carried to the station, and fortunately the train having to wait there more than an hour, she had time to recover sufficiently, lying down in the seat, to go on to Pontarlier. The people at the station were exceedingly kind and attentive. ... We found at the station the landlord

waiting for us, and getting P. carried to a carriage, we went not
far to the Hôtel de la Poste where she was glad to get laid on a bed.
I was up all night giving her arrowroot at short intervals. In the morn-
ing she was better, but we considered it more prudent to remain in our
comfortable quarters, so I wrote to Ruskin, who otherwise would
expect us this afternoon.'

Ruskin's valet Crawley arrived on the 10th with a letter from Ruskin
urging Calverley to try to get Pauline to Neuchâtel where she could
have better nursing, and where doctors from Lausanne could reach
her in two hours. 'Don't think of us but as only able to be happy if
we can be of some use to you in this time of trouble. You see there is
absolutely no need of hurry of any sort, for Venice is in a state of siege,
and we are really as well at this lovely place as we could be anywhere.'
Calverley tried to hire a special train, but failed. His journal—jotted
throughout the day—continued:

'11th. P. in some respects better; but very weak. God grant a favour-
able result to our attempt to go to Neuchâtel!—An invalid carriage
sent from N. Mr. Ruskin came with Crawley and Emma [Joan's
maid] to our help—P. was carried on a chair to the station, and then
laid in the carriage and thank God we got safe to N. through some fine
scenery, which unhappily she could not see though she was delighted
with a glimpse of the Lake from the station—Got comfortable quarters
at the Bellevue and I sent for Dr. Regnier. . . .

'12th. P. had tolerable night and the Diarrh. has ceased, but she
is extremely weak.—Dr. came and prescribed wine and food chiefly
to keep up and restore strength—P.M. P. not progressing satisfactorily.
Ruskin kindly went to the Dr., who came again and I think altered the
treatment with advantage. A rainbow, which I lifted P. up to see. . . .'

The doctor disagreed entirely with the diagnosis of the Paris doctor
and indeed of many other doctors. He did not think her illness had
anything to do with liver. Pauline was able to joke about it, and said
to Ruskin: 'It will be a bore if we have to eat humble pie to this little
doctor after all.'

Calverley did not go to bed at all that night, during the course of
which he roused Ruskin, who went to fetch Dr. Regnier, 'but he was
unsatisfactory'. On the morning of the 13th she seemed a little better
again. 'I got out, Ruskin kindly watching, for a few minutes, and
walked on quay—but day cold and no view of Alps. In the afternoon
dearest Pauline's symptoms of approaching death became unmistak-
able, in failing pulse, coldness and difficulty of breathing, brought on
by diminished action of heart and from about 3 p.m. she gradually

sank till she expired about 10.45 p.m., I hope without much suffering but most heartrending to see the efforts for breathing, which with her sound lungs continued after most other parts were cold and dead. Now I have lost one of the best wives and of friends, who has been a blessing to me during more than thirty years. An unhappy tour has this been so far. With the exception of the journey to Paris, and two days there, it has been a time of suffering to Pauline and of watching and anxiety to me—I was unhappily persuaded to bring her abroad, when she was not in a fit state to travel, and though perhaps with her organic complaints, she could not have expected a long life—yet it was shortened I have no doubt by the fatigues of travelling. . . .'

The rest of this agonized, confused entry was concerned with her glimpse of the rainbow, the last thing that she had admired on earth, and her character—'always working for her own improvement or for the good of others . . . much bodily suffering, but was most patient and cheerful under it all, and so uncomplaining, so that of those about her, few would know how much she suffered.'

That night Calverley slept in the bed in which she had died, Ruskin in another nearby. The body was also in the same room—'her head and hands beautiful in death like wax'. Very early in the morning Calverley got up to bathe in the lake. Afterwards the two went up to the cemetery above the town where a site was chosen with a beautiful view of the Alps—'just the spot dearest Pauline would have selected herself'. Then they walked in the hills and Calverley was even able to note down in his diary some of the names of the plants they found. Ruskin went to Dr. Regnier to arrange for an autopsy. 'Uncle looks very ill and aged,' Connie wrote in her diary, and 'poor Cussy [Joan's name for Ruskin, from Cousin] nearly as bad.'

On the 16th Ruskin wrote to his mother: '. . . We have a telegram saying that Mr. Hilliard is coming, which is an immense comfort to poor little Con. We had the body examined to-day, and the organic disease would have rendered it wholly impossible for her to live much longer. We think a slight jar on the railroad must have been the imme-diate cause of accelerated death. Before she lost consciousness, Sir Walter and I were beside her, he holding her left hand and I her right. I said to Sir Walter that I was grateful to him for wanting me to stay: I did not think he had cared for me so much. "Oh," he said, "we both always esteemed you above any one else." Lady Trevelyan made an effort, and said "He knows that". Those were the last words *I* heard her speak: then I quitted her hand, and went to the foot of the bed and she and her husband said a word or two to each other—low; very

few. Then there was a pause—in a few minutes she raised herself, the face wild and vacant, and said twice, eagerly (using the curious nick-name she had for Sir Walter of "Puzzy") "That will do, Puzzy, that will do." And so fell back—slightly shuddering—a moment after-wards she said "Give me some water." He took the glass and I raised her; as I did for all her medicine;—she drank a little, but had scarcely swallowed it when violent spasm came in her throat, and her husband caught her as I laid her back on the pillow; and then the last struggle began—I went to the foot of the bed and knelt down, and he held her: the spasm passed through every form of suffocating change, and lasted for upwards of an hour, each new form of it getting fainter, but all unconscious, though terrible in sound—he saying softly to her sometimes, "Ah, my dear"—I rose in a little while, thinking it must be too dreadful to him, to assure him that it was unconscious—he said "Yes, I know it." Then I went back to the foot of the bed, and stayed till the last sobs grew fainter—and fainter—and ceased, dimly and uncertainly—one could not tell quite when. At last he raised the chin which had fallen; and laid her head back; and took the candle and called me to look at her. And so it ended.'[2]

Another letter, written by Ruskin at a much later date, can be quoted at this point. It was to the Rev. Edward Coleridge, vicar of Mapledurham: 'I sat all that Sunday by her deathbed: she talking a little now and then, though the rattle in the throat had come on early in the day. She was an entirely pure and noble woman, and had nothing to think of that day but other people's interests. At about one o'clock—nine hours before her death, she asked me very anxiously what I thought of Swinburne—and what he was likely to do and to be. (She had been very kind to him in trying to lead him to better thoughts.) And I answered—that she need not be in pain about him—the abuse she heard of him was dreadful—but not—in the deep sense, *moral* evil at all, but mentally-physical and ungovernable by his will,—and that finally, God never made such good fruits of human work, to grow on an evil tree. So she was content: and that was the last thing she said—except to her husband—and a little word or two to me—to make me understand how they both cared for me.'[3]

Dr. Regnier called to tell Calverley that he had found an 'intricate mass of adhesions and cysts some of them approaching to ulcers', evidently of long standing. The tumour had been the size of a child's head. When Calverley read the horrific report, he was not surprised that Pauline had said only a few days before that if he knew her suffer-ing he would not wish to lengthen her life. Naturally in the course of

the autopsy Regnier had seen where Simpson had successfully operated fifteen years before, without doubt prolonging her life. The liver was more or less normal.

Charles Trevelyan arrived at Neuchâtel after the funeral. It had been agreed that Joan and Connie should continue travelling alone with Ruskin, so the next three days were spent by Calverley and Charles in wandering among the Swiss valleys. Calverley had thought of going up to the Grimsel hospice, but then could not face it. Ruskin was worried, because Charles was going back on the 22nd, so on that day just as he was setting off for Interlaken he wrote: 'It is very lovely among these hills; the flowers so wonderful that you could not but be interested in them—the sense of peace and beauty continual and heavenly. I cannot but feel strongly that it would be better for you to be here.... Please come.' So Calverley came, and stayed until the 28th, when he left for Neuchâtel at 5.30 a.m., 'having taken leave of Ruskin,' who had promised to make a drawing of the grave.*

When at last the stone, inscribed with the Trevelyan family motto, 'Tyme Tryeth Troth', had been erected, Calverley felt able to return to England. He retraced his steps exactly—Pontarlier, Mouchard, Dijon, the nightingale valley, the spot where Pauline had sketched, Paris. By June 4th he was at Cowley. He wrote of the comfort of being with Moussy, 'the sister she loved so dearly and who resembled her so much in many of her best qualities'. He visited the Bath and West show, to see some of Pauline's prize-winning lace designs, a collar and cuffs worked to a design of hare-bells. Then he went to stay in Suffolk with Laura Capel Lofft, to whom he presented a mantilla that Pauline had bought in Seville in 1846. 'Before breakfast in wood thinking of dearest Pauline.' On the 28th he was at Wallington. 'Broke down this morning trying to read prayers.'

'God help you—and me too,' Dr. John Brown had written to him whilst still in Switzerland. 'I have only this moment heard.... My very dear and faithful and beloved friend she always was. There were very few—if any—left for whom I have anything like the same regard. And you—what are you to do!' This is one of several of Brown's comments on Pauline's death. To Ruskin he spoke of her as 'that loving,

* Ruskin took the girls on a tour of his favourite spots in Switzerland. They reached Denmark Hill on July 12th and Connie wrote in her diary: 'Drive into London to see Mr. Jones the artist who is one of Cussy's dearest friends. A nice petting and grave talk. Sweet run in the garden, tea and talks, and another nice petting before I went to bed.'

bright, faithful friend, such as you and I are not likely to see till we see herself, if that is ever to be!'[4]

Carlyle told Loo that Calverley had been seen in the Athenaeum, 'handling papers and looking inexpressibly sorrowful'. And Woolner wrote to her: 'That poor old Sir W. will indeed be utterly unable to get on without her. No husband's life could have been more identified with his wife's.' It was Scott who gave the news to Swinburne. 'We broke down together,' he told Alice Boyd. Later, many years afterwards, Swinburne wrote a long poem in memory of Pauline, called *After Sunset*. He also wrote a shorter sonnet about the same time:

A Study from Memory

If that be yet a living soul which here
 Seemed brighter for the growth of numbered springs
And clothed by Time and Pain with goodlier things
 Each year it saw fulfilled a fresh fleet year,
 Death can have changed not aught that made it dear;
Half humorous goodness, grave-eyed mirth on wings
Bright-balanced, blither voiced than quiring strings;
 Most radiant patience, crowned with conquering cheer;
 A spirit inviolable that smiled and sang
By might of nature and heroic need
More sweet and strong than loftiest dream or deed;
 A song that shone, a light whence music rang
 High as the sunniest heights of kindliest thought
All these must be, or all she was be nought.

George Otto told Edmund Gosse that the death of Pauline was a 'very real and permanent misfortune' to Swinburne, who in after years never spoke of her without emotion.[5]

HELD IN PERPETUITY

IN April 1867 Calverley again stayed with Laura in Suffolk. She had recently lost a nephew, and this bereavement had given them a further bond in common. On the 29th, the day of his departure, Calverley wrote: 'Before breakfast in wood,' and then the word 'Laura!', which is the only clue in any of the diaries or papers that they had become engaged to be married.

The secret was kept until the day of the wedding; not even Charles was told. Clearly both Calverley, who was seventy, and Laura, sixty, believed that they were making a symbolic union in memory of Pauline. The same parson who had officiated at Swaffham in 1835 took the service. They went straight to the Crown Inn, Sevenoaks, and the next morning looked at the trees in Knole Park that Pauline had admired just thirty-two years before. Next they went to the Albion Hotel, Hastings, 'where I was some years ago with my dearest Pauline.' And then to the Hôtel Meurice in Paris for the great new Exhibition, in its splendour the very apotheosis of the Second Empire.

Finally, on September 17th to Neuchâtel, where of course they stayed at the Bellevue—but whether in the fatal room is not recorded. While Laura discreetly did some sketching, Calverley visited the grave and trimmed the roses and ivy on it. 'Weather much the same as when here with my darling dying wife.' The next day he went again, to find that the concierge had put some pots of geraniums and fuschias on the grave, which was 'not improved' thereby. He was also very annoyed to find, when they left Neuchâtel, that they had been over-charged at the hotel.

Life at Wallington became very altered. 'How different they were, the first and the second ladies who reigned there!'[1] complained Scott. When he sent Calverley the finished Chevy Chase spandrels it was several months before they were even unpacked, and the same applied to Woolner's group. Laura got rid of Wooster. She also disliked Swinburne, though Calverley followed his career with a certain solicitude. Relations with Ruskin cooled off as a result of disagreements

over the Governor Eyre controversy. Some attempt was made to keep up with Loo, now less amazonian than Junoesque (which appealed to Robert Browning, who actually proposed to her). Unfortunately she had become very vague and impulsive, as well as tyrannical, and was apt to ask people to stay in the wilds of the Highlands and then forget all about it. So she too was dropped.

Laura grew very stout, like a bundle of knitting wool, someone said, and loved singing duets to the excruciating organ in the hall. Many guests smuggled in bottles of sherry, but would take care to suck peppermints before coming downstairs. Calverley appeared to become meaner as he approached the age of eighty. He seemed lonely to local people, who referred to him as 'that puir body'. Coffee grains were hoarded for reheating over the dining-room fire. American tinned beef was the standard diet at lunch, blancmange and fruit in the evening. The greenhouses were full of exotic plants, but no flowers were allowed in the house; a cut flower, Calverley said, was a flower in decomposition.

Nevertheless food was plentiful for guests, even if one was liable to be faced with fried puff-balls instead of potatoes and boiled stinging nettles instead of spinach. The 'full staff of servants' ate royally too. Yet, so nephews and nieces said, Calverley was always ready for a 'grave kind of mischievous fun', like frightening Laura by pretending that a burglar was outside the shutters. His gout was very much worse though—probably the reason for his starving himself. There were occasions when he could only manage to go upstairs on all fours. If guests were at all 'brainy', Calverley had an endearing way of suddenly getting up and saying: 'I think I may have something that will interest you.' And off he would disappear into the library, to return with some rare volume that was exactly right for the subject under discussion. He still had a reputation as a model landlord, and this remained with him until his death in 1879. His shorthorn herd flourished. He continued with his improvements at Seaton, where his bridge—the second to be built out of concrete in England—was opened in 1877. The visits to Nettlecombe were scarcely more frequent than in Pauline's day, so Julia's rule there was strengthened, especially when Hugh Jermyn left, first to become Vicar of Barking, then Bishop of Colombo in Ceylon, then Bishop of Brechin and Primus of Scotland.

We must skip over Ruskin's many philanthropic projects and achievements, his deepening friendship with the Hilliard family, his bouts of madness and the agonizing story of the last years of Rose La Touche. Likewise such things as the exhumation of Lizzie Rossetti,

the frequent visits of all three Rossettis to Penkill Castle and the *Fleshly School of Poetry* row do not concern this book. The final flare-up between Ruskin and Scott, resulting from Scott's review of an inno- cuous book called *Our Sketching Club*, took place in 1875, it was then that the William Downey photograph (in addition to the Wallington pictures) was dragged up by Ruskin as a *casus belli*.

George Otto married Caroline Philips, heiress to a Lancashire cotton merchant and with a considerable fortune. It was a great romance, with opposition from her family. The year 1876 saw the publication of his *Life and Letters of Lord Macaulay*, which immediately became a best-seller. His third son was born two months before its publication, in honour of which he was christened George Macaulay Trevelyan.

In 1868 George Otto was a Civil Lord of the Admiralty, but in 1870 he resigned from the Government on account of the Education Act. In 1874 his father was created a baronet. In the same year Disraeli came into power; the *Life and Letters* and *The Early History of Charles James Fox* (1880) were thus the fruits of George Otto's six years of Opposition.

Calverley's death was on March 23rd 1879. He was nearly eighty-two.

His end was a good deal more peaceful than Pauline's. Two years before he had been shaken by a fall on some ice and there had been much anxiety. He recovered, and Scott afterwards had been amazed to find no change whatsoever in his appearance. 'When I saw him', he wrote, 'even for the first time, his aspect was that of indefinite age.' To which he added: 'He was a man of the coolest temperament, yet constantly active in many minor pursuits that did not strain his intellect, only kept it occupied, avoiding excitement of every kind, preserving as a duty the normal equanimity of his pulse.'[2]

The early months of 1879 had been exceptionally chilly. About a week before Calverley died, he went down to the hothouses for some plants. Immediately afterwards he developed a cold and cough. On March 22nd he had a shivering fit and began pacing up and down the drawing-room, saying: 'I must not give in to this.' When bedtime came, his valet James wanted to help him upstairs; but Calverley would have none of it and made himself run up quickly 'like a boy'.

In the middle of the night Calverley suddenly sat up in bed and cried: 'Tumours are forming on the lungs!' Laura decided it was high time a doctor should be sent for. He was given a sedative, and when morning came was persuaded to stay in bed. He felt unable to answer

an important letter, so a reply was dictated to Laura. She went into the next room to write it, and when she came back discovered that he was lying back with his eyes closed. She bent over to kiss him, then realized he was dead.

The shock to Laura was so intense that she at once collapsed. Her mind became confused, and she was convinced that after all he was still alive. On April 1st Calverley was buried at Cambo during a heavy snow-storm. The following day Laura died.

Calverley's long and complicated will contained one clause which caused much amusement in the press and merited a humorous poem in *Punch*. This concerned the Wallington wines and spirits, which were left to a slight acquaintance, Dr. Benjamin Ward Richardson, 'for scientific purposes'.[3] Alfred was very resentful about not being left Wallington and immediately began to harass the 'bottle-nosed sharks', as he called Charles and his family. Soon he threatened to sue Charles on the grounds that the fifth baronet, Sir John Trevelyan, intended to entail Wallington as well as Nettlecombe. In due course the case went before Counsel, which gave a recommendation in favour of Charles— who nevertheless was faced not only with legal fees of £3,000 but liabilities for heavy mortgages dating back to the days of the Blacketts. Calverley had seen fit to leave nearly all the furniture and pictures at Wallington to Alfred, who had them removed to Nettlecombe. Thus Charles had to refurnish the house, which he largely did from the Duveen brothers of Hull.

When Charles died in 1886, George Otto was at the height of his career. In 1882, after the Phoenix Park murders, he was nominated Chief Secretary for Ireland. In 1884 he was Chancellor of the Duchy of Lancaster, with a seat in the Cabinet. In 1886 he became Secretary for Scotland, a post which he again filled in 1892.

The death duties he had to pay—five per cent—were considered crushing in those days. Charles had not been able to repay any of the mortgages, and the value of the rents had dropped by £2,000 a year. This could have been a serious situation, but George Otto was easily able to deal with it. In his diary for 1889 he proudly wrote: 'On the 5th March we paid off the last mortgage of £22,190. Wallington is therefore *free* for the first time since 1690, and probably long before. The Wallington mortgages have been paid off by Macaulay's copyrights, and *Life and Letters*.'

It was George Otto's eldest son, Sir Charles Philips Trevelyan, who in 1936 announced that he intended to leave Wallington and its estates to the National Trust. He had been urged to do this by his brother

G. M. Trevelyan. 'As a Socialist,' he said in a broadcast, 'I am not hampered by any sentiment of ownership. I am prompted to act as I am doing by satisfaction at knowing that the place I love will be held in perpetuity for the people of my country.'

It was a decision of which Calverley would have no doubt approved. Ruskin would most certainly have been delighted—for the whole conception of the National Trust owed something to him in the first place. Under the new Country House scheme Wallington became the second estate to be left to the Trust, the first having been Blickling. Sir Charles retained a life interest and the Trust only officially assumed control at his death in 1958. His wife continued to live in the house until she died in 1966.

But what of Nettlecombe? Ill luck dogged its history for some decades, and the estate became reduced to the park and home farm. After the Second World War the main house, denuded of all its original contents except some pictures, became a girl's school—now it is leased as a Field Studies Centre, which one cannot help feeling is more in keeping with its traditions.

A duplicate of Munro's medallion of Pauline is incongruously set into the rococo plasterwork of the wall of the staircase, and there is a memorial to her in the Church. The two Sir Johns lie in the graveyard, as do Julia and some Percevals, all in a row next to the stream. The famous pleasure gardens have mostly disappeared, but it is still a place with its own magic. A few of the Trevelyan forebears of the present owner, John Wolseley, would no doubt have found themselves bewildered by the pop group and bohemian readings at the Poetry Festival he organized in the stables, but Pauline would certainly have given her encouragement.

The National Trust has succeeded in keeping Wallington as vigorous, prosperous and interesting as it has ever been in all its history. The family link has been maintained. Above all, there is a feeling of growth and development. But like all great houses Wallington has a soul, a soul that changes but is in some respects unchangeable, that is influenced by the people who live in it, who care for it and love it, but remains always individual, itself. Wallington is now a splendid national institution. For this, as the years go by, we must be thankful to that postscript in Calverley's letter of November 6th 1862, when he so casually revealed his choice of heir.

Time has darkened the William Bell Scott pictures, but not their serious intention. The white marble of the Woolner group still glows

freshly. Across the hall, with that old odd mixture of fun and pathos, Pauline's face looks towards the group, and at her pilaster of ferns, Ruskin's pilaster of cornflowers and Arthur Hughes's of dog-roses. She seems pleased with her creation. She also seems to be listening— perhaps to Algernon declaiming from Victor Hugo, or to the waves on the pebble beach below her villa at Seaton.

Seaton from above Beer Beach

ACKNOWLEDGEMENTS AND SOURCES

THIS book is based on the Trevelyan mss at the University Library, Newcastle-upon-Tyne, and on other family papers. As long ago as 1905 Sir Charles Dilke remarked that the letters from Ruskin to Pauline Trevelyan deserved publication. Six of them have since appeared in the Cook and Wedderburn collected Works, and a few may have reached other collections. It has only been possible here to quote a small amount from the material available, with a certain emphasis on the Ruskin marriage. Nevertheless a complete annotated edition of the entire collection at Newcastle is being prepared by Virginia Surtees in collaboration with the author.

It is sad that Pauline's diaries and journals, and Calverley's journals for the years when she was most involved with the Pre-Raphaelite circle, should have mysteriously disappeared. Possibly they were destroyed in a flood at Nettlecombe or when a Capel Lofft house was blitzed in London. Eight Swinburne letters survive and have been published in collected editions. Some of Pauline's articles and correspondence have been printed in David Wooster's not very lively opus, published in 1879. Other letters are to be found in D. W. Forrest's book on Dr. John Brown, and there are letters from Pauline in William Bell Scott's *Autobiographical Notes*.

I must first thank Mrs. Pauline Dower, eldest daughter of Sir Charles Philips Trevelyan and the main trustee for the Trevelyan mss, for her unfailing help, hospitality and enthusiasm. I owe a great debt to Raul Balin, who has helped me in innumerable essential ways. Mrs. Virginia Surtees put me on to important trails and has been generous with her expert knowledge. I also am very indebted to Alistair Elliot of the Newcastle University Library, and to the Marquess and late Marchioness of Northampton, who made the Louisa Stewart-Mackenzie (Ashburton) correspondence available to me. My cousin Orme Hancock has provided me with much family information, as have other 'descendants of Maria': Mrs. Mary Cooper, Kate Forbes and Rosemary Hancock. On the Jermyn side my gratitude goes in particular to Sheelah Hynes, Pauline's great-niece. Mrs. Sheila Pettit of the National Trust must also rank high in this list of acknowledgements; it has been a pleasure to observe her love for Wallington.

Anyone writing about the Ruskin marriage must rely on the un-

ravelling in Mary Lutyens's three volumes. She has read my typescript with characteristically scrupulous care. Timothy Burnett and Professor K. J. Fielding have also read the book and have my gratitude. I can only single out a few of the many kind people who have given up their time on my behalf: Dr. Frank Allen, Professor Ramon Araluce, Professor J. L. Bradley, Mrs. Joan Browne-Swinburne, Mrs. Ann Churchill, the late Mrs. Arnold Churchill, Ivor P. Collis of the Somerset Record Office, John Cornforth, Evelyn Courtney-Boyd, laird of Penkill Castle, Leslie Cowan, James S. Dearden of the Ruskin Galleries, Bembridge, J. M. Edmonds late of the University Museum, Oxford, Robert S. Fraser, Professor W. E. Fredeman, Robin Gard of the County of Northumberland Record Office, Rosalie Glynn Grylls, Eileen Gosney, Lt.-Col. Rowland Jermyn, Janet P. Gnosspelius, Geoffrey Halliday, Glenys Halsey, Christina M. Hanson, Dr. H. C. Harley, Osbert Wyndham Hewitt, Diana Holman-Hunt, Peter Jolly, Professor Cecil Y. Lang, Jeremy Maas, John S. Mayfield, Kitty Millar, Diana Mysak, Frederick M. O'Dwyer, Dr. Roger W. Peattie, Jean F. Preston, Dr. F. W. Roberts, Professor C. R. Sanders, Mrs. Jane Sharpe, Frank Taylor of the John Rylands Library, J. G. Thackray, Deborah Willis, John Wolseley, Richard Ormond, and Dr. A. L. Rowse.

Dr. Gilbert Leathart let me read and quote from his grandfather's correspondence, and I am grateful to Alan Cole for showing me Constance Hilliard's diaries, and to Mrs. Vera Smith for lending me her thesis on William Bell Scott for Durham University.

The letters from Ruskin in the Trevelyan collection are published by permission of the Ruskin Literary Trustees and George Allen and Unwin Ltd.; from Effie by permission of Sir Ralph Millais, Bt.; from Woolner by permission of Major-Gen. C. G. W. Woolner. I am grateful to the Pierpont Morgan Library for letting me quote from the letters from Pauline to Ruskin in the Viljoen collection; again to the Pierpont Morgan Library, and to John Murray Ltd., for letters in the Bowerswell collection; to Princeton University Library for letters to William Bell Scott in the Troxell collection; to the University of British Columbia Library for letters from Scott to Alice Boyd in the Penkill collection; the Bodleian Library for letters from Acland to Ruskin. Ruskin's punctuation has been followed as faithfully as possible, but in some other cases—particularly Effie's—some discreet editing has been necessary.

The following plates are published by permission of: Mrs. Ann Churchill 3b; Sir Ralph Millias, Bt. 2b; The National Trust, Wallington 1a, 1c, 2c, 2d, 3a, 3c, 3d, 4a; John Wolesley 1b.

REFERENCES

Note: *Works* refers to the Cook and Wedderburn collected works of Ruskin. Letters to Effie and her family are in the Bowerswell collection.

Ch. 1. *The Jermyns*, pp. 7–15: **1.** *Memoir of the Rev. John Stevens Henslow*, L. Jenyns, London, 1862, p. 3. **2.** Wooster, p. 222.

Ch. 2. *The Trevelyans*, pp. 16–24: **1.** Memoir of Sir Walter Blackett, p. xxxv. **2.** Hewitt, *Listener*. **3.** Letter written probably in 1858 to Dr. J. Brown, quoted Forrest, p. 333, and erroneously dated 1846; now in Nat. Lib. of Scotland.

Ch. 3. *Neuchâtel, Athens, Lisbon*, pp. 25–23: **1.** Shairp, p. 265. **2.** Trinity College Lib., Cambridge, Whewell MSS. **3.** *Praeterita, Works* 35, pp. 206–7. **4.** Chambers, p. xx. **5.** *Murray's Handbook*, 1855 (J. M. Neale).

Ch. 4. *Friendship with the Ruskins*, pp. 34–48: **1.** *Works* 35, p. 457. **2.** Bowerswell Papers, quoted Lutyens I, p. 96f. **3.** *Atlantic Monthly*, XCIII, May 1901, p. 577. **4.** *Works* 35, p. 522. **5.** Viljoen Coll. **6.** *Works* 35, p. 503. **7.** Keith, p. 68. **8.** *Charles Henry Pearson*, ed. Wm. Stebbing, London, 1900, p. 84. **9.** Lutyens I, pp. 134–141. **10.** Woodham-Smith, p. 370. **11.** *Ibid.*, p. 368. **12.** Henry James, p. 198. **13.** *The Prophecies of the Brahan Seer*, Alexander Mackenzie, Stirling, 1909.

Ch. 5. *Obedience to Dr. Simpson*, pp. 49–66: **1.** Lutyens II, p. 171. **2.** Forrest, p. 88. **3.** Quoted *Ruskin's Letters from Venice*, J. L. Bradley, Yale, 1955, p. 18.

Ch. 6. *A Fateful Visit*, pp. 67–80: **1.** Scott II, p. 6. **2.** Cornforth II. **3.** January 1853. *Diary of the Old Water Colour Society*, London, 1941. **4.** Lutyens III, pp. 42–3. **5.** Hewitt, pp. 50–1. **6.** *Works* 12, p. xix. **7.** *Works* 35, p. 458. **8.** *Works* 12, p. xx, except last sentence. Original at Yale. **9.** Troxell Coll. Princeton. Omitted from *Autobiographical Notes*. **10.** Joan Evans in *Millais' Drawings of 1853, Burlington Magazine* XCII, July 1950. *Cf.* Ironside & Gere, p. 41. **11.** Huntingdon Lib. **12.** J. G. Millais I, p. 196.

Ch. 7. *Glenfinlas*, pp. 81–88: **1.** *Cf.* Wilenski, one of the first to mention this. **2.** Atlay, p. 174. **3.** Lutyens III, p. 73. **4.** Huntingdon Lib. **5.** Whitehouse, p. 12. **6.** *Ibid.*, p. 25. **7.** Lutyens III, p. 100 (Lutyens Coll.). **8.** *Ibid.*, p. 120 (Bowerswell Coll.). **9.** Leon, p. 190. **10.** Lutyens III, p. 123. **11.** James, p. 211. **12.** As pointed out by Mary Lutyens. **13.** *Works* 12, p. xxxiii.

Ch. 8. *The Scandal*, pp. 89–106: **1.** *Works* 12, p. xxxiv. **2.** Diary November 19th 1853. Evans & Whitehouse. **3.** Yale. Partly quoted Lutyens III, p. 114. **4.** Lutyens III, p. 195. **5.** Scott II, pp. 256–7. **6.** May 9th 1854. *New Letters & Memorials of Jane Welsh Carlyle* II, ed. Alexander Carlyle, London & New York, 1903, pp. 76–7. **7.** May 17th 1854. Letter to John Forster. Nat. Lib. of Scotland, quoted *The Letters of Mrs. Gaskell*, ed. J. A. V. Chapple & Arthur Pollard, Manchester, 1966. *Cf.* Lutyens I, pp. 61, 65–6 etc. **8.** Bodleian. Ms Acland, d. 72. **9.** *Ibid.*, July 18th 1854. **10.** Letter quoted in full in *Works* 36, pp. 174–7.

REFERENCES

Ch. 9. *Enter Scotus*, pp. 107–120: **1.** Packer, p. 62 *et seq.* **2.** Doughty, p. 163. **3.** Atlay, p. 24. **4.** Pierpont Morgan Lib. **5.** Scott II, p. 5. **6.** *Ibid.*, p. 257. **7.** *Ibid.*, p. 256. **8.** Troxell Coll. **9.** Hewitt, p. 14. **10.** Lutyens III, pp. 212–13. **11.** Letter undated, at Bembridge. **12.** Scott II, p. 9.

Ch. 10. *The Circle Grows*, pp. 121–132: **1.** Lochhead, p. 116. **2.** *Mrs. Brookfield and Her Circle* II, Charles and Frances Brookfield, London, 1905, p. 500. See also Gaskell to C. E. Norton, June 24th 1861, *Letters, op. cit.*, p. 661 and Hudson, p. 97 (a slight variation). **3.** Amy Woolner, p. 114. **4.** *Ibid.*, p. 148. **5.** Tuckwell, p. 48. **6.** Letter to Acland January 20th 1859, quoted *The Oxford Museum*, p. 83 (1893 ed.). **7.** Hare II, p. 276 *et seq.* **8.** Amy Woolner, p. 121. **9.** Scott II, p. 34. **10.** *Ibid.*, pp. 11–12. **11.** *Some Reminiscences* II, pp. 261–2. **12.** Packer, p. 111.

Ch. 11. *Poets and Love Frustrated*, pp. 133–145: **1.** Scott II, p. 14. **2.** Lafourcade, *A Literary Biography*, p. 53. **3.** Lang III, p. 150; Gosse, p. 48. **4.** Lang III, p. 298. 'My father's coeval friend and old schoolfellow'. **5.** Lang IV, p. 128. **6.** Scott II, pp. 15–16. **7.** *The New Terror*, pub. in the *Fortnightly Review*, December 1892. **8.** Gosse, p. 51. **9.** Origo, p. 169. **10.** Mitford, p. 221. **11.** Quoted Scott II, p. 55. **12.** Packer, pp. 110–117. In fairness it must be said that Mrs. Packer's book has many fine qualities, deservedly admired by students of the Pre-Raphaelites. **13.** Gosse, p. 54. **14.** *Life and Letters*. **15.** Lafourcade I, p. 107. **16.** *Works* 7, p. xli.

Ch. 12. *The Lions and the Lionized*, pp. 146–162: **1.** *Works* 7, p. xlvii. **2.** H. Trevelyan, p. 70. **3.** Scott II, p. 57. **4.** Packer, p. 140. **5.** Gosse, p. 49. **6.** Lang I, p. 76. Letter dated *c.* February 10th 1863. **7.** Scott II, p. 18. **8.** *Cf.* D. Holman-Hunt, p. 215 *et seq*, and for details of Annie's 'indiscretions' with Rossetti, which caused a breach between him and Hunt. **9.** Fox I, p. 276. **10.** March 6th 1859. **11.** Williams-Ellis, p. 240. **12.** Virginia Surtees suggests an alternative date for this letter: November 30th 1863. **13.** Lang I, pp. 28–9. *Cf.* Lang for identifications of all literary allusions in Swinburne's letters. **14.** *Ibid.*, p. 35. Letter to his mother, April 15th 1860. **15.** Scott II, p. 64. **16.** James II, pp. 195 *et seq.* **17.** Letter dated December 4th 1862; *New Letters of Thomas Carlyle* II, ed. Alexander Carlyle, London & New York, 1904, p. 215. **18.** West, p. 249. **19.** Tuckwell, p. 50.

Ch. 13. *Sacred and Profane*, pp. 163–179: **1.** Quoted Scott II, p. 55. **2.** Gosse, p. 67. **3.** Hunt II, p. 219; Hudson, p. 92. **4.** G. M. Trevelyan, pp. 50–1; H. Trevelyan, pp. 70–87. **5.** Lafourcade I, p. 178. **6.** Pope-Hennessey I, p. 130. **7.** Quoted Burd, p. 287. **8.** Quoted Origo, pp. 173–4. **9.** June 27th 1861. **10.** Macdonald, p. 103 *et seq.* **11.** Not included in *Autobiographical Notes*. Troxell Coll. **12.** Gosse, pp. 71–2. **13.** Forrest, p. 294; *Works* 36, p. 396. **14.** Ellis, pp. 78–9.

Ch. 14. *A House and its Inheritance*, pp. 180–191: **1.** Letter in *Works* 36, pp. 413–15. **2.** *Ibid.*, pp. 421–2. **3.** Hare II, p. 277 & 348–52. **4.** *The Education of Henry Adams*, Mass. Hist. Soc., 1918, pp. 139–40. **5.** Scott II, p. 69. **6.** Mayfield, pp. 81–94.

Ch. 15. *Tempted to In-Constancy*, pp. 194–209: **1.** *Works* 36, p. 454. **2.** *Works* 35, p. 457. **3.** Huntingdon Lib.: quoted Surtees, pp. 51–2. **4.** *Works* 35, p. 457; in this passage Ruskin mistakenly says he was on his way to Edinburgh—hence error in date, 1853 instead of 1863. **5.** *Cf.* Surtees, p. 256. **6.** Letter reproduced

247

facsimile Forrest, pp. 162–3. **6.** Forrest, pp. 167–8. **7.** Lang I, p. 70. **8.** Gosse, p. 106. **9.** Macdonald, p. 108. **10.** Leon, pp. 359–60. **11.** *Works* 35, p. 458. **12.** Hudson, p. 166. **13.** *Cf.* Lang I, pp. 84–5 & 100. **14.** Leathart Coll. **15.** *Cf.* D. Holman-Hunt *passim*. **16.** G. M. Trevelyan, p. 68. **17.** Forrest, p. 183.

Ch. 16. *Trouble with Algernon*, pp. 210–230: **1.** G. M. Trevelyan, p. 72. **2.** *Cf.* Doughty & Wahl II, p. 522. **3.** *Letters & Memorials* III, p. 522. **4.** Wilson, pp. 568–9. **5.** Norton I, p. 157. **6.** Hudson, pp. 127 & 161. **7.** British Museum Ashley MSS A 1888 vol. VII—46. **8.** Correspondence re withdrawal of permission in 1916 divided between B. M. Ashley MSS & Brotherton Coll., Leeds. *Cf. A Swinburne Library*, T. J. Wise, London, 1925. Proof of letters in unpub. version now in B.M. **9.** D. Holman-Hunt, pp. 286–91. **10.** Lutyens, Cornhill. **11.** March 16th 1866; Bradley, p. 64. **12.** *Works* 35, p. 636. **13.** Lang I, p. 159. **14.** *Ibid.*, p. 182. **15.** Collingwood, p. 176. **16.** Hewitt, *Listener*. **17.** May 3rd 1866. *The Letters of Thomas Carlyle to his brother Alexander*, ed. E. W. Marrs, Cambridge Mass., 1968, p. 751.

Ch. 17. *That Loving, Bright, Faithful Friend*, pp. 231–237: **1.** *Works* 18, p. xlvii. **2.** Bodleian Ms Eng. Letters C. 43–4. **3.** September 12th 1866. Lang I, p. 183. **4.** *Works* 36, p. xcviii. **5.** Gosse, p. 324.

Ch. 18. *Held in Perpetuity*, pp. 238–243: **1.** Scott II, p. 256. **2.** *Ibid.*, pp. 252–3. **3.** *Cf. Macmillan's Magazine* vol. 41, p. 231 *et seq.*

BIBLIOGRAPHY

Henry W. Acland and John Ruskin, *The Oxford Museum*, London, 1859 and 1893.

Helen Rossetti Angeli, *Dante Gabriel Rossetti: His Friends and Enemies*, London, 1949.

Helen Rossetti Angeli, *Pre-Raphaelite Twilight*, London, 1954.

Anon, *Memoirs of the Public Life of Sir Walter Blackett, Bart*, 1819.

Arts Council, *Ruskin and his Circle*, exhibition catalogue, 1964.

Betty Askwith, *Lady Dilke*, London, 1969.

J. B. Atlay, *Henry Acland, a Memoir*, London, 1903.

Sheila Birkenhead, *Illustrious Friends*, London, 1965.

David J. Black, *Hermits and Termits*, Edinburgh, 1972.

Trudy Bliss, *Jane Welsh Carlyle: A New Selection of her Letters*, London, 1949.

John Lewis Bradley, *Ruskin's Letters from Venice*, Yale, 1955.

John Lewis Bradley, *The Letters of John Ruskin to Lord and Lady Mount-Temple*, Columbus, Ohio, 1964.

BIBLIOGRAPHY

David Bruce, *Sun Pictures: the Hill-Adamson Calotypes*, London, 1973.

Van Akin Burd, *The Winnington Letters of John Ruskin*, London, 1969.

G. H. O. Burgess, *Frank Buckland*, London, 1967.

Georgiana Burne-Jones (G.B.J.), *Memorials of Edward Burne-Jones*, London, 1904.

Francis T. Buckland (ed.), *Geology and Mineralogy by the late William Buckland*, London, 1858.

R. J. E. Bush and G. V. S. Corbett, *Nettlecombe Court*, two articles in *Field Studies*, vol. 3, no. 2, p. 275 and p. 289, September 1970.

Ian Campbell, *Thomas Carlyle*, London, 1974.

Robert Chambers, *Vestiges of the Natural History of Creation*, 12th ed., intro. Alexander Ireland, London & Edinburgh, 1884.

Kenneth Clark, *Ruskin Today*, London, 1964.

W. G. Collingwood, *The Life of John Ruskin*, London, 1911.

A. O. J. Cockshut, *Truth to Life*, London, 1974.

E. T. Cook and Alexander Wedderburn, *The Works of John Ruskin*, 39 vols, London, 1903–12.

John Cornforth, *Wallington, Northumberland*, 3 articles in *Country Life*, vol. CXLVII, pp. 854, 922, 986, April 16th, 23rd, 30th, 1970.

John Cornforth, Sheila Pettit and Lewis Jackson-Stops, *Wallington*, National Trust official guide.

James S. Dearden, *John Ruskin*, Aylesbury, 1973.

Emilia Francis Dilke, *The Book of the Spiritual Life*, including a memoir by Sir Charles Dilke, London, 1905.

Oswald Doughty, *A Victorian Romantic*, London, 1949.

Oswald Doughty and J. R. Wahl, *Letters of Dante Gabriel Rossetti*, Oxford, 1965–7.

S. M. Ellis, *A Mid-Victorian Pepys*, London, 1923.

Joan Evans, *John Ruskin*, London, 1954.

Joan Evans and John Howard Whitehouse, *The Diaries of John Ruskin*, Oxford, 1956–9.

G. H. Fleming, *Rossetti and the Pre-Raphaelite Brotherhood*, London, 1967.

Caroline Fox, *Memories of Old Friends*, London, 1882.

D. W. Forrest *et al.*, *Letters of Dr. John Brown*, London, 1907.

William E. Fredeman, *Pre-Raphaelitism, a Bibliocritical Guide*, Harvard, 1965.

William E. Fredeman, *The Letters of Pictor Ignotus*, Part I, Bulletin of the John Rylands University Library of Manchester, vol. 58, Autumn 1975, no. 1.

James Anthony Froude, *Letters and Memorials of Jane Welsh Carlyle, prepared for publication by Thomas Carlyle*, London, 1883.

Jean Overton Fuller, *Swinburne: A Critical Biography*, London, 1968.

William Gaunt, *The Pre-Raphaelite Tragedy*, London, 1943.

John Gloag, *Mr. Loudon's England*, Newcastle, 1970.

Edmund Gosse, *The Life of Algernon Charles Swinburne*, London, 1917.

Edmund Gosse and Thomas James Wise, The *Letters of Algernon Swinburne*, London, 1918.

BIBLIOGRAPHY

Rosalie Glynn Grylls, *Portrait of Rossetti*, London, 1964.

Lawrence and Elizabeth Hanson, *Necessary Evil*, London, 1952.

Augustus J. C. Hare, *The Story of My Life*, vol. 2, London, 1896.

Humphrey Hare, *Swinburne*, London, 1949.

Philip Henderson, *Swinburne: The Portrait of a Poet*, London, 1974.

Osbert Wyndham Hewitt, *Without the Passion of Love*, article in the *Listener*, January 23rd 1958.

Osbert Wyndham Hewitt, *. . . and Mr. Fortescue*, London, 1958.

John Hodgson, *A History of Northumberland*, Part, II, vol. II, Newcastle, 1832.

Diana Holman-Hunt, *My Grandfather, his Wives and Loves*, London, 1969.

William Holman Hunt, *Pre-Raphaelitism and the Pre-Raphaelite Brotherhood*, London, 1905.

Graham Hough, *The Last Romantics*, London, 1949.

Derek Hudson, *Munby, Man of Two Worlds*, London, 1972.

Randolph Hughes, *Unpublished Swinburne, Life and Letters*, vol. 56, no. 125, January 1948.

Randolph Hughes, commentary in *Lesbia Brandon* by Algernon Swinburne, London, 1952.

Robin Ironside, *Pre-Raphaelite Paintings at Wallington*, article in *Architectural Review*, XCII, p. 147, December 1942.

Robin Ironside and John Gere, *Pre-Raphaelite Painters*, London, 1948.

William Irvine and Park Honan, *The Book, the Ring and the Poet*, London, 1974.

Henry James, *William Wetmore Story*, Boston, 1903.

Admiral Sir William James, *The Order of Release*, London, 1947.

Michael Joyce, *Edinburgh: The Golden Age*, London, 1951.

Edward Keith, *Memories of Wallington*, privately printed, 1939.

Georges Lafourcade, *La Jeunesse de Swinburne*, 2 vols, Paris and Oxford, 1928.

Georges Lafourcade, *Swinburne: a Literary Biography*, London, 1932.

Cecil Y. Lang, *The Swinburne Letters*, 6 vols, Yale, 1959–62.

Mary Leith, *The Boyhood of Algernon Charles Swinburne*, London, 1917.

Derrick Leon, *Ruskin The Great Victorian*, London, 1949.

J. G. Links, *The Ruskins in Normandy*, London, 1968.

Marion Lochhead, *Elizabeth Rigby, Lady Eastlake*, London, 1961.

Edward Lurie, *Louis Agassiz*, Chicago, 1960.

Mary Lutyens, *The Ruskins and the Grays* ('Lutyens I'), London, 1972.

Mary Lutyens, *Effie in Venice* ('Lutyens II'), London, 1965.

Mary Lutyens, *Millais and the Ruskins* ('Lutyens III'), London, 1967.

Mary Lutyens, *The Millais-La Touche Correspondence*, article in the *Cornhill*, no. 1051, p. 1, Spring 1968.

Jeremy Maas, *Victorian Painters*, London, 1969.

Jeremy Maas, *Gambart*, London, 1976.

BIBLIOGRAPHY

Greville Macdonald, *Reminiscences of a Specialist*, London, 1932.

Averil Mackenzie-Grieve, *Clara Novello*, London, 1955.

John S. Mayfield, *Swinburneiana*, privately printed, 1974.

John Guille Millais, *The Life and Letters of Sir John Millais*, London, 1899.

Nancy Mitford, *The Stanleys of Alderley*, London, 1939.

John Nicoll, *The Pre-Raphaelites*, London, 1970.

Harold Nicolson, *Swinburne*, London, 1926.

Sara Norton etc., *Letters of Charles Eliot Norton*, New York, 1913.

Iris Origo, *A Measure of Love*, London, 1957.

Ashford Owen (Anne Ogle), *A Lost Love*, London, 1920 ed.

Lona Mosk Packer, *Christina Rossetti*, Berkeley, 1963.

James Pope-Hennessy, *Monckton Milnes*, London, vol. 1, 1949, vol. 2, 1951.

Peter Quennell, *John Ruskin, The Portrait of a Prophet*, London, 1949.

Christopher Ricks, *Tennyson*, London, 1972.

William M. Rossetti, *Dante Gabriel Rossetti: His Family Letters*, London, 1895.

William M. Rossetti, *Ruskin: Rossetti: Pre-Raphaelitism*, London, 1899.

William M. Rossetti, *Some Reminiscences*, New York, 1902.

William M. Rossetti, *Rossetti Papers*, London, 1903.

William Bell Scott, *Autobiographical Notes*, 2 vols, London, 1892.

John Campbell Shairp et al., *Life and Letters of James David Forbes FRS*, London, 1873.

John A. Shepherd, *Simpson and Syme of Edinburgh*, Edinburgh, 1969.

Myrtle Simpson, *Simpson the Obstetrician*, London, 1972.

John G. Smith, *History of Charlton*, privately published, 1970.

Lionel Stevenson, *The Pre-Raphaelite Poets*, University of North Carolina, 1972.

Virginia Surtees, *Dante Gabriel Rossetti*, a catalogue raisonné, Oxford, 1971.

Virginia Surtees, *Sublime and Instructive*, London, 1972.

'T'., *Nettlecombe Court, Somerset*, article in *Country Life*, vol. XXIII, p. 162, February 1st 1908.

Charles Tennyson, *Alfred Tennyson*, London, 1949.

Anna Ticknor, *Life, Letters and Journals of George Ticknor*, 2 vols, Boston, 1876.

Sir Charles Trevelyan, *Wallington, its History and Treasures*, privately published and printed by Co-operative Wholesale Society's Printing Works, Pelaw-on-Tyne, 1930.

George Macaulay Trevelyan, *Sir George Otto Trevelyan*, London, 1932.

George Otto Trevelyan, *The Life and Letters of Lord Macaulay*, London, 1876.

Sir George Otto Trevelyan, *Wallington*, articles in *Country Life* vol. XLIII, pp. 572, 592, June 22nd and 29th, 1918.

Humphrey Trevelyan, *The India We Left*, London, 1972.

Janet Troxell, *Three Rossettis*, Harvard, 1937.

Rev. W. Tuckwell, *Reminiscences of Oxford*, London, 1901.

BIBLIOGRAPHY

Helen Gill Viljoen, *The Brantwood Diary*, Yale, 1971.

Maisie Ward, *Robert Browning and his World*, London, 1969.

Patricia Wardle, *Victorian Lace*, London, 1968.

Geoffrey West, *Charles Darwin*, London, 1937.

J. Howard Whitehouse, *Vindication of Ruskin*, London, 1950.

R. H. Wilenski, *John Ruskin*, London, 1933.

Amabel Williams-Ellis, *The Tragedy of John Ruskin*, London, 1928.

David Alec Wilson and David Wilson MacArthur, *Carlyle in Old Age*, London, 1934.

Cecil Woodham-Smith, *The Great Hunger*, London, 1962.

Amy Woolner, *Thomas Woolner R.A.*, London, 1917.

David Wooster, *Literary and Artistic Remains of Paulina Jermyn Trevelyan*, London and Newcastle, 1879.

Arthur Young, *Six Months Tour in the North of England*, vol. 3, 1771.

INDEX